Aramaic Bowl Spells

Magical and Religious Literature of Late Antiquity

Series Editors

Shaul Shaked z"l
Siam Bhayro

VOLUME 10

The titles published in this series are listed at *brill.com/mrla*

Jewish Babylonian Aramaic Bowls

VOLUME 2

Manuscripts in the Schøyen Collection

VOLUME 41

In memoriam Shaul Shaked z"l (1933–2021)

Aramaic Bowl Spells

Jewish Babylonian Aramaic Bowls
Volume Two

By

Shaul Shaked z"l
James Nathan Ford
Siam Bhayro

With contributions from

Anne Burberry
Matthew Morgenstern
Naama Vilozny

BRILL

LEIDEN | BOSTON

Cover illustration: JBA 73 (MS 2053/126)

The photographs in this volume were taken by Professor Matthew Morgenstern, with the exception of no. 1, which was supplied by Dr Martin Schøyen. The drawings in this volume were created by Dr Naama Vilozny. All photographs and drawings are used with kind permission.

© photographs: Professor Matthew Morgenstern and the Schøyen Collection

© drawings: Dr Naama Vilozny

The Library of Congress Cataloging-in-Publication Data is available online at http://catalog.loc.gov
LC record available at http://lccn.loc.gov/2013009563

Typeface for the Latin, Greek, and Cyrillic scripts: "Brill". See and download: brill.com/brill-typeface.

ISSN 2211-016X
ISBN 978-90-04-47170-2 (hardback)
ISBN 970-90-04-47171-9 (e-book)

Copyright 2022 by Shaul Shaked, James Nathan Ford and Siam Bhayro. Published by Koninklijke Brill NV, Leiden, The Netherlands.
Koninklijke Brill NV incorporates the imprints Brill, Brill Nijhoff, Brill Hotei, Brill Schöningh, Brill Fink, Brill mentis, Vandenhoeck & Ruprecht, Böhlau Verlag and V&R Unipress.
Koninklijke Brill NV reserves the right to protect this publication against unauthorized use. Requests for re-use and/or translations must be addressed to Koninklijke Brill NV via brill.com or copyright.com.

This book is printed on acid-free paper and produced in a sustainable manner.

Dedicated to Miriam Shaked, with warmth, admiration and gratitude.

Contents

Preface XIII
List of Figures XIV
List of Photographs XV
Abbreviations XVI
List of Other Bowls XVIII
Sigla XIX

Introduction. Seals: Function and Meaning 1
 Shaul Shaked z"l
Note on qnyyn' "property" and qyn' "family" 9

I.3
Seals

Introduction 13

I.3.1
Seven Seals

Introduction 17
JBA 65 (MS 1911/1) 19
JBA 66 (MS 1927/46) 22
JBA 67 (MS 2053/56) 25
JBA 68 (MS 2053/57) 28
JBA 69 (MS 2053/90) 30
JBA 70 (MS 2053/92) 32
JBA 71 (MS 2053/113) 36
JBA 72 (MS 2053/119) 38
JBA 73 (MS 2053/126) 40
JBA 74 (MS 2053/131) 44
JBA 75 (MS 2053/139) 46
JBA 76 (MS 2053/143) 49
JBA 77 (MS 2053/153) 52
JBA 78 (MS 2053/187) 55
JBA 79 (MS 2053/201) 57
JBA 80 (MS 2053/221) 61

I.3.2
The Seals of Ashmedai

Introduction 65
JBA 81 (MS 1927/36) 67
JBA 82 (MS 2053/39) 70
JBA 83 (MS 2053/121) 73
JBA 84 (MS 2053/144) 75
JBA 85 (MS 2053/147) 77
JBA 86 (MS 2053/226) 80

I.3.3
The Seal of Yokabar Ziwa

Introduction 87
JBA 87 (MS 2053/47) 88
JBA 88 (MS 2053/248) 90

I.3.4
The Bond of the Lion and the Seal of the Dragon

Introduction 95
JBA 89 (MS 1929/2) 96

I.3.5
Seven Bonds and Eight Seals

Introduction 101
JBA 90 (MS 2053/125) 102

I.4
Signet-Rings

Introduction 107

I.4.1
The Signet-Ring of Solomon

Introduction 111

I.4.1.1
The Lilith Gannav(at)/Gannaqat

Introduction 114
JBA 91 (MS 1927/38) 116
JBA 92 (MS 1927/54) 120
JBA 93 (MS 2053/15) 123
JBA 94 (MS 2053/51) 126
JBA 95 (MS 2053/69) 129
JBA 96 (MS 2053/94) 137
JBA 97 (MS 2053/104) 140
JBA 98 (MS 2053/140) 142
JBA 99 (MS 2053/173) 146
JBA 100 (MS 2053/211) 151
JBA 101 (MS 2053/215) 154

I.4.1.2
From Ashmedai and from All His Army

Introduction 158
JBA 102 (MS 1929/11) 161

JBA 103 (MS 2053/196) 164
JBA 104 (MS 2053/238) 169

I.4.1.3
The Bond and Seal of Arion Son of Zank

Introduction 178
JBA 105 (MS 1928/22) 179
JBA 106 (MS 1928/38) 182

I.4.1.4
Other Spell Units

Introduction 186
JBA 107 (MS 1929/7) 187
JBA 108 (MS 2053/218) 190
JBA 109 (MS 2053/230) 194
JBA 110 (MS 2053/240) 197

I.4.2
The Signet-Ring of El Shaddai

Introduction 201
JBA 111 (MS 1929/13) 202
JBA 112 (MS 2053/84) 205

I.4.3
The Signet-Ring of ʿwrbyd

Introduction 209
JBA 113 (MS 1927/14) 210
JBA 114 (MS 2053/45) 212
JBA 115 (MS 2053/129) 214

I.4.4
Other Signet-Rings

Introduction 219
JBA 116 (MS 1927/50) 220
JBA 117 (MS 2053/59) 224
JBA 118 (MS 2053/88) 226
JBA 119 (MS 2053/142) 228

Bibliography 231
Glossary 236
List of Divine Names, Names of Angels, Demons and Exemplary Figures, and *nomina barbara* 289
List of Clients and Adversaries 301
List of Biblical Quotations 309
List of Texts 310
List of Published Works in the Manuscripts in the Schøyen Collection Series 312
Index 314

Preface

This is the second of an envisaged seven volumes of Jewish Babylonian Aramaic magic bowls from the Schøyen Collection. It contains texts JBA 65 to JBA 119. Various factors delayed the appearance of the present volume, but it is hoped that subsequent volumes will appear in a more expeditious manner.

As with the first volume, we are grateful to Dr Naama Vilozny for providing illustrations and descriptions of the images contained in the bowls. We are grateful to Professor Matthew Morgenstern for his generous advice on various linguistic problems in the texts and for permission to use his photographs, both in this volume and on the Virtual Magic Bowl Archive (VMBA). The VMBA is in the process of being updated and upgraded; hopefully, there will be a full update on this in the next volume. We are also grateful to Siam Bhayro's erstwhile student, Dr Anne Burberry, for producing the Glossary and Lists, as well as checking the editions. Finally, we would like to thank our publisher and typesetter for their patience and expertise, particularly Erika Mandarino, Katelyn Chin, and, more recently, Emma de Looij and Bart Nijsten.

It was with great sadness and a profound sense of loss that, as this volume was being typeset, we learned of the passing of our friend, colleague and mentor, Professor Shaul Shaked.

List of Figures

1	Artist's impression of image from JBA 65	19
2	Artist's impression of image from JBA 66	22
3	Artist's impression of image from JBA 67	25
4	Artist's impression of image from JBA 71	36
5	Artist's impression of image from JBA 72	38
6	Artist's impression of image from JBA 73	40
7	Artist's impression of image from JBA 75	46
8	Artist's impression of image from JBA 76	49
9	Artist's impression of image from JBA 78	55
10	Artist's impression of image from JBA 79	57
11	Artist's impression of image from JBA 80	61
12	Artist's impression of image from JBA 81	67
13	Artist's impression of image from JBA 86	80
14	Artist's impression of image from JBA 88	90
15	Artist's impression of image from JBA 91	116
16	Artist's impression of image from JBA 96	137
17	Artist's impression of image from JBA 99	146
18	Artist's impression of image from JBA 103	164
19	Artist's impression of image from JBA 105	179
20	Artist's impression of image from JBA 107	187
21	Artist's impression of image from JBA 108	190
22	Artist's impression of image from JBA 109	194
23	Artist's impression of image from JBA 111	202

List of Photographs

1	JBA 65 (MS 1911/1)	21		38	JBA 95 (MS 2053/69)—exterior e	135
2	JBA 66 (MS 1927/46)	24		39	JBA 95 (MS 2053/69)—exterior f	135
3	JBA 67 (MS 2053/56)	27		40	JBA 95 (MS 2053/69)—exterior g	136
4	JBA 68 (MS 2053/57)	29		41	JBA 95 (MS 2053/69)—exterior h	136
5	JBA 69 (MS 2053/90)	31		42	JBA 96 (MS 2053/94)	139
6	JBA 70 (MS 2053/92)	34		43	JBA 97 (MS 2053/104)	141
7	JBA 70 (MS 2053/92)—exterior	35		44	JBA 98 (MS 2053/140)	145
8	JBA 71 (MS 2053/113)	37		45	JBA 99 (MS 2053/173)	150
9	JBA 72 (MS 2053/119)	39		46	JBA 100 (MS 2053/211)	153
10	JBA 73 (MS 2053/126)	43		47	JBA 101 (MS 2053/215)	156
11	JBA 74 (MS 2053/131)	45		48	JBA 102 (MS 1929/11)	163
12	JBA 75 (MS 2053/139)	48		49	JBA 103 (MS 2053/196)	168
13	JBA 76 (MS 2053/143)	51		50	JBA 104 (MS 2053/238)	171
14	JBA 77 (MS 2053/153)	54		51	JBA 104 (MS 2053/238)—exterior a	172
15	JBA 78 (MS 2053/187)	56		52	JBA 104 (MS 2053/238)—exterior b	172
16	JBA 79 (MS 2053/201)	59		53	JBA 104 (MS 2053/238)—exterior c	173
17	JBA 79 (MS 2053/201)—exterior	60		54	JBA 104 (MS 2053/238)—exterior d	173
18	JBA 80 (MS 2053/221)	62		55	JBA 104 (MS 2053/238)—exterior e	174
19	JBA 81 (MS 1927/36)	69		56	JBA 104 (MS 2053/238)—exterior f	174
20	JBA 82 (MS 2053/39)	72		57	JBA 104 (MS 2053/238)—exterior g	175
21	JBA 83 (MS 2053/121)	74		58	JBA 104 (MS 2053/238)—exterior h	175
22	JBA 84 (MS 2053/144)	76		59	JBA 104 (MS 2053/238)—exterior i	176
23	JBA 85 (MS 2053/147)	79		60	JBA 105 (MS 1928/22)	181
24	JBA 86 (MS 2053/226)	83		61	JBA 106 (MS 1928/38)	183
25	JBA 87 (MS 2053/47)	89		62	JBA 107 (MS 1929/7)	189
26	JBA 88 (MS 2053/248)	92		63	JBA 108 (MS 2053/218)	193
27	JBA 89 (MS 1929/2)	98		64	JBA 109 (MS 2053/230)	196
28	JBA 90 (MS 2053/125)	103		65	JBA 110 (MS 2053/240)	198
29	JBA 91 (MS 1927/38)	119		66	JBA 111 (MS 1929/13)	204
30	JBA 92 (MS 1927/54)	122		67	JBA 112 (MS 2053/84)	206
31	JBA 93 (MS 2053/15)	125		68	JBA 113 (MS 1927/14)	211
32	JBA 94 (MS 2053/51)	128		69	JBA 114 (MS 2053/45)	213
33	JBA 95 (MS 2053/69)	132		70	JBA 115 (MS 2053/129)	215
34	JBA 95 (MS 2053/69)—exterior a	133		71	JBA 116 (MS 1927/50)	223
35	JBA 95 (MS 2053/69)—exterior b	133		72	JBA 117 (MS 2053/59)	225
36	JBA 95 (MS 2053/69)—exterior c	134		73	JBA 118 (MS 2053/88)	227
37	JBA 95 (MS 2053/69)—exterior d	134		74	JBA 119 (MS 2053/142)	229

Abbreviations

1 En	1 Enoch	JNF	bowl in an anonymous private collection to be published by J.N. Ford
1QapGen	the Genesis Apocryphon		
1 Sam	1 Samuel	JPA	Jewish Palestinian Aramaic
4 Mac	4 Maccabees	l./ll.	line/lines
abs.	absolute	Lev	Leviticus
act.	active	lit.	literally
Akk.	Akkadian	LO	bowl in the Barakat Gallery
Am	Amos	LXX	the Septuagint
AMB	text from Naveh and Shaked 1985	M	text in the Moussaieff Collection
AMBVMB	reference to Bhayro, Ford, Levene and Saar 2018	Mand.	Mandaic
		masc.	masculine
Aram.	Aramaic	MD	reference to Drower and Macuch 1963
BA	Biblical Aramaic	MH	Mishnaic Hebrew
BH	Biblical Hebrew	M-K	text from Müller-Kessler 2005a
BT	Babylonian Talmud	Montgomery	text from Montgomery 1913
CAMIB	text in the British Museum, published in Segal 2000	MP	Middle Persian
		MQ	Moʿed Qatan
conj.	conjunction	MRLA	Magical and Religious Literature of Late Antiquity
CPD	reference to MacKenzie 1971		
CSD	reference to Payne-Smith 1903	MS	text in the Schøyen Collection
CSIB	text from Moriggi 2014	MSF	text from Naveh and Shaked 1993
Dan	Daniel	MT	Masoretic Text
Davidovitz	bowl in a private collection to be published by J.N. Ford	n./nn.	note/notes (in main section); noun (in Glossary)
DC	Drower Collection	ni.	nifʿal
DCG	bowl formerly in the David Crown Gallery to be published by J.N. Ford	Num	Numbers
		obj.	object/objective
dem.	demonstrative	P	Peshiṭta
Deut	Deuteronomy	p.	person
DJBA	reference to Sokoloff 2002	pa.	paʿʿel
DJPA	reference to Sokoloff 1990	pass.	Passive
DMMPP	reference to Durkin-Meisterernst 2004	PC	bowl in a private collection to be published by J.N. Ford
DN	divine name		
emph.	emphatic	pe.	peʿal
encl.	enclitic	pi.	piʿʿēl
Est	Esther	pl.	plural
Ex	Exodus	PN	personal name
Ezr	Ezra	poss.	possessive
fem.	feminine	prep.	preposition
Gen	Genesis	pron.	pronoun/pronominal
Gr.	Greek	Ps	Psalms
Gy	Ginza yamina (Right Ginza)	ptc.	participle
Heb.	Hebrew	quad.	quadriliteral
impf.	imperfect	refl.	reflexive
impv.	imperative	rel.	relative
Is	Isaiah	RH	Rabbinic Hebrew
JBA	Jewish Babylonian Aramaic	SD	text in the Samir Dehays Collection
Jer	Jeremiah	sg.	singular

SL	reference to Sokoloff 2009	vb.	verb
s.v.	under the word (*sub voce*)	Wolfe	bowl in a private collection to be published by J.N. Ford
Syr.	Syriac		
TO	Targum Onqelos	YBC	Yale Babylonian Collection
TPs-J	Targum Pseudo-Jonathan	Zech	Zechariah

List of Other Bowls

(in addition to AMB, CAMIB, CSIB, Davidovitz, JNF, LO, M, M-K, Montgomery, MS, MSF, PC, SD and Wolfe):

Aaron Bowl B	published in Geller 1986
Allard Pierson Museum bowl	published in Smelik 1978
Anonyme Privatsammlung Deutschland	published in Müller-Kessler 2013
BLMJ 10372	unpublished
Deutsch 6	unpublished
Geller B	published in Geller 1980
Gordon B	published in Gordon 1934b
Gordon E	published in Gordon 1934b
Gordon H	published in Gordon 1937
Gordon 11	published in Gordon 1941
IM 142131	published in Faraj 2010
Moriah Bowl 1	published in Gordon 1984

Sigla

[.] missing letter
[...] missing letters
[xxx] restored letters
{xxx} superfluous letters
⟨xxx⟩ scribal omission
א partially preserved letter

INTRODUCTION

Seals: Function and Meaning

Shaul Shaked

1 The Use of the Term 'Seal' and Its Implications[1]

The current volume is dedicated largely to texts that are based on the theme of seals and signet rings. The object that is named in Aramaic **ḥtm'** (Hebrew *ḥōṯām*) is derived from the root ḤTM, which denotes 'to seal, sign', hence also 'to finish' and several further derived meanings such as 'to fasten, lock, lock up; confirm'. In antiquity seals were often attached to a ring worn on a finger. When in such a shape it is called '**zqt'** or **gwšpnq'** (Hebrew *ṭabba'aṯ*). We shall aim at understanding how seals were used in antiquity as a background to the symbolic use of the term in the magic bowls.

In the Bible, the Book of Esther stands out for giving prominence to *ṭabba'aṯ hammelek* 'the king's ring' (TgEsth1: **gwšpnq' dmlk'**; TgEsth2: **'zqtyh dmlk'**),[2] and for transmitting a detailed and vivid description of the manner by which a royal decree was put into use, at least as conceived in the popular imagination from the late Achaemenid to the early Parthian periods. In what looks like a fairytale, Haman, a minister in the service of the king, harbors a grudge against Mordecai, who fulfills an unclear function at the gate of King Ahasuerus.[3] Mordecai refuses to bow down in the presence of Haman and the latter asks the king's permission to execute the whole of the Judean community, including Mordecai, in revenge. Haman claims that the Judeans were not obeying the king's laws. Ahasuerus takes off his ring and hands it to his minister, thus granting him authority to carry out his designs. This happens after the king dismissed his wife Vashti, who had had the audacity to refuse the king's command to present herself to his retinue. The king appoints messengers to look for the most suitable new queen, and Esther, Mordecai's niece and his adopted daughter, is taken by the king to be his next wife. Ahasuerus, however, is not informed that the new queen is closely related to Mordecai, and probably does not know that he is among the Judeans who are to be executed. Haman is equally ignorant of this relationship. He promptly writes a decree and signs it with the royal ring, and the Jews of the kingdom, including Mordecai, are about to be killed at a given date. Mordecai and the other Judeans, however, are saved through the ingenuity of Mordecai and the courage of Queen Esther. After Haman's downfall, the king's ring changes hands. It goes to Mordecai, who is quick to reverse the king's earlier action and to have Haman and his offspring executed. The rapid twists of the story are typical of the genre. The comical role of the king's ring no doubt delighted the audience listening to the story.[4] We may safely assume that the reality of court life was less frivolous than the impression provided by this tale. The king's court surely possessed better intelligence regarding the people at the court and the person chosen to be queen. But these are the rules applying to the type of story that serves to enhance the merriment of the audience.

While a signet ring was a common item for authenticating a royal decree, seals were not always attached to a ring. They were often an independent object, sometimes fashioned with a handle.[5] A seal was usually stamped on a piece of clay or wax attached to a document. This served the dual purpose of securing a folded document so as to keep the text hidden from the eyes of strangers, and, at the same time, confirming the identity of the writer. The earlier style of seals carved on a cylindrical stone was abandoned with the adoption of alphabetical writing on parchment and later on paper. Most seals of the Sasanian period (third to seventh centuries CE, largely corresponding to the period of the incantation bowls) were carved on gems or semi-precious stones. Such seals have little space on their surface for anything beyond the name of its owner and/or a short pious formula or a small design.

A large number of Sasanian seals have survived. A small number among them can be identified as Jewish, recog-

1 I would like to acknowledge with gratitude the editorial help, the very useful references and suggestions, and the patience displayed by my friends and colleagues James Nathan Ford and Siam Bhayro.
2 Esther 3:12 and in several other places.
3 Usually identified with Xšayāršan, known in the Greek sources under the name of Xerxes. Two kings with this name are known in Achaemenid history, the first ruled 486–465 BCE, the second 424–423 BCE. Xerxes I is considered as the most likely candidate for the role of Ahasuerus. The Esther story itself, however, remains unconfirmed in the historical sources.

4 See also Shaked 1982, 292–303.
5 For a detailed discussion of seals from Biblical antiquity, see Avigad 1958.

nizable by certain features to be discussed below.⁶ The Jewish seals, along with the Jewish Aramaic incantation bowls of the kind published in these volumes, are the only epigraphical items to have survived in Babylonia from this very formative period in Jewish history. We seldom have information concerning their precise dating or place of provenance, but they are precious for providing a rare glimpse into the period in which Talmudic literature was produced and, incidentally, inform us of a considerable number of Jewish individuals of the period, including occasional Jewish scholars functioning in Babylonia.

It is noteworthy that a substantial number of amulets in the Sasanian period were shaped like seals, using the verbal appeal of a magic text within an artifact that has the dignity and authority of a seal.⁷ The magic seals often carry a visual scene that conveys a message. Some contain an inscription as well.

There are several applications for a seal and, as a result, its definition is somewhat complex. A seal is primarily a means of authentication. It is frequently used as a device to certify a judicial document. Since a seal is usually stamped at the end of a document—'end' in both the temporal and spatial senses—the very mention of the term signifies an ending. In legal usage the use of a seal can imply: (1) The writing is correct, i.e. it conforms to the rules; (2) The document's contents are reliable; (3) The owner of the seal has authorized someone to act in the particular matter; (4) The decision made is final; it can only be undone by a new legal procedure.

Practitioners of magic often have recourse to legal terminology or to the creation of a legal ambience as a décor to establish authority and power. This conveys the feeling that the magical act is decisive and incontrovertible, enjoying the same authority as a legal deed. The prime example for such a legal effect is the range of magic formulae that mimic a bill of divorce.⁸ This may, on rare occasion, even include an exact date recording the day of the week, the day of the month and the year in which the document was executed.⁹

Although magic texts do not explain the vocabulary that they use, we can detect patterns in their usage. A phrase that is frequently repeated in our corpus is 'seven seals and eight bonds', although the numbers sometimes vary. Here is an example:¹⁰

2 אסיריתון וחתימיתון בשבעה חתמין ובתמניה אסרין {א}	2 You are bound and sealed by seven seals and by eight bonds.
3 חתמא קדמאה דנבורין תינינא דינבורין בר אירי תליתאה דיבול בר סגול	3 The first seal is of **nbwryn**; the second, of **nbwryn** son of **'yry**; the third, of **ybwl** son of **sgwl**;
4 רביעאה דצורבין נור בוזיט גזיא חמישאה דבורגון תקיפא שתיתאה {ט}	4 the fourth, of **ṣwrbyn nwr bwzyṭ gzy'**; the fifth, of the mighty **bwrgwn**; the sixth,
5 דטורמין שביאעאה דטורמיס ובחתמא דשימשא ובעיזקתיה דסהירא ברזא	5 of **ṭwrmyn**; the seventh, of **ṭwrmys**. And by the seal of the sun, and by the signet-ring of the moon. By the mystery
6 דארעה ובסדנא דרקיעא ובשום עיזקתיה דאל שדי רבא ובשום יהוה אהיה אהיה	6 of the earth, and by the base of the sky. And by the name of the signet-ring of the great El Shaddai, and by the name of YHWH "I am, I am",
7 יהוה צבאות שמו הוא אהיה אשר אהיה זה שמי לעלם וזה זכרי לדור דור	7 "YHWH Sabaoth is his name".¹¹ He is "I am that I am".¹² "This is my name for ever, and this is my memorial unto all generations".¹³

6 For further discussion of Sasanian seals, see section 2 below.
7 For a discussion of the seals with detailed typology, see Gyselen 1995.
8 See Shaked, Ford, and Bhayro 2013, 99 ff.; Shaked 1999; Manekin Bamberger 2015.
9 An article on the dated bowls is planned by J.N. Ford and the present writer.

10 JBA 65:2–7.
11 Is 47:4 + *passim*; Jer 10:16 + *passim*.
12 Ex 3:14.
13 Ex 3:15 (MT: זֶה־שְׁמִי לְעֹלָם וְזֶה זִכְרִי לְדֹר דֹּר).

The two terms 'seal' and 'bond' form a pair, but they do not appear to occupy the same semantic level. 'Seals' are used by entities with proper names (or they may themselves be owners of names). They are perhaps spirits or mysterious powers. 'Bonds', in contrast, appear to be without individual identification. Seals are presumably associated with super-human powers, while bonds are just objects. Seals confirm the validity of the spell, whereas bonds ensure that the ensnared evil powers will not free themselves.

We cannot explain the 'names' to which the seven seals belong, but it is clear that they belong to a set of mysterious powers that can be identified by their names. The number 'seven' appears in the formula, but there are more than seven seals involved. We read that there are seals or signet-rings (indicating presumably the same kind of object) serving the sun and the moon, and there are also, in an unclear function, mysteries: one of the earth and another one of the foundation of the firmament. Then we read: 'and by the name of the signet-ring of the great El Shaddai', which implies that the list of the different seal-objects goes on. Thus the highest divine entities who make use of seals and form part of the Jewish tradition are not included in the list of seven seals.

It seems possible to assume that two separate traditions are here fused together. The Jewish tradition concerning YHWH and other divine entities appears in the second half of the spell. The first half contains seven *nomina barbara*:

(1) **nbwryn**, (2) **nbwryn** son of **ʾyry**, (3) **ybwl** son of **sgwl**, (4) **ṣwrbyn nwr bwzyṯ gzyʾ**, (5) **bwrgwn**, (6) **ṭwrmyn**, (7) **ṭwrmys**

These 'names' derive apparently from another magical tradition, probably a non-Jewish one. We may guess that they were borrowed from or invented by a different circle of magical practitioners. We can call this formula 'the Sequence of Seven Seals and Eight Bonds'.

The second half of the spell (lines 5–7) uses a different type of enumeration of powers, which we may label 'the Cosmic Sequence', as it refers to the Sun, Moon, Earth and Sky. As it ends with references to El Shaddai, YHWH, I-am-that-I-am, all well-known Biblical entities, it most likely stems from a Jewish magical tradition.

A different type of formula is found in bowls which use the sequence of 'Three Bonds and Seven Seals'.[14] A sample of such a formula is the following:[15]

[...] אסירין ביתלתא	1	[...] They are bound by three
אסורין וחתים בשבעה חתמין ובחתמא רבא ובח[תמא] דחת[ימין בה שבעה] רקיעין [חתמא קד]מאה טבית תינינא דבידיה	2	bonds and sealed by seven seals. And by the great seal, and by [the] s[eal by] whi[ch the seven] firmaments are sea[led. The fir]st [seal] is ṭbyt; the second, of bydyh;
תליתא דגרזין תקיפא רביאעא דיזבול חמישאה דרמס[י]ן שתיתאה דיה [ר]בא שביעאה דיהוה צבאות ובחתמא רבא דביה	3	the third, of the mighty grzyn; the fourth, of zbwl; the fifth, of rms[yn]; the sixth, of the [gre]at Yah; the seventh, of YHWH Sabaoth. And by the great seal by which
חתימא שמיא וארעא חתים בחתמא דשימשא ובעיזקת[א] דסיהרא [בצור]תא דארעה [וברזא רבא דרקיעה ...]	4	heaven and earth are sealed. (It is) sealed by the seal of the sun and by [the] signet-ring of the moon. [By] the [ima]ge of the earth [and by the great mystery of the sky, ...]

14 JBA 71:2; JBA 74:3,6; JBA 79:4; JBA 80:2–3.
15 JBA 75.

In this version of the 'Bonds and Seals' motif, a somewhat different conception of the global arrangement of seals and bonds seems to prevail. The scheme of this version of the magic formula seems more coherent. As in the former example, each one of the seven seals is associated with the name of a spirit. Here, however, the names sound familiar and are more amenable to an interpretation as reflecting Hebrew or Aramaic words:

(1) Ṭabit 'the good one (fem.) (?)';
(2) Bidiah 'by the hand of Yah (?)';
(3) Gerzin, a reference to Mount Gerizim (?);
(4) Zebul, usually indicating the sky, God's abode;
(5) Rām-Sīn (?) 'the lofty [Mount] Sin(ai)' (?);
(6) the Great Yah;
(7) YHWH Sabaoth, which is eminently suitable to serve as the ultimate conclusion to the list. The seventh entity is assisted by several others: 'And by the great seal by which heaven and earth are sealed. (It is) sealed by the seal of the sun and by [the] signet-ring of the moon. [By] the [ima]ge of the earth [and by the great mystery of the sky]'.

This list appears to be based on terminology derived from Hebrew and Aramaic, although it may have undergone some distortions in the course of transmission. We may assume that this was, with some corruptions, a list circulating among Jewish practitioners of magic.

It seems possible to conclude from these examples that there are at least two distinct formulae of the 'Bonds-Seals' genre. The first one is borrowed from a professional magical source, possibly non-Jewish. Jewish elements were subsequently added to it. The other can be characterized as rather more conventionally 'Jewish', in the sense that it was mostly based on Jewish divine names or attributes.

The notion of 'seals', both as an abstract term and as a set of visual symbols, has been alive in Jewish and Islamic magic ever since the late antique period. It still exists as a prominent element in contemporary magic practice.[16]

2 Sasanian Seals

Seals were used in the period corresponding to that of the bowls as part of the common practice of society, presumably serving primarily people who occupied leading positions in the state government, in their religious communities, or possibly in their local groups. Sasanian seals have been retrieved in large numbers and can be viewed in numerous publications. Jewish and Christian seals are naturally less numerous.[17] Christian seals of that period are preserved in several collections.[18] Sasanian seals, official or private, are not easy to classify. They often carry a short inscription in Middle Persian (written in the Pahlavi script), or drawings of different objects, animals and symbols, that are not always easy to interpret.[19]

Jewish seals of the Sasanian period tend to use the Hebrew script and a small repertoire of Jewish symbols. The inscriptions are generally very short: the space available on the surface of the stone is limited. Seals are not items that may be found in ordinary households. It may be assumed that people occupying a high office in the kingdom or holding a leading position in a religious community would own a seal, but it is not clear whether wealthy people would normally own one.

The shape of the Hebrew letters on seals is close to that which is seen in the magic bowls and is still current in Hebrew printed books. The seal normally carries a name and a patronym, but no title. Next to the text there is often a drawing of Jewish ritual objects such as the two vegetal elements connected with the Tabernacles (*Succoth*) festival, namely, *lulav* 'palm branch' and *etrog* 'citrus fruit'.[20] Sometimes a shovel reminiscent of the rituals performed in the temple of Jerusalem is added. This may serve as a memorial of the exile from Jerusalem several centuries earlier, or hint at the priestly origin of the seal's owner. Old Testament themes found on some Sasanian seals, such

16 For a detailed survey of the practice, its visual representation, and its possible origins, see Graham 2012; Graham 2014.

17 For Jewish seals of the Sasanian period, see Shaked 1977; Shaked 1981; Shaked 1995a; Gyselen 1996; Friedenberg 2009. Friedenberg presented all the previously published Jewish seals and added some further material, but without making a clear distinction between Jewish and other seals.

18 [18] For Christian seals of the Sasanian period, see Lerner 1977; Shaked 1977; Gignoux 1980; Spier 2007; Spier 2011.

19 Only a selection of publications of Sasanian seals can be given here. Bibliothèque Nationale de France: Gignoux 1978, Gyselen 1993. The British Museum: Bivar 1969. The Metropolitan Museum, New York: Brunner 1978; Brunner 1980. Seals and seal impressions from Qasr-e Abu Nasr at the Metropolitan Museum, New York: Frye 1973; Gignoux 1985. The Hermitage Museum, St. Petersburg: Borisov and Lukonin 1963. Vorderasiatisches Museum in Berlin: Horn and Steindorff 1891. Seals in other collections are described in Gignoux and Gyselen 1982; Frye 1970; Frye 1971. A particularly striking seal amulet inscribed in Pahlavi at the Metropolitan Museum in New York was published by Harper et al. 1992 (see also Shaked 1993). Inscriptions of seals have been published by Horn 1904. The most extensive compendium of Christian, Jewish and other seals from various collections is Spier 2007. Additional seals are discussed in Spier 2011.

20 See Kindler 2003.

as the Binding of Isaac or Daniel in the Lion's Den, are mostly, if not exclusively, Christian rather than Jewish.[21] The predominantly Christian interest in these two scenes probably derives from the fact that the stories behind them were interpreted as a prefiguration of the passion of Christ.[22]

In addition to cult motifs, indicating the religious affiliation of the owner, seals may sometimes carry drawings of demons or angels, symbols signifying that they were used to protect their owners, in other words, that they were amulets. Rika Gyselen, in her excellent book *Sceaux magiques en Iran sassanide*, discusses this theme. She finds it difficult to explain how magic seals produced in the Zoroastrian environment during the Sasanian period could be tolerated within a religion that upholds such values as purity, total submission to Ohrmazd, avoidance of any contact with demons, and abhorrence of sorcery.[23] This dilemma, however, is not confined to Zoroastrians. It plagues the other religious cultures of the period, such as Judaism, Christianity and, later, Islam. Magic has thrived in all of these religions from early Antiquity to the present day, sometimes under a veil of secrecy or ambiguity. The magical practices were often performed in private, far from the eyes of strangers. The semi-secrecy often adopted by practitioners may be due to more than one reason. First, official keepers of the religion, priests, rabbis or *mowbeds* (Zoroastrian priests), held the view that magic was forbidden, and this required the practitioners to keep their activity hidden from the knowledge of religious authorities.[24] Second, although clients and practitioners may not have felt that they were transgressing the precepts of the religion, they had a premonition that magic entailed some danger. It certainly meant that they were engaged in a fight with dark powers who could not be expected to relinquish their prey without combat. Dealing with the unknown has always had serious risks. Third, those who practice what we call 'magic' do not consider their occupation as falling in the category of 'witchcraft' (Hebrew *kiššūf* or *kašāfīm*), which is a grievous sin. Even the term 'magic', which is generally considered to be a relatively neutral word, is never employed by people who create amulets and incantation bowls. The magical rituals often require the practitioner to undertake abstinence from pollution or from sexual activity, in the same manner as those who engage in pious mystical activity.[25]

Despite the obvious closeness of the magical beliefs and rituals to those upheld by mystics within the leading religions of the period (Zoroastrianism, Judaism, Christianity, and, ultimately, Islam), the field of magic was equally attractive to members of society who were less given to devotion and meditation. Whereas thinkers and interpreters of the faith usually found themselves arguing with the other faiths, trying to prove the validity of their own religion, the adherents of magic often appear to be interested in the magical traditions of the other communities and willing to borrow magical practices from them. For this reason practitioners of magic can be regarded as adherents of 'popular religion',[26] although this should be held within certain limits.

3 'Seal of the Prophets' and Notes on Manichaean Magic

According to al-Bīrūnī's *Chronology*, Mani (216–274 or 277 CE), the messenger of God and founder of one of the great global religions of Late Antiquity, announced that he was 'the Seal of the Prophets'.[27] If this is historically correct, it would have meant a confirmation of the prophecy of his predecessors (he mentioned in particular a triad of prophets: the Buddha, Zoroaster and Jesus) and probably also a statement that established him as the last prophet, implying that no other prophet would rise after him. Al-Bīrūnī (tenth-eleventh centuries CE) was one of the foremost Islamic thinkers and historians. He claims that Mani

21 Friedenberg 2009, 23–25, expresses a similar view, though he includes such seals in his book. See also Herman 2014, 271–272, who suggests that some of these images may have been borrowed by Jews and Christians from the Zoroastrian repertoire of rituals while changing their meaning to conform to their own faith.

22 See, in the New Testament, Hebrews 11:17–19; see also Schoeps 1946 with regard to the sacrifice of Isaac.

23 Gyselen 1995, 18–19.

24 Religious leaders in various periods condemned sorcery (see note 25). This occurs occasionally among modern scholars too. It is amusing to read in this context the introduction to the first critical edition of *Sefer ha-razim* (Margalioth 1966), where the editor apologizes for engaging with a text that violates the Jewish injunctions against sorcery.

25 On the difficulty of distinguishing between magic and religion in general, and particularly within Judaism, see Harari 2017, 162–175. Magical handbooks tend to insist on religious piety when the practitioner prepares himself for performing his ritual. See *Sefer ha-razim*, in Margalioth 1966, 21–22; *The Sword of Moses*, in Harari 1997, 24 (in Hebrew) and Harari 2012, 72 (in English). For a survey of rabbis in Late Antique Palestine and Babylonia and their involvement with magic, see Levinson 2010. On the relationship between magic and rabbinic lore, see Bohak 2008, 339–341, 351 ff., and *passim* in this richly informative book. For the exchange of magical traditions between Jews and Christians in Babylonia, see Harari 2017, 132 ff.

26 See Shaked 1997.

27 Puech 1949, 61 and 144–146, n. 241. See the text quoted below, from Sachau 1923, 207.

applied this title to himself in a sacred book that he had written.[28] The Arabic text reads as follows:[29]

وذكر في انجيله الذى وضعه على حروف الابجد الاثنين والعشرين حرفا انه الفارقليط الذى بشر به المسيح وانه خاتم النبيين

And in his (i.e. Mani's) gospel, which he put down (using) an alphabet of twenty-two characters, he said that he was the Paraclete foretold by Christ, and that he was the Seal of the Prophets.

This reference does not specify which language was written in the script of twenty-two characters. It theoretically could have been either of the two languages Mani used, that is Syriac or Middle Persian (the language of the Sasanian court). In fact, only one of his books was written in Middle Persian: *Shābuhragān*, a title that roughly means 'dedicated to King Shābūr'.[30] The script used by the Manichaeans for writing Middle Persian is a variety of the Syriac alphabet adapted for the phonetic needs of Middle Persian. A hoard of Manichaean manuscripts written in several Middle Iranian languages (Middle Persian, Parthian and Sogdian) as well as Old Turkish was discovered in the ruins of a Manichaean colony in the Turfan valley in China, one of the most important historical and linguistic discoveries at the turn of the twentieth century. Mani wrote most of his books in Syriac (Aramaic), but not much has been preserved of these books.

The fact that this alphabet was used for writing the Manichaean books has caused scholars who were working on magic bowls to apply the term 'Manichaean script' also to the Syriac bowls written with this script.[31] Mani was indeed very versatile; besides being a prophet adored by his followers, he had a reputation as a painter and was clearly an effective manager of his community and religious mission. It is clear, however, that Mani was not the inventor of this script.[32] Among the most convincing arguments against defining this script as exclusively 'Manichaean' is the fact that a large portion of the Syriac magic bowls are written in this script, although most of the texts have no particular affinity with the Manichaean religion and in several cases appear to have been written by Christian practitioners. It is unlikely that Christian practitioners would have chosen to write their incantations in a script exclusively associated with Manichaeism. Although the bowls postdate Mani by several centuries, it seems most likely that the script used for writing the Manichaean Middle Iranian texts was already current in Babylonia before Mani's time, and was adopted for writing the Manichaean texts, perhaps merely because it was accessible to Mani and his early followers.[33]

Exceptionally, a group of three Syriac magic bowls unequivocally appear to have been prepared by a Manichaean practitioner, as they invoke Mani's name.[34] A few genuine Manichaean spells written in Iranian dialects also exist.[35] A few years ago, Matthew Canepa published a study that tries to attribute magical usage and practice to many more Manichaean texts than has been the custom so far.[36] This very learned and wide-ranging article discusses, as its title puts it, 'the art and ritual of Manichaean magic'. From reading this article, one gets the impression that in Manichaeism almost all liturgical texts are 'magical'. Manichaeism, however, does not differ much from other religions of late antiquity such as Zoroastrianism, Judaism, Christianity and, later, Islam. All of these cultures roughly share a similar structure but their literature can hardly be described as a bundle of magical texts. There is a tacit agreement that, when one talks about magic in the context of an established religion, one should follow a number of criteria that would help identify what may be called 'magic'. Since the language of magic is quite close to that of religion, the distinction between the two is not always easy to make. Texts that belong to the common prayer book, and rituals that are performed in public, are usually regarded as belonging to the realm of religion. Magical acts are usually private, and are often rejected by the religious authorities. Despite such observations, 'normal' religious texts are often based on a set of beliefs shared by those that are recognized as magical. One misses such an analysis in Canepa's article.

Al-Bīrūnī quotes Mani as referring to himself as the 'Seal of the Prophets'. This self-description of Mani is identical with the well-known description of the prophet

28 For references to this passage, see Polotsky 1935, 266; Widengren 1961, 141; Puech 1979, 51; Tardieu 1981, 19 ff.; Stoyanov 2000, 102; Gnoli et al. 2003, 338. These scholars and several others take this phrase as historically plausible. Werner Sundermann, however, one of the foremost scholars of Manichaeism, judged this report as spurious (Sundermann 1988, 202; Sundermann 2001, vol. 2, 813–825). There is no reference to this claim in Sundermann 2009.

29 Reference for this quotation above, n. 27.

30 The full available text was edited by MacKenzie 1979–1980.

31 Thus, for example, BeDuhn 1995.

32 This was already suggested by Montgomery 1912; Montgomery 1913, 34–35; Henning 1958, 72–73. The latest thorough treatment of this subject is Durkin-Meisterernst 2000.

33 See further Shaked 2000; Burtea 2011, 119.

34 Published in Shaked 2000.

35 See Henning 1947; Mirecki 2001; Morano 2004. BeDuhn 1995 argues for a possible Manichaean connection for some of the Aramaic magic bowls.

36 See Canepa 2011.

Muḥammad in the Koran, Sura 33:40. Although Mani's literary output was impressively large, not many of his original works have survived, and the phrase 'Seal of the Prophets' does not occur in any of his extant works.[37] The question of whether the attribution of the phrase quoted by al-Bīrūnī is to be trusted, given that al-Bīrūnī was a Muslim who was acquainted with this Koranic phrase, and that this phrase occurs nowhere in the extant works of Mani, has been debated by scholars for quite some time. Several scholars accept al-Bīrūnī's report, whereas others reject it.[38]

My view can be summarized briefly as follows. It is unlikely that al-Bīrūnī would have invented this quotation from a well-known prophet of antiquity in a religion that was rejected by Islam unless it was factually true. Had it been falsely attributed to Mani, it might have had a twofold negative effect: Manichaeans were still around, their books could be examined and the allegation could be easily disproved. Besides, it might have been considered a sacrilege to attach to Mani, a false prophet, an epithet that the Koran attributed to Muḥammad. Al-Bīrūnī had a good reputation for reliability among his contemporaries, something that persists also among modern scholars.[39] Attributing this phrase to Mani without a solid basis in reality would not have served any purpose. It thus seems likely that Mani actually used a phrase of this nature in one of his works. In that case, there are essentially two possibilities:

(1) Al-Bīrūnī heard or read an epithet which Mani had applied to himself and was impressed by its similarity to the Koranic *ḥātam al-nabiyyīna* 'Seal of the Prophets'. As a result, he saw no harm in using the Koranic wording for Mani's claim. Mani's claim would have been originally formulated either in Middle Persian or in Aramaic. We have no knowledge of how it got to al-Bīrūnī. He may have heard or read it in the original language or in Arabic translation. In either case, one can legitimately wonder if the translation was literal or approximate, and whether it merely struck al-Bīrūnī as close to the Koranic phrase.

(2) The phrase occurring in Mani's book may have been current in Arabia before Muḥammad's time.

It could have been popular in pre-Islamic Arabic as a paradigm of prophecy. If this hypothesis is correct, al-Bīrūnī's quotation of Mani's self-description should be acknowledged as a historical fact.

Of these two alternatives, I tend to favour the first. This usage, no matter how one interprets it, shows how powerful the use of the metaphorical term 'seal' can be to establish the veracity, finality, or excellence of the status of a prophet.[40] It may be appropriate to mention that recent scholarly investigations have tried to establish the authenticity of the phrase 'Seal of the Prophets' in the text of the Koran, while other scholars tended to regard it as a late interpolation. At present there appears to be a scholarly consensus that this phrase is part of the original Koranic text.[41] Surprisingly, however, in the discussion concerning the date of the Koranic phrase, no one seems to have noticed the relevance of the title that Mani may have attributed to himself more than three centuries earlier, when he established one of the leading world religions of Late Antiquity.

4 Personal Names in Seals and Magic Bowls

Although we do not have their names, it is quite clear that, in principle, the practitioners who produced the often complex Jewish Babylonian Aramaic texts written on these bowls were Jewish. Only individuals who grew up in a Jewish environment and received a Jewish education would have had the writing skills and the knowledge of the Hebrew and Aramaic that these scribes possessed. The level of mastery of the scribal art, however, varied from practitioner to practitioner. Occasionally we find bowls that are so badly or clumsily written that one could envisage that they were perhaps written by non-Jews. A case in point is HS 3015, which appears to contain a reference to the passion of Jesus.[42]

The clients or beneficiaries for whom the bowls were prepared, however, are almost always named. In many cases the personal names of the clients reveal their religious affiliation. It is *a priori* likely that many of the clients

37 Stroumsa 1986 discusses phrases from Coptic Manichaean compositions that might confirm such a usage in Manichaean literature; he remains, however, sceptical about the attribution of the phrase to Mani. For a list of what is known and available of Mani's books, see Sundermann 2009.

38 These have been quoted in Shaked (forthcoming). See above, n. 28.

39 See de Blois 2000.

40 Goldziher 1874, 466 (n. 1) discusses the meaning of the term *khātam* in early Arabic literature, pointing out that it does not always refer to finality or confirmation; sometimes it denotes 'the foremost or greatest of a group' (e.g. of poets).

41 Rubin 2014 maintains, in a debate with Powers 2009, that the verse is authentic. Wansbrough 1977, 64–65, interprets the verse calling Muḥammad the 'Seal of the Prophets' as confirming his image of bringer of salvation. See also Friedmann 1986.

42 Published as Bowl 10 in Ford and Morgenstern 2020; see especially 56–57.

of the Jewish practitioners were Jewish themselves. This can be demonstrated with reasonable certainty when they bear proper names that are attested in Jewish sources dating to this period, namely, Babylonian Rabbinic literature and Jewish seals; for example, Isaac son of Papa, Ḥilqiya son of Samuel, and Huna son of Nathan.[43] Some originally Jewish names, however, could have been used by non-Jews, especially by Christians. Other names or onomastic elements were shared by Jews and non-Jews alike; for example, Abba, Papa (Baba, Babak), and Mādar.

The *clientele* of the Jewish practitioner, however, was manifestly not limited to Jews. Many clients bear theophoric names that imply devotion to deities worshipped in other religions or names based on religious symbolism specific to a particular religion, and one may confidently assume these individuals to be affiliated with the respective religious community.

The name Maṯ-Yišū (JBA 24, JBA 46) 'Maidservant-of-Jesus' is unequivocally Christian. Her mother, Baṯ-Sāhdē 'daughter of martyrs', also bears a Christian name. The masculine equivalents 'Avd-Išū 'Servant-of-Jesus' (JBA 116) and Bar-Sāhdē 'son of martyrs' (JBA 27, JBA 31, JBA 32) are also attested. Another typical Christian name is Bar-Ḥa-be-šabbā 'Sunday boy' (JBA 36; see Ford and Morgenstern 2020, 72, n. 244), which celebrates the Christian day of worship. The Jewish equivalents are Bar-šabbəṯā 'Sabbath boy' (HS 3023; Ford and Morgenstern 2020, Bowl 14) with its feminine counterpart Baṯ-šabbəṯā 'Sabbath girl' (MS 1929/6) and the historically famous name Shabbetai.

Many names of clients clearly contain elements derived from the Zoroastrian faith. Examples of such names are Bay-yazad-dād 'Given (or created) by the god Bay'[44] (JBA 34); Hormizd-dukh 'daughter of (the deity) Hormizd' (JBA 48); Māh-dukh 'daughter of the Moon' (a Zoroastrian deity; JBA 1); Nēwān-dukh 'daughter of the Brave (or the Virtuous)' (JBA 1); Mihr-Anāhīd, a name composed of two Zoroastrian deities, Mithra and Anahid (a female deity; JBA 5). Although it is conceivable that some Jews adopted names from the Zoroastrian eponymy, it does not seem likely that such open declaration of adherence to the Zoroastrian faith would be given to Jews at birth. Bearers of Zoroastrian names could, of course, also be Manichaean, as Manichaean mythology abounds with elements of Zoroastrian mythology, but we know of no unequivocal evidence for Manichaeans as clients in Jewish magic.

Despite the closure of the last of the great pagan temples, paganism still survived at this time and traces of it can be discerned in the onomastics of the magic bowls. For example, the name Mannevō 'Maidservant-of-Nevo' (JBA 113) puts its bearer in relation to the god Nabû. The name Maḥləfā (JBA 62) is nonconfessional and could be given to both Jews and non-Jews, but his mother's name, Maššamaš 'Maidservant-of-Šamaš', indicates that his family had pagan origins.

Although most Jews probably commissioned their magic bowls from Jewish practitioners, some Jews similarly turned to non-Jews. A member of the family of Rav Yaqof 'Rav Jacob' son of Miriam and Shemuel 'Samuel' son of Sarōy (PC 19), both bearing distinctively Jewish names, turned to an experienced Mandaic practitioner. The same is true for Rav Ashi son of Aḥāṯ and his son Shemuel (DCG 4).

Practitioners affiliated with various confessional groups must have exchanged formulae, as one finds identical formulae in Jewish and Mandaic bowls or in Jewish and Syriac bowls. On at least one occasion the same formula is attested in all three dialects.[45] As discussed by Harviainen, the practitioners, when using formulae originating in other religious communities, would adapt the confessional features in the introduction and conclusion of the incantation to their own religion.[46] They did not, however, normally adapt the confessional features of the text to the religion of the client. Jewish practitioners almost always used identical formulae for Jewish and for non-Jewish clients alike, and the above cited Mandaic bowls PC 19 and DCG 4, prepared for Jewish clients, are typically Mandaic. It seems that, in the field of magic, the boundaries between the different faith communities were somewhat fluid and members of one community were not necessarily averse to requesting the services of a practitioner belonging to a different one. Nor were all practitioners reluctant to borrow spells originating in other religious communities, provided, of course, that their efficacy was proven!

43 The names on Judeo-Sasanian seals are discussed in the relevant publications by Shaked (see n. 18 above) and by Friedenberg 2009, 13–16. Ilan 2011 collects personal names from a wide range of literary and epigraphic sources, but not all of them can be proven to be Jewish.

44 The older, pre-Sasanian, form of this deity's name is Baγ.

45 See Müller-Kessler 1998. Another likely example is the Syriac fragment in Bhayro et al. 2018, 60–61, which parallels the Mandaic incantation MS 2054/124, and probably originally paralleled part of the Jewish incantation Bowl 21 in Naveh and Shaked 1993, 127–130.

46 See Harviainen 1993.

Note on qnyyn⁾ "property" and qn⁾ "family"

In JBA, we find two phonetically similar nouns:

qnyyn⁾ "possession, property" < QNY "to acquire" (*DJBA*, 1029);

qn⁾ "nest; family" < *QNN (*DJBA*, 1013); as noted by Sokoloff, the same semantic development "nest" > "family" also occurs with Mand. *qina* and Akk. *qinnu* "nest, family" (< *qanānu* "to nest").

Both terms are attested in the JBA magic bowls. The former is ubiquitous in the bowls, where it is usually written **qynyn⁾**. Examples of the latter include **wkl bny byth wkl bny qynh** "and all the children of her house and all the children of her family" (Davidovitz 46:8), and **wrwḥ⁾ mn qynh wlylyt⁾ mn zrʿyth** "and spirit from her family and lilith from her family" (VA 2180:2).

In the bowls, however, it appears that the orthography of the former can sometimes resemble the latter, with the result that it is sometimes difficult to distinguish between **qn⁾** "family" and **qn⁾** "property". A clear example of **qn⁾** "property" is found when we compare JBA 76:1 with JBA 111:3, which were written by the same scribe for the same client, and contain the same sequence:

JBA 76:1–2
ḥtym wmḥtym bytyh wʾysqwptyh wdyrtyh wtrʿyh wqynynyh d...

Sealed and double sealed is the house and the threshold and the dwelling and the gate and the property of ...

JBA 111:2–3
... lḥtmtʾ dbytyh wʾysqwptyh wdyrtyh wtrʿyh wqynyh d...

... for the sealing of the house and the threshold and the dwelling and the gate and the property of ...

In this example, it appears that the scribe has written **qynyh** for the standard **qynynyh** in the second instance. In such cases, therefore, it would seem to be appropriate to understand **qn⁾** as "property" rather than as "family". Thus, in the present volume, see JBA 73:5, JBA 105:3, JBA 111:3 and JBA 116:4. Another example is found in Costa Collection 1:6 (for which Moriggi 2005b, 47–48, posits a scribal error).

Indeed, it appears that, when it appears in a list of a bowl's beneficiaries, **qn⁾** usually means "property". In JBA 105:3, therefore, even though **qynyh** follows **dwtqyh** "his family", which might suggest that **qynyh** also means "his family", we have, nevertheless, rendered the term as "his property": **wbnyh wbntyh wdwtqyh wqynyh** "and his sons and his daughters and his family and his property". Compare the following similar lists: **bytyh wnpšyh wqynynyh wbnyh wbntyh wʾytyh wbny bnyh wʾynšy bytyh** "his house and his soul and his property and his sons and his daughters and his wife and his grandchildren and the people of his house" (MS 1929/5:5); **npšyh wbytyh wqynynyh wkl ʾynšyh** "his soul and his house and his property and all his people" (MS 2053/23:6–7); **mn bytyhwn wmn qynynhwn wmn gwphwn wmn kl ʾynšy bytyhwn** "from their house and from their property and from their body and from all the people of their house" (MS 1927/49:4–5).

One finds the intermediate spelling **qynnyh** in JNF 122:2 and Moriah Bowl 1:24. In MS 2053/23:8–9, **qynyh** appears to have been corrected to **qynynh**: **mn bytyh dydyh wmn kl ʾynwšy bytyh wmn qynyhnh d...** "from his house and from all the people of his house and from the property of ...". On three other occasions in MS 2053/23, the same word is written **qynynyh** in accordance with the standard orthography.

I.3

Seals

∴

Introduction

This chapter contains twenty-six bowls that refer to magical seals—the term in question is ḥtm' (*DJBA*, 490). This is a popular theme in the bowls, with a number of distinct formulae. As this theme is often combined with others, there is a certain arbitrariness to our selection and the arrangement of the chapters. A number of bowls with this theme, therefore, will be published in subsequent volumes. In what follows, we treat the following five variations of this theme: the seven seals that are arranged by number and designated by name, the seals of Ashmedai, the seal of Yokabar Ziwa, the bond of the lion and the seal of the dragon, and, finally, the seven bonds and eight seals.

I.3.1

Seven Seals

∴

Introduction

The texts in this section refer to the theme of the seven seals that are arranged by number and designated by name. This popular theme is represented by several different versions in the texts of this corpus and also occurs in other bowls outside the Schøyen Collection, for example, Montgomery 6 and MSF Bowl 14. Compare also Schäfer 1981, § 368, in which names are also arranged by numbers. A similar motif occurs in DC 35, in which the seven seals bestowed upon Hibil-Ziwa are numbered and named (see Drower 1953, 32).

The names of the seals belong to the category of *nomina barbara*, which we are unable to explain. It is not a surprise, therefore, that there are numerous modifications and variations of these names, and in most cases it is impossible to establish the original form (if such a thing even ever existed). We can, however, offer the following remarks:

The name of the seventh seal in JBA 72:4 is **'rmys**, which may derive from the Greek divine name Ἑρμῆς "Hermes".

Some of these bowls also refer to another name before the seven: **'brḥsy'** (JBA 65:1; compare also **'brḥsyh** in JBA 95:8, JBA 98:14 and JBA 101:14; **'brksyh** in JBA 66:5). This could be the (perhaps original) Aramaic form of the famous Greek angel name Abraxas (for which, see Bohak 2008, 247–250). The Aramaic form was perhaps pronounced Abraḥsia. The first element in this name, *abrā*, could signify "limb", and is attested as the name of an angel in MSF Amulet 21, right column, ll. 2 and 9, as well as in AMB Bowl 3:5 (see also **'br'wt**, in MSF Amulet 22:9, which could also be related to this name). The second element in Abraḥsia could mean something like "holy" or "chaste". The profusion of great epithets given to this entity suggests that this is an important magical figure, which reinforces the possible connection to Abraxas. The forms **'brsks** (AMB Amulet 2:3 and AMB Amulet 12:2), **'brsqws** (AMB Amulet 1:9) and **'brsgs** (Gordon H:4) also occur in Aramaic, but these forms may be instances of borrowing back from the Greek of a word that was originally Aramaic.

JBA 65 and JBA 67 (see also JBA 95, JBA 98 and JBA 101) contain parallel texts that seek the economic prosperity of the clients (for the genre of economic magic in general, see Harari 2000). This is made clear by their use of the phrases **lymzwny** "for livelihood" (JBA 65:8; cf. JBA 67:5; compare also **š'ry mzwnh** "gates of livelihood" in JBA 95:13). These texts also use a quotation from Is 60:11 (JBA 65:9, JBA 67:5–6; see also JBA 95:14), which appears to be a common practice in bowls whose aim is success and prosperity—see also SD 34:13–14 (Levene and Bhayro 2005/2006). In JBA 65, JBA 95 and JBA 98, the end of Is 60:11 has been replaced with a phrase from Gen 27:28 (TO), whereas in JBA 67:5–6 both verses appear to be quoted in full in the same sequence. Parallels for this formula, outside the Schøyen Collection, include JNF 262 and SD 30 (both as yet unpublished).

JBA 68 seeks physical healing from **'yšt'** "fever" and **'rwyt'** "shivering".

It appears that the same scribe wrote the following texts, all of which contain parallel texts that begin at the rim and proceed to the centre of the bowl: JBA 68, JBA 69, JBA 71, JBA 74, JBA 78, JNF 91, JNF 98 and BLMJ 10372. For other possible parallels, see JNF 154, JNF 278 and Wolfe 5.

JBA 65 begins abruptly, as if it were the continuation of another bowl. In JBA 95, the parallel spell is indeed preceded by another spell (featuring the lilith Gannav), which itself begins abruptly in the middle of a sentence. JBA 95, therefore, is probably also the continuation of another bowl.

The clients in JBA 65 appear elsewhere: Ōša'yā son of Ḥāṭay in Deutsch 6, and Ardōy son of Ilu in JNF 262—it appears that all three texts were written by the same hand. The same scribe probably also wrote JBA 79; note that JBA 65 and JBA 79 contain very similar drawings.

The clients in JBA 72, Farrokh son of Rašewanddukht and Dukhtbeh daughter of Gušnasp-frī, are probably the same as the Farrokh son of Rašewanddukh and Dukhtbeh daughter of Gušnasp-frī who appear in JBA 23, JBA 37 and JBA 59. We learn from JBA 23 and JBA 59, therefore, that Dukhtbeh was Farrokh's wife. Compare also Davidovitz 18, which was written by the same hand and for the same clients as JBA 72, and which parallels it in many respects. Dukhtbeh daughter of Gušnasp-frī probably also appears in M 110, where her name is spelled **dwktbyh bt gwšnṣpryy**.

Several bowls in the Schøyen Collection are written for a client called **byzdd br gwšny** "Bayyazaddād son of Gušnay" (see JBA 68, JBA 70 and JBA 110; see also JBA 34, JBA 95 and BLMJ 10372). The name probably derives from *bay-yazad-dād* "given by the deity *bay*" (see the note to JBA 34:12; our original transcription "Bizdad" does not properly reflect this etymology, so we have thus revised it in the present volume). In JBA 70, this Bayyazaddād is described as being married to Dukhtay daughter of Hormizdukh (cf. JBA 110), while his daughter is called Gušnay daughter of Bayyazaddād—she was thus named after her paternal grandmother. The use of a patronym for his daughter is unusual in the magic bowls. MS 2053/148:2

reads **dbyzdd br gwšny wdkwpyty 'yttyh** "of Bayyazaddād son of Gušnay and of Kufitay his wife", and MS 1927/21:13 refers to **gwšny bt kwpyty** "Gušnay daughter of Kufitay". It would appear, therefore, that the younger Gušnay was the daughter of Bayyazaddād's earlier wife, Kufitay, but, by the time JBA 70 and JBA 110 were written, Bayyazaddād was married to Dukhtay—hence its use of the patronym for Gušnay. See also MS 2053/80 and MS 2053/102.

JBA 73 was written by the same hand and for the same client as JBA 96. They both also contain very similar drawings. Again, JBA 75 was written by the same hand as JNF 146, with both also containing very similar drawings. And, again, JBA 76 was written by the same hand and for the same client as JBA 111 and M 59 (Levene 2003a, 31–39).

The following contain parallel texts: JBA 73, JBA 75, JBA 76, JBA 79, and JBA 80; see also JNF 108, JNF 145, JNF 146, JNF 187, SD 33, and Wolfe 78. For a parallel of JBA 66, see JNF 178. These texts share the reading **'ym** for **'ym** (JBA 75:6, JBA 76:8, and JBA 79:8; see also JNF 145:8), which suggests that the spelling with ʿayin had become part of the fixed formula (even when written by different hands). As is well-known, etymlogical ʿayin was weakened in Babylonian Aramaic to the extent that it was pronounced like ʾaleph or lost completely. Compare the forms **nypq'** and **'r'** from the same formula (JBA 73:8, JBA 75:6, JBA 76:9, and JBA 79:9).

Other bowls from the Schøyen Collection that contain similar formulae include MS 1927/62, MS 2053/74, MS 2053/177, and MS 2053/198 (to be published in volume five), and MS 2053/2 (to be published in volume six).

See Shaked 2006, 376–378, for an earlier edition of JBA 65.

Other spells that occur in the bowls in this section:
– The bay tree and tamarisk—JBA 73:7, JBA 75:6, JBA 76:8, JBA 79:8
– The overturned mysteries—JBA 73:8
– The seal of King Solomon—JBA 70:9
– The seal of the sun—JBA 65:5, JBA 67:3, JBA 68:4, JBA 69:4, JBA 71:4, JBA 72:4, JBA 73:4, JBA 74:6, JBA 75:4, JBA 76:6, JBA 77:2, JBA 78:6, JBA 79:6, JBA 80:6; cf. JBA 70:6
– The seven walls of iron and bronze—JBA 77:6
– The signet-ring of El Shaddai—JBA 65:6, JBA 67:3
– The signet-ring of King Solomon—JBA 70:7, JBA 73:10

JBA 65 (MS 1911/1)

170 × 65 mm. Square semi-formal hand. The rim is chipped and there are three deep scratches on the inside of the bowl. The text is surrounded by a circle.

Clients: Ōšaʿyā son of Ḥatay; Ardōy son of Ilu.

Biblical quotations: Ex 3:14; Ex 3:15; Is 40:31; Is 60:11; Gen 27:28 (TO).

Image: In the centre of the bowl, there is a frontal, standing figure (cf. the image in JBA 79). By the exposed chest, which shows two circles, the figure appears to be female. The lower part of her body is probably covered by a long skirt that ends at the ankles; the texture of the skirt's material is shown using three vertical wavy lines. Her hair is very long and curly, falling down both sides of her body towards her ankles. Four short vertical stripes are on top of her head, possibly indicating a wreath or a crown. Her arms are very thin, consisting of two lines that cross her chest. Her hands are thicker, consisting of short curved lines. She is barefoot, with each foot consisting of a single line with no toes indicated. Her head is oval and wide, with two hollow circles for her eyes, a straight horizontal line for her mouth, and a horizontal eyebrow line that is a continuation of her rectangular nose. Her arms are crossed, indicating that they are bound. The legs are bound towards the ankles, and the feet resemble those of a hen, with three toes.

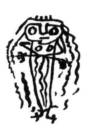

FIGURE 1: Artist's impression of image from JBA 65

1 And by the name of the great, holy ʾbrḥsyʾ, the king of the world. Again,

2 you are bound and sealed by seven seals and by eight bonds.

3 The first seal (is that) of **nbwryn**; the second, of **nbwryn** son of ʾyry; the third, of **ybwl** son of **sgwl**;

4 the fourth, of **ṣwrbyn nwr bwzyṭ gzyʾ**; the fifth, of the mighty **bwrgwn**; the sixth,

5 of **ṭwrmyn**; the seventh, of **ṭwrmys**. And by the seal of the sun, and by the signet-ring of the moon. By the mystery

6 of the earth, and by the base of the sky. And by the name of the signet-ring of the great El Shaddai, and by the name of YHWH "I am, I am",

7 יהוה צבאות שמו הוא אהיה אשר אהיה זה שמי לעלם וזה זכרי לדור דור וקוי יהוה יחליפו כח	7 "YHWH Sabaoth is his name". He is "I am that I am". "This is my name for ever, and this is my memorial unto all generations". "But those who wait upon YHWH shall renew their strength;
8 יעלו איבר כנשרים ירוצו ולא ייגעו יילכו ולא ייעפו ויד פתחו להון לאושעיה בר חתי ולארדוי בר אילו לימזוני	8 they shall mount up with wings as eagles; they shall run and not be weary; they shall walk and not faint". And open (your) hand to them, to Ōšaʿyā son of Ḥaṯay and to Ardōy son of Ilu, for livelihood,
9 שנאמר ופיתחו שעריך תמיד יומם ולילה ולא יסגירו ולהביא איליך מיטרא דרקיעא ומיטובה דארעה וסגיות עיבה	9 as it is said: "And your gates shall be open continually, day and night, and they shall not be closed, and to bring to you", "the rain of the sky, and of the choice produce of the earth, and a multitude of fruit (?),
10 עיבר וחמ[ר] אמן אמן הללויה	10 grain and win[e]". Amen, Amen, Hallelujah.

5. **shyrʾ**: "moon"; probably an error for **syhrʾ** (*DJBA*, 800). It is possible, however, that the spelling reflects a pronunciation *sīrā* (i.e. without *-h*), like Mand. **sira** (*MD*, 329).

7. E.g. Is 47:4 (this phrase occurs thirteen times in the Bible).
Ex 3:14.
Ex 3:15.

7–8. Is 40:31.

9. Is 60:11.
wlylyh: "and night"; it appears that MT **wlylh** (Heb.) has been replaced with Aram. **wlylyh** (see also JBA 95:14).
Note **wlʾ** for MT **lʾ**.
Note **wlhbyʾ** for MT **lhbyʾ**.

9–10. Gen 27:28 (TO).

9. **wmyṭrʾ**: "and the rain"; for TO **mṭlʾ** "of the dew". See JBA 95:14 and JBA 98:18, which read **myṭlʾ** in accordance with TO. The change from **myṭlʾ** to **myṭrʾ** is a result of their phonetic and semantic similiarity.
rqyʿ: "the sky"; for TO **šmyʾ** "the heaven".
ʿybh: "fruit (?)"; perhaps an error for the following **ʿybr** "grain", as it does not appear in the parallels (cf. JBA 67:6, JBA 95:15 and JBA 98:18) or in any targum to Gen 27:28. Nevertheless, in light of the unique variant reading **myṭr** "rain" in the same quotation, we tentatively take **ʿybh** to be a non-standard spelling of **ʾbh** "(growing) fruit" (*DJBA*, 73; *SL*, 1).

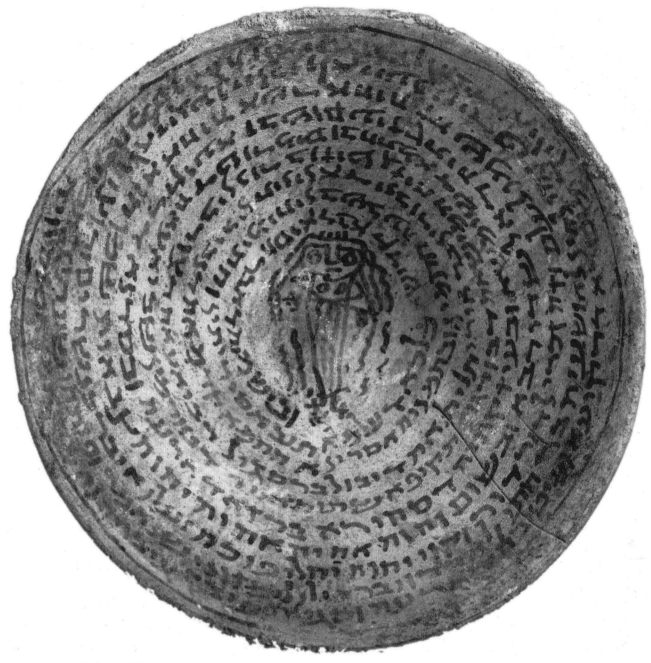

JBA 66 (MS 1927/46)

180×80 mm. Square semi-formal hand. The bowl was broken, but has been repaired. The writing is partly faded towards the centre. The text is surrounded by a circle.

Clients: Bahmandād son of Dūday; Maḥlaftā, his wife.

Image: In the centre of the bowl, there are the very faded remains of what may have been a large figure, consisting of thin round lines. The head appears to have been round, with some straight lines, perhaps representing hair, raised on its right. There seems to be two small eyes on each side of a nose, which itself consists of a straight vertical line that crosses the face. Apparently, there are also eyebrows, and long hair sprouting on each side of the head. The interpretation of this image remains very uncertain.

FIGURE 2: Artist's impression of image from JBA 66

1 [...] בהמנדד בר דודי ודמחלפתה אינתתיה בעיזקתי בשבעה איסרין ובשב[ע]ה

1 [...] Bahmandād son of Dūday and of Maḥlaftā, his wife, by seven bonds and by seve[n]

2 חתמין ד[...] בהון כורסיה רבה דמלכותה בחתמא קדמאה איבול וסיגול בחתמא תינינא יוביזול וסגניאל בחתמא תליתאה

2 seals by which [...] the great throne of the kingdom. By the first seal, **'ybwl** and **sygwl**; by the second seal, **ywbyzwl** and Seganiel; by the third seal,

3 דססגיאל תקיפא בחתמא רביעאה דדירמוסיס רבה בחתמא חמישאה דינכיזורית בחתמא שתיתאה דיזוברון בר ארגיה בחתמא שביע[א]ה דארגיה

3 of the mighty Sasangiel; by the fourth seal, of the great **dyrmwsys**; by the fifth seal, of **nkyzwryt**; by the sixth seal, of **zbwrwn** son of **'rgyh**; by the seven[t]h seal, of **'rgyh**

4 בר נורי בצפתה דארעה וברזא רבה דרקיעה וברזא הדין דישמיה דלית כל דעבר עלוהי דהוא שריר וקיים ומילוהי שרירן אמן אמן סלה ארתת

4 son of **nwry**. By the gemstone (?) of the earth and by the great mystery of the sky, and by this mystery of heaven against which there is not anyone who transgresses, which is sound and established, and its words are sound. Amen, Amen, Selah. **'rtt**

5 אמורתת קיטותיה ואברכסיה

5 **'mwrtt qyṭwtyh** and **'brksyh**.

1–2. **wbšbʿ[h] ḥtmyn d[...] bhwn kwrsyh rbh dmlkwth**: "and by the seve[n] seals by which [...] the great throne of the kingdom"; cf. MS 2053/63:3 (to be published in volume seven), which reads: **wbšbʿh ḥtmyn dʾsyr wdḥtym bhwn {b} kwrsyʾ rbh dmlkwtʾ**: "and by the seven seals by which is bound and sealed the great throne of the kingdom". It may be possible to see faint traces of an initial *ʾaleph* and final *mem* at the start and end of the lacuna, but the writing is too faded to restore the text with any certainty.

4. **bṣpth dʾrʿh**: "by the gemstone (?) of the earth"; cf. Syr. ṣptʾ, glossed in *SL*, 1299, as "stone of a ring", and in *CSD*, 483, as "the *stone* or *setting* of a ring" (equated with ṣbtʾ "ornament"). The term is derived from Gr. ψῆφος "pebble, small round worn stone, precious stone, gem". The phrase ṣpth dʾrʿh, therefore, could be describing the earth as a small stone, in contrast to the "great mystery of the sky", or it could be likening the earth to a precious stone that is set in the sky. The terms **ṣptʾ dʾrʿh** (JNF 178:6) and **ṣybtʾ dʾrʿh** (JNF 154:8) appear as variants of ṣwrtʾ dʾrʿh "image of the earth", in parallelism with ʿyzqtʾ dsyhrʾ "signet-ring of the moon", which could lend support to the latter suggestion. Alternatively, it could be that ṣpth dʾrʿh is equivalent to ʿzqtʾ d ʾrʿh, and that ṣpth represents the seal itself (perhaps made of a precious stone). See also **bṣybyth dʾrʿh** in JBA 70:6–7, and the introduction to **I.4.1.1**.

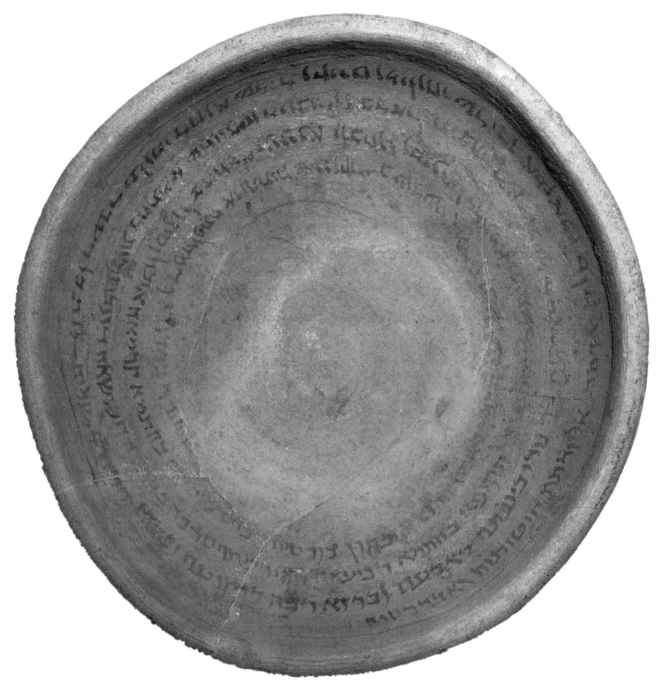

PHOTO 2 JBA 66 (MS 1927/46)

JBA 67 (MS 2053/56)

164×60 mm. Square semi-formal hand. The bowl was broken. It has been repaired, but is missing a small portion. The writing is partly faded. The beginning of the text is lost, so the original number of lines is unknown. The text is surrounded by a circle.

Clients: [...] son of Aḫāt; [...] daughter of Roštafrī.

Biblical quotations: Ex 3:14; Ex 3:15; Is 40:31; Is 60:11; Ps 121:7–8; Gen 27:28 (TO); Zech 3:2.

Image: In the centre of the bowl, there are the faded remains of what appears to be a figure that is standing frontal, except for the feet, which are in profile and facing to the right. The figure appears to be female, on account of her long straight hair, which falls on both sides of her head, and her long garment. Her face is barely preserved, but her right eye and eyebrow are clear. The eye is large and consists of concentric lines. There are short curvy lines protruding from her chin, which might represent a beard. The right foot resembles that of a hen, having three toes.

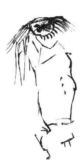

FIGURE 3: Artist's impression of image from JBA 67

[...] 1 [...]

2 רביעאה דצורבין נור [בוזיט גזיא] חמישא[ה דב]ורגון תקיפ[א ש]תיתאה [ד]טורמין שביעאה דטורמס

the fourth, of ṣwrbyn nwr [bwzyṭ gzy']; the fift[h, of the] mighty [b]wrgwn; the [s]ixth, [of] ṭwrmyn; the seventh, of ṭwrms.

3 ובחתמא דשמשא ובעיזקתיה דסיהרא בר[ז] דארעה ו[בסדנא] [דרקיעא וב]שום עיזקתיה ד[אל שדי רבא ובשום

And by the seal of the sun, and by the signet-ring of the moon. By [the] mystery [of the earth, and] by the base [of the sky. And by] the name of the signet-ring of the great El Shaddai, and by the name of

4 יהוה אה אהיה אהיה יהוה {.} צבאו[ת] שמו ה[וא אהיה אשר אהיה זה] שמי לעלם וזה זכרי לדור [דור וקוי יהוה יח]לי[פו כ]ח י[על]ו איבר

YHWH 'h "I am, I am", "YHWH Sabao[th] is his name". H[e is "I am that I am". "This] is my name for ever, and this is my memorial unto all gene[rations". "But those who wait upon YHWH shall r]ene[w their] stre[ngth; they shall] mount up with wings

5	as eagl[e]s; they shall run and not be wear[y]; they shall walk and not [f]ain[t]". And ope[n] (your) hand [to them, to ... so]n of Aḥāt [and to ...] daughter of Roštaf[rī, for] li[veliho]od, as it is said: "And [your gates] shall be ope[n] continually,
כנשר[י]ם ירוצו ולא יגע[ו] ילכו ולא [י]יעפ[ו] ויד פתח[ו] להון ל... ב[]ר אחת [ול...] בת רושתפ[רי ל[מ]זונ[י שנאמר ופית[חו שעריך] תמיד	

6	day and night, and [they] shall not be closed, to bring to you the wealth of nations and their kings [being] l[ed]; ... "of the dew] of the sky, and of the choice produce of the earth, a multitude of grain and wine". Amen, Amen, Selah, Hallelujah. "YHWH
יומם ולילה ולׄו יסגיר[ו]ן להביא אילך חיל גים ומלכיהם נ[הוגים ... מטלא] דרקיעא ומיטובה דארעה סגיות עיבור וחמר אמן אמן סלה הללויה יהוה {נ}	

7	shall preserve you from all evil; and he shall preserve your soul. YHWH shall preserve [your] going o[ut and your coming in from now] and for evermore". Yah. "And YHWH said (unto) Sata[n], YHWH rebuke you, O Satan, even YHWH that has chosen Jerusalem rebuke (you).
ישמורך מיכל רע וישמור את נפשיך יהוה ישמור צא[תך ובואך מיעתה] ועד ע[ול]ם {וימ} ויאמר יהוה {ס} הסט[ן] יגער יהוה בך הסטן ויגער יהוהבוחיר ביירושלים	

8	Is this not a brand plucked out of the fire?". [Ame]n Amen, Selah.
הלו זה אוד מוצל מיאש [אמ]ן אמן סלה	

4. E.g. Is 47:4 (this phrase occurs thirteen times in the Bible).
Ex 3:14.
Ex 3:15.

4–5. Is 40:31.

5–6. Is 60:11.
Note **wlw** for MT **l'**.

6. Gen 27:28 (TO).
rqyʿ: "the sky"; for TO **šmyʾ** "the heaven".

6-7. Ps 121:7–8.

7. Note **wyšmwr** for MT **yšmr**.

7-8. Zech 3:2.

7. {**wym**} **wyʾmr**: The scribe initially omitted the silent ʾaleph, but he then started the word again in order to include it.
{**s**} **hsṭn**: It appears that the scribe omitted the definite article, and then began the word again after realising his error. He also omitted the preposition ʾl.
yhwhbwḥyr: Error by haplography for **yhwh bk hbwḥyr**.

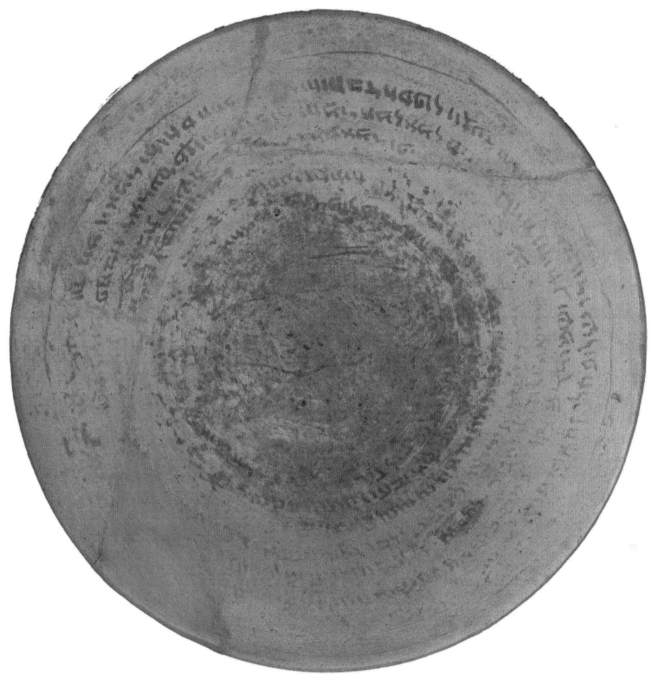

PHOTO 3 JBA 67 (MS 2053/56)

JBA 68 (MS 2053/57)

163 × 60 mm. Semi-formal hand. The rim is chipped. The bowl was broken. It has been repaired, but is missing two small portions on one side. The writing is almost entirely faded on the other side. The text begins at the rim and proceeds towards the centre.

Linguistic and orthographic features: Note the use of **–h** rather than **–yh** for the 3 p. masc. sg. pron. suffix in **lh** (l. 1). Note also **tlyt'** for **tlyt'h** (l. 3).

Client: Ba[yyazaddād] son of Gušnay.

[... כל אי]נאשי דאיתלה להדין ב[יזדד] בר גושני כולהון חתימין ומחתמין מן שידי ומן שיבטי ומן ד[יוי ...]	1	[... all the pe]ople that this Ba[yyazaddād] son of Gušnay has. All of them are sealed and double sealed from demons and from afflictions and from d[ēvs ...]
[... ומן] ליל[ית]א דיכרי ומן לילי[תא ניקבתא] ומן כל רוחי בישתא ד[ידכיר ש]מיהון ודלא דכיר שמיהון [...]	2	[... and from] male lil[ith]s and from [female] lili[ths] and from all evil spirits, (both) those w[h]ose [na]mes are [mentioned] and those whose names are not mentioned [...]
[... חת]ימין בשבעה חתמ[ין חתמא ק]דמאה דיבידתה [תינינא דיבו]ל בר סיגול תליתא דאגרוס [...]	3	[...] they are [sea]led by seven seal[s]. The f]irst [seal] (is that) of **bydth**; [the second, of **ybw**]**l** son of **sygwl**; the third, of **'grws** [...];
[רביעאה ...ר]ן בר אדי חמישאה ד[...] בר נורי שתיתא[ה ...]מין שביעאה דאטרמין [בחתמה דשימשא]	4	[the fourth ...]**rn** son of **'dy**; the fifth, of [...] son of **nwry**; [the] sixth [...]**myn**; the seventh, of **ṭrmyn**. [By the seal of the sun,]
[וב]עיזקתיה דסיהרא בצורתא דארעה וברזא רבה דרקיעה מן שידי ומן שיבטי	5	[and by] the signet-ring of the moon. By the image of the earth and by the great mystery of the sky. From demons and from afflictions
ומן דיוי ומן אישתא ומן עריותא ומן כל רוחי בישתא דידכיר	6	and from *dēv*s and from fever and from shivering and from all evil spirits, (both) those whose names
שמיהון ודלא דכיר שמיהון מן יומא דין	7	are mentioned and those whose names are not mentioned, from this day
ולעלם	8	and for ever.

In the centre:

אמן	9	Amen,
אמן סלה	10	Amen, Selah.

1. **b[yzdd] br gwšny:** "Ba[yyazaddād] son of Gušnay"; see the introduction to this section.

3. **dybydth:** "of **bydth**"; all the parallels by the same scribe read **dbydt tynyn'**. Here, however, it is paleographically unlikely that the final letter is a *taw* (i.e. for the start of **tynyn'** "the second").

5. **bṣwrt' d'r'h:** "by the image of the earth"; perhaps "by the (magic) circle of the earth", for which compare Mand. ṣurta "a line or barrier placed or described about a thing or person, circle, magic circle" (*MD*, 391–392, s.v. ṣurta 2, meaning a).

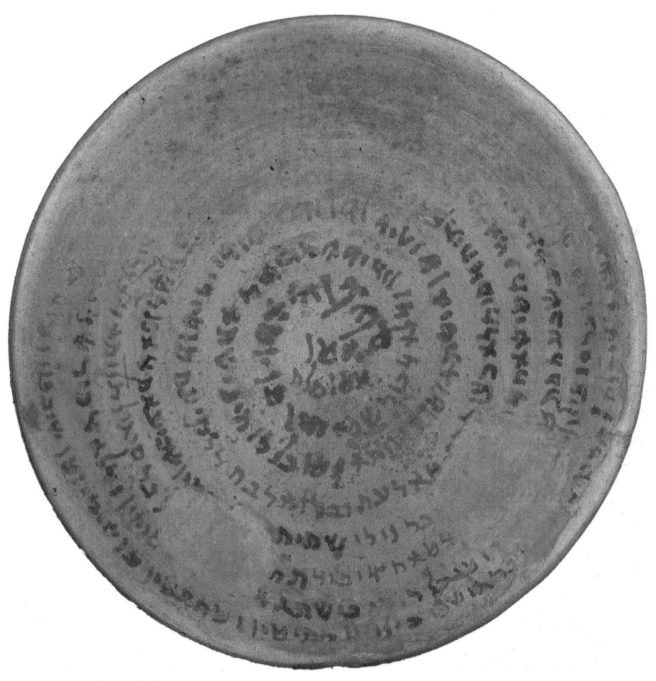

PHOTO 4 JBA 68 (MS 2053/57)

JBA 69 (MS 2053/90)

165 × 65 mm. Semi-formal hand. The bowl was broken, but has been repaired. The text begins at the rim and proceeds towards the centre. The writing is mostly faded. The text appears to be surrounded by a circle.

Linguistic and orthographic features: Note the use of –**h** rather than –**yh** for the 3 p. masc. sg. pron. suffix in **brh**, **bnth**, **bnh** and **lh** (all l. 1).

Clients: Bahman son of [...]; Gaya, his son; Mārī, his son.

1 [...] וגיא ברה ומרי ברה ובנתה ובני בנה וכל
אינשי דאית לה לבהמן בר [...] כו[ל]הון חתימין
ומ[חתמין] מ[ן ...]

1 [...] and Gaya, his son, and Mārī, his son, and his daughters, and his grandchildren, and all the people that Bahman son of [...] has. Al[l of] them are sealed and double [sealed] fr[om ...]

2 [...] חתימין ביתלתא אס[ר]ין מחתמי[ן] ב[...]

2 [...] they are sealed by three bon[d]s, th[ey] are double sealed by [...]

[...] 3 [...]

4 [...] ובעיז[קתיה דסיהרא ב]...]

4 [... and by] the [sig]net-ring of the moon. By [...]

[...] 5 [...]

[...] 6 [...]

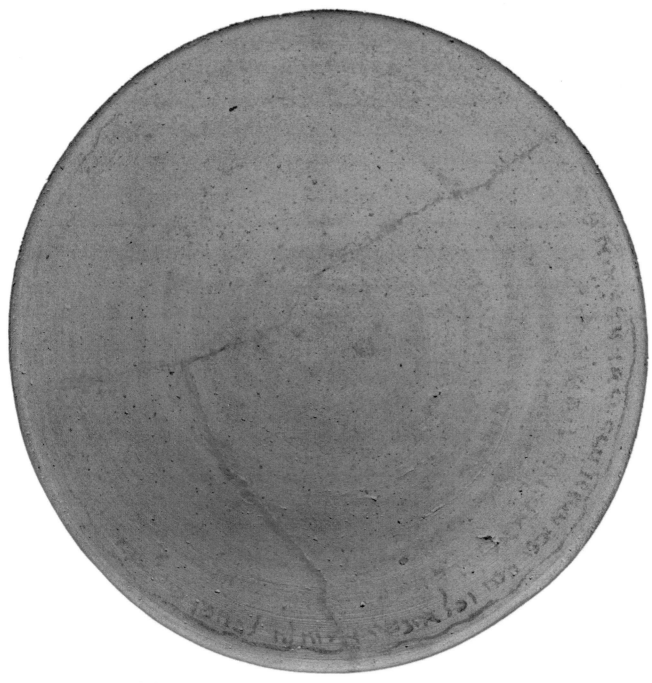

PHOTO 5 JBA 69 (MS 2053/90)

JBA 70 (MS 2053/92)

160 × 55 mm. Semi-formal hand. The bowl was broken. It has been repaired, but is missing a small portion. The rim is chipped. The writing is faded towards the rim.

Linguistic and orthographic features: Note the use of –**nn'** for the 1 p. pl. encl. pron. in **mḥtmnn'** (l. 1) and **ḥtymnn'** (l. 7)—see also [...]**nn'** (l. 8).

Clients: Bayyazaddād son of Gušnay; Dukhtay daughter of Hormizdukh, his wife; Gušnay daughter of Bayyazaddād.

1 חתימנא ומחתמנגא אנחנא ביזדד בר גושני
 ודוכתי אנתתי

1 We are sealed and double sealed, we, Bayyazaddād son of Gušnay, and Dukhtay, my wife,

2 בת הורמיזדוך וגושני בת ביזדד מן סטני ומן ירורי
 ומן דיוי ומן

2 daughter of Hormizdukh, and Gušnay daughter of Bayyazaddād, from satans and from *yaror* demons and from *dēv*s and from

3 שידי ומן פגעי ומן ליליתא ומן פתכרי וטעיתא
 דיכרי וניקבתא ומן כל רוחי בישתא

3 demons and from affliction demons and from liliths and from idol spirits and error spirits, male and female, and from all evil spirits,

4 דיכרי וניקבתא בשבעה איסרי ובתמניה חתמי
 חתמא {חתמא} קדמאה דנבידית

4 male and female. By seven bonds and by eight seals. The first seal (is that) of **nbydyt**;

5 תינינא דיבול בר סיגול תליתאה דזברה בר אלחי
 רביעאה [...] חמישאה דנגסוס

5 the second, of **ybwl** son of **sygwl**; the third, of **zbrh** son of **'lḥy**; the fourth [...]; the fifth, of the mighty

6 תקיפא שתיתאה דט[...] שבי[ע]אה דטורמיס
 בחתמא דסיהרא [ובעיז]קתה דש[מ]שא
 בציביתה

6 **ngsws**; the sixth, of ṭ[...]; the seve[n]th, of **ṭwrmys**. By the seal of the moon, [and by the sig]net-ring of the s[u]n. By the gemstone (?)

7 דארעה ברזה [רבא] דרקיע[א] בעיזקתא
 דש[ל]מה מלכא בר דויד תוב חתימננא [...]
 ביזדד בר גושני] ודוכתי

7 of the earth, by the [great] mystery of [the] sky, [by the signet-ring of] King [So]lomon son of David. Again we are sealed [... Bayyazaddād son of Gušnay] and Dukhtay

8 בת הורמ[י]זדוך [...]ננא אנא ביזדד בר גושני
 וד[ו]כ[ת]י [...

8 daughter of Hormizdukh [...] we are [...] I, Bayyazaddād son of Gušnay, and D[u]kh[tay ...]

9 [...] בחתמא {דיל} דשלמה מלכא ב[ר דויד ...

9 [...] by the seal of King Solomon so[n of David ...]

[...] באיסרא [...] 10 [...] by the bond [...]

[...] 11 [...]

Outside:

חתמתא 12 Sealing.

1. **ḥtymnʾ wmḥtmnnʾ**: "We are sealed and double sealed"; we have understood **ḥtymnʾ** as a 1 p. pl. form because of the context and the occurrence of **ḥtymnnʾ** in l. 7. It appears that the scribe omitted a *nun* in this instance. **byzdd br gwšny**: "Bayyazaddād son of Gušnay"; see the introduction to this section.

3. **ṭʿytʾ**: "error spirits" (see *DJBA*, 510); alternatively **ṭʿwtʾ** "error spirits" (see *DJBA*, 509)—the reading is ambiguous.

6. **bḥtmʾ dsyhrʾ wbʿyzqth dšmšʾ**: "By the seal of the moon, and by the signet-ring of the sun"; the usual expression is **bḥtmʾ dšmšʾ wbʿyzqtyh dsyhrʾ** "by the seal of the sun, and by the signet-ring of the moon" (e.g. JBA 67:3).

6–7. **bṣybyṭʾ dʾrʿh**: "by the gemstone (?) of the earth"; see the note to JBA 66:4. A variant reading for this phrase is **bṣwrtʾ dʾrʿh** "by the image of the earth" (e.g. JBA 68:5; JBA 73:5).

9. **bḥtmʾ {dyl} dšlmh mlkʾ**: "by the seal of King Solomon"; references to the "seal of Solomon" are rare in the magic bowls, which usually refer to the "signet-ring of Solomon". Exceptions include **bḥwtmʾ dyšlwmw mlkʾ** "by the seal of King Solomon" (Gordon 11:17–18).

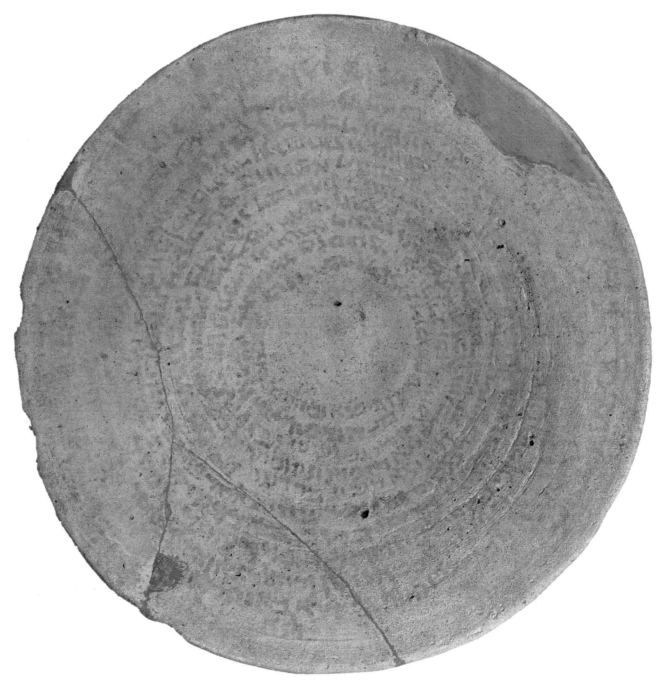

PHOTO 6 JBA 70 (MS 2053/92)

PHOTO 7 JBA 70 (MS 2053/92)—exterior

160 × 70 mm. Semi-formal hand. The rim is badly chipped on one side. The text begins at the rim and proceeds towards the centre. The writing is faded towards the rim. The text appears to be surrounded by a circle that is drawn with a wavy line.

Image: In the centre of the bowl, there is a circle that consists of a thick wavy line and is divided into quarters by two wavy lines (cf. JBA 78).

FIGURE 4: Artist's impression of image from JBA 71

[...]	1	[...]
[...] חתימין [ומח]תמין ביתלתא אסרין ובשבעה חת[מין חתמא קדמאה]	2	[...] they are sealed [and double se]aled by three bonds and by seven sea[ls. The first seal (is that)]
דיבי[ד]ת[] תי[נינא דיבול בר] ס[יג]ול תליתאה דאגרוס תקין תקיפה רביעאה דזברן בר אדי	3	of **byd**[**t**]; [the] se[cond, of **ybwl** son of] s[**yg**]**wl**; the third, of the mighty **'grws tqyn**; the fourth, of **zbrn** son of **'dy**;
[חמישאה] [ד]נבו[...] בר נורי שתיתאה חוטמ[י][ן] שביעאה דאטרמין בחתמה דשימשה	4	[the fifth,] of **nbw**[...] son of **nwry**; the sixth, **ḥwṭm**[**y**]**n**; the seventh, of **'ṭrmyn**. By the seal of the sun,
ובעיזקתי[ה] דסיהרא בצורתא דארע[ה] וברזה רבה דרקיעה מן יומא	5	and by the signet-ring of the moon. By the image of the earth and by the great mystery of the sky, from [this]
[דין] ול[עלם א][מן אמן סל[ה]	6	day and for [ever. A]men, Amen, Sela[h.]

5. **bṣwrt' d'r'h**: "by the image of the earth"; see the note to JBA 68:5.

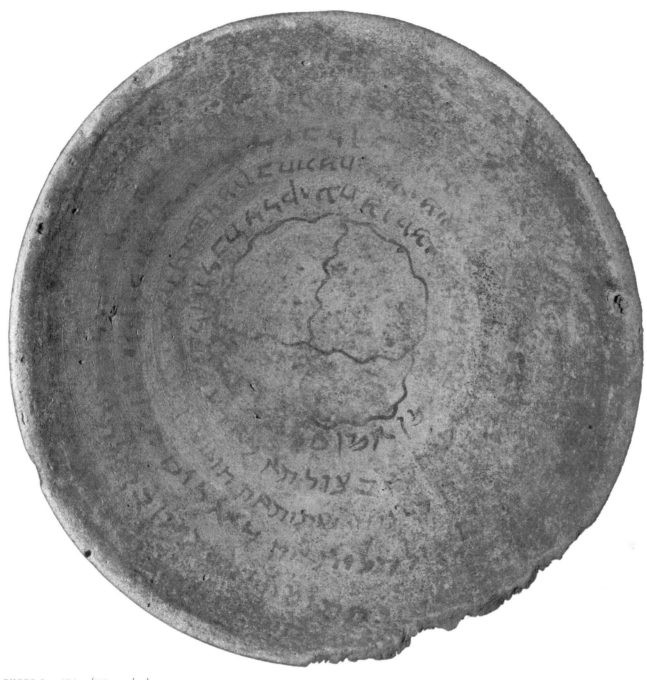

JBA 72 (MS 2053/119)

185 × 60 mm. Semi-formal hand. The bowl was broken. It has been repaired, but is missing several small portions.

Clients: Farrokh son of Rašewanddukht; Dukhtbeh daughter of Gušnasp-frī.

Image: In the centre of the bowl, surrounded by a circle, there is a frontal, hybrid figure, which is standing on three legs. The body and limbs consist of bands that are decorated with stripes. The body is curved and continues into the left and right hand legs, while another straight vertical band descends from the center of body to form the third leg. The feet resemble those of a hen, having three toes. Two arms stretch up from the body. The head is round and sits immediately on top of the body. It has two big round eyes that fill almost the entire face, each of which contains a pupil. Four long hairs protrude from one side of the head.

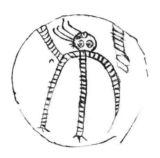

FIGURE 5: Artist's impression of image from JBA 72

1 חתים וימחתם וימנטר וימזרז [וי]מתקן בית[י]ה דפ[רוך בר רשונ]דוכת

1 Sealed and double sealed and guarded and strengthened [and] established is the house of Fa[rrokh son of Rašewan]ddukht,

2 ודירתה דדוכתבי בת גושנספפר[י] בשבעה חתמין ובית[מניא איסור]ין ביחתמא קבלאה

2 and the dwelling of Dukhtbeh daughter of Gušnasp-fr[ī]. By seven seals and by e[ight bond]s. By the first seal,

3 דינבודיד תינינא דאיבול בר סגול ת[ן]לי[ת]אה דזבוזיר בר איד[י] רביאעא[ה] דנרבוזיד בר נורי

3 of nbwdyd; the second, of 'ybwl son of sgwl; the th[ir]d, of zbwzyr son of 'yd[y]; the fourt]h, of nrbwzyd son of nwry;

4 חמישאה דנרגין תקיפא שתיתאה דארמין שביאעאה דארמיס ביחתמא [ד]שימשא בעיזקתא ד[ס]יהרא

4 the fifth, of the mighty nrgyn; the sixth, of 'rmyn; the seventh, of 'rmys. By the seal [of] the sun, by the signet-ring of the [m]oon.

5 בסדנא רבה דירקיעאה ביחתמא דיחתימין ביה שמיא וארעה חתים וימחתם ביתיה דפרוך בר רשונדוכת ודירתה

5 By the great base of the sky. By the seal by which heaven and earth are sealed. Sealed and double sealed is the house of Farrokh son of Rašewanddukht, and the dwelling

6 דדוכתב{ב}י בת גושנספפרי מן שידין ומן [פ]גע[ין] ומן דיוין ומן לילחנין [ומן] ליליתא בי[ש]תא ומן מבכלתא בישתא בישמיה

6 of Dukhtbeh daughter of Gušnasp-frī, from demons and from [afflic]tion demons and from *dēv*s and from servitors [and from] ev[i]l liliths and from evil *mevakkalta* demons. By the name

7 דיהוה אמן אמן סלה

7 of YHWH. Amen, Amen, Selah.

2. **byḥtm' qbl'h**: "By the first seal"; variant of the more common **byḥtm' qdm'h**. The same spelling appears, inter alia, in the parallel Davidovitz 18:3, which was written by the same scribe for the same client.

3. **dzbwzyr**: "of zbwzyr"; alternatively, read **dybwzyr** "of bwzyr".

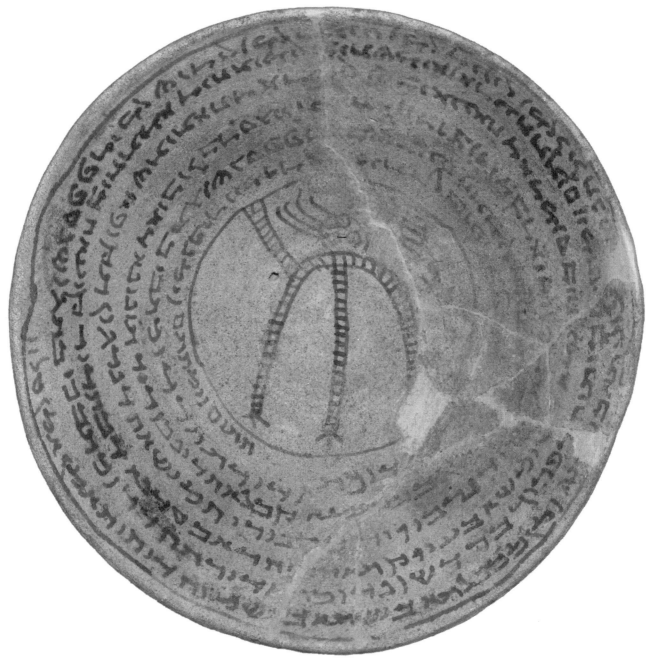

PHOTO 9 JBA 72 (MS 2053/119)

JBA 73 (MS 2053/126)

165 × 50 mm. Semi-formal hand. The bowl was broken, but has been repaired. Occasionally, the repair obscures the writing. The text is surrounded by a circle. Two passages, which fit into ll. 2 and 3, have been written between the lines.

Linguistic and orthographic features: Note the use of –h rather than –yh for the 3 p. masc. sg. pron. suffix in **bh** (ll. 3 and 4).

Clients: Mākhusrō son of Mādukh; Narsōy daughter of Ādarōy, his wife.

Biblical quotation: Num 9:23.

Image: In the centre of the bowl, there is a frontal, standing hybrid creature whose garment and facial features resemble that of the male *Pazuzu* demon (cf. the image in JBA 96). He has two sharp horns protruding from his head, between which is a head-covering that appears to descend to the back of his neck. The head is oval shaped, with two big eyes, each of which loops from the outside towards the centre of the face, and within which are hollow circles that indicate the pupils. A vertical straight line between the eyes indicates the nose, below which are two horizontal lines that indicate the mouth and chin. Around the neck, there is a rope that continues to encircle the figure's chest. He is wearing a short tunic, which is decorated with crossing diagonal stripes. The tunic has long sleeves, which are decorated with short stripes. The legs are exposed and triangular in shape. The feet are horizontal, with curved lines resembling claws. The hands are large, each consisting of a semi-circle, which forms the wrist and outer two fingers, and three additional lines for the other fingers. A rope descends from the right hand towards the legs, which are themselves bound by a thin rope at the ankles. Another rope appears to descend between the legs, joining the rope that binds the ankles.

FIGURE 6: Artist's impression of image from JBA 73

1 חתים ומחתם ביתיה וקיניניה וכל בעיריה וכל אינשי ביתיה דמאכוסרו בר מדוך ודירתה

1 Sealed and double sealed is the house and property and all the cattle and all the people of the house of Mākhusrō son of Mādukh, and the dwelling

2 דנרסוי בת אדרוי חתימין ומחתמין מן כל שידין ושיפטין ודיוין וסטנין וזעין ופגעין וסטנין בשום יורבא יורגא וגברא מלאכה אמן אמן סלה אסירין בתלתא

2 of Narsōy daughter of Ādarōy. They are sealed and double sealed from all demons and afflictions and *dēv*s and satans and shakers and affliction demons and satans. By the name of **ywrb' ywrg'** and the angel Gabra. Amen, Amen, Selah. They are bound by three

3 bonds and they are sealed by seven seals. By the great seal by which heaven and earth and the seven firmaments are sealed. The first seal is **tybwt**; the second, of **bydyh**; the third, of **gzrywn**; the fourth, **hdyn bwl**; the fifth, of **rmsyn**; the sixth, of the great Yah; the seventh,

איסרין וחתימין בשבע חתמין בחתמא רבה
דחתמין בה שמיא וארעה ושבע רקיעין חתמא
קדמאה טיבות תנינא דבידיה תליתאה דגזרין רביעאה הדין
בול חמישא דרמסין שתיתאה דיה רבא שביעא

4 of YYYY and Sabaoth. By the great seal by which heaven and earth are sealed. Sealed by the seal of the sun and the moon, and by the signet-ring of the moon. By the image of the earth and by the great mystery

דייי וצבאות בחתמא רבא דחתמין בה שמיא
וארעה חתים בחתמא דשימשא וסיהרא
ובעיזקתא דסיהרא בצורתא דארעה וברזא
רבא

5 of the sky, in order that you shall not come near to any of the sons or to any of the daughters or to any of the possessions or to any of the cattle or to the food or to any of the people of the house of Mākhusrō son of Mādukh, to Narsōy daughter of

דירקיעא דלא תיקרבון לכל ביניהון ולכל בנתהון
ולכל קיניהון ולכל בעיריהון ולאמזונהון ולכל אינשי
בתיהון דמאכוסרו בר מדוך לנרסוי בת

6 Ādarōy, his wife, all demons and afflictions and *dēv*s and satans and no-good ones and idol spirits and all idol spirits, all of those whose names are mentioned (and) those whose names are not mentioned in the amulet [... trans]gress

אדרוי אינתתיה כל שידין ושיפטין ודיוין וסטנין
ולטבין ופתכרין וכול פתכרי כולהון דדכירין
שמיהון דלא דכירין שמיהון ביקמיעה ע]...ע[בר

7 against this command, [may] he burst like a bay tree and be split open like a tamarisk, and may his voice go [like a di]viner, and may he remain under a ban just like the evil Cain remains, son of the evil one, from this day [and for] ever. [Ame]n, Amen, Selah. ["At the commandment of]

על מימרא הדין [ני]פקא כי ארא וניצטרי כי
בינא וניזיל קליה [כי מ]נחשא וניקום בשמתא
כמא דקאיים קין בישא בר בישא מן יומ[א] דן
[ול]עלם [אמ]ן אמן סלה [על פי]

8 YYYY they encamped, at the commandment of YYYY they journeyed. They kept the charge of YYYY at the commandment of YYYY by the hand of Mose[s]". Amen. 'bswny' Overturned is the mystery [of] Paṭḥiel. Overturned is the mystery of Karkum son of L[evia]than. Overturned is the mystery of the great 'rm[.]' o[f] darkness,

ייי יחנו על פי ייי י[ת י]סעו את משמרת ייי
שמרו על פי ייי ביד מש[ה] אמן אבסוניא אפך
רזא [ד]פתחיאל אפיך רזא דכרכום בר ל[ויי]תן
אפיך רזא דארמ[.]א רבה ד[י]חשוכא

9 אסורא דמייה איסוי אפיך רזה דמלאכי {א}
מרומא אפ[יכ]א ל[י]ל[י]יתא ונידרא וקריתא
ו[ש]יקופתא [ו]שלתא דלא יפל מאכוסרו
בר מדוך קד[ם] אילהי דיכרי קדם איסתרתא
נוקבתא אפיכא פל[גא] דתלת מאה שתין ושית

9 a bond of black water. Overturned is the mystery of the angels of the upper world. Overtur[ned] is the l[il]ith and the vow demon and the mishap and the [b]low demon [and] the spell, in order that Mākhusrō son of Mādukh shall not fall befor[e] male gods (or) before female goddesses. Overturned is the phala[nx] of three hundred and sixty-six

10 זרע[י]ת[א] בשבעין רזין בההיא עיזקתא רבתא
דשלמה מלכה ב[ר] דויד אמן אמן אמן סלה

10 cla[n]s. By seventy mysteries. By that great signet-ring of King Solomon so[n of] David. Amen, Amen, Amen, Selah.

3. **rbyʿh hdyn bwl**: "the fourth, **hdyn bwl**"; probably a corruption of **rbyʿh dyzbwl** "the fourth, of **zbwl**", with the *zayin* of **dyzbwl** having been mistaken for *nun*—compare, e.g., JBA 75:3.

4. **bṣwrtʾ dʾrʿh**: "by the image of the earth"; see the note to JBA 68:5.

5. **qynyhwn**: "their possessions"; for **qynynyhwn**. See also JBA 105:3, JBA 111:3 and JBA 116:4.

7. **mnḥšʾ**: "diviner"; for this spell, see JBA 44:9–11, JBA 75:6–7, JBA 76:7–8, JBA 79:9–10 and MS 1927/62:9–10; see also JBA 118:4–6, Geller B:13 and Montgomery 6:11–12. For the alternative interpretation as "vessel of bronze", which takes **mnḥšʾ** to be a *sandhi* spelling of **mn nḥšʾ**, see Ford 2014, 241–242.

7–8. Num 9:23.

8. Note ʿl for MT wʿl.
ptḥyʾl: "Patḥiel"; given the pejorative context and the following reference to "Karkum son of Leviathan", it is possible that **ptḥyʾl** should be identified with the Mandaic supernatural being Ptahil.
krkwm br lywytn: "Karkum son of Leviathan". The demonic figure Karkum appears in Mandaic magic bowls and amulets and is also mentioned in the Ginza Rabba—see Ford 2002, 259 and the references cited there, especially DC 37, 8–9 and now also Davidovitz Amulet 2, 111a:13, which reads ʿsir hilḫ d-krkum br liuiatin "Bound is the power of Karkum son of Leviathan".

9. **myyh ʾyswy**: "black water"; see *DJBA*, 801, s.v. **syyb**.
ʾpyk rzh dmlʾky mrwmʾ: "overturned is the mystery of the angels of the upper world"; the angels here appear as maleficent beings—in Mandaic magic, **malakia** "angels" are often treated as a class of demons.
wšltʾ: "and the spell"; i.e. an error for **wʾšlmtʾ**—the terms **šyqwptʾ** and **ʾšlmtʾ** frequently occur together in the magic bowls, e.g. in CAMIB 23A:8.
plgʾ: "phalanx"; see Müller-Kessler 2012, 22. If our reconstruction is correct, the JBA noun is feminine like Mand. **planga** "phalanx" (see *MD*, 373).

9–10. **tlt mʾh štyn wšyt zrʿytʾ**: "three hundred and sixty-six clans"; compare ʿhia utlatma ušitin šurbata dila "she and her three hundred and sixty tribes" (YBC 2364:5–6 in Müller-Kessler 1996, 186), and **tlt mʾh wšytyn wšyth šydyn** "three hundred and sixty-six demons" (VA 3854:17–18 in Levene 2003b, 105).

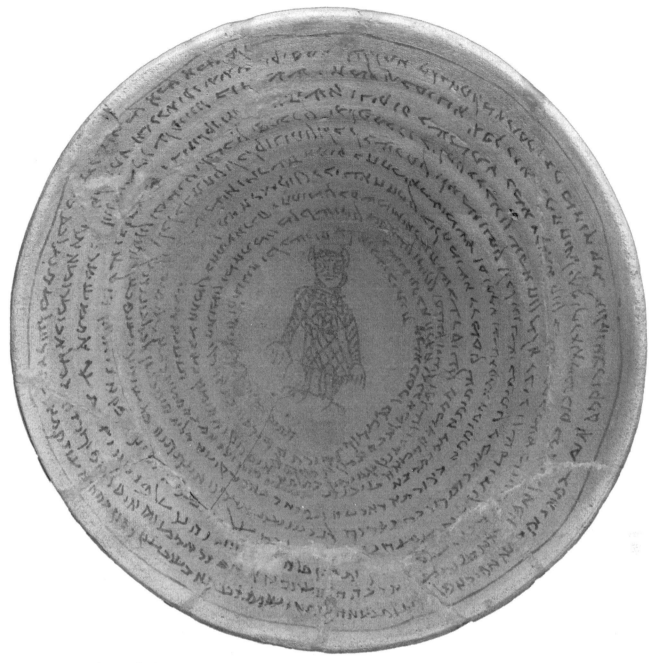

JBA 74 (MS 2053/131)

165×53 mm. Semi-formal hand. The bowl was broken, but has been repaired. The text begins at the rim and proceeds towards the centre. The writing is badly faded, especially towards the centre. The text is surrounded by a circle.

Linguistic and orthographic features: Note the use of –h rather than –yh for the 3 p. masc. sg. pron. suffix in **byth**, **bnh**, **bnth**, **lh** and **qynynh** (all l. 1).

Client: [...] son of Nānā.

Image: There appears to have been a drawing in the centre, but it is almost completely erased.

1 חתים ומחתמ הדין ביתה וקינינה ואיתתיה ובנה ובנתה ובנ^י ב[נ]ה וכל אינש^י דאית^לה ל[...] בר נאנא [כולהון]

1 Sealed and double sealed is this, his house and his property and his wife and his sons and his daughters and his grandchild[ren] and all the people that [...] son of Nānā has. [All of them]

2 חתימין ומחתמין מן לוטתה ומן קרית[א] ומ[ן] אישתה ומן עריתא ומן חילמ[י] בישי ומן חיזוני קשיי ומן [כל]

2 are sealed and double sealed from curse demons and from mishap[s] and fr[om] fever and from shivering and from evil dream[s] and from severe visions and from [every]

3 מידעם ב[י]ש חתימי[ן] ביתלתא אסרין מחתמין בשבעה חתמין [חתמ]ה קדמ[א]ה דיבידת ת[י]נינא

3 [ev]il thing. [Th]ey are sealed by three bonds. They are double sealed by seven seals. The firs[t seal] (is that) of **bydt**; the s[e]cond,

4 דיבול בר [סי]גו[ל] תליתא] דאגרוס תקין תקיפה רביע[אה] דזברן בר אד^י חמי[שאה]

4 of **ybwl** son of [sy]gw[l; the third], of the mighty **'grws tqyn**; [the] four[th], of **zbrn** son of **'dy**; [the] fi[fth],

5 [...] בר [נורי ש]תיתאה חוט[מין שביעאה]

5 [...] son of [**nwry**]; the [s]ixth, ḥwṭ[**myn**; the seventh],

6 דאט[רמין] בח[תמה דשימשה ובע]יזקתיה [ד]סיהר[א]

6 of **'ṭ**[**rmyn**]. By [the] s[eal of the sun, and by] the [si]gnet-ring of [the] moon.

7 [בצורתא ד]אר[עה ...]

7 [By the image] of [the] ear[th ...]

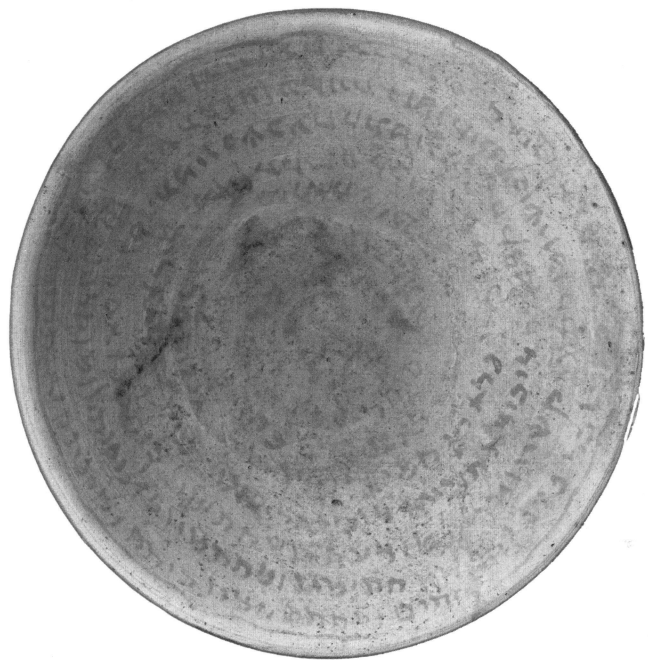

JBA 75 (MS 2053/139)

16 × 60 mm. Semi-formal hand. The arrangement of the text is not easy to discern because it is faded, particularly towards the centre, and the lines are irregular on account of the large image.

Linguistic and orthographic features: Note the use of –**h** rather than –**yh** for the 3 p. masc. sg. pron. suffix in **lh** (l. 4) and **qlh** (l. 6); note also **tlyt'** for **tlyt'h** (l. 3); note also the use of **'ym** for **'ym** (l. 6).

Clients: A[...] son of Ḥ[...]; Immī daughter of Nišdukh.

Biblical quotation: Num 9:23.

Image: In the centre of the bowl, there is a partly faded frontal, standing figure with a large rectangular body (cf. the image in JNF 146). The head is round, and sits upon a short, thin neck consisting of three vertical lines. Fourteen wavy lines protrude from the head, indicating dishevelled hair. The eyes are hollow, with one more circular and the other more square, and are framed by a single line that indicates both the eyebrows and the nose, which is rectangular. Two horizontal lines below the nose indicate the mouth and chin. Ears protrude from the lower part of each side of the head, beneath the hair, resembling the ears of a goat. The arms appear to descend from the shoulders to the chest, and might have crossed at the centre; only a part of the left arm remains. On the right shoulder, there is a small circle whose meaning is unclear. The left foot appears to be turned out but is again unclear. It is possible that bars bound the two legs.

FIGURE 7: Artist's impression of image from JBA 75

דין קמיעה לחתמתא דביתיה [...] מן פגעין ומן כ[ל] שידין ומן כ[ל] דיוין אסירין ביתלתא	1	This amulet is for the sealing of the house of [...] from affliction demons and from al[l] demons and from al[l] *dēv*s. They are bound by three
אסורין וחתים בשבעה חתמין ובחתמא רבא ובח[תמא] דחת[ימין בה שבעה] רקיעין [חתמא קד]מאה טבית תינינא דבידיה	2	bonds and (they are) sealed by seven seals. And by the great seal, and by [the] s[eal by] whi[ch the seven] firmaments are sea[led. The fir]st [seal] is **ṭbyt**; the second, of **bydyh**;
תליתא דגרזין תקיפא רביאעה דיזבול חמישאה דרמס[ין] שתיתאה דיה [ר]בא שביעאה דיהוה צבאות ובחתמא רבא דביה	3	the third, of the mighty **grzyn**; the fourth, of **zbwl**; the fifth, of **rms[yn]**; the sixth, of the [gre]at Yah; the seventh, of YHWH Sabaoth. And by the great seal by which

4 חתימא שמיא וארעה חתים בחתמא דשימשא ובעיזקת[א] דסיהרא [בצור]תא דארעה [וברזא רבא דרקיעה דלא יקיר]בון לה

heaven and earth are sealed. Sealed by the seal of the sun and by [the] signet-ring of the moon. [By] the [ima]ge of the earth [and by the great mystery of the sky, in order that] they [shall not come ne]ar to

5 לביתיה דא[...] בר ח[...] ודאימ[י] בת נישדוך כל שידין ושיבט{.}ין ופגעין ודיוין וסטני[ן וכ]ל [...] ולילית[א ...] כולהון

the house of A[...] son of Ḥ[...] and of Imm[ī] daughter of Nišdukh, all demons and afflictions and affliction demons and *dēv*s and satan[s and al]l [...] and lilith[s ...], all of them.

6 דעים עבר[ין] על מאמרה הדין ניפקא כי ארא וניצטרי כי בינא וניזי קלה כי מנחש[א] וניקום ב[שמתא] כמא

For if [they] transgress against this command, may he burst like a bay tree and be split open like a tamarisk, and may his voice go like a divine[r], and may he remain under [the ban] just like

7 דקאים [בה] בישא בר בישא מן יומא דנן לעולם אס אמן אמן סלה על פי יהוה [יחנו] ועל פי יהוה יסע[ו] את

the evil (Cain) remains [under it], son of the evil one, from this day (and) for ever. 's Amen, Amen, Selah. "At the commandment of YHWH [they encamped], and at the commandment of YHWH [they] journeyed.

8 [משמרת] יהוה שומורו על פי יהוה ביד משה

They kept [the charge of] YHWH at the commandment of YHWH by the hand of Moses".

2. ḥtym: "(they are) sealed"; error for ḥtymyn (cf. JBA 73:3).

4. bṣwrt' d'r'h: "by the image of the earth"; see the note to JBA 68:5.

5. ḥ[...]: possibly ḥty or ḥwby.

6. mnḥš': "diviner"; see the note to JBA 73:7.

6–7. km' dq'ym [bh] byš': "just like the evil (Cain) remains [under it]"; the expected text is km' dq'ym bh qyn byš' "just like the evil Cain remains under it" (compare JBA 79:9–10), but there is not sufficient space for this—the faint traces suggest bh rather than qyn.

7–8. Num 9:23.

8. šwmwrw: "they kept"; for MT šmrw, with the first two *waw*s representing *qamaṣ*. The same reading also occurs in JNF 146:8 (see above).

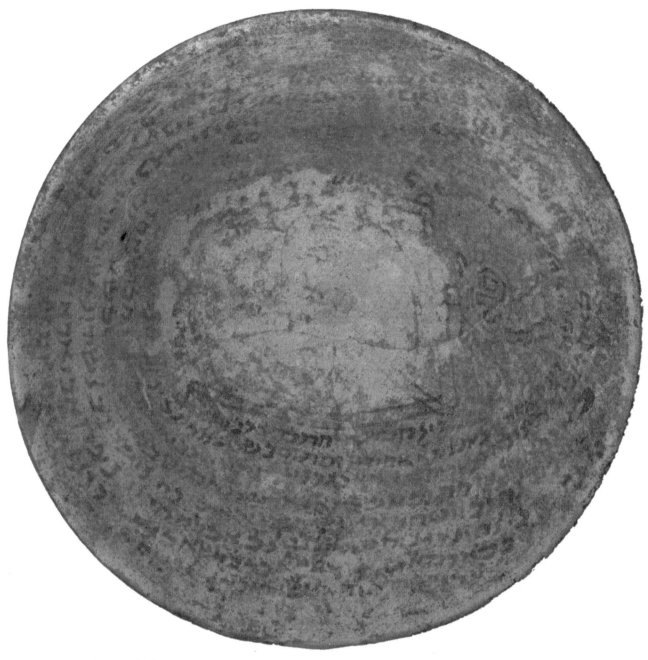

PHOTO 12 JBA 75 (MS 2053/139)

JBA 76 (MS 2053/143)

163 × 54 mm. Semi-formal hand. The bowl was broken, but has been repaired. Occasionally, the repair obscures the writing. The arrangement of the text is not easy to discern because it is partly faded and the lines are irregular on account of the large image.

Linguistic and orthographic features: Note the use of –h rather than –yh for the 3 p. masc. sg. pron. suffix in **lh** (ll. 3 and 8), **bh** (l. 4) and **qlh** (l. 9). Note also **tlyt'** for **tlyt'h** and **rby"h** for **rby°h** (both l. 5), and **šby"h** for **šby°h** (l. 6). Note also **yqyrbwn** for **yqrbwn** (l. 7). Note also the use of **'ym** for **'ym** (l. 8).

Clients: Ardōy son of Khwarkhšēddukh, nicknamed Gayay.

Image: In the centre of the bowl, there is a large figure whose head and body are frontal, while its legs are in profile. The head is elliptic, with the eyes indicated by two hollow circles, each with a dot for the pupil. Two curved lines descend from the top of the head to form the eyebrows and the nose. Five dots encircle the left eye and three are arranged vertically beside the right eyebrow. A rectangular line encloses the lower part of the head, forming a wide chin. The arms appear to stretch behind the head, but the hands are not seen. The torso is naked. The figure is wearing a skirt that reaches the knees, from which two thin lines descend indicating legs. The legs end with three short toes, perhaps resembling claws, and are bound by a rope at the ankles.

FIGURE 8: Artist's impression of image from JBA 76

חת[ים] ומחתים ביתיה ואיסקופתיה	1	Sea[led] and double sealed is the house and the threshold
ודירתיה ותרעיה וקיניניה דארדוי ב[ר]	2	and the dwelling and the gate and the property of Ardōy so[n of]
{כורש} כורכשידוך וכל שום ד[אית] לה מן כל פגעין ומן כל שידין ומן דיוין ומן ליליתא בישתא דיכרי	3	Khwarkhšēddukh and any name that he [has] from all affliction demons and from all demons and from dēvs and from evil liliths, male
[וניקבתא אסירין] ביתלתא אס[ו]רין וחת[י]מ[י]ן בש[בעה] חתמין וביחתמא רבה וחתמא דחת[י]מין ב[ה] שבעה	4	[and female. They are bound] by three bo[n]ds and [they are] seal[ed] by se[ven] seals. And by the great seal and the seal by which the seven firma[ments]

5 רק]יעין חתמא קד[מאה טבית תינינא דביד]יה[
 תליתא דגר[...] תקיפא רביאעה דיזבול חמישאה
 דר[מ]סין שת]י[תאה דיה רבה

are seal[ed]. The [fi]rst [seal] is **ṭbyt**; the second, of **byd[yh**; the third, of the mighty **gr[...]**; the fourth, of **zbwl**; the fifth, of **r[m]syn**; the s[i]xth, of the great Yah;

6 שביא[ע]ה [די]הוה צ]באות[ובחתמא ר]ב[ה
 דביה חת]י[מ]א ש[מ]יא וארעה וחתים בחתמא
 דשימשא ובעיזקתא [ד]סיהרא [ו]ברזא רבה

the seve[n]th, [of Y]HWH Sa[baoth.] And by the gr[e]at seal by which [he]aven and earth [are] seal[ed]. And sealed by the seal of the sun and by the signet-ring [of] the moon, [and] by the great mystery

7 דירקיע]א[דלא יקירבון להון לבית]יה[
 ו]א[סקופת]יה[ודי]ר[תיה דארדוי דמיתקרי גייי
 בר {.} כורכשידוך

of [the] sky, in order that they shall not come near to them, to [the] house and [the th]reshold and the dwe[ll]ing of Ardōy, who is called Gayay, son of Khwarkhšēddukh,

8 וכל שום דאית לה כל פגעין ושידין ושיבטין
 ודיו]ין[וסטנין ו]כ[ל פתכרי כולהון דעים עברין
 על מאמרא

and any name that he has, all affliction demons and demons and afflictions and *dēv*[s] and satans and [al]l idol spirits, all of them. For if they transgress against this

9 הדין ניפקא כי ארא וניצטרי כ]י[בינא וני]ז[י קלה
 כ]י[מנחשא] ניקו[ום] בשמתא כמא [דק]אים
 בהין קי]ן[

command, may he burst like a bay tree and be split open li[ke] a tamarisk, and may his voice [go] li[ke a diviner,] may he re[main] under bans just lik[e] the [evil] Cai[n]

10]ביש[א בר בישא מן ימא דנן

[re]mains under them, son of the evil one, from this day

11]ול[עולם אמן אמן סל]ה[

[and for] ever. Amen, Amen, Sela[h.]

1. **mḥtym**: "double sealed"; for this form of the *pa.* masc. sg. pass. ptc., see Moriggi 2005a, 261–264; Ford 2014, 237–239 (see also JBA 86:9).

3. {**kwrš**}: false start for the following proper noun; it appears that the scribe started the word again, having initially erred by beginning to write *šin* instead of the second *kaph*.

9. **mnḥš'**: "diviner"; see the note to JBA 73:7.

šmt': "bans"; for **šmtt'**—the use of **bhyn** "under them" later in the same line makes it clear that the pl. is intended.

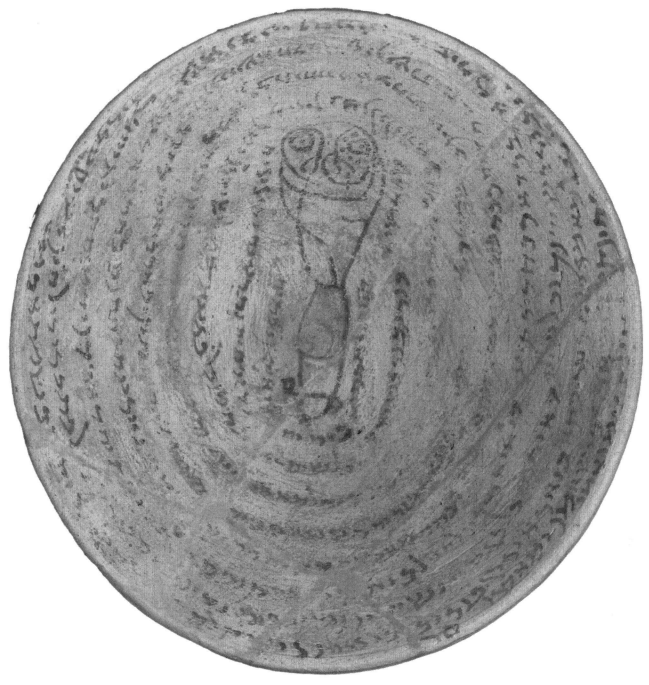

PHOTO 13 JBA 76 (MS 2053/143)

JBA 77 (MS 2053/153)

160 × 75 mm. Semi-formal hand. The bowl was broken, but has been repaired. The text begins at the rim and proceeds towards the centre. The writing is faded towards the rim, and occasionally obscured by the repair.

Clients: Aḥā son of Qāqay; [...] daughter of Daredukh.

חתים ומחת[ם] ומזר[ז] ביתיה ואיסקופתיה 1
דאחא בר קאקאי [...] בת דרידוך חתים בשבעה
חתמין ומחתם בשבעה רשמין חתמא קדמאה
ד[.]ידי תינינא דיבול ב[ר] {.} סיבול תלי[ת...]

1 Sealed and double seal[ed] and strength[ened] is the house and the threshold of Aḥā son of Qāqay [...] daughter of Daredukh. Sealed by seven seals and double sealed by seven seal impressions. The first seal (is that) of [.]ydy; the second, of ybwl so[n of] sybwl; [the] thir[d ...]

[...] תלי̇תאה דארג[י]ה בר נורי רביעאה דזברן
[ב]ר אדי שתיתאה חתמין שבישא שב[י]עאה
דאטרמין בחתמא דשמשה ב{...} בעזקתא
דסיהרה באחרא

2 [...] the third, of 'rg[yh] son of nwry; the fourth, of zbrn [so]n of 'dy; the sixth, ḥtymyn šbyš'; the sev[e]nth, of 'ṭrmyn. By the seal of the sun, by the signet-ring of the moon, by another

דארעה ו[ברז]ה ר[בה] דירק[עא] ד[לא יקר]ב[ו]ן
ליה לביתיה ולאיסקופתיה דאחא בר קאקאי כל
חרשין [ב]ישין וכל {שי} עובדין תקיפין מן יומא
דנן ולעלם אמן אמן שריר וקים תוב חתים

3 of the earth, and [by] the gr[eat mystery] of the sky, in order that [they shall not come ne]ar to the house and to the threshold of Aḥā son of Qāqay, all [e]vil sorcery and all severe magical acts, from this day and for ever. Amen, Amen. Sound and established. Again, sealed

ומחתם ביתיה וא[יסק]ופתיה ד[א]חא בר קאקי
בשירא ובעיזקתא רבתי דישררא [ת]וב {ת}
חתים ומחתם ביתיה ואיסקופתיה דאחא בר
קא⟨קא⟩י בחתמא דיקים

4 and double sealed is the house and the th[res]hold of [A]ḥā son of Qāqay, by the ring and by the great signet-ring of strength. [Ag]ain, sealed and double sealed is the house and the threshold of Aḥā son of Qā⟨qay⟩, by the seal of the *dēv*

דיוא ובצורת[א ...] מהימנא כד {כד} כביש 5
כ[בי]ש ביתיה ואיסקופתיה דאחא בר קאקאי על
ברזלא ונחשה ועל שפודא רבא דיגללא

5 **qym**, and by [the] image [...] the trustworthy. When it is pressed down, [it is] pres[sed do]wn, the house and the threshold of Aḥā son of Qāqay, upon iron and bronze, and upon the great spit of stone,

6 in order that sorcery not come near to him and falsities not strike his heart. [Se]ven walls of iron and bronze surround him, and he is double protected and protected and double sealed and fastened

דלא חרשין קרבין ליה ולא זיפין מחן לביה הדירין ליה [ש]בעה שורין דברזלא וינחשה {ומ} ומנט וינטיר ומחת ונקיט

7 by this amulet [...]

בהדא חומרתא [...]

1. **drydwk**: "Daredukh"; compare **'drydwk** "Ādaredukh" in JBA 104 and JNF 33. Both forms are probably variants of **'drdwk** "Ādardukh".
ršmyn: "seal impressions"; see *DJBA*, 1067, s.v. **rwšm'**.

1–2. **tlyt[...] tlyt'h**: "the third [...] the third"; it appears, from the lacuna, that the scribe repeated the reference to the third seal, but with a different name. To compensate, he later omitted the reference to the fifth seal.

2. **ḥtymyn šbyš'**: The first word is probably a variation of **ḥwṭmyn** (compare JBA 68:4, JBA 71:4 and JBA 74:5). The second word has no obvious counterpart in the parallels, and may be a false start for the following **šby°h**.
{b...}: Possibly **by'**, as a false start for **b'zqt'**.

2–3. **b'ḥr' d'r'h**: "by another of the earth"; we would expect **'wḥry** or such like for **'ḥr'**, as fem. **'ḥr'** has not hitherto been attested in JBA (see *DJBA*, 105–106). Alternatively, perhaps read **b'sr' d'r'h** "by the bond of the earth".

4. **bšyr' wb'yzqt'**: "by the ring and by the signet-ring"; see the introduction to I.4.1.1.

5. **wbṣwrt['...] mhymn'**: "and by the image [...] the trustworthy"; traces of **šdy** may be visible, so perhaps restore **wbṣwrt' d'l šdy mhymn'** "and by the image of the trustworthy El Shaddai".

6. **ḥršyn... zypyn**: "sorcery ... falsities"; as maleficent forces attacking the client. See the note to HS 3015:3 in Ford and Morgenstern 2020, 54–55.
mḥn lbyh: "strike his heart"; cf. the Elisur Bagdana formula, which refers to someone being struck (using the same root) in the membrane of their heart (e.g. JBA 31:5 etc.).
For the motif of metallic walls protectively surrounding a house or client, see MS 2055/10:4 and AMB Bowl 1:11–12 (both in Syriac) and the Mandaic text DC 43D, 54–55.
wmnṭ... wmḥt: "and he is double protected ... and double sealed"; apparently, each a *pa.* pass. ptc. showing loss of final *reš* and *mem* respectively—see Morgenstern 2007, 259–260 and 263–264.

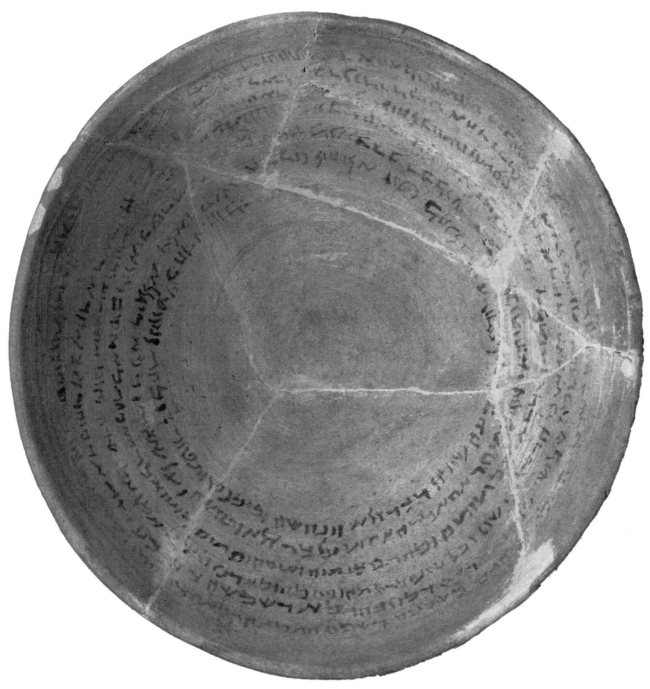

PHOTO 14 JBA 77 (MS 2053/153)

JBA 78 (MS 2053/187)

165 × 60 mm. Semi-formal hand. The bowl was broken, but has been repaired. The text begins at the rim and proceeds towards the centre, although it appears that the first line of the text is written within the central design. The writing is mostly faded.

Image: In the centre of the bowl, there is a circle that consists of a thick wavy line and is divided into quarters by two wavy lines (cf. JBA 71).

FIGURE 9: Artist's impression of image from JBA 78

Within the central design:

1 [א]סותא מן שמיה לה[די]ן [...] [He]aling from heaven for t[hi]s [...]

Continuing from the rim:

2 [...] וכל א[י]נ[ש]י ... כו]להון חתימין [...] [...] and all the p[eo]pl[e of ... al]l of them are sealed [...]

3 [...] ד[י]דכיר שמיה[ון ...] [...] wh[ose] names are mentioned [...]

4 [...] [...]

5 [...] [...]

6 [...] ובעיזקתיה דסיהרא בצורתא [...]ד [...] and by the signet-ring of the moon. By the image of [...]

7 [...] דרקיעה [מן] יומא [ד]ין ולעלם אמן אמן סלה הללו[יה] [...] of the sky, [from th]is day and for ever. Amen, Amen, Selah. Hallelu[jah.]

6. bṣwrtʾ: "by the image"; see the note to JBA 68:5.

PHOTO 15 JBA 78 (MS 2053/187)

JBA 79 (MS 2053/201)

162 × 70 mm. Semi-formal hand. The text is surrounded by a circle.

Linguistic and orthographic features: Note the use of –**h** rather than –**yh** for the 3 p. masc. sg. pron. suffix in **bh** (l. 4). Note also **yqyrbwn** for **yqrbwn** (l. 7). Note also the use of ʿ**ym** for ʾ**ym** (l. 8).

Clients: Abbā son of Immā; Maḥlaftā daughter of Ayyā; Aḥā and Mārī, the sons of Maḥlaftā.

Image: In the centre of the bowl, there is a frontal, standing figure (cf. the image in JBA 65). By the exposed chest, which shows two circles, the figure appears to be female. The lower part of her body is probably covered by a long skirt that ends at the ankles; the texture of the skirt's material is shown using two vertical wavy lines. Her hair is long, falling down both sides of her body. Four short vertical stripes are on top of her head, possibly indicating a wreath or a crown. Her arms are very thin, consisting of two lines that cross her chest. Her hands are thicker, consisting of short lines. She is barefoot, with each foot consisting of a single line with no toes indicated. Her head is oval and wide, with two hollow circles for her eyes, a straight horizontal line for her mouth, and a horizontal eyebrow line that is a continuation of her rectangular nose. Her arms are crossed, indicating that they are bound. The legs are bound towards the ankles, and the feet resemble those of a hen, with three toes.

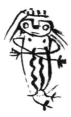

FIGURE 10: Artist's impression of image from JBA 79

חתים ומחתם ביתיה ואיסקופתיה דאבה	1	Sealed and double sealed is the house and the threshold of Abbā
בר אימא ודמחלפתא בת אייה ואחא ומרי בני מחלפתא	2	son of Immā and of Maḥlaftā daughter of Ayyā, and Aḥā and Mārī, the sons of Maḥlaftā,
מן כל פגעין ומן כל שידין ומן כל דיוין אסירין בתלתא אסרין וחתים	3	from all affliction demons and from all demons and from all *dēv*s. They are bound by three bonds and (they are) sealed
בשבעה חתמין בחתמא רבא דחתימין בה שבעה רקיעין חתמא קדמאה טבית	4	by seven seals. By the great seal by which the seven firmaments are sealed. The first seal is **ṭbyt**;
תינינא דבידיה תליתאה דגרזיין תקיפא רביאעאה דיזבול חמישאה דרמסין שתיתאה	5	the second, of **bydyh**; the third, of the mighty **grzyyn**; the fourth, of **zbwl**; the fifth, of **rmsyn**; the sixth,

6 of the great Yah; the seventh, of YHWH Sabaoth. And by the great seal by which heaven and earth are sealed. Sealed by the seal

דיה רבא שביאעאה דיהוה צבאות ובחתמא רבא דביה חתימא שמיא וארעה חתים בחתמא

7 of the sun, by the signet-ring of the moon, by the image of the earth, and by the great mystery of the sky, in order that they shall not come near to them, to the house

דשימשא בעיזקתיה דסהירא בצורתא דארעה וברזא רבא דרקיעא דלא יקירבון להון לביתיה

8 or to any of the people of the house of Abbā son of Immā and of Maḥlaftā [daugh]ter of Ay[y]ā, all demons and *dēv*s and affliction demons and satans and all idol spirits, all of them. For if

ולכל אינשי ביתיה {דאבא} דאבה בר אימה ודמחלפתא [ב]ת אי[י]ה כל שידין ודיוין ופגעין וסטנין וכל פתכרי כולהון דעים

9 they transgress against this command, may he burst like a bay tree and be split open like a tamarisk, may his voice go like a diviner, may he remain under the ban just like the evil Cain remains under it,

עברין על מאמרה הדין ניפקא כי ארא וניצטרי כי בינא ניזי קליה כי מנחשא {נ}ניקום בשמתא כמא דקאים בה קין בישא

10 son of the evil one, from this day and for ever. Amen, Amen, Selah. Hallelujah.

בר בישא מן יומא דנן ולעלם אמן אמן סלה הללויה

Outside:

11 For the outer (gate).

דבריתא

3. **ḥtym:** "(they are) sealed"; error for **ḥtymyn** (cf. JBA 73:3).

5. **grzyyn:** It is difficult to distinguish between *waw* and *zayin*, so it is possible that we should read something like **grwyyn** (compare JBA 80:4). On the other hand, it is possible that **grzyyn** is a metathesised variant of **rwgzyn** (compare SD 33:2 and Wolfe 78:3).

7. **shyrʾ:** "moon"; see the note to JBA 65:5.
bṣwrtʾ: "by the image"; see the note to JBA 68:5.

9. **mnḥšʾ:** "diviner"; see the note to JBA 73:7.

11. **brytʾ:** "outer"; an ellipsis for **bbʾ brytʾ** "outer gate" (see also MS 1927/21:15 and MS 2053/223:15)

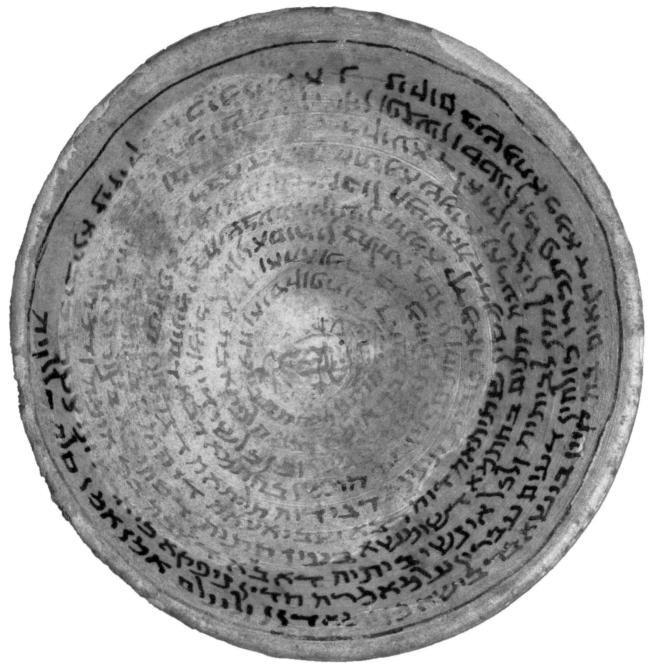

PHOTO 17 JBA 79 (MS 2053/201)—exterior

JBA 80 (MS 2053/221)

140 × 60 mm. Semi-formal hand. The bowl was broken, but has been repaired. The text is surrounded by a circle.

Linguistic and orthographic features: Note the use of –**h** rather than –**yh** for the 3 p. masc. sg. pron. suffix in **bh** (l. 3). Note also **rby'ʿh** for **rbyʿh** (l. 4) and **šby'ʿh** for **šbyʿh** (l. 5). Note also –**'** for –**'h**, representing the reduction of final –$\bar{a}\bar{a}$ to –\bar{a}, in **qdm'** (l. 4), and in **ḥmyš'** and **štyt'** (both l. 5)—see Morgenstern 2013, 40.

Clients: Māhōy son of Aḥāt.

Image: In the centre of the bowl, there is a frontal, standing figure, with its head in profile facing to its left. The figure is apparently feminine, on account of the two hollow circles on her chest that indicate breasts, but she is not human; her head and body resemble that of a hen. The head consists of a semicircle with four long hairs descending from its rear and four short vertical lines protruding from its flat crown. The face has one hollow eye and a beak. The body has a distended belly. The arms are thin, and indicated using long curved lines. The hands almost meet on the torso, and each appears to have three short fingers. The legs are short, and the feet resemble those of a hen, with three toes. The legs appear to be bound by a thin rope.

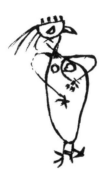

FIGURE 11: Artist's impression of image from JBA 80

1 חתים ומחתם ביתיה ואיסקופתיה דמהוי בר אחת

1 Sealed and double sealed is the house and the threshold of Māhōy son of Aḥāt,

2 מן כל פגעין ומן כל שידין ומן כל דיוין אסירין בתלתא אסרין וחתים

2 from all affliction demons and from all demons and from all *dēv*s. They are bound by three bonds and (they are) sealed

3 בשבעה חתמין בחתמא רבא דביה חת'מא שמיא דחתימין בה שבעה

3 by seven seals. By the great seal by which heaven is sealed, by which the seven firmaments

4 רקיעין חתמא קדמא טבית תינינא דבידיה תליתאה דגרויין תקיפא רביאעה

4 are sealed. The first seal is **ṭbyt**; the second, of **bydyh**; the third, of the mighty **grwyyn**; the fourth,

5 דיזבול חמישא דרמסין שתיתא דיה רבא שביאעה דיהוה צבאות ובחתמא {ק}

5 of **zbwl**; the fifth, of **rmsyn**; the sixth, of the great Yah; the seventh, of YHWH Sabaoth. And by the great

6 seal by which heaven and earth are sealed. Sealed by the seal of the sun, by the signet-ring of the moon, by the image

7 of the earth.

6 רבא דביה חתימא שמיה וארעה חתים בחתמא
דשימשא בעיזקתיה דסהירא בצורתא

7 דארעה

2. ḥtym: "(they are) sealed"; error for ḥtymyn (cf. JBA 73:3).

6. shyrʾ: "moon"; see the note to JBA 65:5.
bṣwrtʾ: "by the image"; see the note to JBA 68:5.

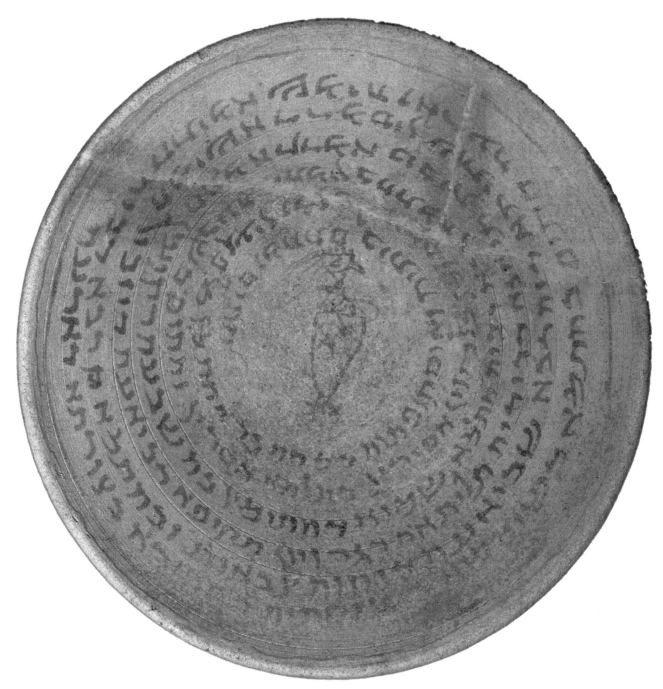

PHOTO 18 JBA 80 (MS 2053/221)

I.3.2

The Seals of Ashmedai

∴

Introduction

The texts in this section all contain the same basic formula that invokes three distinct authorities from the world of demons (see also the introduction to 1.3.4). First, the formula invokes two seals of Ashmedai, the king of demons (for the figure of Ashmedai in the magic bowls, see Ten-Ami 2012–2013). The formula continues by invoking the demons' parents—Palḥadad and Palḥas—who are known from other bowls (see JBA 15, JBA 19, JBA24, and JBA 62). In these other bowls, Palḥas is the father and Palḥadad is the mother, whereas, in the bowls in this section, it is the other way around. Finally, the formula invokes the primeval seal of Abraxas (for whom see the introduction to 1.3.1).

The demons are presented as thieves who seek to harm the seed of humans. In MRLA 1, we translated the phrase **gbryn gnbyn** as "mighty thieves" (albeit in a different context; see JBA 18:10), assuming that **gbryn** is a defective spelling of **gybryn**. In this section, we have translated the phrase **gbryn gnbyn** as "thieving men", taking **gbryn** to be the plural of **gbr**ʼ "man" (see also JBA 94:10; see further Ford 2014, 236).

The forms **šydy**ʼ (JBA 81:2, JBA 82:13 & 19, and JBA 84:4 & 5) and **dywy**ʼ (JBA 81:3, JBA 82:13 & 19, and JBA 84:6) display a use of the masc. pl. emph. termination **-y**ʼ, which is unusual in the bowls (see Juusola 1999, 144–145).

As frequently happens in Mandaic, either or both the conj. with negation **wl**ʼ "and not" and the prep. with obj. pron. suffix **bhwn** "them" are affixed to the vb. in the phrase **wlʼtyḥṭ(w)bhwn** "and you shall not harm them"—see JBA 81:5, JBA 82:16, JBA 84:8, and JBA 85:18. Furthermore, it would seem that, in all cases, the final *nun* of the expected impf. **tyḥṭwn** has assimilated to the following *beth*, while, in JBA 82 and JBA 84, the same scribe has omitted the preceding *waw*.

The same clause continues with **wlʼ bzrhwn dymmʼ wlʼ bṭwmhwn dlylyʼ** "and neither their seed of the day nor their seed of the night". The first word for "seed" thus shows a loss of *ʻayin*, while the second, being derived from MP *tōhm* (see DMMPP, 330), shows a loss of either *he* or *ḥeth*. JBA 82 and JBA 85 also use another MP loanword: **drmn(**ʼ**)** < *darmān* "remedy, medicine, healing" (see DMMPP, 139). JBA 82:19 also shows a loss of *ʻayin* in **tyštwn** (for **tyštʻwn**).

JBA 82, JBA 84, and JBA 85 all appear to have been written by the same scribe. Each contains some words written within the central section of the bowl, surrounded by the main inscription. The main inscription in JBA 85 begins with the words **ʼswtʼ wdrmnʼ** "healing and remedy" (JBA 85:14), which occurs repeatedly in the central section of JBA 82. This suggests that the central sections are meant to introduce the main inscriptions. Both JBA 84 and JBA 85 are comparatively small bowls, with a flat base and wide rim. These three bowls also appear to have been written by the same scribe as MS 2053/85 (to be published in volume seven). The client in JBA 82 is **dwty bt pddws** "Dūtay daughter of Pidaddōs". The mother's name is a shortened form of Pidardōst "beloved by her father"; the same client also occurs in MS 2053/161: **dwty bt pdrdst** "Dutay daughter of Pidardōst" (again, to be published in volume seven).

Parallels for this formula, outside the Schøyen Collection, include JNF 8, JNF 84, and PC 109.

Other spells that occur in the bowls in this section:

JBA 86 contains a supplementary interlinear unit that is similar to that contained in Louise Michail Collection Bowl 1 (see Moriggi 2005a). On the basis of a photograph generously supplied by Marco Moriggi, we provide the following reading of the latter:

חתים ומחתים אבנדאד בר שישאי בחתמא רבה דביה חתימא	1	Sealed and double sealed is Ābāndād son of Šišay, by the great seal by which heaven
שמיא וארעה ובעיזקתא דישלמא מלכא בר דויד ומחתמ[א] וחתימא	2	and earth are sealed, and by the signet-ring of King Solomon son of David. And double seal[ed] and sealed
שיש[א]י ב[ת] דודאי בחתמא רבה דביה ⟨חתימא⟩ שמיא [וארעה וב]עיזקתא⟩ דשלומה מלכא בר דויד	3	is Šiša[y daugh]ter of Dūday, by the great seal by which heaven [and earth] ⟨are sealed⟩, and by [the signet-ring] of King Solomon son of David,

4 מן [יומ]א דין ולעלם אמן אמן וסל[ה ...] from this [day] and for ever. Amen, Amen, and Sela[h ...]

5 [...] אמן אמן סלה [...] Amen, Amen, Selah.

JBA 81 (MS 1927/36)

190 × 50 mm. Semi-formal hand. The bowl was broken, but has been repaired. The writing is partly faded, especially towards the centre. The text is surrounded by a circle.

Linguistic and orthographic features: Note the use of –yh rather than –h for the 3 p. fem. sg. pron. suffix in **bytyh** (l. 4).

Clients: Farrokh son of Rašewanddukh; Muškōy daughter of Māhōy.

Image: In the centre of the bowl, there is a partially-preserved frontal, standing figure, with its hands meeting on its belly. The figure is apparently feminine, with her breasts clearly indicated, and she appears to be human. Part of her headdress is preserved, indicated by a semicircular band divided by short lines. The text begins beside what appear to be her feet.

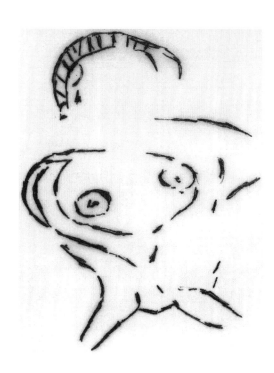

FIGURE 12: Artist's impression of image from JBA 81

1 דין חתמא וחתים ביתיה [ו]דירתיה [ד]פרוך בר רשונדוך [אסירין]

1 This is the seal and sealed is the house [and] the dwelling [of] Farrokh son of Rašewanddukh. [Bound are]

2 שידיא וחתימין לילין אסירין שידיא בחתמא רבה דשמדי מלכא דשי[די ובה]תמא

2 the demons and sealed are the lilis. Bound are the demons by the great seal of Ashmedai, the king of demo[ns, and by] another

3 אוחרנא דשמדי מלכא דיויא מומינא לכון בפלחדד שידיא דהוא אבוכ[ו]ן בפלחס ליליתא

3 [s]eal of Ashmedai, the king of *dēv*s. I adjure you by Palḥadad, the demon who is yo[u]r father, by Palḥas, the lilith,

4 your mother, that yo[u may move] and go out from the house of Muškōy daughter of Māhōy and from her dwelling, and you shall not appear i[n] the for[m of thieving] men who steal

4 אימיכון דת[יזהון] ותיפקון מן ביתיה דמושכוי בת מהוי ומן דירתה ולא תידמון ב[י]דמון[ת] גברין [גנבין] דגנבין

5 and snatch, and [you shall] not ha[rm] them, and neither their seed of the day nor their seed of the night, from now on. Amen. You are bound and sealed by the [prim]eval s[e]al

5 וחטפין ולא [תי]ח[ט]ובהון ולא בזרהון דיממא ולטווהון דליליא מיכן ואילך אמין אסירת וחתימתה בח[ת]מא [קד]מאה

6 of the great Abraxas who binds and it is not loosed. May you be bound and not loosed. Amen, Amen, Amen, Selah. Ame[n], Amen, [Amen], Selah. Amen, Amen,

6 דאברכסס רבה דאסר ולא שרריא תיתסרון ולא תישתרון אמן אמן אמן סלה אמ[ן] אמן [אמן] סלה אמן אמן

7 Selah. Ame[n], Amen, Selah.

7 סלה אמ[ן] אמן סלה

3. **mlkʾ dywyʾ**: "the king of *dēv*s"; see also JBA 82:13, JBA 83:4, JBA 84:5–6, and JBA 85:16. For the assimilation of the rel. pron. **d-** to the initial *daleth* of **dywyʾ**, see Morgenstern and Ford 2017, 218–219 (n. 103).
šydyʾ: "the demon"; error for **šydʾ** (cf. JBA 82:14).

5. **wlṭṭwhwn**: "nor their seed"; apparently an error for **wlʾ bṭwmhwn** (cf. JBA 82:16).

6. **šrryʾ**: "it is (not) loosed"; error for **šryʾ** (cf. JBA 82:17).

JBA 82 (MS 2053/39)

175 × 50 mm. Semi-formal hand. The bowl was broken, but has been repaired. The final part of the text is enclosed in a large cartouche. The centre of the bowl is divided into four sections by a cross, with each section containing either two or three very short lines.

Linguistic and orthographic features: Note the use of –**yh** rather than –**h** for the 3 p. fem. sg. pron. suffix in **bytyh**, **dyrtyh**, and **bynynyh** (all l. 12).

Client: Dūtay daughter of Pidaddōs.

Central sections:

אסותא	1	Healing
לדותי בת	2	for Dūtay daughter of
פדדוס	3	Pidaddōs.
אסותא	4	Healing
ודרמנא	5	and remedy.
אסותא	6	Healing
ודרמ	7	and reme
נא	8	dy.
אסותא	9	Healing
ודרמנ	10	and remedy of
ייי	11	YYYY.

Main inscription:

12 דין חתמא וחתים ביתיה ודירתיה ובעיניה דהדא דותי בת פדדוס

12 This is the seal and sealed is the house and the dwelling and the building of this Dūtay daughter of Pidaddōs.

13 אסירין שידי וחתימין לילין אסירין שידיא בחתמא רבה דאשמדי מלכא דיווא

13 Bound are the demons and sealed are the lilis. Bound are the demons by the great seal of Ashmedai, the king of *dēv*s,

14 ובחתמא אוחרנא דשמדי מל[כא דשידיא מ[ומינא ל]כו[ן בפלחדד שידא דהוא אבוכון ופלחס

14 and by another seal of Ashmedai, [the] kin[g of demons.] I [ad]jure [yo]u by Palḥadad, the demon who is your father, and Palḥas,

15 the lilith, your mother, that yo[u] may move [and] go out from the house of Dūtay daugh[ter of Pi]daddōs, from this day and for ever, and you shall not appear to them in the form of

לילתא אימיכון דתיזה[ון ות]יפקון מן ביתא דדותי ב[ת פ]דדוס מן יומא דנן ולעלם ולא תידמון להון בידמות

16 thieving men who steal and snatc[h], and you shall not harm the[m], and neither their seed of [the] day no[r] their seed of the night, from no[w o]n. Amen. You are bound and sealed

גברין גנבין דגבין וחטפ[ין] ולאתיחטבהו[ן] ולא בזרהון דיממ[א ו]ל[א בטומהון דליליא מיכ]ן ו[אילך אמין אסירת וחתימתא

17 by the primeval seal of the [gre]at Abraxas who binds and it is not loosed. May you be bound and not loose[d]. Amen, Amen, Selah. Sealed and double sealed is Dūtay daughter of Pidaddōs by the names

בחתמא קדמאה דאברכסס [ר]בה דאסר ולא שריא תיתסרון ולא תישתר[ון] אמן אמן סלה חתימא ומתמא דותי בת פדדוס בישמיהון

18 of the kings. Healing and remedy for Dūta[y] daughter of Pidaddōs. And may she be healed by the mercy of heaven, from fever and from [shiver]ing, and from the evil ey[e] and from the severe eye, and from

דמלכיא אסותא ודרמן לדות[י] בת פדדוס ותיתסי {בחמי} ברחמי שמיא מן אישתא ומן [ערו]יתא ומן עי[נא]בישתא ומן עינא תקיפתא ומן

19 demons and from *dēv*s, and from evil sorcery and from severe magical acts, and from the lilith who is called the *mevakkalta* demon, and from all enmity and evil, and from all blast demons and evil tormentors, that Dūtay daughter of Pidaddōs

שידיא ומן דיויא ומן חרשין בישין ומן עבדין תקיפין ומן לילתא דמיתקריא מבכלתא ומן כל פיטירותא ובישתא ומן כל זיקי ומזיקי בישיא דתישתיזב

20 shall be saved. By the name of Suriel, Suriel. Amen, Amen, Selah.

דותי בת פדדוס בשום סוריאל סוריאל אמן אמן סלה

3. **pddws**: "Pidaddōs"; see the introduction to this section.

10–11. **drmn yyyy**: "remedy of YYYY"; i.e. apparently with cstr. **drmn**, although written with non-final *nun*.

13. **mlk' dywy'**: "the king of *dēv*s"; see the note to JBA 81:3.

16. **dgbyn**: "who steal"; error for **dgnbyn** (cf. JBA 81:4).

17. **wmtm'**: "and double sealed"; the *taw* is unclear, but more likely than *ḥeth*. For the loss of *ḥeth* in this root, see the note to JBA 88:3.

18. **mlky'**: "the kings"; perhaps in accordance with the use of the plural term in Mandaic for angels and other higher beings (see *MD*, 245).

['rw]yt': perhaps **['r]wt'** as the lacuna may be too small for three letters.

I.3.2. THE SEALS OF ASHMEDAI

PHOTO 20 JBA 82 (MS 2053/39)

JBA 83 (MS 2053/121)

125 × 43 mm. Semi-formal hand. The writing is badly faded towards the rim.

Clients: Burzaq son of Dukhtbeh.

1 אסו דין חתמא וחתים דבביתיה	1 Healing. This is the seal and sealed is that which is in the house
2 ודירתיה דבורזק בר דוכתביה אסירין שידי	2 and the dwelling of Burzaq son of Dukhtbeh. Bound are the demons
3 וחתימין לילין אסירין שידי בחתמא רבה דאשמדי	3 and sealed are the lilis. Bound are the demons by the great seal of Ashmedai,
4 מלכא דשידי ובחתמא אוחרנא דאשמדי מלכא דיוי ומומנא	4 the king of demons, and by another seal of Ashmedai, the king of *dēv*s. I adjure
5 [...] פלחס לי̇ליתא [...]	5 [...] Palḥas, the lilith, [...]
6 [... דגנבי]ן̇ וחטפין	6 [... who stea]l and snatch,
7 ולא [...] וחתימת	7 and [...] not [...] and you are sealed
8 בחתמה̇ [קדמ]א דא[ברכסס ...]	8 by the [primev]al seal of [...] A[braxas ...]

4. **mlkʾ dywy:** "the king of *dēv*s"; see the note to JBA 81:3.

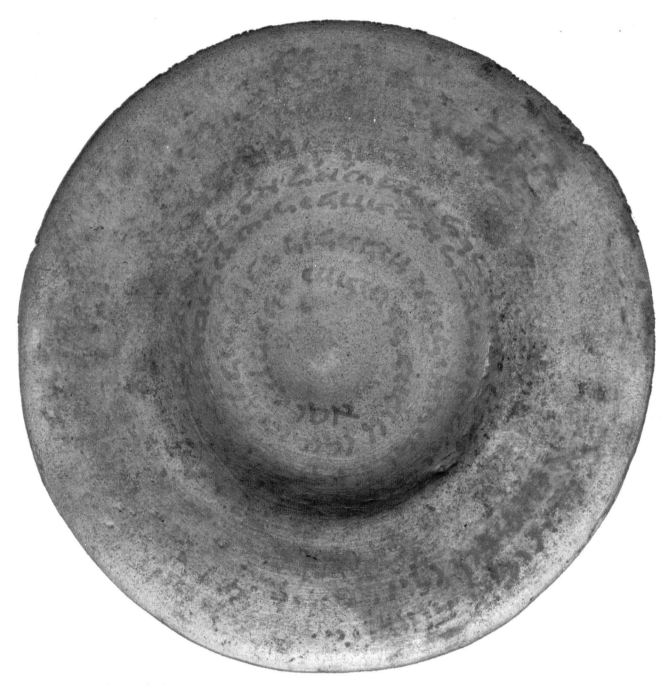

PHOTO 21 JBA 83 (MS 2053/121)

JBA 84 (MS 2053/144)

140 × 45 mm. Semi-formal hand. The bowl is missing a small portion. Two short lines cross in the centre of the bowl. The text is surrounded by a circle.

Client: Farrokh son of Rašewanddukh.

In the centre:

1 דין חתמא ו{ח} This is the seal and

2 חתים ביתא sealed is the house.

Main inscription:

3 דין חתמא וחתים ביתיה דפרוך בר רשונדוך This is the seal and sealed is the house of Farrokh son of Rašewanddukh.

4 אסירין שידי וחתימין לילין אסירין שידיא בחתמא Bound are the demons and sealed are the lilis. Bound are the demons by the great

5 {דא} רבה דאשמדי מלכא דשידיא ובחתמא אוחרנא דשמדיא מלכא seal of Ashmedai, the king of demons, and by another seal of Ashmedai, the king

6 דיויא מומינא לכון בפלחדד שידא {דהא} דהוא אבוכון בפלחס ליליתא אימיכון of *dēv*s. I adjure you by Palḥadad, the demon who is your father, by Palḥas, the lilith, your mother,

7 דתיזהון ותיפקון מן ביתיה דפרוך בר רשיונדוך ולא תידמון להון בידמות [גברין גנבין] that you may move and go out from the house of Farrokh son of Rašewanddukh, and you shall not appear to them in the form of [thieving men]

8 דגנבין [וחטפ]ין [ו]לא תיחטבהון ולא בזרהון דיממא ולא בטומהון דליליא מיכן ואלך אמין אסי[רת וחתימתא] who steal [and snatch, and] you shall not harm them, and neither their seed of the day nor their seed of the night, from now on. Amen. [You are] boun[d and sealed]

9 [בח]תמא קדמאה [דא]ברכסס רבא דאסר ולא שרי תיתסרון ולא תישתרון אמן אמן סלה [by] the primeval [s]eal [of] the great [A]braxas who binds and it is not loosed. May you be bound and not loosed. Amen, Amen, Selah.

5. **šmdyʼ**: "Ashmedai"; error for (ʼ)**šmdy**. The intervocalic *ʼaleph* has elided.

5–6. **mlkʼ dywyʼ**: "the king of *dēv*s"; see the note to JBA 81:3.

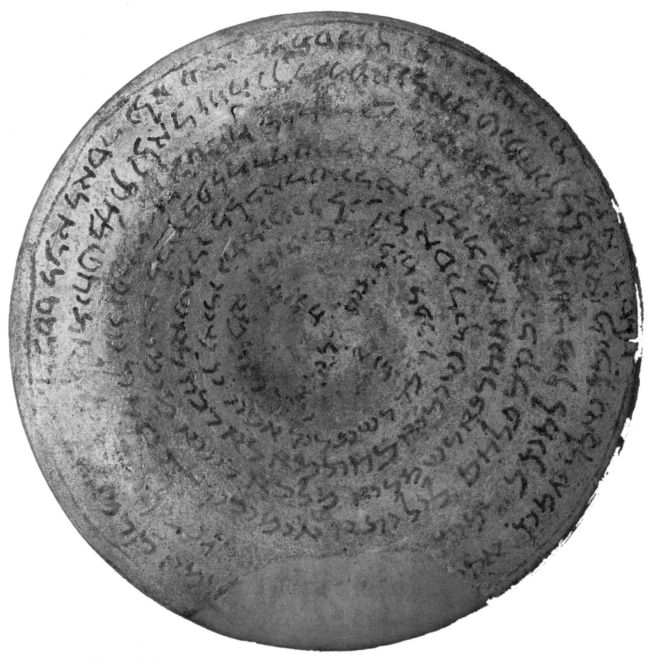

PHOTO 22　JBA 84 (MS 2053/144)

JBA 85 (MS 2053/147)

140 × 55 mm. Semi-formal hand. The bowl was broken. It has been repaired, but is missing a small portion. The centre of the bowl is divided into four sections by two lines that cross each other, with each section containing between two and four very short lines. The text is surrounded by a circle.

Client: Šakarōy daughter of Mihranāhīd.

Central sections:

דין חתמא וחתים	1	This is the seal and sealed is
ביתה {דש} דש⟨כ⟩רוי	2	the house of Šakarōy
בת מיה	3	daughter of Mih-
רנהיד	4	ranāhīd.
אסותא	5	Healing
מן ש	6	from he-
מיה	7	aven.
אמן	8	Amen.
אסותא	9	Healing
מן ש	10	from he-
מי	11	ave-
{חתי}ה	12	n.
חתים	13	Sealed.

Main inscription:

14 אסותא ודרמנא דין חתמא וחתים ביתה דשכרוי בת — Healing and remedy. This is the seal and sealed is the house of Šakarōy daughter of

15 מיהרנהיד אסירין שידי וחתימין לילין אסירין שידי בחתמא רבה — Mihranāhīd. Bound are the demons and sealed are the lilis. Bound are the demons by the great seal

16 דאשמדי מלכא דשידי ובחתמא אוחרנא דאשמדי מלכא דיוי מומינא לכון ב[פ]לחדד — of Ashmedai, the king of demons, and by another seal of Ashmedai, the king of *dēv*s. I adjure you by [Pa]lḥadad,

17	the demon, your father, by Ḥablas, the lilith, your mother, that you may move and go out from the house of Šakarōy daughter of Mihranā[h]īd, and [you shall]
18	[not ap]pear to them in the form of thieving men who steal and snatch, and you shall not harm them, and neither their seed of the day nor th[e]ir seed of the n[ig]ht,
19	fr[om no]w on. Amen. You are bound and sealed by the primeval seal of the great Abraxas who binds and it is not loos[ed]. May you be bound and not loosed. Amen,
20	[Ame]n, Se[lah. So]und and established. Amen, Amen, Amen, Amen, Amen, Amen, Amen, Amen, Amen, Amen.

Hebrew text (lines 17–20):

17 שידא אבוכון בחבלס ליליתא אימיכון דתיזהון ותיפקון מן ביתה דשכרוי בת מיהרנ[ה]יד ו[לא]

18 [תיד]מון להון בידמות גברין גנבין דגנבין וחטפין ולא תיחטובהון ולא בזרהון דימטא ולא בטוהמה[ו]ן דל[י]ל[י]ה

19 מ[יכ]ן ואילך אמין אסירת וחתימא בחתמא קדמאה דאברכסס רבה דאסר ולשר[י] תיתסרון ולא תישתרון אמן

20 [אמ]ן ס[לה ש]רי[ר] וקיאים אמן אמן אמן אמן אמן אמן אמן אמן אמן

10–12. **mn šmyh**: "from heaven"; it appears that the scribe began to write **ḥtym** "sealed" in l. 12, but then completed **šmyh**, thus writing **ḥtym** on l. 13.

16. **mlkʾ dywy**: "the king of *dēv*s"; see the note to JBA 81:3.

17. **bḥbls lylytʾ**: "by Ḥablas, the lilith"; the parallels read **bplḥs lylytʾ** "by Palḥas, the lilith" (e.g. JBA 84:6). The lilith Ḥablas is attested in the Elisur Bagdana bowls (see I.2.2). The use of Ḥablas in this bowl may be on account of the phonetic similarity between the two names.

19. **ʾsyrt wḥtymʾ**: "you are bound and sealed"; the second verb should read something like **ḥtymtʾ** (cf. JBA 82:16).
wlšry: "and it is not loosed"; i.e. for **wlʾ šryʾ** (cf. JBA 82:17).

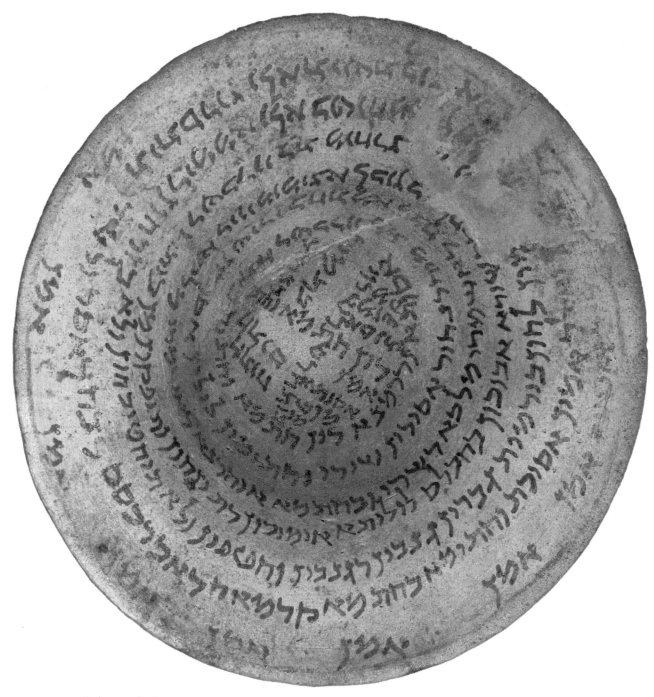

JBA 86 (MS 2053/226)

155×65 mm. Semi-formal hand. The bowl is badly faded towards the centre. Upon reaching the rim, the scribe continued by writing an interlinear text beginning above where l. 2 ends and l. 3 begins (see the introduction to 1.3.2). The text is surrounded by a circle.

Linguistic and orthographic features: Note the use of the masc. pl. abs. form **nyqbyn** rather than the usual fem. pl. **nyqbt'** (l. 3; see Morgenstern and Ford 2017, 223 n. 121). Note also the use of *plene 'aleph* in **dm'm'** (l. 6) and **ḥ't'myh** (l. 11). Finally, note the unconventional placement of *yudh* in **dwdy** for plene **dwyd** (l. 9), **drytyh** for **dyrtyh** (l. 4) and **rbyq'** for **rybq'** (l. 5).

Clients: Abbay son of Māmay; Rebecca daughter of Kakkār (see the note to HS 3012:2 in Ford and Morgenstern 2020, 47–48); Bustay daughter of Rebecca.

Image: There was a drawing in the centre, but it is almost completely erased and is beyond description. It appears to have been surrounded by three concentric circles that were joined by two sets of stripes. This results in two bands that resemble the limbs found on some of the figures on other bowls. It could possibly be an *ouroboros*, but neither head nor tail is visible.

FIGURE 13: Artist's impression of image from JBA 86

Main inscription:

1 [...]יי בישמך אני עושה אסותא מן שמיה תיהוי לה {אלה} לאידרונא {דב} דאב[אי] בר מ[א]מ[י] מן שמ[י]ה

1 [...]yy By your name I act. May there be healing from heaven for the inner room of Abb[ay] son of M[ā]ma[y], from heav[e]n.

2 בי[שמ]ך אני {עש} עושה אסירין שידי ומחתמין לילתא בחתמא רבה דביה חתימא [...] בחתמא ד[א]שמדי

2 By your [name] I act. Bound are the demons and double sealed are the liliths by the great seal by which are sealed [...] by the seal of [A]shmedai,

3 מלכא {דשמדי} דשידי ובחתמא אוחרנא דאשמדי מלכא דדיוי מומינא ומשבענא לכון ש[יד]י דיכר[י]ן ולילתא ניקבין

3 the king of demons, and by another seal of Ashmedai, the king of *dēv*s. I adjure and put you under oath, male de[mon]s and female liliths

4 ומבכלתא בישתא בפאלחס שידא דהוא {דהוא} אובוכון ופלחדוד לילתא דהיא אימכון דת[נ]יזהון ותיפקון] מ[ן] ביתיה ודריתיה

4 and evil *mevakkalta* demons, by Palḥas, the demon who is your father, and Palḥadod, the lilith who is your mother, that you [may move and go out] fr[om] the house and the dwelling

5 of Abbay son of Māmay, of Rebecca daughter of Kakkār, of Bustay daughter of Rebecca [...] to them as mighty men who st[eal and] snatch them, neither the seed of the night

דאבאי בר {ממאי} מאמי דריבקא בת ככר
דבוסתאי בת רביקא [...] להון בגיברין גברין
דג[נבין ו]חטפין בהון לא בזרעא דליליה

6 nor the seed of the day. But you may release and release, but release, release, [...] Again, [...] this incantation they write upon a bowl, and [th]ey bury it at the doorposts of the door (of) the new dwelling

ולא בזרעא דמאמא אילה תיפנו ותיפנו אילה
פנו פנו א[.]א אט[...]נא תוב י[...] הדא מילתא
כתבין על כסא וקבר[י]ן [י]תיה בסיפי בבא
דירתא חדתא

7 of Abbay son of Māmay. (A)men,

דאבאי בר מאמי מן

Interlinear inscription:

8 Amen. Bound are the demons and double sealed are the liliths by the great seal by which heaven and earth are sealed. Amen, Amen, Amen, Selah. Sealed

אמן אסירן י שידין ומחתמין ליליתא בחתמא
רבה דביה {דביה} חתימא {דביה חתמא} שמיא
וארעה אמן אמן אמן סלה {ב} חתימים

9 and double sealed is the house of Abbay son of Māmay, by the great seal by which heaven and earth are sealed, and by the seal of the signet-ring of yš[...] King Solomon son of [Da]vid.

ומחתים ביתיה {דאיבי} דאבי בר מאמי בחתמא
רבה דביה חתימא שמיא וארעה ובחתמא
דעזקתא דיש[...] שלומה מלכא בר [ד]ודי

10 Amen. By the seal by which heaven [...] are sealed. Amen, Amen [...] Amen, Halle[lu]jah [...] Amen, Selah. Amen, [A]men, Amen [...]

אמן בחתמא דביה {ביה} חתימא שמיא [...] אמן
אמן [...] אמן הל[ל]יה [...] אמן סלה אמן [א]מן
[...] אמן

11 [...] his seal is designated. Amen, Amen, h Amen, Amen, Amen, Se(lah) [...] Amen, Amen, [...] Amen, Amen, Amen [...]

[...] מזמן חאתאמיה אמן אמן ה אמן אמן אמן ס
[.]אהא[...]מיא אמן אמן [...] אמן אמן אמן [...]

2. **bḥtm' rbh dbyh ḥtym' [...] bḥtm' d'šmdy**: "by the great seal by which is sealed [...] by the seal of Ashmedai"; the lacuna only has room for two letters at most. It appears that the scribe wrote **dbyh ḥtym'** before realising that he had diverged from the usual formula. He then resumed along the lines of the expected formula with **bḥtm' d'šmdy**.

4. **'bwkwn**: "your father"; i.e. error for **'bwkwn**.
 drytyh: "his dwelling"; i.e. error for **dyrtyh**.

5. **wḥṭpyn bhwn**: "and snatch them"; this is most likely an error for **wḥṭpyn wl' tyḥṭwbhwn** "and snatch, and you shall not harm them" (cf. JBA 85:18).

6. **dm'm'**: "of the day"; for **dymm'** (cf. JBA 85:18)—i.e. apparently a *plene* spelling with a medial *'aleph*, but written defectively without the initial *yudh*.
 'ylh typnw wtypnw 'ylh pnw pnw: "But you may release and release, but release, release"; compare JNF 8:6 (**'ylh typnw pnw pnw**) and JNF 84:11 (**'ylh typlw typlw 'ylh hykw hykw**). The given translation assumes that the text is intended to be meaningful, but this is not certain. Compare also Syr. PNY "turn, turn around" (*SL*, 1205) and

Mand. PNA "turn, overturn" (*MD*, 374) for other possible ways to understand this phrase.

8. **'syrn y:** "Bound"; it appears that the scribe omitted the second *yudh* in **'syryn**. Usually, the omitted letter would be written above the line, but, given that this is already an interlinear text, it was probably more practical to write it following the word.
ḥtymym: "Sealed"; i.e. error for **ḥtym**.

9. **mḥtym:** "double sealed"; for this form of the *pa.* masc. sg. pass. ptc., see Moriggi 2005a, 261–264; Ford 2014, 237–239 (see also JBA 76:1).
dyš[...] šlwmh: "of [...] Solomon"; given the amount of repetition in this text, it is likely that the lacuna contained **šlwmh**.
dwdy: "David"; given what was observed for **'syrn y** (l. 8), it would appear that the scribe intended to write **dwyd** (i.e. the usual *plene* spelling that accompanies **šlwmh**), but originally omitted the *yudh*.

10. **ḥtym' šmy'** [...]: "heaven [...] are sealed"; the traces in the lacuna do not resemble **w'r'h**, so the text would appear to be corrupt at this point.

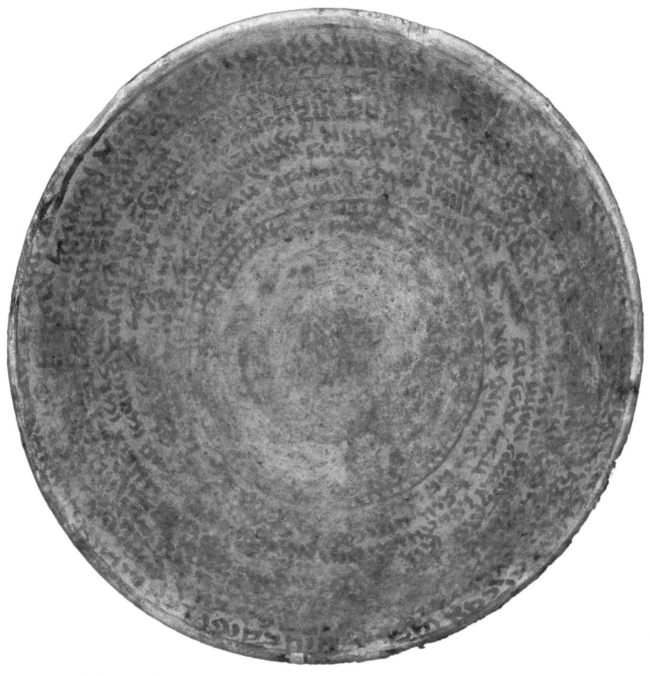

I.3.3

The Seal of Yokabar Ziwa

∴

Introduction

The texts in this section refer to the beneficent supernatural figure Yokabar Ziwa, which would appear to be of Mandaic origin—see Smelik 1978, 177 (n. 2) and Müller-Kessler 1999, 111–112. Thus the phrase **bšumh d-gbra qadmaiih iukbar ziua šumh** "in the name of the primeval man, Yokabar Ziwa is his name" occurs in a Mandaic magic bowl from the Schøyen Collection (MS 2054/40:17; compare DC 44:323–325; DC 52:259–260).

The signet-ring of Yokabar Ziwa occurs in a magical context in DC 37:271–272, which reads '**sira htima b'siqta d-iukabar ziua rba d-hiia** "it is bound, it is sealed, by the signet-ring of Yokabar Ziwa, the great one of Life". Likewise, a number of Jewish Aramaic magic bowls refer to his signet-ring, e.g.: **ḥtym wmḥtm ... b'yzqtyh dywkbr zyw' br rby** "sealed and double sealed ... by the signet-ring of Yokabar Ziwa son of Rabay" (Gordon E:6); **ytḥtmwn wytnṭrwn ... b'yzqt' dḥtym bh ywkbr zyw' br 'b'y** "may they be sealed and protected ... by the signet-ring by which Yokabar Ziwa son of Abay is sealed" (MS 1927/10:4–5; compare Allard Pierson Museum bowl: 1–2, CAMIB 56A:1–2, MS 2053/11:2–4 and MS 2053/182:1–3).

The seal of Yokabar Ziwa occurs in at least one Jewish Aramaic magic bowl: **ḥtym wmḥtm ... bḥwtmyh dywkbr zwh br rby** "sealed and double sealed ... by the seal of Yokabar Ziwa son of Rabay" (JNF 171:1–2). The present chapter contains two bowls that relate to this theme, although neither explicitly mentions it. JBA 87:8 refers to **ḥytwmyh dywkbr zyw' br 'by** "the signature of Yokabar Ziwa son of Abay" in a context that parallels MS 1927/10 (quoted above) and JBA 26:5. On the other hand, JBA 88:4 refers to **ḥtm dḥtym bh dywkbwd zyw'** "the seal by which is sealed of (!) Yokabod Ziwa", which appears to result from a confusion of '**yzqt' dḥtym bh ywkbr zyw'** "the signet-ring by which Yokabar Ziwa is sealed" (MS 1927/10:5) with **ḥytwmyh dywkbr zyw'** "the signature of Yokabar Ziwa" (JBA 87:8).

JBA 87 is a comparatively small bowl, with a flat base and wide rim. It appears to have been written by the same scribe as PC 122, a parallel text that was produced for the same family and is similar in shape. It opens with **mlk mlky hmlkym ḥtym 'lyh** "the king of kings of kings seals it". The Hebrew subject of this opening clause is a common phrase in the rabbinic corpora. In this context, it makes more sense to understand the ambiguous verb as an act. ptc.

JBA 88 appears to have been written by the same scribe and for the same clients as MS 2053/247, with which it shares some distinctive orthographic features and phonetic spellings. The images on each bowl also share some common features. JBA 88 partly parallels MS 2053/99 and MS 2053/134, which helps alleviate some of the problems caused by its non-normative grammatical features.

Parallels for this formula, outside the Schøyen Collection, include PC 122.

Other spells that occur in the bowls in this section:
- Bond of a fast—JBA 88:3
- Twelve hidden mysteries—JBA 88:4

JBA 87 (MS 2053/47)

130 × 65 mm. Crude semi-formal hand. In the centre of the bowl, within a circle, there are four very short lines. The writing is partly faded. The text appears to be surrounded by a circle.

Clients: Khōkhbūd son of Qāqay; Gušnazdukh daughter of Sāhdōy, his wife.

Biblical quotation: Gen 49:18.

In the centre:

1 מלך מלכי — The King of kings of

2 המלכים — kings

3 חתים — has put his seal

4 עליה — upon it.

Main inscription:

5 חתים ומחתם ביתיה ודירתיה ואיסקו[פתי]ה — Sealed and double sealed is the house and the dwelling and the thres[hold]

6 דכוכבוד בר קאקי ודגושנזדוך אינתתיה בת סהדוי — of Khōkhbūd son of Qāqay and of Gušnazdukh, his wife, daughter of Sāhdōy,

7 ודבניהון ודקינינהון וכל שמא דאית להון בשיר שירא ובזיה — and of their children and of their property, and any name that they have, by the ring šyr, and by zyh

8 זימרן ובחיתומיה דיוכבר זיוא בר אבי מן כל שידין ומן כל דיוין ומן כל — zymrn, and by the signature of Yokabar Ziwa son of Abay, from all demons and from all *dēv*s and from all

9 לילייתא כולהין אמן אמן סלה סיסא וסג[...] לישועתך קויתי — liliths, all of them. Amen, Amen, Selah. sysʼ wsg[...] "I wait for your salvation,

10 יהוה — O YHWH".

6. **kwkbwd**: "Khōkhbūd"; reading with PC 122, a parallel text that was written by the same scribe for the same client. This appears to be derived from *xōg* "nature, character, disposition" (*CPD*, 94) with the suffixed element *būd* from the verb "to be, become". The name would mean something like "possessor of (good) character".

7. **bšyr šyrʼ**: "by the ring šyr"; for this expression, see the introduction to **1.4.1.1**.

7–8. **zyh zymrn**: The same reading occurs in PC 122:6. Compare **zyh zywʼ** in JBA 26:5 and JNF 171:1–2; **zw zymrh** in JBA 88:4; and **zwm zymrʼ** in MS 1927/10:5 (see also the introduction to **1.4.1.1**).

8. **wbḥytwmyh dywkbr zyw' br 'by:** "and by the signature of Yokabar Ziwa son of Abay". We tentatively identify **wbḥytwmyh** with MH ḥytwm "signature". The same phrase appears in PC 122. Most of the parallels read **bʿyzqtyh dywkbr zyw'** "by the signet-ring of Yokabar Ziwa" or the like, but compare JNF 171:2: **bšyr šyr' wbzyh zymr' wbḥwtmyh dywkbr zwh br rby** "by the ring šyr, and by **zyh zymr'**, and by the sealing of Yokabar Ziwa son of Rabbay".

9. **sys' wsg[...]:** Compare PC 122:7, which gives the following series of *nomina barbara*: **sys' wsgr' srgwn' wbrgny'**.

9–10. Gen 49:18.

10. At the end of the text, the scribe has used a vertical stroke to begin inscribing the circle that appears to surround the text.

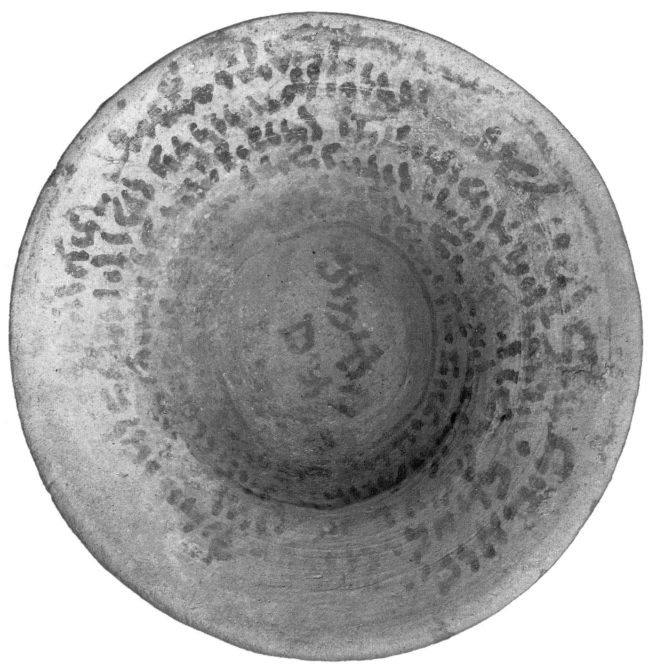

PHOTO 25 JBA 87 (MS 2053/47)

JBA 88 (MS 2053/248)

156 × 63 mm. Crude semi-formal hand. The bowl was broken. It has been repaired, but is missing some small portions. The writing is partly faded towards the rim.

Linguistic and orthographic features: The scribe usually differentiates between *daleth* and *reš*. The scribe makes no distinction between non-final and final *mem*, using the non-final form even in final position. Note the omission of *'aleph* at the start of the following words: **ytth** (l. 1) and **yttyh** (l, 3)—both a phonetic spelling for **'yttyh** (with the former also using **–h** rather than **–yh** for the 3 p. masc. sg. pron. suffix); **swr** (l. 3)—a phonetic spelling for **'swr**; **syr** (l. 1 and twice in l. 3)—a phonetic spelling for **'syr**, for which see Ford 2012, 243 (n. 79); **šṭqwpt'** (l. 2)—a phonetic spelling for **'šṭqwpt'** (with emph. *ṭet* resulting from its proximity to *qoph*). Note the omission of *ḥet* at the start of the following words: **tym** (ll. 3 and 4)—a phonetic spelling for **ḥtym**; **tm** (ll. 3 and 4)—a phonetic spelling for **ḥtm'**. Note also the omission of *'ayin* at the start of the following words: **yzqt'** (l. 4)—a phonetic spelling for **'yzqt'**; **nqth** (l. 2; cf. MS 2053/219:8)—a phonetic spelling for **'nqt'** (although **'nqt'** is also attested). Note also the use of *'ayin* as *mater lectionis* in **ksy'** for both sg. *kasyā* (l. 3) and pl. *kəsē* (l. 4), and perhaps also in **ywy'y** (l. 1; cf. l. 3). The preposition **b-** appears as voiceless **p-** in **pswr** < **b'swr'** (l. 3; for another example, see MS 2053/247:6). A shift from voiced to voiceless dental plosive occurs in **ztq** < **zdq'**, which also shows a loss of final *'aleph* (ll. 3 and 4; see also the note below). The opposite shift from voiceless to voiced dental plosive occurs in **drysr** < **trysr** (l. 4). It appears that the scribe uses a truncated form for a noun that comes at the end of a list: **nqth wšṭqwpt' w'ḥrmt** (l. 2; for other examples, see MS 2053/247). Similarly, the absolute form is sometimes used before the relative pronoun: in expressions of possession—**swr dṣwm'** (l. 3); **tm dztq** (ll. 3 and 4); and when introducing a subordinate clause—**ḥtm dḥtym bh** (l. 4). Note the use of **–h** rather than **–yh** for the 3 p. masc. sg. pron. suffix in **bh** (l. 4). Finally, note the possible metathesis of *lamedh* and *he* in **'hlt'** (l. 2).

Clients: Rabbā son of Aḥātā; Riqita daughter of Yōyay, his wife.

Image: In the centre of the bowl, there is a standing figure with frontal head and chest and limbs turned towards its left. Most of its features are human, and it appears to be female on account of its long hair, which is curly and consists of four strands on each side of its head. The head is round but narrows a bit at the chin. Facial features include two vertical lines that form the nose, and a horizontal line that forms the eyes. The face and the body are covered with dots. The arms are bent at the elbows, and end with three small lines that indicate fingers. Three long lines protrude from the hands, each ending with a small circle; it appears that these are being held by the figure. Both feet have three toes that resemble claws. The figure is bound by thin ropes around the arms and ankles. To the figure's right, there is a fan-like object, consisting of nine lines each of which ends with a small circle perhaps indicating objects held by the hand. One arrow crosses the chest and points at this object, while a second arrow points in the opposite direction towards the similar objects in the figure's hands. Compare the object depicted in MS 2053/247.

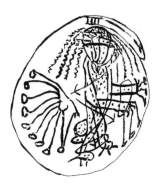

FIGURE 14: Artist's impression of image from JBA 88

1 Bound, sealed and double sealed is the house of Rabbā son of Aḥātā [and] R[i]qita daughter of Yōyay, his wife, from the evil eye and from evil sorcery, fr[om] severe

סיר חתים ומחתם ביתם דירבא בר אחתא
[ו]ר[י]קיתא בת יויעי יתהה מן עינא בישתא ומן
{ש} חרשי בישי מ[ן ...]

2 [magical acts,] from the cu[r]se demon, and from the neck(lace) charm demon and the blow demon and the anathema, from the dispatch (of witchcraft), and from the worship of (pagan) deities (?), from mishap, and from evil l[i]liths, and from all blast demons and tormentors,

תקפי מן לו[ט]תה ומן נקתה ושטקופתא
ואחרמת מן שרותא ומן אהלתא מאקריתא
ומן ל[י]ליתא בישותא ומן כל זיקי ומזיקין

3 and from every evil thing, by the hidden and protected mystery. Again, bound, sealed and double sealed is the house of Rabbā son of Aḥātā and Riqita son (!) of Yōyay, his wife. Bound by a bond of a fast [and] sealed by a seal [of] righteousness,

ומן כל מידי בישא ברזא כסיע ונטיר תוב סיר תים
ומחתם ביתה דירבה בר אחתא וריקתא בר יועי
יתתיה סיר פסור דצומא [ו]חתים בתם [ד]זתק

4 by [z]w zymrh. Sealed by a seal of righteousness, by the ring šyr, by zw zymr', by the signet-ring zrzyr, and the seal by which is sealed of (!) Yokabod Ziwa, those twelve hidden and protected mysteries which [...]

ב[ז]ו זימרה תים בתם דזתק בשיר שירא בזו
זימרא בזרזיר יוקתא וחתם דחתום בה דיוכבוד
זיוא הנהו דריסר רזי כסיע נטירי ד[...]

5 [...] 'nṭty 'tqš pdy nd ṣṣlh ṭṭr' ypnk A[men ...] sss

[...] אנטטי אתקש פדי נד צצלה טטרא יפנך
א[מן ...] סנס

1. **ytth**: "his wife"; cf. **yttyh** (l. 3). Compare MS 2053/247, which also has **ytth** (l. 1) followed by **yttyh** (l. 2).
[...]: "[magical acts,]"; the missing word is either **mbdy** (for **m'bdy**) or **'bdy**.

2. **šrwt'**: "the dispatch (of witchcraft)"; apparently for **šdr(w)t'**, which we take to be derived from ŠDR I "to send" rather than ŠDR II "to be twisted" (cf. *DJBA*, 1112–1113, which glosses **šdrt'** as "spine"). For the loss of either *daleth* or *reš* in derivatives of ŠDR "to send" in the magic bowls, see Ford 2011, 266–267.
'hlt': "worship of (pagan) deities (?)"; possibly a metathesised form of **'lhwt** (see *SL*, 47); compare a similar list in DCG 1:5, a Syriac magic bowl in Ford (forthcoming a), which reads **wkwl šydnwt' wmšdrnwt' wkwl ptkrwt' w'lhwt'** "and all demon worship and sending (of witchcraft), and all idolatry and worship of (pagan) deities".

Alternatively, again assuming a metathesis, this could be either the fem. sg. or pl. "goddess/goddesses".
m'qryt': "from mishap"; given the context, this is probably an error for **mn qryt'**.

3. **mn kl mydy byš'**: "from every evil thing"; the usual form of this expression in the magic bowls is **mn kl myd(y)'m byš** (e.g. JBA 54:2). The form **mydy** is common in Rabbinic Babylonian Aramaic (for this term, see Morgenstern 2011), but it does occur in at least one other magic bowl (BM 91770:13; see Levene 2013, 123). The present scribe's use of emph. **byš'** rather than the usual abs. **byš** accords with his eccentric approach to states in both this text and MS 2053/247. Emph. **byš'** does occur in this expression, however, in at least one other JBA magic bowl (MSF Bowl 25:4), as well as in a number of Syriac magic bowls (e.g. MS 2055/26:7).

ryqtʾ br ywʿyy: "Riqita son (!) of Yōyay"; the same error of **br** for **bt** "daughter of" occurs in MS 2053/247:1. The mother's name is unclear, perhaps on account of an imperfection in the surface of the bowl, whereas the reading **ywʿy** is clear in l. 1.

ztq: "righteousness"; compare Syr. **zdqʾ** (*CSD*, 110–111) and Mand. **zidqa** (*MD*, 165), as opposed to JBA ṢDQ (*DJBA*, 952).

4. **šyr šyrʾ:** "the ring šyr"; see the introduction to **I.4.1.1**.
zrzyr yzqtʾ: "the signet-ring zrzyr"; this corresponds to Mand. **zarziʾil ʿsiqta** "the signet-ring Zarziel" (*MD*, 161)—see Ford 2002, 245–246 (and n. 3); Ford 2012, 243 (n. 80). See also the introduction to **I.4.1.2**.

5. **sss:** See the note to JBA 97:8.

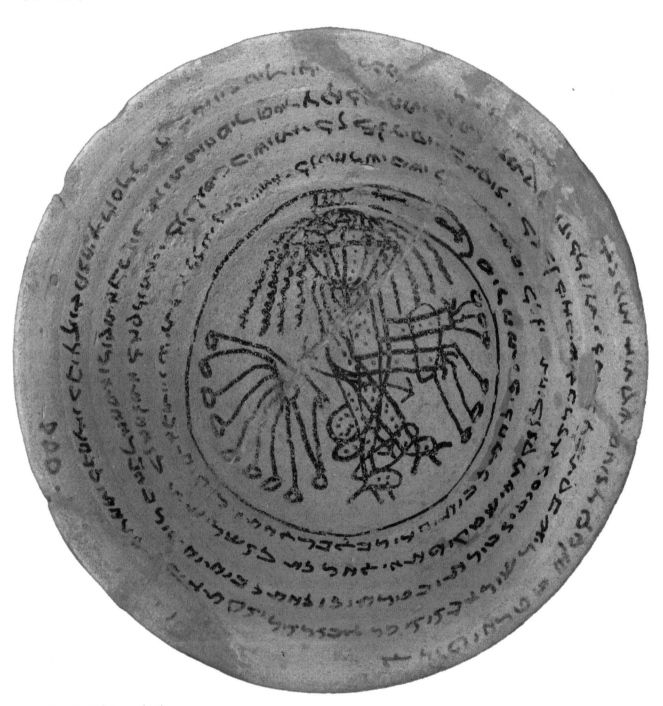

PHOTO 26 JBA 88 (MS 2053/248)

I.3.4

The Bond of the Lion and the Seal of the Dragon

∴

Introduction

The text in this section, JBA 89, contains a formula that occurs in several Syriac magic bowls, including CSIB 17, CSIB 25, CSIB35, CSIB 39 and MS 2055/26—see Moriggi 2014, 93; Ford (forthcoming a). The contrast between the relative popularity of this formula in the Syriac bowls and its sole occurrence in the more numerous Jewish Aramaic bowls, coupled with the lack of specifically Jewish features, suggests that JBA 89 is a translation of a Syriac original.

This is lent further support by the use of the Syr. dem. pron. **hn'** (JBA 89:1, 10 & 11). Interestingly, this form does occur very rarely in some other Jewish Aramaic bowls (e.g. MS 2053/152; see also the three examples cited in *DJBA*, 385), none of which contain other indications of a Syriac *Vorlage*. Furthermore, the use of *ʿayin* in z'yqy "blast demons" (JBA 89:9 & 12) reflects the form attested in the Syriac parallels (e.g. CSIB 17:6 & 7) rather than the usual JBA **zyqyn** (see *DJBA*, 411). Similarly, **mwblh** "burden" (JBA 89:9) is better attested as a Syriac noun (see *SL*, 721), and **'ytwhy** (JBA 89:11) also reflects Syriac orthography (as opposed to JBA **'ytyh**). The scribe distinguishes between *daleth* and *reš*.

Just as with the seals of Ashmedai formula (see the introduction to **1.3.2**), this formula contains further examples of forcing demons to submit to figures of authority within the demonic hierarchy. The first such figures are the lion and the dragon, for which compare also **'syryn b'ry' wḥtmyn btnyn'** "they are bound by the lion and sealed by the dragon" (Montgomery 19:15, as corrected by Epstein 1921, 50) and **tytsr b'ry' wtytḥtym btnyn'** "may she be bound by the lion and sealed by the dragon" (M-K 33b:11). The lion and dragon appear together in several other formulae—in the present volume, see also JBA 116:8. The second pair of authoritative figures are Ibol and Iborit, who also occur elsewhere, e.g. **bšmyk mry' 'ybwl mlk' rb' d'lhy wbšmyk mrtyn 'ybwlyt mlkt' rbt' d'ystr't'** "by your name, Lord Ibol, the great king of the gods, and by your name, Our Lady Ibolit, the great queen of the goddesses" (Montgomery 19:5–6). The other authorities invoked are the **bgdny** "*bagdana*-spirits" and **z'yqy** "blast demons" (in rather enigmatic terms in ll. 9 & 12).

Other spells that occur in the bowl in this section:
– The bond of Ibol and seal of Iborit—JBA 89:7
– The great burden of the blast demons—JBA 89:9
– The signet-ring of sixty brothers of blast demons and eighty descending *bagdana*-spirits—JBA 89:12

JBA 89 (MS 1929/2)

175 × 80 mm. Semi-cursive hand. The bowl was broken, but has been repaired. In the centre of the bowl, there is a small circle. The text is surrounded by a circle.

Clients: Aḥay and Nānay, children of Gušnazdukh.

1	מזמן הנא קמיעה חתמא ונט[רתא]	Designated is this amulet, seal and pro[tection]
2	לביתיהון דאחי וננִי בני גושנזדוך	for the house of Aḥay and Nānay, children of Gušnazdukh,
3	{דניתנט} דיניתנטר ביתיהון מן דיוי ושידי ולילִיתא ומן	in order that their house may be protected from *dēv*s and demons and liliths and from
4	שידא רגאמא זה דיוא ולטבא עירא ושכבא וכל אילהותא בישתא	the accusing demon. Depart, *dēv* and no-good one, watcher and sleeper, and all evil goddesses,
5	מן ביתא הדין ומן דיארי דבגויה שרן אסיר שידא ולטבה וחומרתא דיכרא	from this house and from the inhabitants who dwell within it. Bound is the demon and the no-good one and the amulet spirit, male
6	וניקבתא ולילִיתא דיתה דאתיא ושריא בהדין ביתא דאחי וננִי בני גושנזדוך	or female, and the lilith that is (there), that comes and dwells in this house of Aḥay and Nānay, children of Gušnazdukh.
7	אסירא באיסוריה דאריא וחתימא בחתמיה דתנינא אסירא באיסוריה דאיבול	Bound by the bond of the lion and sealed by the seal of the dragon. Bound by the bond of Ibol
8	וחתימא בחתמא דבגדִני אסירא באיסוריה אסירא בחת} וחתימא בחתמיה דאבורית אסירִין	and sealed by the seal of Iborit. They are bound
9	באיסור זעִ׳קי וחתימין בחתמא דבגדני אסירין וחתימין במובלה רבה דזעִיקי דכול שידי בִישי ולטבי	by the bond of the blast demons and they are sealed by the seal of the *bagdana*-spirits. They are bound and sealed by the great burden of the blast demons, in order that all evil demons and no-good ones
10	וחומרי ופתכרי ואיסתרתא ולִילִיתא וחומרי ולילִיתא וכל אינש אינש בשמיה לותיה דהדין ביתא דהנא קמיעה	and amulet spirits and idol spirits and goddesses and liliths and amulet spirits and liliths, and each and every one by his name, towards this house, in which this

11 הדא [א]סיר אסיריה לגויה ניקרבון לא איתוהי ביה
 רוחא בישתא וחומרתא ושידא ודיוא ולילתא
 ושידא רגאמא וכל דבהנא

amulet is (present), shall not come near to within it. Bound is this evil spirit and amulet spirit and demon and *dēv* and lilith and accusing demon, and every (spirit) that dwells

12 ביתא ובהדא דירתא שרי אסירין וחתימין בעיזקת
 שיתין אחי זעיקי ותמנן נחתין בגדנא וניתנטר
 ביתיהון ודירתיהון

in this house and in this dwelling. They are bound and sealed by the signet-ring of sixty brothers of blast demons and eighty descending *bagdana*-spirits. And may the house and dwelling of Aḥay

13 דאחי וננ̇י בני גושנזדוך מן דיוי ושידי ולילית̇א ומן
 שידא רגאמא אמן אמן סלה

and Nānay, children of Gušnazdukh, be protected from *dēv*s and demons and liliths, and from the accusing demon. Amen, Amen, Selah.

3. {**dnytnṭ**}: The final two letters are difficult to discern. It appears that the *ṭet* was awkwardly written, prompting the scribe to begin the word again.

4. **šyd' rg'm'**: "the accusing demon" (also in ll. 11 & 13); this is probably the origin of the Arabic phrase *aš-šayṭān ar-rajūm*—see Ford 2014, 243 (n. 38).

 'yr' wškb': "watcher and sleeper". The term **'yr'** "watcher" is used to refer to a type of angel in the Syriac tradition (SL, 1098), which demonstrates the vibrancy of a particular reception history of Dan 4:10, 14 & 20—compare also LXX's use of ἄγγελος in this passage. The context of the use of the term here, however, appears to suggest that a "fallen angel" is intended, in the sense of one that wishes to transgress sexual boundaries between angels and humans. This reflects a persistence in the use of the term attested in a number of early Jewish texts (e.g. 1 En 10:7 & 9; 1QapGen 2:1 & 16). The term thus forms a natural pair with the following **škb'** "sleeper", i.e. one who lies down to have conjugal relations (see *DJBA*, 1142, s.v. **škb** vb., meanings 1 & 3), in suggesting aggressive sexual intent on the part of the evil spirits. In his edition of the Syriac parallels, Moriggi translated this phrase as "awake and asleep" (e.g. CSIB 17:4; see also the note in Moriggi 2014, 94), i.e. as an antonymic pair, whereas the suggestion given here would see the terms as synonymous.

 'ylhwt' byšt': "evil goddesses"; or "evil deities" (compare Moriggi 2014, 93–94). See also Morgenstern 2010, 290, who cites Epstein's discussion of how the pl. termination –*wātā* can be used for both masc. and fem. nouns. In this context, however, there is no reason not to translate it as fem., as this allows for a sexual threat from both genders—a theme that recurs later in this text (e.g. ll. 5–6, 10).

6. **dyth d'ty' wšry'**: "that is, that comes and dwells". The known Syriac parallels either have the particle of existence or the verb 'T' "to come": **w'yt' wšry'** "and she comes and dwells" (CSIB 17:5); **d'tt wšrt** "that came and dwelt" (CSIB 25:3); **d't' wšr'** "that came and dwelt" (CSIB 35:4); **d'yt wšry'** "that is and dwells" (MS 2055/26:3). Given this, it is likely that the present text represents a conflation of two textual traditions.

8. The scribe clearly became confused and jumped to a later part of the formula. He then stopped halfway through a word and corrected himself.

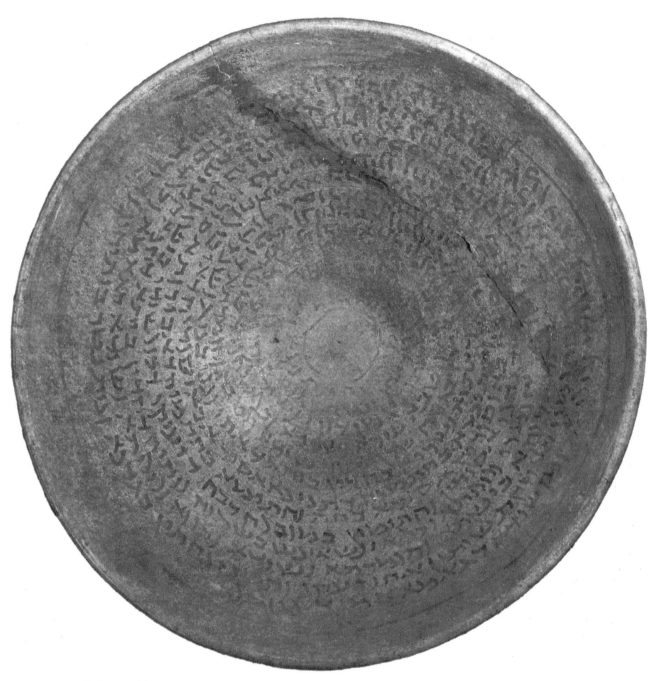

PHOTO 27 JBA 89 (MS 1929/2)

I.3.5

Seven Bonds and Eight Seals

∴

Introduction

The text in this section, JBA 90, makes use of the numerical sequence seven-eight in the phrase **bšbʿh 'ysryn wbytmny' ḥtmyn** "by seven bonds and by eight seals" (cf. also JBA 98:14–15); for **bšbʿ 'ysryn wbšbʿh ḥtmyn** "by seven bonds and by seven seals", see MS 2053/63:3. The use of such numerical sequences is discussed in Ford (forthcoming c), in which several examples from the magic bowls are adduced.

JBA 90 appears to have been written by the same scribe as MS 1928/49, with which it shares a common list of *nomina barbara*. Furthermore, in both cases, the text begins at the rim and proceeds towards the centre.

JBA 90 (MS 2053/125)

170 × 60 mm. Crude semi-formal hand. The text begins at the rim and proceeds towards the centre. In the centre of the bowl, there is a very small triangular design. The writing is partly faded towards the rim. The text is surrounded by a circle.

Clients: Simro Khusb[.]ro, nicknamed Farrokhdād, son of Dukhtbeh; Tilula daughter of Mireh, his wife.

Biblical quotation: Is 12:3.

1 לשמך אני עושה {ה} הדין חתמא יהי לאסו לביתא דסימרו כוסב[.]רו דמ[יתקרי פר]וכדד בר דוכתביה ודתילולא

1 By your name I act. May this seal be for healing for the house of Simro Khusb[.]ro, who is [called Farr]okhdād, son of Dukhtbeh, and of Tilula

2 בת מיריה אינתתיה ויתחתם מן כל שידי ודיוי ופגעי וסטני ומן לילית̈א ומבכלתא דיכרי וניקבתא

2 daughter of Mireh, his wife. And may he be sealed from all demons and *dēv*s and affliction demons and satans and from liliths and *mevakkalta* demons, male and female.

3 אסיר וחתים הדין ביתא בשבעה איסרין וביתמניא חתמין בשום אנפראי

3 Bound and sealed is this house by seven bonds and by eight seals. By the name of ʾnprʾy

4 מרק רצר חף צידן אחיף זדן גרם זדן גרום זדון איפרסת

4 **mrq rṣr ḥp ṣydn ʾḥyp zdn grm zdn grwm zdwn ʾyprst**

5 דמדסת מהידוסת לאתידוסת ושבתם מים

5 **dmdst mhydwst lʾtydwst** "And you shall draw water

6 בששון מימעיני הישועה אמן

6 with joy from the wells of salvation". Amen,

7 אמן סלה שרירה

7 Amen, Selah. Sound.

5. **wšbtm**: "and you shall draw"; apparently a phonetic spelling of MT **wšʾbtm**, showing loss of *aleph*.

5–6. Is 12:3.

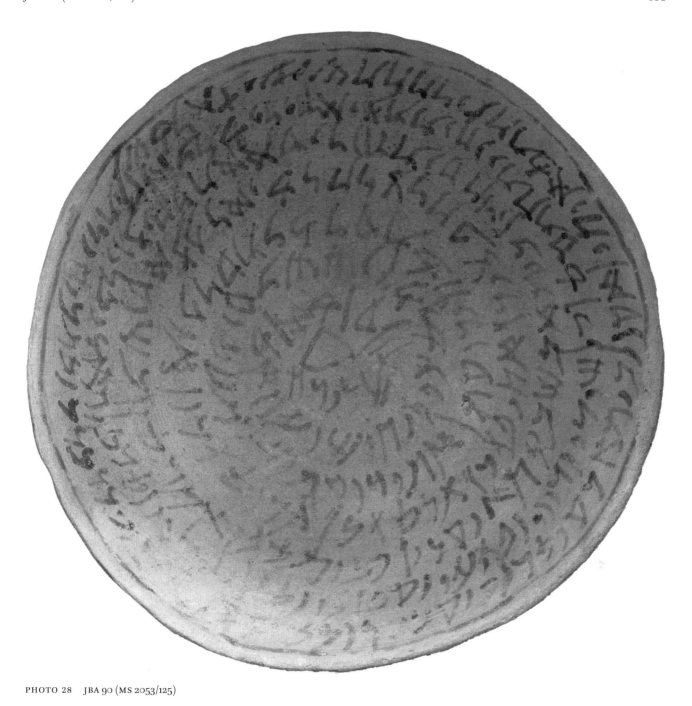

PHOTO 28 JBA 90 (MS 2053/125)

I.4

Signet-Rings

∴

Introduction

The texts in this chapter refer to the signet-ring of various entities. For the use of this general motif in Jewish magic, see Schäfer and Shaked 1999, 79–80. For its use in the magic bowls, including Mandaic and Syriac bowls, see Levine 1970, 364–368. Other bowls that refer to signet-rings, to be published in subsequent volumes, include MS 1928/31, MS 2053/32, MS 2053/99, MS 2053/134, and MS 2053/169.

I.4.1

The Signet-Ring of Solomon

∴

Introduction

The texts in this section refer to the theme of the signet-ring of King Solomon son of David. Other bowls that refer to this particular signet-ring, to be published in subsequent volumes, include MS 2053/23, MS 2053/223, MS 2053/252, and MS 2053/278. The same motif occurs in Syriac bowls (e.g. Moriggi 2014, 47–51 & 138–143) and manuscripts (e.g. Gollancz 1912, xlvi & xlix–l), as well as Mandaic bowls (e.g. Lidzbarski 1902, 102–105) and manuscripts (e.g. DC 40:907–909, DC 44:1693–1694).

I.4.1.1

The Lilith Gannav(at)/Gannaqat

∴

Introduction

The texts in this section refer to the theme of the signet-ring of Solomon in conjunction with šwṭʾ dnwrʾ "the whip of fire" and a magical object possessed by a certain demoness, variously called the lilith Gannav (JBA 91, JBA 95, JBA 98 and JBA 101; see also JNF 36, JNF 102 and JNF 110), the lilith Gannavat (JBA 91 and JBA 99; see also M 15 and PC 104) or the lilith Gannaqat (JBA 92, JBA 93 and JBA 94; at present, not attested outside the Schøyen Collection). The magical "whip of fire" is mentioned in other JBA bowls (e.g. MS 2053/28:11 and MS 2053/146:5), in the Babylonian Talmud (BT MQ 28a; cf. *DJBA*, 1116), and in later Mandaic magical literature (DC 37:410; for additional references, see *MD*, 440). Three bowls in this section are fragmentary and the name of the demoness is not preserved (JBA 96, JBA 97 and JBA 100), but there is no doubt that they carry the same basic formula. The three names appear to be variant appelations of the same demoness. Gannav and Gannavat are often given the epithet dhyʾ ryš šytyn wšyt ḥwmryn "who is head of sixty-six amulet spirits" (e.g. JBA 91:4–5), whereas Gannaqat always appears without an epithet.

Most of the bowls refer to the lilith's ḥwmrtʾ "seal stone" (*DJBA*, 440), the interpretation of which is suggested by the parallelism with ʿyzqtʾ "signet-ring". The distinction between these two types of seals is that the former has a hole bored through it, by which it is held on a string much like a bead, whereas the latter is in the form of a ring that is worn on the finger. In three texts (JBA 95, JBA 98 and JBA 101; see also JNF 110), the term šyrʾ is used instead of ḥwmrtʾ. Given JBA šyrʾ "bracelet" (*DJBA*, 1140) and Syriac šʾrʾ "bracelet, nose ring" (*SL*, 1498), and the likelihood that šyrʾ belongs to the same semantic field as both ḥwmrtʾ and ʿyzqtʾ, it would appear that, in this context, šyrʾ refers to a "ring (used as a seal)". Compare also JBA 77:4, JBA 88:4, JBA 104:1–2, JBA 113:5, JBA 114:10 and JBA 117:6, in which šyrʾ parallels ʿyzqtʾ. The same parallelism also occurs in the Mandaic bowls MS 2054/6 and MS 2054/101.

This allows us to revisit the phrase byšr šyrʾ in JBA 26:5, which we translated "by a rope" (Shaked, Ford and Bhayro 2013, 153) despite the fact that the two words are clearly written separately. The phrases bšyr šyrʾ "by the ring šyr" (JBA 88:4 and MS 1927/10:5; cf. JBA 102:3), bšršyrʾ "by the ring šr" (JBA 104:1), and bzyr šyrʾ "by the ring zyr" (JBA 113:5, JBA 114:10 and JBA 117:6) recur in a number of JBA bowls—compare the Mandaic examples bšaršira "by the ring šar" (MS 2054/6:11 and CAMIB 83M:14), and bšar šira "by the ring šar" (MS 2054/101:12, DC 43B:15 and DC 19:254), and also the Syriac example bšyr šyrʾ "by the ring šyr" (MS 2055/13:8). Whether written as one word or two, the meaning "by the ring …" is clear.

The main spell unit in this chapter is often accompanied by other spell units. In some bowls, it is preceded by a spell unit that adjures all the demons, irrespective of their age, size and usual place of residence, explicitly stressing their lewd and promiscuous nature (JBA 95, JBA 96, JBA 98, JBA 99 [preceded by a unique threat against the demons] and JBA 101). In most of the others, it is preceded by two spell units, the first of which contains a description of a demon who appears as a male and/or female thief in the night, and the second of which refers to the angel Asriel (JBA 91, JBA 92, JBA 93, JBA 94, JBA 97 and JBA 100). In three bowls (JBA 95, JBA 98 and JBA 101), the main spell unit is followed by two spell units that parallel JBA 65 and JBA 67. Most of the other bowls (JBA 91, JBA 92, JBA 93, JBA 94, JBA 96, JBA 99 and JBA 100) conclude with a spell unit that begins with an obscure adjuration bmry gnzyk wṣwṣytyky "by the master of your treasure houses and the tufts of your hair" (e.g. JBA 92:9)—the same formula appears in JBA 18:9–10 in a different context.

Two terms for types of bonds occur in these bowls. The first is the qwlyn. Sokoloff defined qwlʾ as "snare", following the Targumic Aramaic and Mandaic cognates and the Geonic identification of the term with Hebrew pḥ (*DJBA*, 991). The Geonic explanation, however, further derives qwlʾ from qwlr "collar", i.e. as an instrument of restraint. This better accords with phrases such as qwlyn dynḥš ʿl ṣwryky (JBA 91:10), which we would translate "collars of bronze upon your neck" (cf. *SL*, 1328, s.v. qwlʾ dṣwrʾ "collar").

The second type of bond mentioned in these bowls is the rʿyn dbrzl (JBA 91:10) or ryʿyn dbrzl (JBA 99:21) "bonds of iron". This word is new to the Aramaic lexicon, but is attested in a number of unpublished JBA and Syriac bowls (cf. rʿyʾ przyl "bonds of iron" in MS 2055/10:4). Although we cannot propose an etymology at present, the general meaning of the term is clear from the context. Possibly compare Akk. erû (weriu, werû) "copper".

The following bowls contain parallel texts: JBA 91, JBA 92, JBA 93, JBA 94, JBA 96, JBA 99 and JBA 100 (see also JNF 36, JNF 102, M 15, PC 104 and PC 128). JBA 99 and M 15 are duplicate texts that were prepared for the same client.

JBA 92, JBA 93 and JBA 94 appear to have been written by the same hand, which is also probably responsible for JBA 1, JBA 2, JBA 3, JBA 4, JBA 5, JBA 6, JBA 7 and JBA 9. The clients in JBA 92 and JBA 93 are Undas son of Rašewand-dukh and Māhdukh daughter of Nēwāndukh, his wife.

Elsewhere, the former is called Gundas son of Rašewanddukh (JBA 15, MS 2053/116 and M 13) or Gundasp son of Rašewanddukh (JBA 29 and M 20). As his mother's name, Rašewanddukh, is not very common, it is possible that the client in JBA 30 and JBA 37, Farrokh son of Rašewanddukh, is his brother.

JBA 96 was written by the same hand and for the same client as JBA 73. They also contain similar images.

Four of the bowls contain a phrase along the lines of **wyšlmwn ytyky wtytmsryn** "and they shall hand you over and you shall be delivered" (JBA 91:11, JBA 94:12, JBA 99:23 and JBA 100:9; see also JNF 36:11, M 15:22 and PC 128:7). The same pair of verbs occurs in the Targum to Deut 32:30, but a direct literary connection seems unlikely.

The following contain parallel texts that seek the economic prosperity of the clients: JBA 95, JBA 98 and JBA 101 (see also JBA 65 and JBA 67)—see the introduction to **I.3.1**. JBA 95 begins abruptly in the middle of a formula and, therefore, is probably the continuation of another bowl. One of the clients in JBA 98, Zəvīntā daughter of Baṯ-sāhdē ("Daughter of Martyrs"), has a Christian matronymic; Baṯ-ḥapšabbā ("Daughter of Sunday") in JBA 99 may also have been a Christian. JBA 98:14–15 also contains an adjuration **bšbʿ ḥtmyn wbytmnyʾ ʿyśryn** "by seven seals and by eight bonds", for which see **I.3.5**.

A preliminary translation of JBA 92:1–8 was published in Shaked 2002, 124–125.

Other spells that occur in the bowls in this section:
- Place these evil wounds—JBA 99:10
- The angel Asriel—JBA 91:3, JBA 92:4, JBA 93:5, JBA 94:4, JBA 97:4, JBA 100:2
- The seal of the sun—JBA 95:10, JBA 98:16, JBA 101:16
- The signet-ring of El Shaddai—JBA 95:11, JBA 98:16, JBA 101:16
- The thief in the night—JBA 91:2, JBA 92:3, JBA 93:3, JBA 94:3, JBA 97:3
- Treasure houses, tufts of hair and sixty mighty thieves—JBA 91:8, JBA 92:8, JBA 93:8, JBA 94:9, JBA 96:6, JBA 99:20; see also JBA 100:6
- Who dwell in various valleys and love fornication—JBA 95:1, JBA 96:1, JBA 98:7, JBA 99:12, JBA 101:7

JBA 91 (MS 1927/38)

175 × 70 mm. Semi-formal hand. The text is surrounded by a circle.

Linguistic and orthographic features: Note the loss of ʿ*ayin* in ʾrbtʾyhwn for ʾrbʿtʾyhwn (l. 11).

Clients: Pāpā son of Hormizdukh; Bībī daughter of Maḥlaftā, his wife.

Image: In the centre of the bowl, within a circle, there is an image of a frontal standing figure, whose head and feet are facing to the left. The figure appears to be female, judging by the narrowing at her waist. She is wearing a long dress and some kind of headdress with bands flowing behind her head. Her hair is represented by one tightly curled line descending along the side of her head. Her face consists of one short line for the eye, another for the mouth, and another for the nose. Five fingers are indicated for each hand, while her feet consist of just one line. She is bound by a thick rope that begins around the neck and proceeds to bind one arm and both legs.

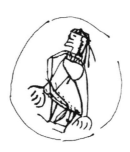

FIGURE 15: Artist's impression of image from JBA 91

1 אסירת וחתימת אנתי ליליתא ומבכלתא בישתא
ובת קלא דשריא בביתיה דפאפא

1 You are bound and sealed, you, lilith and evil *mevakkalta* demon and voice, who dwells in the house of Pāpā

2 בר הורמיזדוך ויבדירתה דביבי בת מחלפתא
דקריא בלילי כיגבר ומידמיא להון כבני אינשא

2 son of Hormizdukh and in the dwelling of Bībī daughter of Maḥlaftā, who calls in the night like a man, and appears to them like human beings

3 ויכאתתא גנביתא דחטיא בימזוני ומנזקא בדרדקי
אסירת בישמיה דאסראל מלאכה דאסר ולא שרי
וקטר

3 and like a thieving woman, who harms livelihood, and injures children. You are bound by the name of the angel Asriel, who binds and it is not loosed, and ties

4 ולא מישתרי חתימת בשוטא דנורא וביחומרתא
דיגנב ליליתא דהיא ריש שיתין ושית חומרין
וביחומרתא דיגנבת

4 and it is not untied. You are sealed by the whip of fire, and by the seal stone of the lilith Gannav, who is head of sixty-six amulet spirits, and by the seal stone of the lilith

5 ליליתא דהיא ריש שיתין ושית חומרין וביעיזקתא
דישלומה מלכה בר דויד דעלה צירין כל מלאכיה
ושידין ושיפטין ודיוין וסטנין

5 Gannavat, who is head of sixty-six amulet spirits, and by the signet-ring of King Solomon son of David, upon which are drawn all angels and demons and afflictions and *dēv*s and satans

ורוחין דחלין מיניה וניפקון מן אתר דאיתניהו מן כל אתר דאיתינון שרן ביה אף אנתי לילתא וימבכלתא בישתא דמיחזיא בה[די]ן	6	and spirits; they are afraid of it, and they go out from the place where they are, from every place in which they dwell. Also, you, lilith and evil *mevakkalta* demon, who appears in t[hi]s
קמי[...] זועי ר[ו]ת[י] ופוקי מן ביתיה דפאפא בר הורמיזדוך מן דירתה דביבי בת מחלפתא לא תיחטין לא ליה ולא לאינתיה ולא בבניה ולא בבנתיה	7	amu[let], shake, tr[e]mbl[e], and go out from the house of Pāpā son of Hormizdukh, from the dwelling of Bībī daughter of Maḥlaftā. Do not harm, neither him nor his wife, and neither his sons nor his daughters,
ולא בבעיריה לא ב[מ]זוניה ולא באנתתיה אשבעית עלך במריגנזי וביבצוציתיכי דאם נפקת מן ביתיה דפאפא בר הורמיזדוך מן דירתה דביבי בת מחלפתא	8	and neither his cattle nor his livelihood nor his wife. I have put you under oath by the master of treasure houses and by the tufts of your hair, that if you go out from the house of Pāpā son of Hormizdukh, from the dwelling of Bībī daughter of Maḥlaftā,
אינתתיה מוטב אם לא מיתינא עלך דעלך יקיר ודעלך חסין מא הוא דעלי יקיר ודעלי חסין מיתינא שיתין גברין אסרין יתכי כבלין דינחש בריגליכי ועיקין דינחש	9	his wife, it will be well. If not, I will bring against you that which is dear to you, and that which is powerful to you. What is dear to me and powerful to me? I will bring sixty men; they will bind you (with) chains of bronze by your feet, and fetters (!) of bronze
על ידיכי ורעין דברזל על איבריכי קולין דינחש על צוריכי בישמיה דגבראל מלאכה ובישמיה דעזריאל עזיזא ותקיפא דהוא ממני על קולין ועל שושלין דאינון תרויהון	10	upon your hands, and bonds of iron upon your limbs, collars of bronze upon your neck. By the name of the angel Gabriel and by the name of ʿAzriel, the strong and mighty one who is appointed over collars and over chains. For they, the two of them,
תלתיהון וארבעתאיהון דיתון וניפקון יתיכי מן ביתיה דפאפא בר הורמיזדוך וישלמון יתיכי {ותד} תתמסר בידי אמן אמן אמן ס[ל]ה חתמתא תיהוויליה	11	the three of them, and the four of them, for they will come and cause you to go forth from the house of Pāpā son of Hormizdukh, and they will hand you over and you will be surrendered into my hand. Amen, Amen, Amen, Se[la]h. May there be sealing for him.

4–5. **dygnb lylytʾ... dygnbt lylytʾ**: "of the lilith Gannav ... of the lilith Gannavat"; both **gnb lylytʾ** (e.g. JBA 98:13) and **gnbt lylytʾ** (e.g. JBA 99:16) occur as variants in the magic bowls, but this is the only text hitherto discovered that contains both.

6. **wnypqwn**: "and they go out"; the parallels consistently read **wnpqyn**.

6–7. **dmyḥzyʾ bhdyn qmy[...]**: "who appears in this amu[let]"; error for **myḥzk hdyn qmyʿh** "when you see this amulet" (e.g. JBA 92:7) or such like. The reading of the end of **qmy[...]** is uncertain, but the meaning is beyond doubt.

9. **wʿyqyn**: "and fetters"; see the note to JBA 94:11. In this case, **wʿyqyn** is probably an error for **wʿyzqyn**.

10. **rʿyn**: "bonds"; see the introduction to this section.
qwlyn: "collars"; see the introduction to this section.
šwšlyn: "chains"; the parallels tend to read **šwšln** (e.g. JBA 93:10), but the traces suggest the above reading in this case.

11. **wnypqwn**: The parallels consistently read *af.* **wypqwn** (e.g. JBA 92:11); compare also l. 6. If the reading is correct, it is possible that we have a *nun* preformative with the vowel shift /a/ > /i/ (as discussed in Morgenstern 2005, 354, with the example **wlypqynwn** "let him take them out"). It is also possible, however, that the scribe has written either **wwypqwn** or **wyypqwn**, both of which would be errors for **wypqwn**.

wtd ttmsr: "and you will be given"; a false start. In the correction, the scribe has omitted the 2 p. fem. sg. ending –īn.

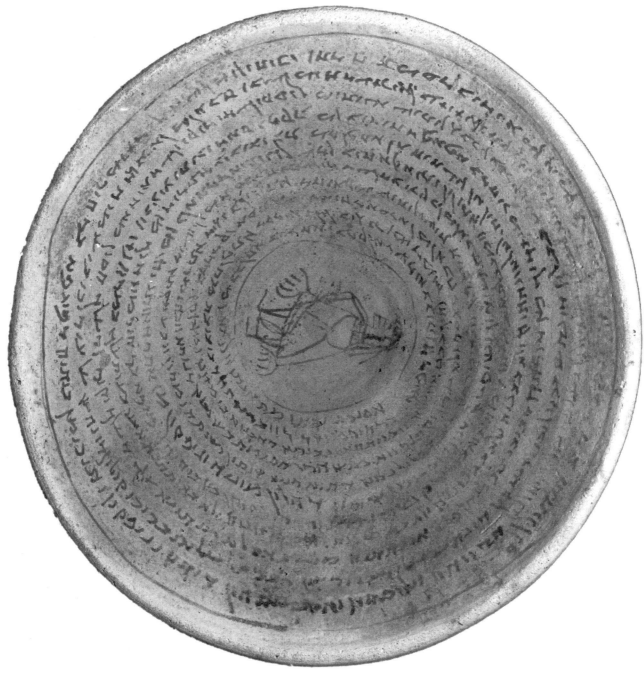

PHOTO 29 JBA 91 (MS 1927/38)

JBA 92 (MS 1927/54)

185 × 65 mm. Elegant semi-formal hand. The bowl was broken, but has been repaired. The writing is partly faded towards the rim. The text is surrounded by a circle.

Clients: Undas son of Rašewanddukh; Māhdukh daughter of Nēwāndukh, his wife.

1 אסירת וחתימת אנתי ליליתא

1 You are bound and sealed, you, lilith

2 ומבכלתא דשר[יא] בביתיה דאונדס בר רשיונדוך ובדירתה

2 and *mevakkalta* demon, who dwel[ls] in the house of Undas son of Rašewanddukh and in the dwelling

3 ד[מ]הדוך בת ניונדוך אינתתיה ומיחזיא בליליא כיגבר גנב וקריא להון

3 of [Mā]hdukh daughter of Nēwāndukh, his wife, and appears in the night like a thieving man, and calls to them

4 בליליה כיבני אינשא וכיאינתתא גנביתא וחטיא במזוני ומנזקא דרדקי אסירת בישמיה

4 in the night like human beings and like a thieving woman, and harms livelihood, and injures children. You are bound by the name

5 דאסריאל מלאכה דאסר ולא שרי קטר ולא מישתרי וחתימת בשוטא דנורא וביחומרתא דגנקת ליליתא ובעיזקת

5 of the angel Asriel, who binds and it is not loosed, (who) ties and it is not untied. And you are sealed by the whip of fire, and by the seal stone of the lilith Gannaqat, and by the signet-ring of

6 שלמה מלכא בר דויד דעלה צירין כולהון שידין וד[יוי]ן וזעיין ורייתין ודחלין מיניה ונפקין מן כל אתר ואתר דאיתנון ומן כל אתר

6 King Solomon son of David, upon which are drawn all demons and d[ēv]s, and they shake and tremble and are afraid of it, and they go out from each and every place where they are, and from each and every

7 ואתר דאינון שרן אף אנתי ליליתא ומבכלתא בישתא מיחזך הדין קמיעה זועי געורי ורותי ופוקי מן מהדוך בת ניונדוך מן ביתה ומן בנה

7 place where they dwell. Also, you, lilith and evil *mevakkalta* demon, when you see this amulet, shake, be rebuked and tremble, and go out from Māhdukh daughter of Nēwāndukh, from her house, and from her sons

8 ומן בנתה ומן דאית לה ומן דהון לה אשביעית עלכי דלא תנזקין לא בה לא ביבעלה לא ביבנה ולא ביבנתה ולא בנינה ולא בניכדה ותוב אשבעית

8 and from her daughters, and from those that she has and from those that she will have. I have put you under oath that you should not harm, neither her nor her husband, neither her sons nor her daughters, and neither her child nor her grandchild. And again I have put you under oath

9 you by the master of your treasure houses and the tufts of your hair, that if you go out from their house, from their dwelling, (it will be well). But if not, I will bring against you that which is dear to you, that which is powerful to you. And I will bring against you sixty thievin[g] men and they will bind

עלכי במרי גנזיך וצוציתיכי דאם נפקת מן בתיהון מן דירתיהון ואם לא מיתינא עלכי דעלך יקיר דעלך חסין ומיתינא עלכי שיתין גברין גנבי[ן] ואסרין

10 you with chains of bronze and with shackles of iron. By the name of the angel Gabriel and by the name of ʿAzriel, the strong and mighty one who is appointed over collars and over chain[s]. They, the two of them, the three of them, the f[ou]r of them,

יתיכי בשושלן דנחש ויבכבלין דפרזל בשמיה דגבריאל מלאכה ובשמיה דעזריאל עזיזא ותקיפא דממני על קולין ועל שושל[ן] אינון תרויהון תלתיהון א[רב]עתיהון

11 will come and cause you to go forth from the house of Undas son of Rašewanddukh, from the doorway of [Mā]hdukh daughter of Nēwāndukh, from her child, from her grandchild, from her sons, from her daughters, from her doorway, from her dw[ell]ing, from the sixty[-six] members of

ייתון ויפקון [י]תיכי מן ביתיה דאונדאס בר רשיונדוך מן פיתחה ד[מ]הדוך בת ניונדוך מן נינה מן ניכדה מן בנה מן בנתה מן פיתחה מן ד[יר]תה מן שיתין [ושיתא] הדמי

12 [her] body. And may she be healed [fr]om heaven, from this day and for ever, [swiftly and] do [not] tarry! Amen, Amen, Se[lah].

קומת[...] ותיתסי [מ]ן שמיה מן יומה דן ולעלם [בעגלא ולא] תעכבון אמן אמן ס[לה]

6. **wzʿyn**: "and they shake"; apparently a 3 p. masc. pl. act. ptc. from zʿy "shake" (compare Montgomery 1913, 152). The existence of this root appears to be further confirmed by the impv. **zʿy** (e.g. in MS 1927/9:8) and the 3 p. masc. pl. act. ptc. **zʿyn** (e.g. in JBA 116:8). On the other hand, the hitherto attested **zwʿ** "shake" (DJBA, 405) underlies the impv. **zwʿy** that occurs later in the present text (l. 7). This could suggest that having **zʿyn** for the expected **zyʿn** (compare JBA 99:18) reflects something akin to /zāyʿīn/ > /zāyīn/, i.e. with ʿayin being written but not pronounced. Finally, compare **zyʿyn** in JBA 93:6, which, being written by the same scribe for the same client, could suggest that **zʿyn** is simply missing a yodh. However, given that this biconsonantal root appears with both II-waw and reduplicated reflexes in Syriac (SL, 374, 390), the existence of a III-yodh reflex in JBA, in addition to the II-waw, would not be unexpected.
dʾytnwn: "where they are"; a contraction of **dʾyt ʾynwn**.

7. **myḥzk**: "when you see"; for the use of the infinitive without a preposition to express a temporal clause, see Nöldeke 1875, 388–389; Muraoka 2011, 106.

8. **wlʾ bnynh wlʾ bnykdh**: "and neither her child nor her grandchild" (compare l. 11); see the note to JBA 15:10.

9. **mytynʾ ʿlky dʿlk yqyr** "I will bring against you that which is dear to you"; we translate **yqyr** as "dear" because this phrase often contains the pair **yqyr/ḥbyb** "dear/loved" (e.g. JBA 99:21).
gbryn gnbyn: "thieving men"; see the introduction to 1.3.2.

10. **qwlyn**: "collars"; see the introduction to this section.

12. **qwmt[...]**: "[her] body"; perhaps read **qwmth** "her body". For **-ʾh** as 3 p. fem. sg. pron. suffix, see Morgenstern 2013, 40.

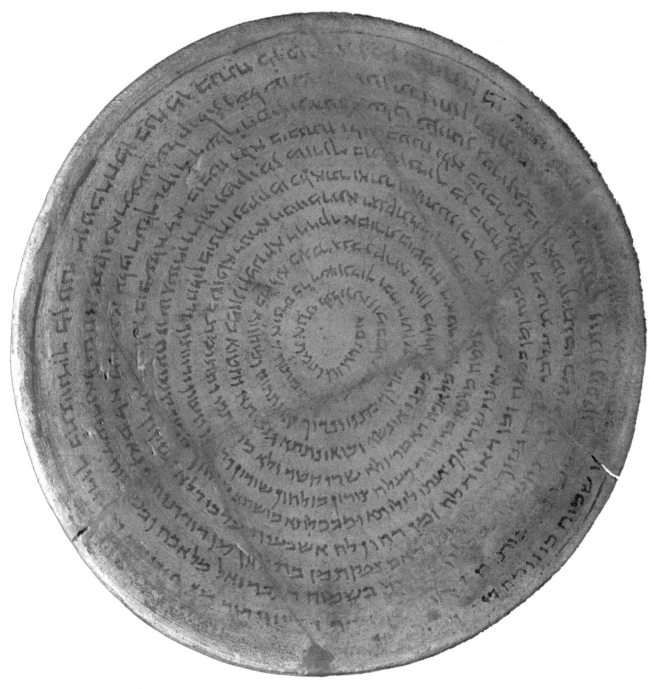

PHOTO 30 JBA 92 (MS 1927/54)

JBA 93 (MS 2053/15)

195 × 65 mm. Elegant semi-formal hand. The bowl was broken. It has been repaired, but is missing a large portion. The writing is partly faded. The text is surrounded by a circle.

Linguistic and orthographic features: Note 'tnwn for 'ytnwn (l. 7).

Clients: Undas son of Rašewanddukh; Māhdukh daughter of Nēwāndukh, his wife.

1 אסותא [מן שמיה תיהוי לה ל]מהדוך ב[ת‬ ניונדוך אסירת

[May there be] healing [from heaven for] Māhdukh [daugh]ter of Nēwāndukh. You are bound

2 וחתימת אנתי ליליתא ומבכלתא בישתא [דשריא] בב[י]ת[י]ה

and sealed, you, lilith and evil *mevakkalta* demon, [who dwells] in the ho[u]se

3 ד[או]נדאס בר רשיונדוך ויבדירתה דמהדוך בת ניונדוך אינתתיה ומיחזיא להון

of [U]ndas son of Rašewanddukh and in the dwelling of Māhdukh daughter of Nēwāndukh, his wife, and appears to them

4 בליליא כגבר גנב וקריא להון בליליא כ[ב]ני אינש[א] וכי אינתתא גנביתא וחטיא במזוני ומנזקא {.}

in the night like a thieving man, and calls to them in the night like [hu]man bein[gs] and like a thieving woman, and harms livelihood, and injures

5 דרדקי אסירת בשמיה דאסריאל מלאכה דאסר ול[א] שרי קטר ולא מישתרי וחתימת בשוטא דנורא ובחומרתא

children. You are bound by the name of the angel Asriel, who binds and it is no[t] loosed, (who) ties and it is not untied. And you are sealed by the whip of fire, and by the seal stone

6 [דג]נקת ליליתא ובעזקת שלמה מלכא בר דויד דעלה צירין כולהון שידין ודיוין וזיעין ורייתין ודחלין מיניה ונפקין

[of] the lilith [Ga]nnaqat, and by the signet-ring of King Solomon son of David, upon which are drawn all demons and *dēv*s, and they shake and tremble and are afraid of it, and they go out

7 מן כל אתר ואתר דאתנון מן כל אתר ואתר דאינו[ן] שרן אף אנתי לילי[ת]א ומבכלתא בישתא מיחזך [הדי]ן קמי[עה] זועי געורי ורותי ופוקי

from each and every place where they are, from each and every place where the[y] dwell. Also, you, lili]th and evil *mevakkalta* demon, when you see [thi]s amul[et], shake, be rebuked and tremble, and go out

8 from the house of Undas son of Rašewanddukh, from the doorway of Māhdu[kh daughter of Nēwāndukh ...] I [have put] you [under oa]th by the master of your treasure houses and the tufts of [your] hair, [that i]f you g[o] out from the doorway and from the threshold of the house

מן ביתיה דאונדס בר רשיונדוך מן פיתחה
דמהדו[ך בת ניונדוך ... אשב[ע]ית עלכי במרי
גנזיך וצוציתי[כי דא]ם נ[פ]קת מן פיתחה ומן
איסכופת ביתיה

9 of Undas son of Rašewanddukh, from the doorway and from the dwelling of Māhdukh daughter of Nēwān[dukh ...] you, that if you go out [from their house and from] their dwelling, it will be well. But if not, I will bring against you that which is dear to you,

דאונדס בר רשיונדוך מן פיתחה ומן דירתה
דמהדוך בת ניונ[דוך ...] עלכי דאם נפקת [מן
בתיהון ומן] דירתיהון מוטב ואם לא מיתינא עלכי
דעלך יקיר

10 that which is [power]ful to you. And I will bring against you sixty thieving m[e]n and they will bind you with chains of i[ron ... By the name of] the angel [Gabrie]l and by the name of ʿAzriel, [the strong and] mighty one who is appointed over collars and over chains. They,

דעלך [חסי]ן ומיתינא עלכי שיתין גב[רי]ן
גנבין ואסרין יתיכי בשושלן דב[רזל ...] בשמיה
דגבריא[ל מלאכה] ובשמיה דעזריאל [עזיזא
ו]תקיפא דממני על קולין ועל שושלן אינון

11 the two of them, the three of them, the four of them, will come and cause you to go forth from their house, from thei[r] dwelling [... Amen, A]men, Selah.

תרויהון תלתיהון ארבעתיהון יתון ויפקונכי מן
בתיהון מן דירתיהו[ן ... אמן א]מן סלה

4. Following **wmnzq'** "and injures", there is a stroke that may be the initial stroke of an *aleph*.

7. **d'tnwn:** "where they are"; a contraction of **d'yt 'ynwn**.
myḥzk: "when you see"; see the note to JBA 92:7.

10. **gbryn gnbyn:** "thieving men"; see the introduction to I.3.2.
qwlyn: "collars"; see the introduction to this section.

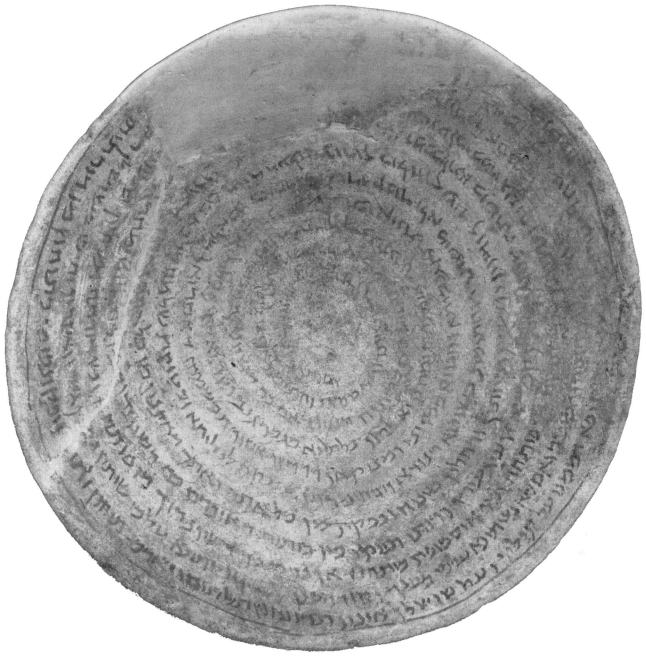

JBA 94 (MS 2053/51)

180×60 mm. Elegant semi-formal hand. The bowl was broken. It has been repaired, but is missing some portions. The writing is partly faded. The text is surrounded by a circle.

Linguistic and orthographic features: Note the loss of *ḥet* in **pyth** (l. 8; for **pytḥh**).

Client: Māhdukh daughter of Nēwāndukh.

1 אסירת וחת[ימת] ומחתמת

1 You are bound and sea[led] and double sealed

2 ומבטלת [אנ]תי ליליתא ומבכלתא ומשמתא ביש[תא]

2 and removed, [yo]u, lilith and *mevakkalta* demon and ev[il] ban demon,

3 דשריא בדירתה דמהדוך בת ניונדוך [...] וקריא

3 who dwells in the dwelling of Māhdukh daughter of Nēwāndukh [...] and calls

4 בליליא כי בני אינשא וכי אינתתא [גנביתא] וחטיא [...] אסיר[ת]

4 in the night like human beings and like a [thieving] woman, and harms [...] You [are bound]

5 [ב]שמיה דאסריאל מלאכא דאסר ולא שרי ק[טר ולא] מישתרי [...]

5 [by] the name of the angel Asriel, who binds and it is not loosed, (who) ti[es and] it is [not] untied [...]

6 [ד]גנקת ליליתא ובעזקת שלמה מלכא בר ד[ויד] ד[עלה צ]יר[]ן כולהון שידין ודיו[]ן [...]

6 [of] the lilith Gannaqat, and by the signet-ring of King Solomon son of Da[vid], upon [which] are dr[awn] all demons and *dēv*[s ...]

7 מין כול אתר ואתר דאיתנון מן כול אתר ואתר דאינון ש[רן אף] אנת[י ליל]יתא [ו]מבכלתא [ביש]תא מיחז[ד] הדין קמ[יע]א זועי

7 from each and every place where they are, from each and every place where they dw[ell. Also], yo[u, lil]ith [and evi]l *mevakkalta* demon, when [you] see this amu[let], shake,

8 גערי [...] מן פיתה דמהדוך בת ניונד[וך ...] מן פיתחה ומן דיר[תה] ומ[ן א]רבע סי[פי בבה] מן נינה ומ[ן נ]יכדה

8 be rebuked [...] from the doorway of Māhdukh daughter of Nēwānd[ukh ...] from her doorway and from [her] dwell[ing] and fr[om the f]our door[posts of her gate], from her child and fr[om] her [gra]ndchild,

9 ולא תנזקין לא [...] ולא במזונה ולא ב[...] אשבעית ע[לכי במרי] גנזיך וצוצ[י]תיכי דאם נפקת מין [בתיהון] מן

9 and do not harm neither [...] and neither her food nor [...] I have put [you] under oath [by the master of] your treasure houses and the tuf[t]s of your hair, that if you go out from [their house], from

10 their dwel[li]ng, from the threshold of their house, from the[ir] child, from [their] grandch[ild ...] that which is dear to you, that which is powerful to you. And I will [bri]ng [...] sixty thieving men and [th]ey will bin[d] you

מן [ז]דיו[ר]תיהון מן איסכופת בתיהון מן נינהו[ן]
[ינ]א ומ[ית] דהון ... [דעלך יקיר דעלך חסין ומ
יתיכי ואס[רי]ן גנבין גברין שיתין [...]

11 with chains of bronze and with shackles of iron and fetters of bronze [...]el, the strong and mighty one who is [ap]pointed [...] They, the two of them, the three [of] them, the fou[r] of them,

בשושלן דנחש ובכבלין דברזל ועיזקן דנחש
תרויהון אינון [...] דמ[מ]ני [...] אל עזיזא ותקיפא[...]
תלת[י]הון ארב[עת]יהון

12 [...] from their house, [from] their [dwelling], and [they] shall hand y[ou] over and you shall be deliv[ered ...]

[...] מן בתיהון [מן דירת]יהון וישלמ[ון ית כ]י[י]
ותתמס[רין ...]

7. **d'ytnwn:** "where they are"; a contraction of **d'yt 'ynwn**. **myḥzk:** "when you see"; see the note to JBA 92:7.

8. **pyth:** "her doorway"; a phonetic spelling of **pythh**. Compare the note to JBA 37:5 with the remarks of Morgenstern 2013, 40; we would no longer view **pyth** as an error. **mn nynh wmn nykdh:** "from her child and from her grandchild" (compare l. 10); see the note to JBA 15:10.

10. **gbryn gnbyn:** "thieving men"; see the introduction to I.3.2.

11. **ʿyzqn dnḥš:** "fetters of bronze"; compare PC 128:3–4, which reads: **w'sryn ytyky bšyšln dbrzl wkyblyn dynḥš bryglky w'sqyn ytyky w'yzqn dnḥš rmn bydky** "and they will bind you with chains of iron and shackles of bronze on your feet, and they will fetter you and cast fetters of bronze on your hands". Compare also Syr. **ʾrmyt ʾnwn bʿzqʾ** "I cast them in fetters" from the Aḥiqar legend (Conybeare et al. 1898, 66). Sokoloff (*SL*, 393) would emend **bʿzqʾ** to **bzqʾ** (following Fraenkel), but the bowls confirm the given spelling. See also the note to JBA 91:9.

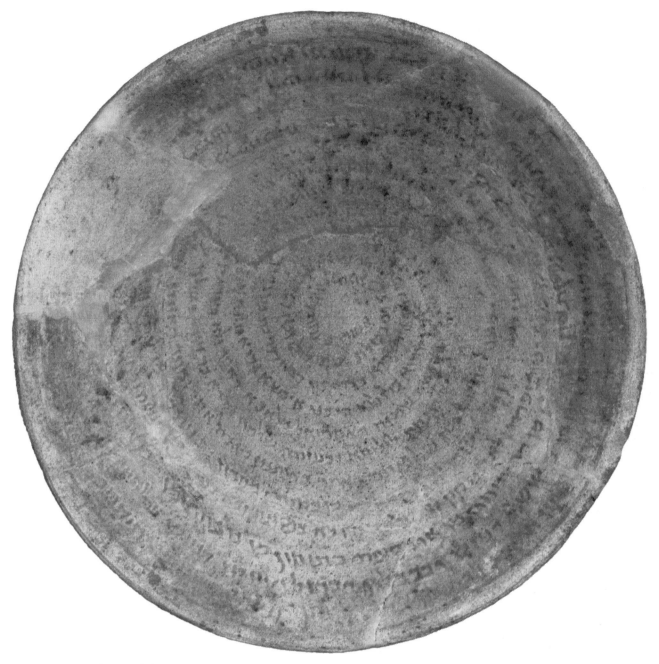

PHOTO 32 JBA 94 (MS 2053/51)

JBA 95 (MS 2053/69)

165 × 60 mm. Crude semi-formal hand. The bowl was broken. It has been repaired, but is missing some very small portions.

Linguistic and orthographic features: Note the use of –h rather than –yh for the 3 p. masc. sg. pron. suffix in **byth** (ll. 4, 5 and 7).

Client: Bayyazaddād son of Gušnay.

Biblical quotations: Ex 3:14; Ex 3:15; Is 40:31; Is 60:11; Gen 27:28 (TO).

ומזנן ומשגרין ורחמין זימתא וזנותא ובתחרי דמגנבא וזמרתא	1	and they act promiscuously, and they inflame with lust and love carnality and fornication, and the noblewoman who deceives, and the singing-girl
דמבזיא נפשה פוקו כולכון סטנין בישין ורוחין ולילין ודיוין ולילחנין	2	who shames herself. Go out, all of you, evil satans and spirits and lilis and *dēv*s and servitors
ופתכרין וכל איסתרתא וכל איכורתא ולוטניתא וכיסי ולוטתא ומזיקי וליליתא כולכון	3	and idol spirits and all goddesses and all shrine spirits and curse spirits and bonds and curse demons and tormentors and liliths, all of you,
פוקו ואתרכו כולכון מן ביתה דביזדד בר גושני ומן דירתהון ו{מן דירתהון {מן אינשי	4	go out and be divorced, all of you, from the house of Bayyazaddād son of Gušnay, and from their dwelling, and from the people of
ביתה תוב אסיריתון וחתימיתון ומסטמיתון בשוטא דנורא ובשירא דגנב ליליתא ובעיזקתא	5	his house. Again, you are bound and sealed and shackled by the whip of fire and by the ring of the lilith Gannav and by the signet-ring
דשלמה מלכא בר דויד דעלה צירין מלכי דשידי ומלכי דדיוי ומלכי דיפתכרי תוב אסירִיתון	6	of King Solomon son of David, upon which are drawn the kings of demons and the kings of *dēv*s and the kings of idol spirits. Again, you are bound
וחתימיתון כל חרשי בישי ומאבדי וכיסי וליליתא וקיבלי ולוטתא ופתכרי ופתכרת[א די]שרין בביתה	7	and sealed, all evil sorcery and magical acts and bonds and liliths and counter-charms and curse demons and male idol spirits and female idol spirit[s who] dwell in the house
דביזדד בר גושני בשמיה דאברחסיה רבא וקדישא מלך עלמא תוב אסיר[י]תון וחת[י]מי[תון] בשבעה	8	of Bayyazaddād son of Gušnay, by the name of the great and holy ʾbrḥsyh, the king of the world. Again, you are bound and seale[d] by seven

9 seals and by eig[h]t bonds. The fir[s]t seal (is that) of **nbyrwn**; the second, of **byrwn** son of 'yry; the third, of [']ybwl [so]n of **sygwl**; the fourth,

חתמין ובתמנ[י]ה אסרין חתמא קדמ[א]ה דינבירון תינינא דיבירון בר אירי תליתאה ד[א]יבול [ב]ר סיגול רביעאה

10 of ṣw[...]gy'; the fifth, of the mighty **bwrgwn**; the sixth, of **ṭwrmyn**; the seventh, of **ṭwrmys**. By the seal of the sun,

דצו[ן...]גיא חמישאה דבורגון תקיפא שתיתאה דטורמין שביעאה דטורמיס בחתמא דשימשא

11 and by the signet-ring of the moon. By the mystery of the ear[th], and by the great mystery of the sky. And by the signet-ring of El Shaddai, upon which they are drawn. And by the name of YHWH "I am", "YHWH

ובעיזקתא דסיהרא בראזה דאר[ע]ה וברזא {ד} רבא דרקיעה ובעיזקתה דאל שדי דעלה צירין ובשום יהוה אהיה יהוה

12 Sabaoth is his name". He is "I am that I am". "This is my name [for] ever, and this is my memorial unto all generati[o]ns". "But those who wait upon YHWH shall re[new] their strength; they shall mount up with w[in]gs as eagles; they shall run and not be weary; [they] shall walk [and] not

צבאות שמו הוא אהיה אשר אהיה זה שמי [ל]עולם וזה זיכרי לדור ד[ו]ר וקווי יהוה יח[ליפו] כח יעלו א[י]ב[ר] כנשרים ירוצו ולא יגעו ילכ[ו ו]לא

13 faint". And open (your) hand to Bayyazaddād son of Gušnay, ga[t]es of livelihood,

יעפו ויד פתח לביזדד בר גושני ש[ע]רי מזונה

The text continues on the outside:

14 as it is said: "Your gates shall be open continually, day and night, and [they] shall not be clos[ed], to bring to you", "of the dew o[f] the [sky], of the choice produce of the earth, a mul[titu]de of

שנאמר פיתחו שעריך תמיד {יום} יומם ולילא ולא יסגי[רון] להביאל[י]ך מיטלא ד[ירקיע]א מטובה דארעה ס[גי]ות

15 grain (and) wine". Amen, Amen, Selah, Hallelujah.

עיבר חמר אמן אמן סלה הללויה

1. **wmšgryn**: "and they inflame with lust"; the scribe appears to have initially written a *gimel* following the *mem*, but then corrected it to *šin*.

3. **lwṭnyt' wkysy**: "curse spirits and bonds". The first term, **lwṭnyt'**, derives from **lwṭṭ'** "curse, curse demon", which also occurs in the same line, with the addition of the suffix **-nyt'** (for which, see Morgenstern and Ford 2017, 221–223); compare **ṭwlnyt'** "shadow demon" < **ṭwl'** "shade,

shadow" + **-nyt'** (*DJBA*, 505). The second term, **kysy**, may derive from Akk. *kīsu* "bond, fetter" (*CAD* K, 432–433; *DJBA*, 576), hence the given translation.

4. **'trkw**: "be divorced"; in JBA, the root TRK is best attested in the *pa.* and *itpa.* stems. The form **'ytrykw** in JBA 98:11, however, suggests that **'trkw** may be a defectively spelled *itpe.* form. For the *itpe.* of TRK, see Jastrow 1950, 1699. For the *pe.* pass. ptc. in JBA, see *DJBA*, 1234.

byzdd br gwšny: "Bayyazaddād son of Gušnay"; see the introduction to **I.3.1**.

wmn dyrthwn w{mn dyrthwn} mn 'ynšy: "and from their dwelling, and from the people of"; for the second conjunction not being superfluous, compare JBA 98:12.

5. **wbšyrʾ:** "and by the ring"; see the introduction to this section.

7. **wmʾbdy:** "and magical acts"; a phonetic spelling of **wmʿbdy** (compare, e.g., JBA 54:5). See JBA 98:13 and JBA 101:14, which read **wmbdy**, i.e. with a complete loss of the original *ʿayin*.

9. **ʾybwl:** the *lamedh* appears to be a correction from another letter. Its distinctive upper part is clear, but the base resembles more a *kaph* or *samekh*.

11. **dʿlh ṣyryn:** "upon which they are drawn"; as it stands, the text could be suggesting that the preceding mysteries are drawn on the signet-ring of El Shaddai. This is unlikely, however, as the parallels simply read **rbʾ**, i.e. "the signet-ring of the great El Shaddai" (compare JBA 65:6 and JBA 98:16). It would appear, therefore, that the scribe has erred, perhaps under the influence of the reference to the signet-ring of Solomon (ll. 5–6).

11–12. E.g. Is 47:4 (this phrase occurs thirteen times in the Bible).

12. Ex 3:14.
 Ex 3:15.

12–13. Is 40:31.

13. **wyd ptḥ ... šʿry mzwnh:** "And open (your) hand ... gates of livelihood"; we would expect something like **wyd ptḥw ... lymzwny** "And open (your) hand ... for livelihood" (e.g. JBA 65:8). It is possible that the scribe has conflated **wyd ptḥ** with something like **ptḥ šʿry mzwnh** "open gates of livelihood".

14. Is 60:11.
 wlylyʾ: "and night"; it appears that MT **wlylh** (Heb.) has been replaced with Aram. **wlylyʾ** (see also JBA 65:9).
 Note **wlʾ** for MT **lʾ**.
 Note **lhbyʾlyk:** a *sandhi* spelling for MT **lhbyʾ ʾlyk** (see also JBA 98:18).

14–15. Gen 27:28 (TO).

15. **hllwyh:** "Hallelujah"; the *waw* and *yodh* are written very close to each other, and thus appear as a single thick stroke.

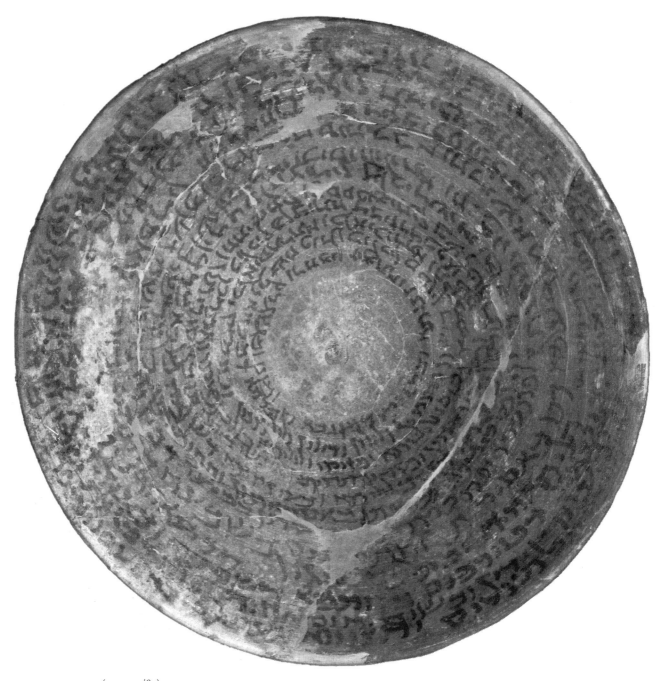

PHOTO 33 JBA 95 (MS 2053/69)

PHOTO 34 JBA 95 (MS 2053/69)—exterior a

PHOTO 35 JBA 95 (MS 2053/69)—exterior b

PHOTO 36 JBA 95 (MS 2053/69)—exterior c

PHOTO 37 JBA 95 (MS 2053/69)—exterior d

PHOTO 38 JBA 95 (MS 2053/69)—exterior e

PHOTO 39 JBA 95 (MS 2053/69)—exterior f

PHOTO 40 JBA 95 (MS 2053/69)—exterior g

PHOTO 41 JBA 95 (MS 2053/69)—exterior h

JBA 96 (MS 2053/94)

175 × 65 mm. Semi-formal hand. The writing is partly faded, especially towards the rim. The last three lines are mostly illegible; no meaningful transcription or translation can be proposed. The text is surrounded by a circle.

Client: Mākhusrō son of Mādukh.

Image: In the centre of the bowl, there are two figures. One is a frontal, standing hybrid creature that resembles the image in JBA 73, and could thus represent a male *Pazuzu* demon. He has two sharp horns protruding from his head, between which is a pointed head-covering. The head is oval shaped, with two big eyes, each of which loops from the outside towards the centre of the face, and within which are circles that indicate the pupils. A line between the eyes indicates the nose, below which are two horizontal lines that may indicate the mouth and chin. He is wearing a short tunic. The other is standing in profile, facing the frontal figure, and appears to be a human female, judging by the narrowing at her waist. She is wearing a long dress and some kind of headdress with bands flowing behind her head. Her face includes simply one dot to indicate her eye, and five fingers are indicated for her hand. The necks of both figures are bound together by a rope that descends beside the frontal figure.

FIGURE 16: Artist's impression of image from JBA 96

1 אסיריתון וחתימיתון כל פתכרי דיכרי כולהון ומרברב'הון ועד ד[...]יהון מיעולמיהון

1 You are bound and sealed, all male idol spirits, all of them, and from their adults and to their ch[ildren], from their young ones

2 ועד סביהון דיתבין בג בקיני קיני דיתבין תלי תילי דיתבין בפקעתא ביקעתא דעויר על בני אינשא דעויר

2 and to their old ones, who dwell in various nests, who dwell (in) various mounds, who dwell in various valleys, who haunt (!) human beings, who haunt (!)

3 על בני אינשא ורחמין בת חרי ונקטין נשי ברביתא וזמרתא דימ[ג]נבא נפשה א[סירת] וחתימת חתימא ומחת[מ]א[...]

3 human beings, and love the noblewoman, and seize women in a lying position, and the singing-girl who de[c]eives herself. [You are] bo[und] and sealed. Sealed and double sea[l]ed [...]

4 [...] שלומה מלכה בר דויד דעלה צירין כל מלאכיא שידיא ופתכריא דכולהון דחלין [...]

4 [...] King Solomon son of David, upon which are drawn all angels, demons, and idol spirits, all of whom are afraid [...]

5 [...] Mākhus[rō] son of Mādukh. Do not harm, not him, not his wife, neither his so[ns] nor his dau[gh]ters, and nei[ther his] cat[tle ...]

[...] מאכוס[רו] בר מדוך לא תיחטון לא ליה
לא לאינתתיה לא בב[ני]ה ולא בב[נ]תיה ול[א]
בבע]יריה [...]

6 [... and] I [will bring] against you sixty m[e]n, they will bind you with collars and chains of iron. Amen, Amen, Selah [...]

[... ומיתי]נא עלך שיתין ג[ב]רין אסרין יתיכי
בקולין ושושלין דברזל אמן אמן סלה [...]

7 [... Mā]khusrō son of Mādukh [...]

[...] מא[כוסרו בר מדוך [...]

8 [...] [...]

9 [...] [...]

1. **d[...]yhwn**: "their children"; the reading is uncertain, but the meaning is beyond doubt (cf. JBA 25:5).

2. **bg bqyny qyny**: "in various nests"; **bg** is a false start for what follows, showing perhaps an inadvertent voicing of *qoph*.
bpqʿtʾ byqʿtʾ: "in various valleys"; for the devoicing of *beth* to *pe* in **pqʿtʾ**, cf. the JBA variant **pqtʾ** (*DJBA*, 927), as well as Mand. **paqata** (*MD*, 362) and Syr. **pqʿtʾ** (*SL*, 1224).

2–3. **dʿwyr ʿl bny ʾynšʾ dʿwyr ʿl bny ʾynšʾ**: "who haunt (!) human beings, who haunt (!) human beings"; in both cases, **ʿwyr** appears to be an error for **šrn** (cf. JBA 99:14). The error may have been caused by the scribe confusing *šin* with *ʿayin-waw*.

3. **wrḥmyn... npšh**: "and love ... herself"; the passage is corrupt (cf. JBA 95:1–2 and JBA 99:14–15). A similarly corrupt version, written by a different scribe, appears in JNF 45:5. The version here appears to conflate two phrases, e.g. **bt ḥryn dmgnbʾ wzmrtʾ dmbzyʾ npšh** "the noblewoman who deceives and the singing-girl who shames herself" (JBA 99:15).

6. **qwlyn**: "collars"; see the introduction to this section.

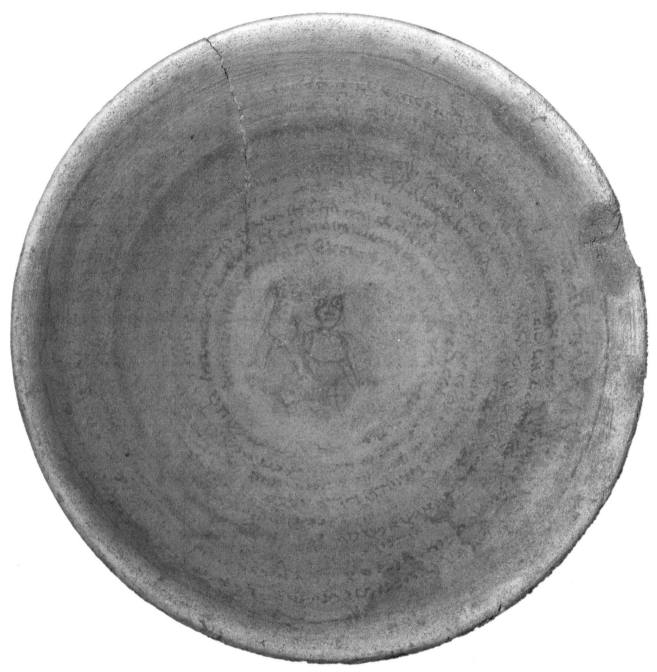

PHOTO 42 JBA 96 (MS 2053/94)

JBA 97 (MS 2053/104)

150×58 mm. Semi-formal hand. The writing is mostly faded. The text is surrounded by a circle.

Linguistic and orthographic features: Note the loss of 'aleph in **dyt** (l. 2; for **d'yt**).

Clients: Šakarōy daughter of Mihranāhīd.

1 [...] מומינא ליכי ומשבענא ליכי [...]
1 I adjure you and I put you under oath [...]

2 [...] דית בגו ביתה דשכרוי [ב]ת מיהר[נ]היד [...]תא
2 [...] who is within the house of Šakarōy [daugh]ter of Mihra[nā]hīd [...]

3 טמיתא ומיתחזית לה[ו]ן בחיל[מא ...]
3 unclean [...] and you appear to th[e]m by dre[am ...]

4 [...] הוא אסר ולא שרי הוא קט[ר]
4 [...] he binds and it is not loosed, he tie[s]

5 [ולא] מי[שתרי ...] שיתין ושית חומרין ובעי[זקתא]
5 [and] it is [not untied ...] sixty-six amulet spirits, and by the sig[net-ring]

6 [...]
6 [...]

7 [... שכרוי בת מי]הרנהיד ולא תתחזין להון ל[...]
7 [... Šakarōy daughter of Mi]hranāhīd, and you shall not appear to them [...]

8 [...] אמן [...] ססססססס [...]
8 [...] Amen [...] sssssss [...]

8. sssssss: The letter *samekh* is possibly an abbreviation of slh "Selah". A similar sequence occurs, for example, in JBA 88:5 and MS 1927/44:5; see also the bowl edited in Gorea 2003, 86, and reedited in Ford 2012, 219 (n. 8).

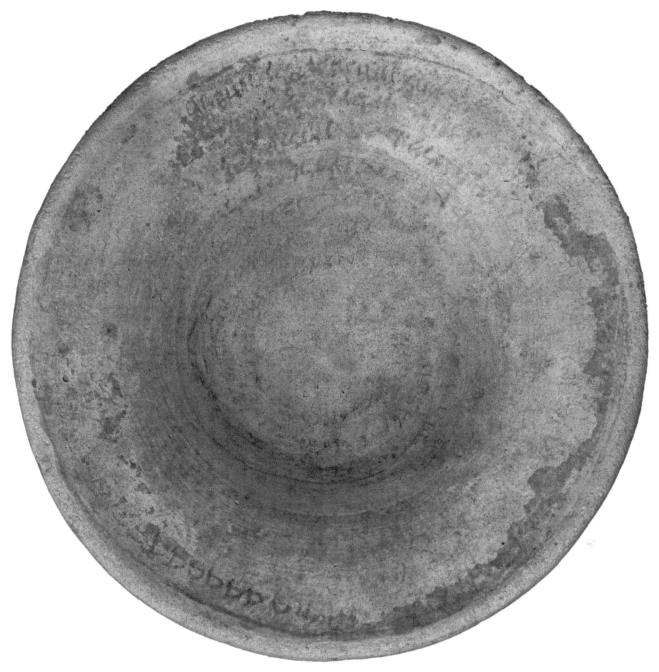

PHOTO 43 JBA 97 (MS 2053/104)

JBA 98 (MS 2053/140)

165 × 80 mm. Semi-formal hand. The bowl was broken. It has been repaired, but is missing one small portion at the rim, and the repairs occasionally obscure the text. The text is badly faded towards the centre.

Clients: Arday son of Ḥubbay; Zəvīntā daughter of Baṭ-sāhdē, his wife.

Biblical quotations: Ex 3:14; Ex 3:15; Is 40:31; Is 60:11; Gen 27:28 (TO).

[...]	1	[...]
[...] ולילי‍תא [...]	2	[...] and liliths [...]
[ו]‍[...]שי וטול[נ]‍ית[א]	3	[...] and [...] and shadow [de]mon[s]
[...] כל מזיק[י ...] בישתא וחו[מ]‍ר[י] זיד[ני]‍תא [בן] דיכר[א]	4	[...] all tormentor[s ...] evil [...] and wic[k]ed amu[let] spirit[s, whether] mal[e]
[וב]‍ן ניק[ב]‍ת[א ...]‍ביתיה דארדי בר ח[ו]‍ב[א]‍י ודזבי[נ]‍תא בת	5	[o]r fem[a]l[e ...] the house of Arday son of Ḥ[u]bba[y], and of Zəvī]ntā daughter of
ב[תש]‍הדי אינת[תי]‍ה דמ[י]‍תחזין לה[ו]‍ן בחילמא סניא [...]‍א תיתרחקון ותבטלון מן [...]	6	Ba[ṭ-sā]hdē, [h]is wif[e], who a[ppear] to th[e]m in an unsavory dream [...] you may be far away and cease from [...]
[...] בתיהון ומן זר[עי]‍ה דארד[י] ב[ר]‍ חו[ב]‍י ומן זרעה דז[בי]‍נתא בת בתשהדי אינתתיה תוב [אסיריתון] וח[תימי]‍תון	7	[...] their house, and from the se[e]d of Arda[y] son of Ḥu[bba]y, and from the seed of Zə[vī]ntā daughter of Baṭ-sāhdē, his wife. Again, you [are bound] and se[aled],
שידי כולכון ודיוי כו[ל]‍[כ]‍ון ופת[כרי כ]‍[ו]‍[ל]‍כון ולילי‍תא כול‍[כ]‍[ו]‍ן מ[ע]‍[ו]‍[ל]‍[י]‍מ[י]‍כון] ועד סביכון מירברביכ[ו]‍ן ו[עד זעיריכון מ[י]‍דכר [ו]‍עד	8	demons, all of you, and dēvs, al[l of] y[ou, and idol] spirits, a[l]l of [you,] and liliths, all of y[ou, fr]om you[r] yo[u]ng [one]s and to your old ones, from yo[ur] adults [and] to your young, fr[om] male [and] to
[ניק]‍בא מיעבדא ועד ברחרי [...] בתילי תילי באיכור[י] איכור[י] בבק[עתא ב]‍קעתא ...]	9	[fema]le, from the servant and to the nobleman [...] in various mounds, in variou[s] shrine[s, in var]ious val[leys ...]
[ע]‍ל איסקופתא ודשלטין ביבני א[י]‍[נ]‍ש[א] [...] וקטלין נשי [ג]‍ברי [ד]‍[ר]‍[ד]‍קי ודרד[קת]‍א מזנין ומשגריין ורחמין זימתא וזנ[ו]‍תא [ב]‍תחרי דימ[ג]‍ב[]‍א וזמרתא די[מבזיא	10	[up]on thresholds, and who have power over human b[e]in[g]s [...] and kill women, [m]en, [b]o[ys] and gi[rl]s. They act promiscuously, and they inflame with lust and love carnality and forni[ca]tion, the [no]blewoman who [decei]ves, [and the singing-girl who] shames

11 [her]se[lf.] Go out, all of you, e[vil] satans [...] evil idol spirits and lilis and *dēv*s and servitors and wick[e]d amu[le]t spirits and all shrine spirits and shadow demons and bonds and [...] and curs[e demons,] all of yo[u, go out and] be divorce[d,]

12 from the house of Arday son of [Ḥ]ubbay and of Zəvīn[tā] daughter of [Ba]t̠-sāhdē, his wife, from their house, and from their dwelling, and from the [peo]ple of th[eir] house, and from their possessions, and from their grain, and from their food. Again, you are bound [and] sealed

13 [by the whip] of fire and by the ring of the lilith Gannav [and] by the signet-ring of King Solomon son of David, upon which are drawn the kings of de[mons] and the kings of *dē*[*v*]s and the ki[n]gs of idol spirits. Again, y[o]u are bound and sealed, e[v]i[l] sorcer[y] and magical acts and bond[s]

14 and liliths and curse demons and female idol spirits, that you shall not [...] in the house of Arday son of Ḥubbay and of Zəvīntā daughter of Bat̠-sāhdē, his w[i]f[e], b[y] the name of the holy (and) great **'brḥsyh**, the king of the world. Again, you are bound [and] sealed by sev[e]n

15 s[e]als and by eight bonds. The [first] seal, [...]; the second, of **nbwryn** son of **'yry**; the third, of **'ybwl** so[n of ...]; the fourth, of **ṣwrbn nwr bwzyṭ gy'**; the fifth, of the mighty (!) **bwrgwn**; the six[t]h, of **ṭwrms**;

16 the seve[n]th, of **ṭwrmys**. By the seal of the sun, and [by] the signet-ri[ng of] the [mo]on. By the mystery of the earth, and by the great base of [the] s[ky]. By the name of [the signet]-ri[ng] of the great El Shaddai. And by the name of "I am", YHWH, "YHWH Sabaoth is his name". He is "I am that

17 I am". ["Th]is is my name for ever, and this is my memorial unto all generations". "But [those who] wa[it upon] YHWH [shall re]new their strength; they shall mount up with wings as eagles; they shall run and not be weary; they shall walk and not fai[nt". And open (your) hand] to th[em,] to Arday son of Ḥubbay and to Zəvīntā daughter of Baṯ-sāhdē, his wife, for livelihood, as it is said: "Your gates

18 shall be open continually, d[a]y and night, and they shall not be closed, to bring to you", "of the dew of the sky, of the choice produce of the earth, a multitude of grain and wine". Amen, A[men ...]

אהיה [ז]ה שמי לעלם וזה זכרי לדר דר וק[וי] 17
יהוה [יח]ליפ[ו] כוח יעלו איבר כנשרים ירוצו
ולא יגעו ילכו ולא ייע[פו ויד פתח [לה]ון] לארדי
בר חובי ולזבינתא בת בתשהדי אינתתיה למיזני
שנאמר פיתחו

שעריך תמיד י[ו]מם ולילה ולא יסגירו להביאליך 18
מיטלא דרקיעא ומיטובה דארעה סגיות עיבור
וחמר אמן א[מן ...]

10. **wmšgryyn**: "and they inflame with lust", for **wmšgryn** (cf. JBA 99:14).
wkysy: "and bonds"; see the note to JBA 95:3.

11. **w'ytrykw**: "and be divorced"; see the note to JBA 95:4.

13. **wbšyr'**: "and by the ring"; see the introduction to this section.
wmbdy: "and magical acts"; for **wm'bdy** (cf, e.g., JBA 54:5) with loss of ʿayin (see also the note to JBA 95:7).

15. **'yśryn**: "bonds"; a hypercorrection for **'ysryn** (cf. JBA 95:9). For the use of śin, compare the archaic spelling of the client's matronymic **btśhdy**. For the use of ʿayin for historic ʾaleph, compare the loss of ʿayin in **mbdy** (l. 13), and the writing of **rbyʿh** for **rbyᵒh** in this line.

tqym'h: probably a graphic corruption of **tqyp'** "mighty" (cf. JBA 95:10). The same reading occurs in JBA 101:15.

16. E.g. Is 47:4 (this phrase occurs thirteen times in the Bible).

16–17. Ex 3:14.

17. Ex 3:15; Is 40:31.
lmyzny: "for livelihood"; for **lymzwny** (cf. JBA 65:8).

17–18. Is 60:11.
Note **wl'** for MT **l'**.
Note **lhby'lyk**: a sandhi spelling for MT **lhby' 'lyk** (see also JBA 95:14).

18. Gen 27:28 (TO).

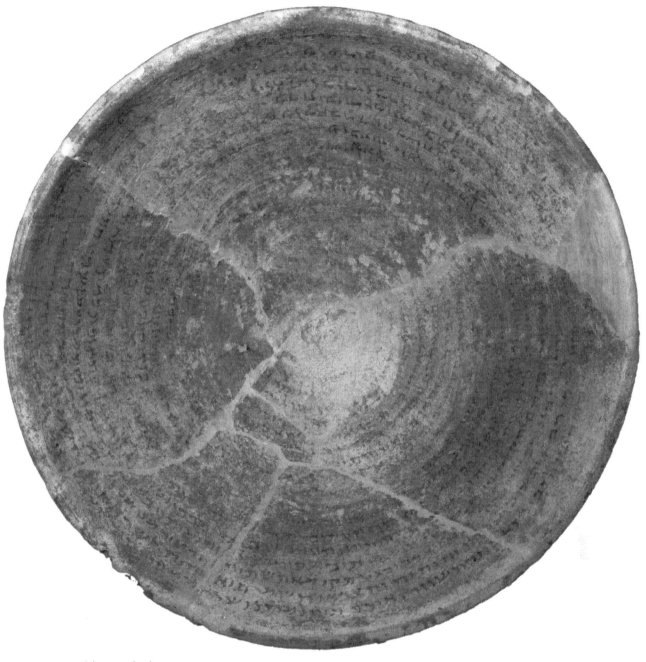

PHOTO 44 JBA 98 (MS 2053/140)

JBA 99 (MS 2053/173)

146 × 55 mm. Semi-formal hand. The text is surrounded by a circle. Two words are in a cartouche.

Linguistic and orthographic features: Note the use of –h rather than –yh for the 3 p. masc. sg. pron. suffix in **byth** (l. 4). Note also the loss of the unaccented final long vowel in **pwq** (l. 20; for **pwqw**).

Client: Barānay son of Ḥubbay; Bat-ḥapšabbā daughter of Immā, his wife.

Image: On one side of the bowl, running parallel to the rim within the text, there is a standing creature with a long body and two hen-like feet, each with three toes. The head is small and drawn with one line. It has two dots for eyes and six short lines for hair, and perhaps a seventh curled strand. The image interrupts ll. 12–15 of the main text, contains four lines of text (ll. 24–27), and has another two lines written alongside and beneath it (ll. 28–29).

FIGURE 17: Artist's impression of image from JBA 99

1 אסותא מישמיא תיהוי ליה לברני — May there be healing from heaven for Barānay

2 בר חובאי ולבתחפשבא אינתתיה בת אימא — son of Ḥubbay, and for Bat-ḥapšabbā, his wife, daughter of Immā.

3 ויתסון ברחמי ‹שמיא› מן כל מידעם ביש אמן אמן סלה הדין — And may they be healed by the mercy of ⟨heaven⟩ from every evil thing. Amen, Amen, Selah. This

4 קמיעה והדין אסרא והדין רזא להדין ביתה דהדין ברנאי בר חובאי — amulet and this charm and this mystery is for this house of this Barānay son of Ḥubbay,

5 ולהדא דירתה דבתחפשבא אינתתיה בת אימא דאית ביה פתכרא או פתכרתא — and for this dwelling of Bat-ḥapšabbā, his wife, daughter of Immā, in which there is a male idol spirit or a female idol spirit,

6 או ליליתא או סטנא או שידא או שיבטא או דיוא או שיבטא בישא או זכיא או ברמות — or a lilith or a satan, or a demon or an affliction, or a *dēv* or an evil affliction, or a *zakya* or a one-condemned-to-death,

7 or a *worodaq* or any evil thing. This is the breaking of male idol spirits and of female idol spirits, of demons, of *dēv*s, of afflictions, of the *zakya*,

8 of the one-condemned-to-death, and of the *worodaq*, and of evil liliths, and of evil dreams, and of the evil eye. And if you do not accept this adjuration, I will bring

9 against you, I will open against you doorways, I will cast against you troops, I will cast against you **dwknyn**, I will render judgment (?) against you **dwknyn**, I will boil against you

10 bowls. I put you under oath by the name of the holy and great angels of the house of majesty. I say to **srby sm' slmsws**: "Place these evil

11 wounds, all of them, upon the loins and upon the head of the demon, of the affliction, of the *dēv*, of the satan, of the male idol spirit, and of the female idol spirit, of the *zakya*, of the one-condemned-to-death, and of the *worodaq*, and of the liliths,

12 and of the evil eye, who hear but do not accept". Amen, Amen, Selah. You are bound and sealed, all idol spirits, all of them, and all

13 liliths, all of them, and all tormentors, all of them, from their adults and to their children, from their young ones and to their old ones, who dwell (in) various nests, who dwell

14 in various mounds, who dwell in various date palm trees, who dwell in various valleys, who haunt human beings. They seize women in a lying position, and arouse

15 and inflame with lust and seduce. They love carnality and fornication. They love the noblewoman who deceives and the singing-girl who shames herself. You are bound and sealed,

16 אתון או פתכרי או פתכרתא או שידי או דיוי או לילתא או עינא בישתא או כל מידעם ביש או זכיא או ורודק בשוטא דנורא ובחומרתא דגנבת לילתא	16 you, whether male idol spirits, or female idol spirits, or demons, or *dēv*s, or liliths, or the evil eye, or any evil thing, or the *zakya*, or the *worodaq*, by the whip of fire, and by the seal stone of the lilith Gannavat,
17 דהיא ריש שיתין ושית חומרין אסירת וחתימת אנתא כל מידעם ביש {דמי} דשמיהון מפרש לעילא או פתכרא או לילתא וחתימא כולה קומתך בלבושך בההיא עיזיקתא דשלמה מלכה	17 who is head of sixty-six amulet spirits. You are bound and sealed, you, every evil thing, whose name is specified above, whether the idol spirit or the lilith, and your whole body is sealed in your garment by that signet-ring of King Solomon
18 בר דויד דעלה צירין כולהון {מלא} מלאכיא ושידיא ופתכריא ולילי ולילתא וזיעין ודחלין וריתין מיניה ונפקין מן כל אתר דאיתנון ומן כל אתר דאינון שרן ביה אף אתון פתכרא או לילתא	18 son of David, upon which are drawn all angels and demons and idol spirits and lilis and liliths, and they shake and are afraid and tremble from it, and they go out from every place where they are, and from every place in which they dwell. Also, you, idol spirit, or lilith,
19 או כל מידעם ביש זועו ועיטרו ופוקו מן ביתיה דברני דן בר חובאי ומן דירתה דבתחפשבא אינתתיה בת אימא ולא תניקו לא להון ולא לבניהון ולא לזרעיהון דליליא ולא לפירהון דיממא	19 or any evil thing, shake and go away and go out from the house of this Barānay son of Ḥubbay, and from the dwelling of Baṯ-ḥapšabbā, his wife, daughter of Immā, and do not harm, neither them nor their children, and neither their seed of the night nor their fruit of the day,
20 ולא תיחטון לא ביבעיריהון ולא בימ[זונ]הון אשבעית עליכון במרי גנזיכון וצוציתכון באלהכון ובמלכותכון את זכיא וכל מ[י]דעם ביש אם תיפקון תיחדון ואם לא מיתינא עליכון חביבין	20 and do not harm, neither their cattle nor their liveliho[od]. I have put you under oath by the master of your treasure houses and the tufts of your hair, by your god and by your kingdom, you, *zakya*, and any evil th[i]ng, go out. If you go out, you shall rejoice. But if not, I will bring against you those who are loved by you,
21 ועליכון יקירין ועלי כבירין ועליכון חביבין ועלי יקירין מיתינא עליכון שיתין גברין גיברין וירמון יתכון בקולין ובריעין דיברזל על איבריכון בשמיה דגבריאל ובכבלין דינחש על איבריכון בשמיה דעזיזאל	21 and are dear to you, and are great to me, and are loved by you, and are dear to me. I will bring against you sixty mighty men, and they will cast you into collars and into bonds of iron upon your limbs, by the name of Gabriel, and into shackles of bronze upon your limbs, by the name of the ʿAziziel,
22 עזיזא ותקיפא דהוא ממני על כבלין וסוסטמין דיפרזל אינון תרוין תליתהון וארבעתיהון	22 the strong and mighty one who is appointed over shackles and fetters

וחמישתיהון אינון יתון ויפקון יתכון מ[ן] ביתי[ה] ומן פגריה דברני דנן בר חובאי ומן דירתה ומן פגרה דבתחפשבא אינתתיה

of iron. They, the two of them, the three of them, and the four of them, and the five of them, they will come and cause you to go forth fr[om] the house and from the body of this Barānay son of Ḥubbay, and from the dwelling and from the body of Baṯ-ḥapšabbā, his wife,

23 בת אימא וישלמון יתכון לידי ותיתמסרון קבלי

23 daughter of Immā, and they will hand you over into my hand and you will be surrendered before me.

Inside the drawing:

24 נשבו בינים הימון ובר

24 **nšbw bynym hymwn** and the son of

25 אלהין קטלין קטלא

25 God, they kill the killing.

26 צצצצ

26 **ṣṣṣṣ**

27 (*magic characters*)

27 (*magic characters*)

Alongside the drawing:

28 אנה אסרית בכבלין דיפרזל

28 I have bound with shackles of iron

Beneath the drawing:

29 בריגלך

29 on your feet.

3. **brḥmy ⟨šmy'⟩**: "by the mercy of ⟨heaven⟩"; the missing word is restored in accordance with the duplicate M 15.

8–10. **mytyn'... qwlyn**: "I will bring ... bowls"; the reading of this passage is certain, but the meaning is not entirely clear. The initial clause, **mytyn' 'lykwn** "I will bring against you", appears to be missing its direct object—the same reading occurs in M 15. The first use of the term **dwknyn** should probably be amended to **rkwbyn** "riders" in accordance with M 15:8–9, thus paralleling the earlier **gysyn** "troops". Both the present text and M 15 share the reading **psyqn' 'lykwn dwknyn**, but its interpretation is uncertain. The apparent reference in the final clause to boiling bowls, coupled with the earlier references to troops and riders, brings to mind M 145:3–5, which reads: **kd dywy npq lyqrb' wlylyt' npq lymnwby' dl plg' dšydy wmrkbt' rbt' dltby wdl gwd' ddywy wkl' rbt' dlylyt'... tpy dwdy brwgz' tpy dwdy rrby dḥbwl'** "when the *dēvs* went out to battle and the liliths went out for wailing, the phalanx of demons and the chariot contingent of the no-good-ones were in commotion, the troop of *dēvs* and the great assembly of the liliths were in commotion ... the cauldrons seethed with wrath, the great cauldrons of destruction seethed" (for **mnwby'** "wailing", see Morgenstern and Ford 2017, 207–208).

11. **wdyptkt'**: for **wdyptkrt'**.

15. **wmsṭnyn**: "and seduce"; for this meaning, see Jastrow 1950, 973.

19. **w'yṭrw**: "and go away"; for this verb, see Morgenstern 2013, 48, and the note to JBA 30:12.

21. **kbyryn**: "are great"; cf. Mand. **kabir** "great, mighty" (*MD*, 195, which gives the example **maṣbuta iaqirta ukabirta** "precious and great baptism").
qwlyn: "collars"; see the introduction to this section.
ry'yn: "bonds"; see the introduction to this section.

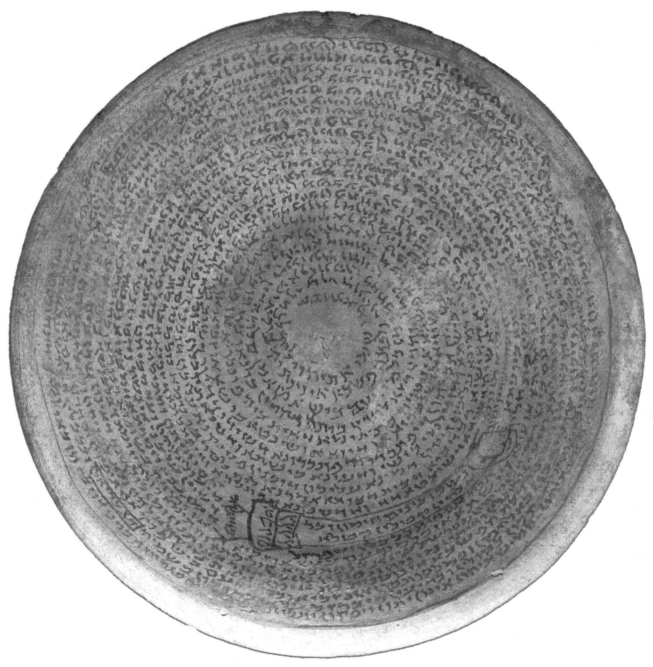

PHOTO 45 JBA 99 (MS 2053/173)

JBA 100 (MS 2053/211)

160 × 65 mm. Semi-formal hand. The writing is badly faded in parts, especially in the centre, resulting in the loss of an unknown number of lines at the beginning of the text. The text is surrounded by a circle.

Linguistic and orthographic features: Note that the negative particle l' is written l- in **lbzr'yhwn** (l. 5).

Clients: Gaddānā son of Ḥāṯōy; Qāqay daughter of Miriam, his wife.

[...]	1	[...]
[דאסר ולא] שרי וקטר ולא מ[...]	2	[who binds and] it is [not] loosed and ties and it is not [...]
ובעיזקתיה דשלמא מלכא בר ד[וי]ד ד[עלה] ציר[ין ...] שיד[י]ן וד[י]וי וסטני ולטב[י ...]	3	and by the signet-ring of King Solomon son of Da[vi]d, [upon] which [are] drawn [...] demon[s] and d[ēv]s and satans and no-good one[s ...]
[...] מן כל אתר דאינון שרן ביה אף אנתי לילית בישתא במיחזיכי הד[י]ן כסא רותי ואיסתלקי ופוקי מין [בי]תיה [ומן דירתיה ד]הדין גדנא	4	[...] from every place in which they dwell. Also, you, evil lilith, when you see th[i]s bowl, tremble, and depart, and go out from the [hou]se [and from the dwelling of] this Gaddānā
בר חאתו[י] מן כל אתר דשרית ביה ותוב לא תיתחזן לה לקאקא[י] א[י]תי[ה] בת מרים לא בח[י]למא דליליא ולא בשחרתא דיממא ולא תיח[טן] לב[ז]רע[יהו]ן [דימ]מא ולא בפיריהון	5	son of Ḥāṯō[y], from every place in which you dwell, and you shall not appear any more to Qāqa[y], hi[s] w[i]fe, daughter of Miriam, neither [by dr]eam of night nor by slumber of day, and do not ha[rm], neither [the]ir [s]eed [of the d]ay nor their fruit
דליליא ולא [תיח]טן לא בבעירהון ולא במזוניהון ול[א] בקיניניהון ולא בכל אינ[ש]י בי[ת]י[הו]ן לא בל[י]ל[י]א ולא בימא מיטול דאשבעית עלך במרגיניך ויצרעתך דאם נפקת מן ביתיה	6	of the night, and [do] not [ha]rm, neither their cattle nor their livelihood, nei[th]er their possessions nor all the peo[pl]e of th[e]ir hou[se], neither by n[i]gh[t nor] by day, because I have put you under oath, by **mrgynyk** and **ṣr'tk**, that if you go out from the house
ומן דירתיה דהדין גדנא בר חאתוי ומן קאקאי א[י]תתיה בת מ[...]ים [מוטב ואם] לא נפקת [...] עליכי דעליכי יקיר ודעליכי חסין ודעליכי מ[...] אלפא ושבעא מלאכין	7	and from the dwelling of this Gaddānā son of Ḥāṯōy, and from Qāqay, [his] w[ife], daughter of Mi[r]iam, [it will be well. But if] you do not go out [...] against you that which is dear to you, and that which is powerful to you, and that which is [...] to you [...] one thousand and seven angels,

8 and these are their names: Gabriel and Michael and Raphael and 'Azaziel, the strong and mighty. You [... cause] the evil lilith to go forth from the house and from the dwelling [of this] Gaddānā son of Ḫāṯōy, and from Qāqay,

ואילין שמהתהון גבריאל ומיכואל ורפואל ועזזיאל עזיזא ותקיפא אתון [... א]פיקו ית ליליתן[א] בישתא מין ביתיה ומין דירתן[י]ה [דהדין] גדנא בר חאתוי ומין קאקי

9 his wife, daughter of Miriam, and may their children en[dure] for them, and they will hand you over and you will be surrendere[d] into [my hand]. Amen, Amen, Selah [...]

איתתיה בת מרים ויתק[ימ]ון להון בניהון וישלמון יתכי ותיתמסר[ין] ב[ידי] אמן אמן סלה [...]

2. **wlʾ m[...]**: "and it is not [...]"; we would expect **myštry** "untied" (e.g. JBA 91:3–4), but the remaining traces (if they are actually letters) do not appear to accord with this.

3. **br**: "son of"; there appears to be a mark that descends from the left-hand tip of the *reš*, but it is unlikely to be part of the letter.

5. **mrym**: "Miriam"; cf. l. 9. In this case, however, perhaps read **m[y]rym** as there is sufficient space between the *mem* and the *reš* for a *yodh*. The other occurrence of this name in l. 7 is unclear, but the traces suggest **m[r]ym**.

6. **mrgynyk wyṣrʿtk**: probably a graphic corruption of something along the lines of **mrgynzk wyṣwṣytk** "the master of your treasure house and the tuft of your hair".

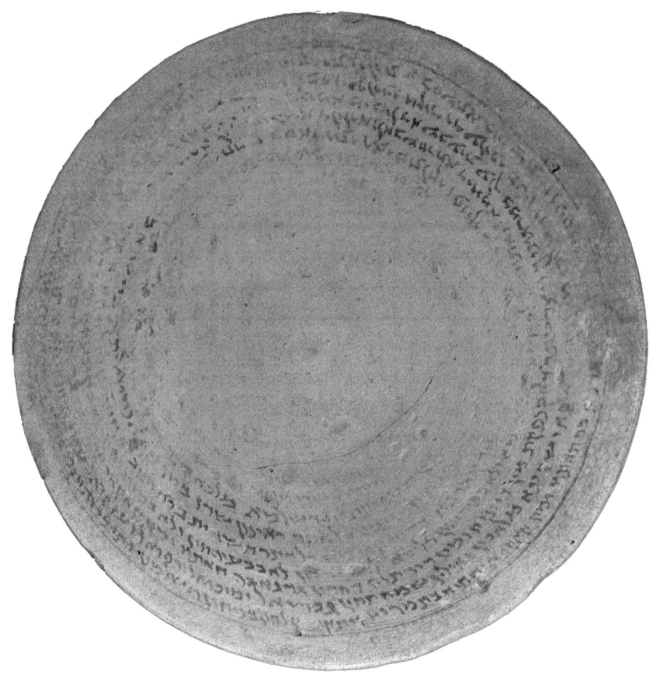

JBA 101 (MS 2053/215)

165 × 50 mm. Semi-formal hand. The bowl was broken, but has been repaired. Much of the writing is faded, and some parts have suffered from flaking of the surface of the bowl. The text parallels JBA 98, almost word for word, but extensive reconstructions have been avoided. The text appears to be surrounded by a circle.

Clients: Abbā son of Puʿat (?; the reading of the matronymic is uncertain—cf. **pwʿh** in Ex 1:15); Aḥāt̠ daughter of Ḥāt̠ay, his wife.

Biblical quotations: Ex 3:14; Ex 3:15; Is 40:31; Is 60:11; Gen 27:28 (TO).

1 [...] [...]

2 [...] and so[r]cery [...]וח[ר]שי

3 [...] [...]

4 [...] [...]

5 [in] an unsav[ory] drea[m ...] [ב]חילמ[א] סנ[י]א [...

6 [...] [...]

7 [... his] wife. Again, you [are bound] and sea[led ... and d]ēvs, all of y[ou], and id]ol spirits, all of you, [...] אינתת[יה] תוב [אסירי]תון וחתי[מיתון ... וד]יוי כול[כ]ון ויפ[תכרי כולכון

8 [and] lili[ths, all of you], from [your] youn[g ones ...] and to [the no]bleman, who dwell [ו]לילי[תא כולכון] מיעול[ימיכון ...] ועד [בר] חרי דיתבין

9 in various gardens, in vario[u]s plants, in va[rious date palm trees ... in various] valleys, and who haunt [th]resholds, and who have [power] over human beings, בגיני גיני בצימ[ח]י צימחי בד[י]קלי דיקלי ... בבקעתא [בקעתא ודישרן [על אי]סקופתא ודש[לטין] ביבני אינשא

10 and beat and strike and ki[l]l women, men, boys and girls [...] and love ca[r]nality [and] fornication, the noblewoman who de[ceive]s, and the singing-girl who shames herself. Go out, ושקפין ומחין וקטל[י]ן נשי גברי דרדקי ודרדקתא [...] ורחמין ז[י]מתא [ו]זנותא בתחרי דימג[נב]א וזמרתא דימבזיא נפשה פוקו

11 all of you, evil satans, and de[m]ons [...] and shadow demons and bonds and liliths and curse demons, all of y[ou], כולכון סטנין בישין ושי[י]דין [...] וטולניתא וכיסי ולילייתא ולוטתא כול[כ]ון {פ}

12 go out and be divor[c]e[d], from [the house of Abbā son of] Puʿat (?), [and of Aḥāṯ] daughter of Ḥāṭa[y], his wife, from their house, and from [...] and from the people of their house, and from their possessions, and from their grai[n], and from their f[oo]d. Again, you are boun[d]

פוקו ואיתר[י]כ[ו] מן [ביתיה דאבה בר] פועאת [ודאחת] בת חתא[י] אינתתיה מן בתיהון ומן [...] ומן אינשי בתיהון ומן קיניניהון ומן עיבו[ר]הון ומן מ[זו]נהון תוב אסי[ר]יתון

13 and sealed [...] by the ring [o]f [the] lilith Gannav [...] of King So[lomon ... are] drawn the kings of demons [and] the kings of *dēv*s and the kings [of id]ol spirits. Again, you are bound and sealed, evil

וחתימיתון [...] בשירא [ד]י[גנב לילית]א [...] דש[למה] מלכ[א ...] ציר[ין] מלכי דשידי ו[מ]לכי דדיוי ומלכי דאברח[סי]ה קדישא רבא [דיפ]תכרי תוב אסיריתון וחתימיתון חרשי

14 sorcery and magical acts and bond[s] and l[ili]ths [...] the house of Abbā son of Puʿat (?) and [of] Aḥāṯ [daugh]ter of Ḥāṭay, his wife, by the name of the holy (and) great ʾbrḥ[sy]h, the king of the world. Again, you a[r]e bound

בישי ומבדי וכיס[י]ן ול[ילי]ת[א ...] ביתיה דאבה בר פו[עאת] {דת} ו[ד]אחת [ב]ת חתאי אינתתיה בישמיה דאברח[סי]ה קדישא רבא מלך עלמיא תוב אסיר[י]תון

15 and sealed by seven seals [...] The first seal [... the thi]rd, of *ybwl* son of *sygwl*; the fo[ur]th, of *ṣwrbn nwr* [...] *gyʾ*; the fifth, of the mighty (!) *bwrgwn*; the sixth,

וחתימיתון בשבעה חתמין [...] חתמא קדמאה [...] תלי[תאה דאיבול בר סיגול ר]ביא[עה דצורבן נור [...] גיא חמישאה דבורגון תקימאה שתיתאה

16 of ṭ[...] the seventh, of ṭ[...] By the se[al of] the [su]n, and by [the] signet-ring [...] By the mystery of the ea[r]th, and by the great base of the sky. By the name of [the] signet-ring [...] By the name of [... "YHWH] Saba[o]th is [his name]". He is "I am th[at I am". "This]

דט[...] שביאעה דיט[...] בחת[מא דשימ]שא ובעיזקת[א ...] ברזה דא[ר]עה ובסדנה רבא דרקיעא ובשום עיזקתי[ה ...] בשום [... יהוה] צב[או]ת [שמו] הוא אהיה א[שר אהיה זה]

17 is my name for ever, and this is my memorial unto all generations". "But those who wait upon YHWH [...]". And open (your) hand to the[m], to Abbā [so]n of Puʿat (?) and to Aḥāṯ daugh[ter of Ḥāṭay, his w]ife [...] as it is said: "[...] shall be open [... da]y and night [...]

שמי לעלם וזה זיכרי לדרדר וקוי יהוה [...] ויד פתח לה[ון] לאבה [ב]ר פועאת ולאחת ב[ת חתאי אי[נתת]יה [...] שנאמר פיתח[ו ... יומ[ם וליל]ה [...]

18 [... the s]ky, [of the choice pro]duce of the earth, a multitude of grain [and wine]". Amen, Ame[n], Selah.

[... ר]קיע[א מיטו]בה דארעה סגיות עיבור [וחמר] אמן אמ[ן] סלה

11. **wkysy:** "and bonds"; see the note to JBA 95:3.

12. **w'ytrykw:** "and be divorced"; see the note to JBA 95:4.

13. **bšyr':** "by the ring"; see the introduction to this section.

14. **wmbdy:** "and magical acts"; for **wm'bdy** (cf, e.g., JBA 54:5) with loss of *'ayin* (see also the note to JBA 95:7).

15. **tqym'h:** probably a graphic corruption of **tqyp'** "mighty" (cf. JBA 95:10). The same reading occurs in JBA 98:15.

16. E.g. Is 47:4 (this phrase occurs thirteen times in the Bible).

16. Ex 3:14.

16–17. Ex 3:15

17. Is 40:31. It is possible to discern traces of some of this verse's words, but not sufficiently to provide a transcription.

17–18. Is 60:11.

18. Gen 27:28 (TO).

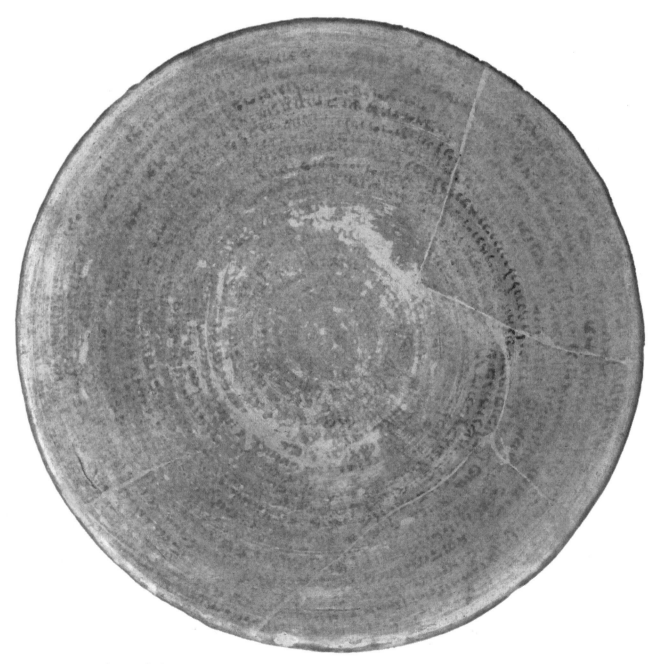

PHOTO 47 JBA 101 (MS 2053/215)

I.4.1.2

From Ashmedai and from All His Army

Introduction

The texts in this section refer to the signet-ring of Solomon together with **šyr šyr'** "the ring šyr" (see the introduction to 1.4.1.1) and a signet-ring variously called **zrdyn** (JBA 103:7) or **zrzyn** (JBA 104:2); cf. also **zrzyr** in JBA 88:4 (and accompanying note) and [...]**yrn** in JBA 102:3. Published parallels include M 6 (Shaked 1995b, 211–216), and HS 3041 + HS 3070x (Ford and Morgenstern 2020, 113–119), the latter without reference to the rings. Unpublished parallels include JNF 88, JNF 121, PC 89, PC 90, PC 91, PC 92, PC 93 and Wolfe 105. JBA 104 is written in the same distinctive hand as JNF 88 and JNF 121; PC 93 has a similar hand, and may have been prepared by another member of the same scribal school. JBA 103:9–10 contains a description of the pernicious activity of Danaḥiš that is, at present, unknown in any other manuscript.

The main spell unit contains a reference to several demons, each of whom is accompanied by a group of either military or familial units. One of these demons, **ṭys'ypwryn**, is presently only known from this spell unit. Another is called either **'ny** or **'ny nhr'**, and is thus far attested only once outside of this spell unit: **wrmt' bhwn 'ytmsy' wḥršyn šydyn wšybṭyn wdywyn wrwḥyn wzky' wrwny wdnḥyš w'ny wlylyn bhwn 'yt'qrw mn 'lm'** "and the hills melted away by them, and sorcery (and) demons and plagues and *dēv*s and spirits and *zakya* and Roni and Danaḥiš and Anay and *lili*s were uprooted by them from the world" (JNF 89:3–4). The reading **'n'y** in PC 92 indicates that the name was pronounced Anay. As none of the extant bowls with **'ny nhr'** distinguishes between *daleth* and *reš*, the reading **'ny nhd'** is also possible. The latter reading would recall the Iranian DN Anāhīd (< Anāhitā). The group accompanying Anay is called **mw'h** (or **my'h**). We follow Ford and Morgenstern 2020, 115, in interpreting the term as a military unit.

Other spells that occur in the bowls in this section:
– A garment of radiance—JBA 103:1
In JBA 103 and M 6, the main spell unit is preceded by another that opens with a reference to a "garment of radiance" that protects the client. The opening of this spell unit in M 6:11 reads: **lbwš zyw' rbh lbyšyn wmksn 'rgw'n' rbh dzyw' wklyl myšḥw br'šyhwn tryṣ lhwn wḥwmry zkwryt' 'l ḥdyyhwn mḥtyn lhwn dbhyn ḥtymyn...** "They wear a great garment of radiance, and they are covered (by) a great purple cloth of radiance, and they have set a crown of brilliance on their heads, and they have placed divining (?) seal stones upon their chests, by which are sealed ...".

References to magical garments that protect either the client or the practitioner are not uncommon in Aramaic magic (other examples in the Schøyen Collection include MS 2053/197 and MS 2053/252). Compare, for example, the following Mandaic spell: **šuba lbušia ḏ-ziua lbišna ana iahia bihram br haua simat šuba himiania ḏ-ziua bhalṣai ʿsirlia ušuba ksuiia ḏ-ziua ^nhura^ mkasina ušuba qurahia ḏ-nhura brišai matnalia ušuba sandlia ḏ-ziua bligrai matnalia** "I wear seven garments of radiance, I, Y. son of H., I have bound seven girdles of radiance upon my loins, and I am covered with seven coverings of radiance ^light^, and I have put seven helmets of light upon my head, and I have put seven sandals of radiance on my feet" (DC 37:299–303 and DC 43C:6–8). In the case of the present spell unit, those wearing the protective garments are referred to in the third person in M 6 and in the first person in JBA 103. Furthermore, in MSF Bowl 22 (see below), it appears to be the house of client that is thus clothed. It would seem, therefore, that contra Müller-Kessler 2012, 16, the garments are protecting the clients rather than angels.

One of the items being worn is a **klyl myšḥw**, which we translate "crown of brilliance" following Müller-Kessler 2012, 18 (but see below). Compare also PC 44:2, which reads: **lbwš zyw' lbyšn' wklyl ṣymḥ' br'šy mḥytn'** "I wear a garment of radiance, and a crown of splendour on my head I place". Also being donned are **ḥwmry zkwryt'** "divining (?) seal stones" (following Shaked 1995b, 211, and contra Müller-Kessler 2012, 15, whose reading **zkwkyt'** is not supported by the photographic evidence). The interpretation of **zkwryt'** remains obscure at this time, but see Shaked 1995b, 214–215 (n. 96).

It should be noted, however, that the overall image may possibly be referencing the garments of the High Priest as described in Ex 28, which describes in similar terms the garment, the crown (cf. **klyl'** in P Ex 28:36), the ephod (with purple), and the breastplate that contains twelve stones. If this analogy is intended, then it should be noted that Heb. **mṣḥ** "forehead" is used in Ex 28:38 to refer to the forehead of Aaron, which would appear to support the interpretation of **klyl myšḥw** as "crown of his forehead" (thus Shaked 1995b, 214 and n. 94). This may also support the understanding of **zkwryt'** as referring to divination, as the High Priest's breastplate appears to have been used for this purpose (e.g. 1Sam 28:6). If this was indeed the original sense of this spell unit, it would appear to have been lost on later practitioners.

INTRODUCTION

The "garment of radiance" unit also refers to a *šwṭʾ dtlt mʾh wšytyn ḥwmry mmllṭʾ* "whip of three hundred and sixty forged seal stones" (JBA 103:5; see *DJBA*, 682). The "forging" in question could relate either to the production of metallic beads or seals, or to the practice of setting stones within metal; the reference to a "whip" suggests the former.

The "garment of radiance" unit also appears in MSF Bowl 22, in which, just like M 6, it is preceded by the "angels on all sides" unit—see already Shaked 1995b, 200 (n. 18). With the aid of the parallels, we are now able to give the following revised (albeit still provisional) edition:

1 הדין קמיעא דחתמ[תא ... דמר]ותא בת דודא
 This amulet, which is a seal[ing ... of Mār]ūtā daughter of Dūdā.

2 מן ימינה חרביא[ל] ומשמאלה מיכאל ומלפנה סוסיאל [ומע]ליה
 On her right is Ḥarbie[l], and on her left is Michael, and in front of her is Susiel, [and abo]ve her is

3 שכינת אל ומאחורה מ[...] קדישאל [...]
 the Divine Presence of God, and behind her [...] Qaddišʾel [...]

4 אלהים מכל שטן ומכל פגע [...]
 God, from every satan and from every affliction demon [...]

5 [...]
 [...]

6 עדה עדה עליאל אמן אמן סלה [לבוש זיוא ... לביש] הדין ביתה דמרותא ומכסי ארגונא רבה דזיוא וכליל מ[י]צחו
 ʿdh ʿdh ʾylʾl Amen, Amen, Selah. This house of Mārūtā [wears a garment of radiance ...] and is covered (by) a great purple cloth of radiance, and it has set a crown

7 בראשיה תריצליה וחומרי זכוריתה על חדיה [...] וככבי ומזלי וזיקי ואורי ופיקדי ולטבי
 of bril[li]ance on its head, and divining (?) seal stones upon its chest [...] and stars and constellations, and winds and airs, and *piqdas* and no-good ones

8 ופתכרי דיכרי ואיסתרתא ניקבתא תוב חתים ומחתם הדין ביתה [...] מרותא בת דודא [...] מילי באימרא
 and male idol spirits and female goddesses. Again, sealed and double sealed is this house [...] Mārūtā daughter of Dūdā [...] words, by reciting

9 ושי[מ]עא ובכלא רבה דזיוא ובנרגא רב[ה] ד[...] מאה [...] על פי יהוה יחנו ועל פי יהוה [
 and he[e]ding, and by a great hammer of radiance, and by a grea[t] axe of [...] hundred [... "At the commandment of YHWH they encamped, and at the commandment of YHWH]

10 [יסעו א]ת משמרת יהוה שמרו על פי יהוה ביד משה [...]
 [they journeyed.] They kept the charge of YHWH at the commandment of YHWH by the hand of Moses". [...]

11 for ever and ever. "And their iniquities shall be upon their bones. For the ter[ror of the mighty is in the land of the living". ...]

עלמי עד ותהי עוונותם על עצמותם כי חת]ית גבורים בארץ חיים [...

12 [...] my nerves, by [...] my sinews, by (the ring) šr [... Solomon] so[n of David ...]

[...] ק‏טינתי ב[...] שיריני דידי בשר]... שלמה ב]ר דויד [...

JBA 102 (MS 1929/11)

190 × 70 mm. Semi-formal hand. The writing is partly faded. The text is surrounded by a circle.

Linguistic and orthographic features: Note the loss of ʿayin in **ʾrby** (twice in l. 5; for **ʾrbʿ**). Note also the use of abs. **zwyyʾ** for *nomen regens* in (l. 5). Note also the use of –**h** rather than –**yh** for the 3 p. masc. sg. pron. suffix in **kwlh** (ll. 7, 9 and 11). Finally, note the 2 p. sg. poss. pron. suffix –**yk** for masc. in **dwtqyk** (l. 13), **mšrytyk** (l. 11), **plgyk** (l. 11) and **šwrbtyk** (l. 12), and for fem. in **zrʿytyk** (l. 12), **myk** (l. 12) and **mrkbtyk** (l. 12).

Clients: Nukhraytā daughter of Maḥlaftā; Ḥiṣqīl son of Māmay, her husband.

Biblical quotation: Ex 3:14.

1 חת[ימא ו]מחתמא נוכריתא

1 Sea[led and] double sealed is Nukhraytā

2 בת [מחלפתא] וחיצ[קי]ל בר מאמי בעלה

2 daughter of [Maḥlaftā] and Ḥiṣ[qī]l son of Māmay, her husband,

3 בשיר [שירא ...]ירן עיזקתא ובעיזקתא דשלמוה

3 by [the ring] šyr, [by] the signet-ring [...]yrn, and by the signet-ring of King

4 מלכא בר [דויד] מלך ישראל תוב חתים ומחתם חיצקיל בר

4 Solomon son of [David], the king of Israel. Again, sealed and double sealed is Ḥiṣqīl son of

5 מאמי ונוכריתא [בת מחלפת]א אינתתיה מן ארבי זוייא ביתיה ומן ארבי קרני

5 Māmay and Nukhraytā [daughter of Maḥlaft]ā, his wife, from the four corners of his house, and from the four corners of

6 איגריה תוב [...] בשכינתא עיליתא ובשכינתא מיציתא ובשכינתא ⟨תחתיתא⟩ מ[ן]

6 his roof. Again, [...] by the upper Divine Presence, and by the middle Divine Presence, and by the ⟨lower⟩ Divine Presence, fr[om]

7 אשמדי ומן כולה פ[לגי]ה ו[מ]ן טיסאיפורין ומן כולה משריתיה ומן אגרת ב[ת] מחלת ומן כולהין מרכבתה

7 Ashmedai and from all [h]is a[rmy], and [fr]om ṭysʾypwryn and from all his retinue, and from Agrat daugh[ter of] Maḥlat and from all her chariots,

8 ומ[ן א]ני נהרא ומן כו[ל]הון [מואה ו]מן לילתא ומן כולהין זרעיתה ומן דנחיש ומן כולה שורבתיה ומן

8 and fr[om ʾ]ny nhrʾ and from al[l her centuriae, and] from Lilith and from all her clans, and from Danaḥiš and from all his tribe, and from

9 זכיא ומ[ן] כול[ה] דותקיה בש[ום] חי [ובשום] חת ובשום יהו יהו ובשום צבאות ובשום אהיה אשר אהיה ובשום אל שדי תוב

9 zkyʾ and fr[om all] his family. By the na[me of] ḥy, [and by the name of] ḥt, and by the name of YHW YHW, and by the name of Sabaoth, and by the name of "I am that I am", and by the name of El Shaddai. Again,

10 משבענא עליכון כולכון שיד[י ... ול]טבי ופתכרי דיכרי ואיסתרתא ניקבתא ד[לא תיקירבון ולא תיזקון בחיצקיל בר מאמי

10 I put you under oath, all of you, demon[s ... and no-]good ones and male idol spirits and female goddesses, that you should not approach and not harm Ḥiṣqīl son of Māmay

11 ובנוכריתא בת מחלפתא אינתתיה [ל]א את אשמדי ולא כולה פליגך ולא את טיסאיפרין ולא כולה משריתיך ולא את אגרת בת מחלת

11 and Nukhraytā daughter of Maḥlaftā, his wife—[nei]ther you, Ashmedai, nor all your army, and neither you, **ṭysʾypryn**, nor all your retinue, and neither you, Agrat daughter of Maḥlat,

12 ולא כולהין מרכבתיך ולא את אני נהרא ולא [כ]ולהון מוך ולא את ליליתא ולא כולהין זרעיתיך ולא את דנחיש ולא כולה שורבתיך ולא את זכיא ולא כוליה

12 nor all your chariots, and neither you, **ʾny nhrʾ**, nor [a]ll your centuriae, and neither you, Lilith, nor all your clans, and neither you, Danaḥiš, nor all your tribe, and neither you, **zkyʾ**, nor all

13 דותקיך מן יומא דנן וילעולם אמן אמן סלה

13 your family, from this day and for ever. Amen, Amen, Selah.

3. **šyr šyrʾ**: "the ring šyr"; see the introduction to **I.4.1.1**.

5. **ʾrby**: "four"; a phonetic spelling, showing loss of *ʿayin*, of historical **ʾrbʿ**. This corresponds to the hybrid spelling **ʾrbʿy** in the better Talmudic manuscripts, for which see Morgenstern 2011, 72.

zwyyʾ: "corners of"; the expected form would be something like **zwyt** (e.g. Montgomery 4:2), but the form **zwyʾ** does occurs in other magic bowls (e.g. Davidovitz 2:6, PC 33:6, PC 34:6 and PC 35:6). The form **zwyʾ/zwyyʾ** for the *nomen regens* may derive from the abs. **zwyn** with loss of final *nun*—cf. Syr. **ʾrbʿ zwyn byty** "the four corners of my house" in JNF 239:5. For the occasional use of the absolute for the *nomen regens* in Mandaic, see Nöldeke 1875, 312–313. For an example in a JBA magic bowl, see Morgenstern and Ford 2017, 202.

6. The adj. **tḥtytʾ** "lower" is restored on the basis of the following reading found in an unnumbered bowl from the Moussaieff collection (but in a different formula): **wbyškyntʾ ʿlytʾ wbyškyntʾ myṣyṭʾ wbyškyntʾ tḥtytʾ** (reading kindly supplied by Matthew Morgenstern).

9. Ex 3:14.

10. **wlʾ tyzqwn**: "and you should not harm"; the *zayin* is unclear. If the reading is correct, it is probably an example of the root NZQ in the *pe.*, something not presently listed in any eastern Aramaic lexicon. It does appear, however, in JPA (*DJPA*, 345) and in the Targum of Psalms (e.g. Ps 91:7, which reads **lwtk lʾ yqrbwn lmnzq** "they shall not approach you in order to harm").

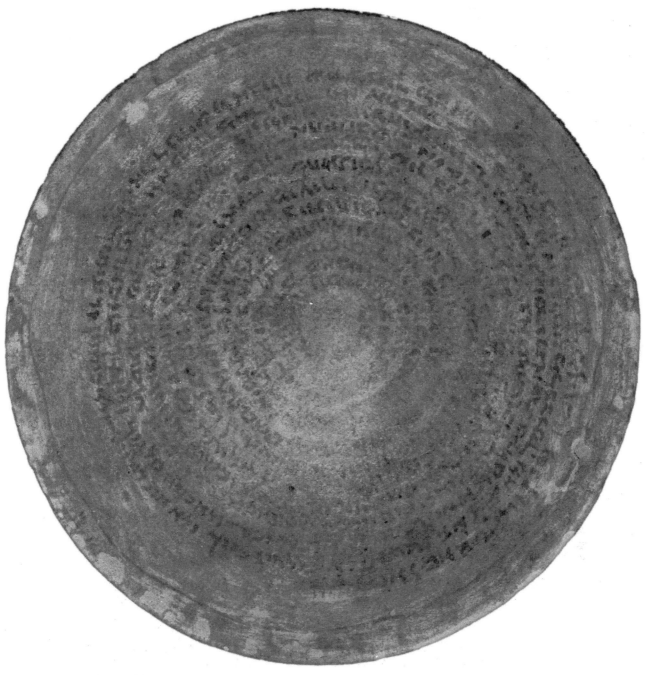

PHOTO 48 JBA 102 (MS 1929/11)

JBA 103 (MS 2053/196)

270×105 mm. Elegant semi-formal hand. The bowl was broken. It has been repaired, but the repairs occasionally obscure the text. It has a flat bottom and its rim has a crenelated style. The writing is partly faded towards the rim. The text is surrounded by a circle.

Linguistic and orthographic features: Note the masc. pl. dem. pron. **hnwn** (l. 4). Note also the hybrid spelling, showing the weakening of *'ayin* to *'aleph*, in **''yl** (l. 9). Finally, note the use of –**h** rather than –**yh** for the 3 p. masc. sg. pron. suffix in **kwlh** (ll. 8, 9 and 12).

Client: Dukhtānšāh daughter of Gušnōy.

Biblical quotations: Num 9:23; Zech 3:2; Ps 55:8; Ps 91:7.

Image: In the centre of the bowl, there is a largely faded image of uncertain shape, with what appears to be some sort of grid pattern and possibly two dark stains beneath it.

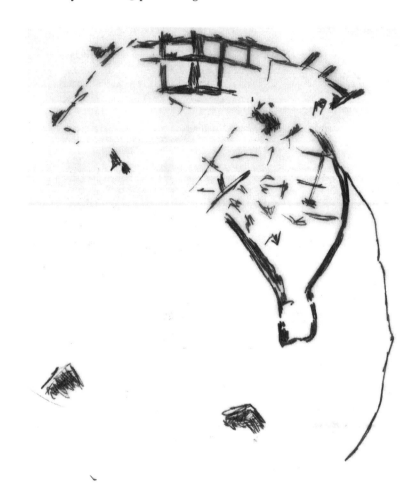

FIGURE 18: Artist's impression of image from JBA 103

1 לבוש [זי]ו[]א לבי[שנא אנה דוכתנשה בת גושנוי ומכסינא בא[ר]גונא רבא [דזיוא] וכליל

1 I [wea]r a garment of [radi]an[ce], I, Dukhtānšāh daughter of Gušnōy, and I am covered by a great pur[ple] cloth [of radiance], and I have set

[מי]צחו וצימחי בראישי תריצלי וחומרי זידניתא על חדי מחתן [לי] רברביהון חתימין	2 a crown of [brilli]ance and splendour on my head, and I have placed wicked amulet spirits upon my chest, their great ones. Sealed are
שמיא וארעה נורא ומיא סיהרא וכוכבי ומזלי וזיקי ואויר דשידי ודיוי ופקדי ולטבי וסטני ודנחיש ופתכרי	3 heaven and earth, fire and water, moon and stars and constellations, and winds and air, and (!) demons and *dēv*s and *piqda*s and no-good ones and satans and Danaḥišs and male idol
דיכרי ואיסתרתא נוקבתא ת[ו]ב חתימנא ומחתמנא אנה דוכתנשה בת גושנוי בהנן תלתא מלין [ד]אמרין ושמעין	4 spirits and female goddesses. Ag[a]in, I am sealed and double sealed, I, Dukhtānšāh daughter of Gušnōy, by those three words [that] they recite and (others) heed
בהון ואכלא רבא דזיוא ונרגא רבא דשריותא {ושוטא דתלת מאה} ושוטא דתלת מאה ושיתין חומרי ממללתא אמן אמן סלה	5 them, and a great hammer of radiance, and a great axe of release, and a whip of three hundred and sixty forged seal stones. Amen, Amen, Selah.
על פי יייי יחנו על פי ⟨יייי⟩ יסעו ויאמר יייי אל הסטן ויגער יייי בך הסטן ויגער יייי בך הבוחיר בירושלים הלו זה אוד מוצל מיאש	6 "At the commandment of YYYY they encamped, at the commandment of ⟨YYYY⟩ they journeyed". "And YYYY said unto Satan, YYYY rebuke you, O Satan, even YYYY that has chosen Jerusalem rebuke you. Is this not a brand plucked out of the fire?".
תוב חתימנא ומחתמנא אנה דוכתנשה בת גושנוי בעשר איצבעתי בעשרין קטינתא דידי ובשוריני דידי ובשיר שירא ובזרדין עיזקתא	7 Again, I am sealed and double sealed, I, Dukhtānšāh daughter of Gušnōy, by my ten fingers, by my twenty nerves, and by my sinews, and by the ring **šyr**, and by the signet-ring **zrdyn**,
ובעיזקתא דשלמה מלכה בר דויד מן אשמדי ומן כולה פליגיה ומן טיסו איפורן מן כולהין מרכבתיה ומן אני נהרא ומן כולהון מואה ומן אגרת	8 and by the signet-ring of King Solomon son of David, from Ashmedai and from all his army, and from **ṭysw 'ypwrn** and from all his chariots, and from **'ny nhr'** and from all her centuriae, and from Agrat
בת מחלת ומן כולהין מרכבתה ומן דנחיש ומ[ן] כולהין שורבתיה ומן זכיא וח[ו][מ]רתא ומן כולה דותקיה ומן חיליה דדנחיש שידא הוא דעייל בעיזקתא	9 daughter of Maḥlat and from all her chariots, and from Danaḥiš and fr[om] all his tribes, and from **zky'** and the amu[let] spirit and from all his family, and from the army of the demon Danaḥiš, the one who enters into the anus

10 of people, and sits in the stomach, and causes stomach ache, [and kn]eads d[o]ugh, and sits and uses [...] the body. By the name of [ḥy], and the name of ḥy, and the name of ḥt. By the name of YHW YHW. By the name of Sabaoth

דאינשי ויתׄב בליבא ומרׄס מירסא [וגׄ]ביל
גׄ[וׄ]בלא {ומׄ} ויתיב ומישתמש [...]לה קומתא
בשום [חי] ושום חי ושום חת בשום יהו יהו בשום
צבאות

11 Sabaoth. By the name of El Shaddai [...] demons and afflictions and sgy and satans and Dana[ḥ]iš and his army and the [e]vil Roni (?) and pi[q]das and no-good ones and male idol spirits and female goddesses and all

צבאות בשום אל שדי [...] שידי ושיבטי וסגי
וסטני ודנ[חׄ]יׄש וחיליה ורונׄי [ב]יׄשא ופׄ[קׄ]די
ולטבי ופתכרי דיכרי ואיסתרתא נוקבתא וכל

12 [...] and all [...] and [... and] evil [tor]mentor[s], that you should not come near to Du[kh]tānšāh daughter of Gušnōy, nei[ther] you, Ash[medai, no]r all [your a]r[my], and nei]ther yo[u, ṭysw] ʾypwrn, nor

[...]ין וכל [...][נין ול...] ומ[...זיק]ין] בישין דלא
תיקרבון לה לדו[נכ]תנשה בת גושנוי ל[א] את
אש[מדי ו]נ[ל]א] כולה [פׄ]ל]לׄ]גיד ול]אׄ] ת טיסו]
איפורן ולא

13 all your chariots, and neither (you), [ʾ]ny nhrʾ, nor a[ll] your centuriae, and neither (you), Agrat daughter of Maḥlat, nor all your cha[ri]ots, and neither you, Danaḥiš, no[r] all [your] retinue, [and nei]ther you, zkyʾ and the amulet spirit, n[o]r all

כולהין מרכבתך ולא [א]נׄי נהרא ולא כ]ולהוׄ]ן
מוך ולא אגרת בת מחלת ולא כולהין מר[כב]תיד
ולא את דנחיש ול[א] כולהין משרית]ד ול[א] את
זכיא וחומרתא ול]א] כולהין

14 your retinue and your family and your [fa]mily, fr[om this] day and for [e]ver. A[men, Amen,] Selah. ṭṣṣʿyṭʾ špr [...] "Beho[ld], I would wand[er] far off, I would remain in the wilderness. Selah". "A thousa[nd] shall fall at [your] sid[e], [and] ten thousand at your right hand, but it shall not touch you". Sound

משריתך וקינך ו[דו]תקד מ[ן] יומא [דין]
ול[ע]לם א[מן אמן] סלה טססעיתא שפר[...]
הנ[ה] ארח[יק] נדד אלין במדבר סלה יפול
מיצ[דד] אל]ף ו]רבבה מימינך אליך לא יגש
שריר

15 and established.

וקים

1. dwktnšh: "Dukhtānšāh"; compare the fem. PN **duktanša** in the Mandaic bowl 2054/93:14 (see also Justi 1895, 86).

2. wḥwmry zydnytʾ: "and wicked amulet spirits"; it appears that the scribe has mistakenly used this phrase that is common in the bowls (e.g. JBA 25:8) instead of something like **wḥwmry zkwryṭʾ** (for which, see the introduction to this section).

rbrbyhwn: "their great ones"; probably an error for **dbhyn** "by which" (cf. M 6:11, which is discussed in the introduction to this section).

3. dšydy: Error for **wšydy**.

4–5. dʾmryn wšmʿyn bhwn: "that they recite and (others) heed them"; the subjects of these active participles are impersonal and distinct. M 6:13 has the nominal forms **ʾymrʾ wšymʿh** "reciting and heeding" (cf. MSF Bowl 22:8–9, edited above), which corresponds to Mand. **ʿmra ušima** (see Widengren 1968, 574–577; cf.

also Ford 2002, 261–262, who, regrettably, overlooked Widengren's remarks).

6. Num 9:23; note 'l for MT w'l.
Zech 3:2; note wygʻr, byrwšlym and hlw for MT ygʻr, byrwšlm and hlw' respectively.

7. šyr šyr': "the ring šyr"; see the introduction to 1.4.1.1.

9. d'ʻyl bʻyzqt': "who enters into the anus". For the verb, the *ʼaleph* represents the pronunciation /ʼāyil/, whereas the *ʻayin* represents the historical root consonant. The same hybrid spelling occurs in JBA 113:5. For the noun, if our reading is correct, this would be the first attestation of this meaning for 'yzqt' in JBA. Compare Syr. ʻzqt' (*SL*, 1090) and JPA ʻzqh (*DJPA*, 401); cf. also RH ṭbʻt "ring, seal ring", but py ḥtbʻt "anus" (Jastrow 1950, 519).

10. wytyb blybʼ wmrys myrsʼ: "and sits in the stomach, and causes stomach ache". Supralinear *yudh*s have been added to the two verbs to give a *plene* spelling for both participles. For **lybʼ** meaning "stomach", see *DJBA*, 624. This meaning is confirmed for this context by the following reference to **myrsʼ** "stomach ache".
wgbyl gwblʼ: "and kneads dough"; probably a reference to a lump of undigested food that is causing discomfort in the stomach.
{wm}: Probably a false start for **wmyštmš** two words later.

11. wsgy: "and sgy"; this type of demon is not attested elsewhere in the bowls (but cf. JBA 55:5). The final two letters appears to have been rewritten with broader strokes after redipping the stylus, so this is unlikely to be a false start for the following word.
wrwny byšʼ: "and the evil Roni (?)"; the reading **wrwḥ byšʼ** "and the evil spirit" is also possible, but the demon Roni occurs elsewhere with Danaḥiš (e.g. JBA 52:3, JBA 53:2 and JBA 54:3; see also Ford 2006, 209). The phrase **rwny byšʼ** "the evil Roni" also occurs in LO 793:2, and **rwny šydʼ byšʼ** "Roni, the evil demon" occurs in MS 2053/80:5.

14. Ps 55:8.
Ps 91:7.

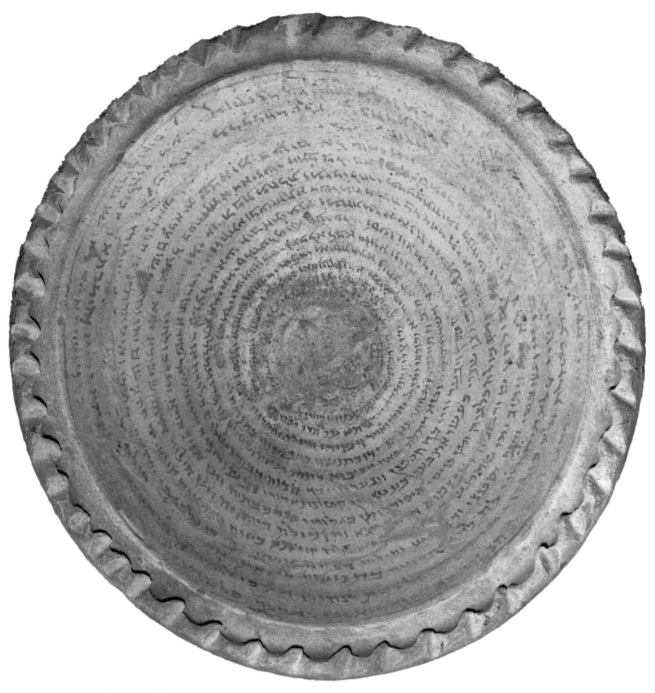

PHOTO 49 JBA 103 (MS 2053/196)

JBA 104 (MS 2053/238)

162 × 60 mm. Semi-formal hand. The text begins at the rim, proceeding towards the centre, and then continues on the outside of the bowl. The writing on the outside of the bowl is partly faded.

Linguistic and orthographic features: Note the use of **-h** rather than **-yh** for the 3 p. masc. sg. poss. pron. suffix in **byth** (ll. 1, 5, 8 and 15), **bnh** (l. 6), **gwph** (l. 6), **dwtqh** (l. 4), **kwlh** (ll. 2, 4, 8 and 11), **mzwnh** (l. 6), **qynynh** (l. 6), and **šwrbth** (l. 3). Note also the 2 p. sg. poss. pron. suffix –**yk** for masc. in **dwtqyk** (l. 11), **mšrytyk** (l. 9), **plgyk** (l. 8) and **šwrbtyk** (l. 10), and for fem. in **mrkbtyk** (l. 10).

Clients: Abraham son of Ādar(e)dukh; Māmā daughter of Š[...]y, his wife.

Biblical quotations: Ex 3:14; Zech 3:2.

1. חתים ומחתם ביתה דאברהם בר א[ד]רדוך בעשר איצבעתי בעישרין קטיניתי בשיתין שוריני דידי ובשר שירא

 Sealed and double sealed is the house of Abraham son of Ā[da]rdukh, by my ten fingers, by my twenty nerves, by my sixty sinews, and by the ring **šr**,

2. בזרזין עיזקתא ובעיזקת[א די]שלמה בר דויד מלכא דישראל מן אשמדי מיכולה פלגיה מן טיסו איפורן

 by the signet-ring **zrzyn**, and by [the] signet-ring [of] Solomon son of David, the king of Israel, from Ashmedai, from all his army, from **ṭysw ʼypwrn**,

3. מיכולה משריתיה מן אגרת בת מחלת מיכולה מרכבתה מן דנחיש מיכולה שורבתה מן אני

 from all his retinue, from Agrat daughter of Maḥlat, from all her chariots, from Danaḥiš, from all his tribe, from **ʼny**,

4. מיכולהון מואה מן זכיא מיכולה דותקה בשום חי ושום חי ושום חית בשום יהו יהו בשום צבאות

 from all her centuriae, from **zkyʼ**, from all his family. By the name of **ḥy**, and the name of **ḥy**, and the name of **ḥyt**. By the name of YHW YHW. By the name of Sabaoth

5. צבאות ובשום שדי ובשום אהיה אשר אהיה דלא תקרבון לביתה דאברהם בר אדרידוך

 Sabaoth, and by the name of Shaddai, and by the name of "I am that I am", that you should not come near to the house of Abraham son of Ādaredukh,

6. לא במזונה ולא בקינינה ולא בבנה ולא בגופה ויזועון ויזהון ויעידון ויתרחקון

 neither his food nor his property, and neither his sons nor his body. And may they move and depart and pass over and be far away

7. ויעירקון כל פתכרי ופיקדי ולטבי ורוחי בישתא ולילתא לילי דיכרי וניקבתא

 and flee, all idol spirits and *piqda*s and no-good ones and evil spirits and liliths, male and female lilis,

8. מן ביתה דאברהם בר אדרדוך לא את אשמדי ולא כולה פלגיך לא את טיסו

 from the house of Abraham son of Ādardukh. Neither you, Ashmedai, nor all your army, neither you, **ṭysw**

איפורן ולא כולה משריתיך לא את אגרת בת מחלת ולא כולה	9	**'ypwrn**, nor all your retinue, neither you, Agrat daughter of Maḥlat, nor all
מרכבתיך לא את דנחיש ולא כולה שורבתיך לא את	10	your chariots, neither you, Danaḥiš, nor all your tribe, neither you,
זכיא ולא כולה דותקיך לא את אני ולא כולהון	11	**zky'**, nor all your family, neither you, **'ny**, nor all
מואך מן יומא דנן ולעל[ם] מן	12	your centuriae, from this day and for eve[r], from
זרי פרזלא אמן אמן	13	**zry** of iron. Amen, Amen,
סלה	14	Selah.

Outside:

אסירין חתימין [ו]משצטמין כל שידי ודיוי ו[פיקדי ו]לטבי ורוחי בישתא ולילתא ופתכרתא ומבכלתא מן ביתה	15	Bound, sealed [and] shackled are all demons and *dēv*s and [*piqdas* and] no-good ones and evil spirits and liliths and female idol spirits and *mevakkalta*s, from the house
דאברהם בר אדרדוך ומאמא בת ש[...]י אינת[י]ה באיסור איל ש[די] רבא אמ[ן] אמן סלה ויאמר יהוה אל הס[ט]ן	16	of Abraham son of Ādardukh and Māmā daughter of Š[...]y, [his] wife, [by the bond of] the great [El Sha]ddai. Ame[n], Amen, Selah. "And YHWH said unto Sa[ta]n,
יגער יהוה בך הסטן יגער יהוה [ב]ך הב[ו]חיר ב[ירושלי]ם הלא זה אוד מוצל מאש אמן אמן סלה	17	YHWH rebuke you, O Satan, YHWH that has ch[o]sen [Jerusale]m rebuke you. Is this not a brand plucked out of the fire?". Amen, Amen, Selah.

1. **šr šyr'**: "the ring **šr**"; see the introduction to **I.4.1.1.**

5. Ex 3:14.

12–13. **mn zry przl'**: "from **zry** of iron"; the same obscure expression occurs in JNF 88:14 and JNF 121:11. In one parallel, PC 91, the equivalent expression reads **m'h 'zwry przl'** "a hundred girdles of iron".

16. The restorations follow JNF 121:14.

16–17. Zech 3:2; note **yg'r** for MT **wyg'r**.

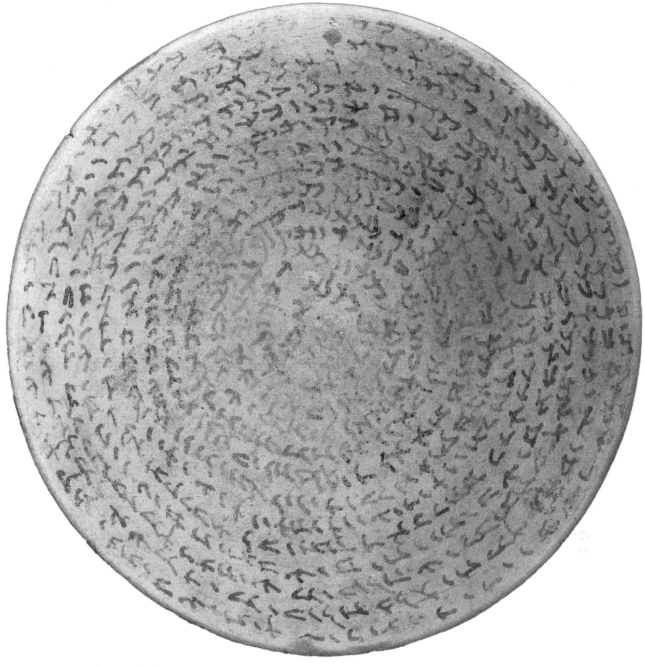

PHOTO 51 JBA 104 (MS 2053/238)—exterior a

PHOTO 52 JBA 104 (MS 2053/238)—exterior b

PHOTO 53 JBA 104 (MS 2053/238)—exterior c

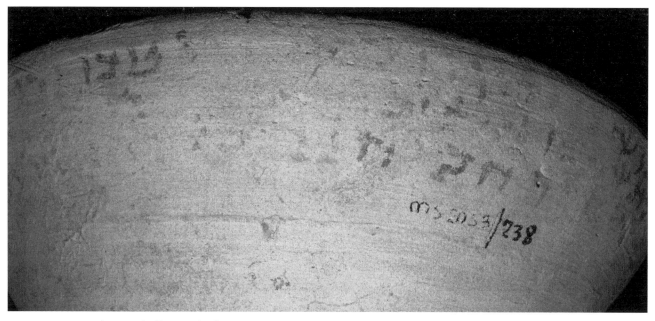

PHOTO 54 JBA 104 (MS 2053/238)—exterior d

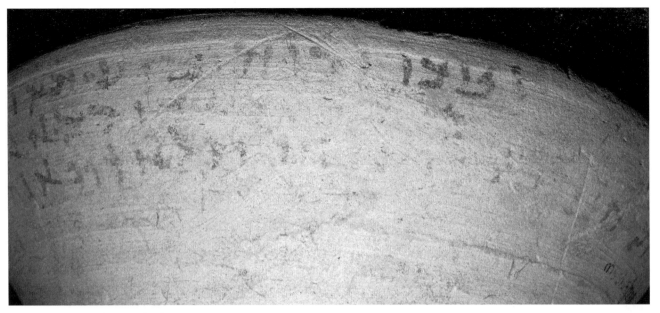

PHOTO 55 JBA 104 (MS 2053/238)—exterior e

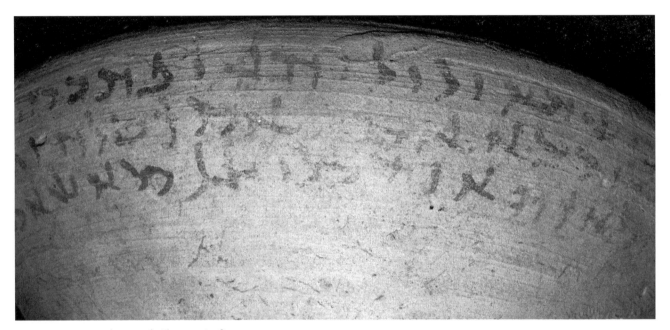

PHOTO 56 JBA 104 (MS 2053/238)—exterior f

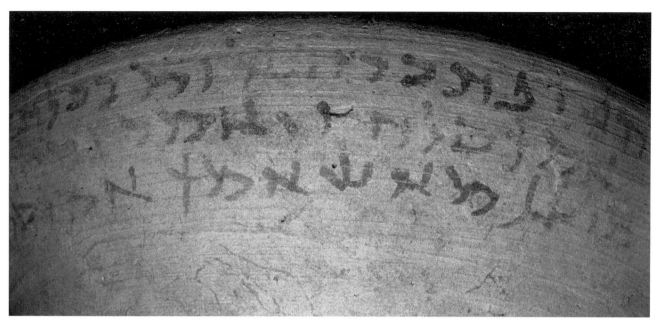

PHOTO 57 JBA 104 (MS 2053/238)—exterior g

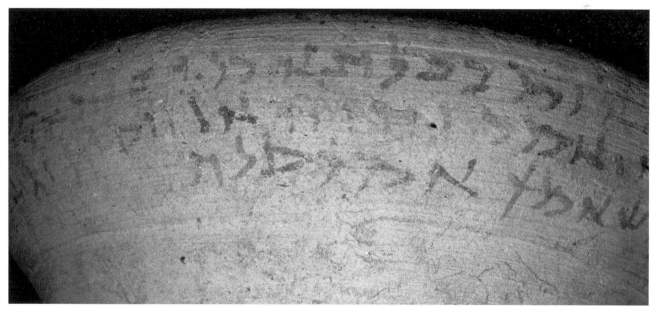

PHOTO 58 JBA 104 (MS 2053/238)—exterior h

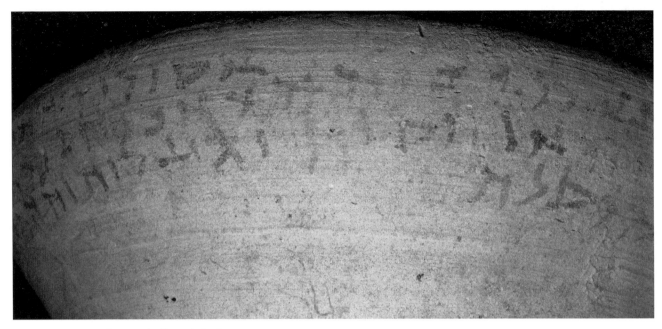

PHOTO 59 JBA 104 (MS 2053/238)—exterior i

I.4.1.3

The Bond and Seal of Arion Son of Zank

∴

Introduction

The spell unit in this section refers to the signet-ring of Solomon together with a number of bonds and seals, including the bond and seal **drywn br znk** "of Arion son of Zank". In addition to these two JBA bowls, the same spell unit is found in two Syriac bowls: Montgomery 34 (for which, see Moriggi 2014, 47–51) and MS 2055/14. The Syriac bowls read **d'rywn br znd** (Montgomery 34:8 and MS 2055/14:8). The same name occurs in the JBA bowls Montgomery 19:13 & 17 and MS 1927/34:10 & 13, where it is also written **'rywn br znd** (see also the notes in Müller-Kessler 2005a, 102; Moriggi 2014, 50). This allows us to read the first name as "Arion" in the present bowls, with the *'aleph* elided after the particle **d-** (the same elision occurs in JBA 105:6 with **dbrksws** "of Abraxos"). In the present bowls, the patronym appears to be written with a final *kaph* rather than a *daleth*, although, admittedly, the two letters are similar in appearance. The two bowls in this section were probably written by the same scribe, and were certainly written for the same family. Two of the clients were married to each other—Gayye son of Baṯ-ḥayyē and Aḥātā daughter of Baṯ-ḥayyē; the identical matronyms may be coincidental, although, if these people were Zoroastrian, marriage of two siblings to each other was highly praised, as were also other forms of next-of-kin marriage, which were called *xwēdōdah*. The partially preserved name -ḥapšabbā is either Bar-ḥapšabbā or Bat-ḥapšabbā, and could suggest a Christian connection for some members of the family. Though generally well preserved, much of JBA 106 remains difficult to decipher and interpret.

JBA 105 (MS 1928/22)

172 × 60 mm. Semi-formal hand. The bowl was broken, but has been repaired. The writing is partly faded in the centre. The text is surrounded by a circle.

Clients: Gayye son of Baṯ-ḥayyē; Aḥāṯā daughter of Baṯ-ḥayyē, his wife.

Image: In the centre of the bowl, within a circle, there is a faded image of what may possibly be a figure standing with open feet and wearing a short tunic. The figure appears to have a sword, which is either being held in its right hand or is hanging diagonally across its body, and it may be holding a shield in its left hand.

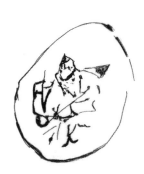

FIGURE 19: Artist's impression of image from JBA 105

1 בשמך [אנ]י עשה אסירה וחתימ[ה] ומזרז{ל}א

1 By your name [I] act. Bound and seale[d] and strengthened (!) is

2 איסקופתיה ודירת{ו}יה וירתיה ובניה ובנתיה

2 the threshold and the dwelling and the heirs and the sons and the daughters

3 ע[...]ה וירתיה ובניה ובנתיה ודותקיה וקיניה ונפשיה

3 [...] and the heirs and the sons and the daughters and the family and the property and the soul

4 וגופיה {ו}דגיי בר בתחיי ודאחתה בת בתחיי איתתיה באסוריה ובחתמיה

4 and the body of Gayye son of Baṯ-ḥayyē and of Aḥāṯā daughter of Baṯ-ḥayyē, his wife, by the bond and by the seal

5 דריון בר זנך ובעיזקתיה דשלמא מלכה בר דוד דבה חתמין עשמי ולטבי

5 of Arion son of Zank, and by the signet-ring of King Solomon son of David, by which are sealed wrath demons and no-good ones.

6 חתימיןתי בחתמא דאל שדי יהוה צבאות ודברכסוס מריא תקיפא ובחתמא רבה

6 You are sealed by the seal of El Shaddai, YHWH Sabaoth, and of Abraxos, the mighty lord, and by the great seal

7 דחתימא ביה שמיא וארעה דכל שידי ודיוי פקדי וללחני מן קודמוהי מיתזעין וחתמא

7 by which heaven and earth are sealed, before which all demons and *dēv*s, *piqda*s and servitors tremble. And this

8 seal he shall not break, and against this amulet and counterchram he shall neither transgress nor prevail. And everyone who regards with malice and roams and jumps

הדין לא ניתבר ועל קמיעה וקיבלה הדין לא ניבר ולא נישתרר וכל דמסקר ושייט ושור

9 shall be bound by a bond of fire and by a chain of water until the loosening of heaven and earth. Ame[n], Amen, Selah.

ניתסר באסור נורא ובשישיל מיא עדאמי למישרא שמיא וארעה אמ[ן] אמן סלֹהֹ

1–2. **wmzrz{l}' 'ysqwptyh**: "and strengthened (!) is his threshold". The subject of the first two participles in this sentence is **'ysqwptyh** "his threshold". The scribe appears to have then switched to a formula resembling that in JBA 106, in which the unspecified subject of the participles is the masculine magic bowl—**'syr whtym wmzrz lgyy br bthyy** "Bound and seal and strengthened for Gayye son of Bat-ḥayyē". It thus appears that the scribe began to write either **wmzrz l'ysqwptyh** "and strengthened for his threshold" or possibly even **wmzrz l'ḥth** "and strengthened for Aḥātā" (cf. JBA 106:3–4), but then returned to the original formula, thus rendering the *lamedh* redundant.

3. **qynyh**: "his property"; for standard **qynynyh**. See also the notes to JBA 73:5, JBA 111:3 and JBA 116:4.

5. **'šmy**: "wrath demons"; for the meaning of this term and its probable Iranian derivation, see Shaked 1985, 514.

6. **ḥtm' d'l šdy**: "the seal of El Shaddai"; see the introduction to **I.4.2**.

8. The first three verbs in this line have an unspecified subject. For the last of these, **nyštrr** "he shall prevail", compare the Syriac cognate (*SL*, 1612).

wkl dmsqr wšyyṭ wšwr: "and everyone who regards with malice and roams and jumps". The first verb relates to the idea of casting the evil eye (cf. *MSF*, 64–65). For the second verb as a ptc. of **šwṭ** "to roam", a typical demonic activity, see Epstein 1922, 52, who aptly compared the same root in Biblical Hebrew (cf. Job 1:7). For the third verb as a demonic activity, see *DJBA*, 1116.

9. **šyšyl**: "a chain of"; the standard JBA form is fem. **šwšylt'** (*DJBA*, 1125). This form appears to be the masc. sg. cstr., for which compare the masc. pl. **šyšlyn** "chains" (e.g. JNF 9:4).

'd'my: "until"; a variant of **'dm'**, which is occasionally attested in the magic bowls and, according to Sokoloff, derived from Syr. **'dm'** (*DJBA*, 844; cf. Morgenstern and Ford 2017, 195).

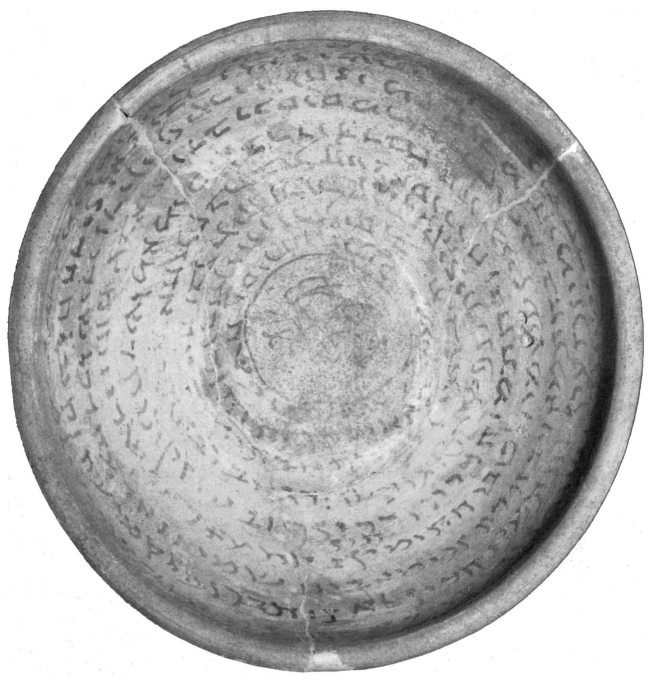

JBA 106 (MS 1928/38)

180 × 60 mm. Semi-formal hand. The bowl was broken, but has been repaired. The writing is partly faded in the centre. The text is surrounded by a circle, and some words are in a cartouche.

Clients: Dāday daughter of Aḥātā; [...] and [...]-ḥapšabbā children of Dāday; Avī (?) son of Dāday; Gayye son of Baṯ-ḥayyē; Aḥātā daughter of Baṯ-ḥayyē, his wife.

Image: There was an image in the centre of the bowl, within a circle, but it is now almost completely faded (cf. JBA 105).

[...]בל[סירה א]ו[שה ע] [אני] [שמד ב]	1	[By] your name [I] a[ct. B]ound [...]
[...] ודאדי בת אחתא [...]מה[י] וחת[...]	2	[...] and se[a]led [...] and Dāday daughter of Aḥātā [...]
[...]ḥapšabbā בני דאדי אבי בר דאדי אסיר וחתים ומזרז לגיי {ו}	3	[...]-ḥapšabbā children of Dāday, Avī (?) son of Dāday. Bound and sealed and strengthened for Gayye
בר בתחיי ובתחיי ואחתה בת איתתיה באסוריהתמיה דריון בר זנך	4	son of Baṯ-ḥayyē and Aḥātā daughter of Baṯ-ḥayyē (!), his wife, by the bond and by the seal (!) of Arion son of Zank,
ובעיזק<ת>יה דש{מ}למא כרי כרא כל עאלמי ודלמי[.]א עדמא עלמא מלכא	5	and by the signet-ring of Solomon ... all the worlds and ... until eternity. The king,
כל מלכה ביאמך למא ליתר וביאסיה מלמא [...] מך אמן מאגמי לייי	6	every king ... and by the healer, ... Amen ... to YYY
למא ומן יאנייל ומן יהוה יה יה יה יה יה יה יה יה יה [יה י]ה ואמן סלה סילה	7	... and from Yaniel, and from YHWH YH YH YH YH YH YH YH YH YH [YH Y]H and Amen, Selah, Selah,
אמן על כל מן שמיא ואמן סל[...]שיל משמ[י]א למשרא למ'שרא עאלמא אמן סלה	8	Amen, against all, from heaven, and Amen, Sela(h) [...] from heav[e]n, for the dissolution, for the dissolution of the world. Amen, Selah,
[.]אלמן כל מן אעלמא מן לסלמה מן ילמ[.]ם אמן אמן סלה	9	[.] ... from eternity, ... Amen, Amen, Selah.

4. The scribe has made two errors in this line. The first relates to the final client's name. The scribe initially wrote the matronym, but then added the correct name above it. The matronym was not repeated in the text, however, meaning that we have to read **wbthyy** (above: **w'ḥth**) **bt** as **w'ḥth bt bthyy**. The second error relates to the two items in the possession of Arion son of Zank. From JBA 105:4, we would expect something like **b'swryh wbḥtmyh** "by the bond and by the seal". In the present text, however, these two items have been merged into **b'swryhtmyh**.

6–9. We cannot propose a meaningful translation of these lines at this time.

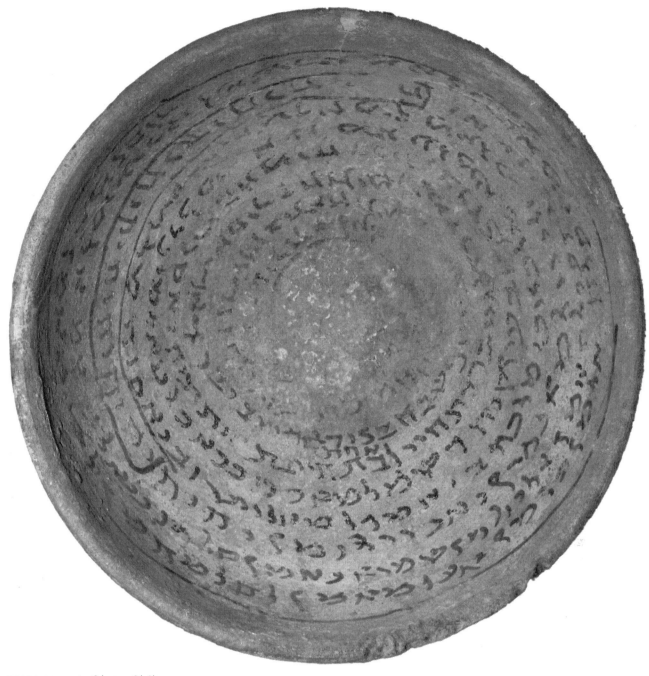

I.4.1.4

Other Spell Units

∴

Introduction

This section contains four distinct texts that refer to the signet-ring of Solomon. The first, JBA 107, contains a well-known spell unit. Published parallels include Gordon B and Abousamra 2010. Unpublished parallels include JNF 54, JNF 123, JNF 162, JNF 163 and PC 114. It appears that the same scribe was responsible for JBA 107, Abousamra 2010, JNF 123, JNF 162, JNF 163 and PC 114. See also Müller-Kessler 2005a, 25; Morgenstern and Ford 2017, 203–204. The clients in JBA 107, Busay son of [...] and his wife Marqonta daughter of [...], are probably the same as in the Syriac bowl MS 2055/5.

The second text, JBA 108, is poorly preserved and apparently poorly written, containing several errors that result from dittography, haplography and the writing of superfluous letters.

The third text, JBA 109, contains a simple spell followed by two biblical verses, the second of which has been adapted to refer to the client in the third person. This bowl, which is inscribed with a large and crude hand, contains a non-standard orthography for both the Aramaic and Hebrew passages, as well as several errors.

The fourth text, JBA 110, invokes both the signet-ring of Solomon and the seven seal stones of Lord Bagdana son of Ibol, who is said to be the father of the evil spirits, in order to counteract a curse sent against the clients.

JBA 107 (MS 1929/7)

170 × 65 mm. Semi-formal hand. The writing is partly faded in the centre. The text is surrounded by a circle.

Clients: Būsay son of [...]; Marqōntā daughter of [...], his wife.

Image: In the centre of the bowl, there is a faded design within a small circle. Nearly identical and clear versions are found in JNF 123, JNF 162 and JNF 163, parallel texts that appear to be by the same scribe. In these versions, the small circle contains a stick figure, showing a tiny head, outstretched arms, and legs with turned out feet. Another unclear version is probably found in PC 114.

FIGURE 20: Artist's impression of image from JBA 107

1 The demon nṭy' [ṭ]ty' qly' btyh [Nu]riel, שידא נטיא [ט]טיא קליא בתיה [נו]ריאל

2 the holy rock. [Sealed] and double sealed and fortified is [the] house [and the children] and [the] property צור קדוש [חתים] ומחתם ומסגי בית[יה ובניה] וקיני[ן]יה]

3 of Būsay son of [...] Marqōntā daughter of [...], his wife. דבוסי בר [...] מרקונתא בת [...] אינתתיה

4 They are sealed by the signet-[ring of El Shadda]i, blessed is he, and by the signet-ring of King Solomon son of David, חתימין בעיז[קתא דאל שד]י ברוך הוא ובעיזקתא דשלמוה מלכא בר דוד

5 who performed magical rites against male demons and against female liliths. They are sealed and double sealed and fortified against דעבד עיבידתא בשידי דיכרי ובליליתא ניקבתא חתימין ומחתמין ומסגן מן

6 the male demon and against the female lilith, against the vow demon, and against the curse demon, and against the mishap, and against the blow demon, and against the evil שידא דיכרא ומן לילית ניקבתא מן נידרא ומן לוטתא ומן קריתא ומן אישתקופתא ומן עינא

7 בישתא ומן חרשין בישין מן חרשי אימא וברתא ומן חרשי כלתא וחמתא ומן חרשי איתתא זידניתא	eye, and against evil sorcery, against the sorcery of a mother and a daughter, and against the sorcery of a daughter-in-law and a mother-in-law, and against the sorcery of a wicked woman
8 מחשכא עינין ומפחא נפש ומן חרשי בישי דעל ידי אינשה מיתעבדין ומן כל מידעם ביש בשום יהוה	(who) darkens eyes and makes the soul despair, and against the evil sorcery that is performed by a man, and against every evil thing. By the name of YHWH
9 יהוה צבאות שמו אמן אמן סלה	"YHWH Sabaoth is his name". Amen, Amen, Selah.

1. **nṭyʾ ṭṭyʾ qlyʾ btyh:** Following Gordon 1934b, 324–325 (see also Isbell 1975, 110), we tentatively interpret these words as magic names. It is unclear whether they refer to the initial demon or the following Nuriel. If they refer to the harmful demon, the phrase **qlyʾ btyh** could mean "he burns houses"—compare the use of QLY in JBA 47:10. Alternatively, Abousamra interprets these as names of demons, but also suggests that they may be adjectival epithets of the initial demon (Abousamra 2010, 112).

2. **msgy:** "made great" (see also l. 5); Gordon explained **msgn** in Gordon B:2 as a *pa.* masc. pl. pass. ptc. that, when followed by the prep. **mn**, would have the meaning "made greater than" and hence "made safe from, fortified against". On the other hand, Abousamra understands it as a variant of the root SGR and translates it as "attaché/fermé" (Abousamra 2010, 113; see *DJBA*, 787). If this understanding is correct, we would translate the phrase "closed off from".

6. **nydrʾ:** "vow demon"; read also **nydrʾ** for Gordon's **ʿbd** in Gordon B:6.

8. **mḥškʾ ʿynyn wmpḥʾ npš:** "she darkens eyes and makes the soul despair"; see Gordon 1934b, 326, who rightly compares these expressions with TO Lev 26:16 (as well as TO, TPs-J and P of Deut 28:65).

9. E.g. Is 47:4 (this phrase occurs thirteen times in the Bible).

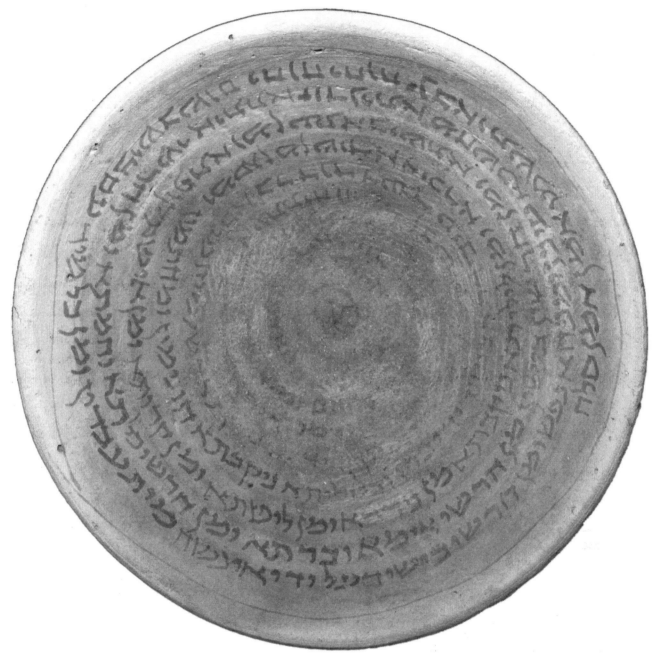

JBA 108 (MS 2053/218)

165×55 mm. Crude semi-formal hand. The bowl was broken. It has been repaired, but is missing one small portion at the rim, and the repairs often obscure the text. The text begins at the rim and proceeds towards the centre. Much of the text is badly faded. The text is surrounded by a circle.

Linguistic and orthographic features: Note the use of *waw* for *qamaṣ* in Aramaic **'ynwšy** (ll. 2 and 4), as well as in Hebrew **hswṭwn** (twice in l. 8) and **mpwrwš** (l. 7).

Clients: Kafnay son of Dēdukh; Avūy (?) son of Dēdukh; [... son or daughter of] Qāqā.

Biblical quotations: Zech 3:2; Num 12:13.

Image: There was an image in the centre of the bowl, but it is now almost completely faded. It appears to have depicted a rounded figure. The remains of what could be one leg may be discerned beneath it. The image was surrounded by a large circle, with numerous short lines protruding towards the centre of the bowl.

FIGURE 21: Artist's impression of image from JBA 108

1 [May there be] healing from hea[ven] for the house and for the dwelling [and] for [...] Qāqā, in order that th[ey] may [be healed] and protected from every enemy [...] Seale[d and double sealed ...] his c[a]ttle stall and his donkeys and his goats

2 and his (other) animals and [his] p[igs ...] Avūy (?) son of Dēdukh [...] Qāqā. Sealed and double sealed is the property [and] all the people [of] the house of Kafna[y]

3 son of Dēdukh [...] and fr[om] the satan [and] fr[om] the *mevakkalta* and from the ban demon [and fr]om dreams and from sev[e]re visions and from

4 every evil enemy [...] from the house and from th[e] dwel[ling ...] the threshold, from the property and fr[om the pe]ople of the house of [Ka]fnay

5 son of Dēdukh [... Sealed and double] sealed is the [ho]use, the dwelling and the thre[s]hold and the property [and al]l the p[eople] of the house of Kaf[nay] son of

6 Dēdukh [...] and [by the sig]net-ring of the angel Gabriel, and by the sig[ne]t-ring of [K]ing Solo[mon son of Da]vid, [...]

7 [...]rbyy and by his signet-ring, on [which] the ineffable name is [draw]n (and) car[v]ed, from the six [days of crea]tion [and for] ever. [Amen], Amen, [Selah].

8 "[And] YHWH [said un]to Satan, YHWH rebuke you, O Satan, YHWH that has chosen [...] rebuke you [...] a brand plucked out of the fi[re]?".

9 "[And] Moses [cri]ed to YHWH saying, O God, heal!". Amen, Amen, [Selah].

1. **q'qh dytswn:** "Qāqā, in order that they may be healed"; the reading is uncertain. For the personal name, compare l. 2 (cf. also **q'q'** in SD 58). It is probably a variant of the more common **q'q'y** or **q'qy** "Qāqay" (e.g. JBA 48, JBA 54 and JBA 63).

{w}mn: "from"; the superfluous *waw* suggests that a list of evil spirits has been omitted (cf. ll. 3–4).

'wryh: "his cattle stall"; the reading is uncertain. Compare the following from Aaron Bowl B:5–6, which we read: 'wryh wḥmryh wgydyh wgyddtʾ wʿyzyh wḥywtyh ḥzyryh wḥzyrtyh "his cattle stall and his donkeys and his male kids and his female kids and his goats and his (other) animals, his pigs and his sows". In both JBA 108 and Aaron Bowl B, these animal terms could be singular morphologically.

2. 'bwy... qʾqh: "Avūy ... Qāqā"; the reading is uncertain. The first name could perhaps be [b]'bwy (e.g. CAMIB 23A) rather than 'bwy.

kpny: "Kafnay"; the *yodh* has probably been covered by the following *beth*.

3. mšwmwtʾ: "the ban demon"; for standard mšmtʾ (cf. JBA 94:2). The first *waw* probably represents the common shift /a/ > /u/ before labial *mem*. The second *waw* remains unexplained.

5. wʾs[...]ptyh: "and his threshold"; there is room for approximately three letters in the lacuna.

6. bdwyd: "son of David"; the traces and available space suggest that the scribe omitted either the *reš* or the *daleth* by haplography.

8. Zech 3:2.

9. Num 12:13. Note **lymr** for MT **lʾmr**, and the omission of MT **lh**.

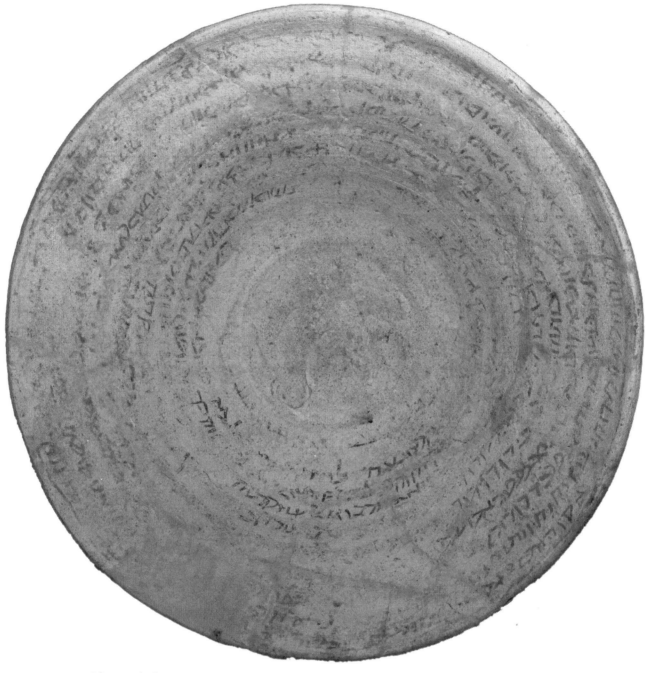

JBA 109 (MS 2053/230)

177×65 mm. Crude semi-formal hand. The bowl was broken. It has been repaired, but is missing one small portion at the rim. The lines are written in concentric circles rather than a spiral. With the exception of the last line, each line begins at approximately the same place. The text is surrounded by a circle.

Linguistic and orthographic features: Note the use of –h rather than –yh for the 3 p. masc. sg. pron. suffix in **'sqwpth** and **byth** (both l. 1) and **lh** (l. 6). Note the defective spelling of the pass. ptc. in **ḥtm** (l. 1) and **ḥtm'** (l. 3). Note the loss of intervocalic 'aleph in **wr'h** (l. 3).

Clients: Rasay son of Nēwdukh (or possibly Nowdukh).

Biblical quotations: Zech 3:2; Ps 55:9.

Image: In the centre of the bowl, there is an image consisting of a crudely drawn pair of circles, one within the other, that may represent either an eye or the concentric circles of the text.

FIGURE 22: Artist's impression of image from JBA 109

חתם ומחם ביתה אסקופתה	1	Sealed and double sealed (!) is the house (and) the threshold
דרסי בר נודוך בעיזקת דשל{מלכ}	2	of Rasay son of Nēwdukh, by the signet-ring of King
מו{כ} מלכה בר דוד דחתמא בה שמיא ורעה	3	Solomon (!) son of David, by which heaven and earth are sealed.
ויאמר יהוה אל הסטני יגער יהוה בך הסטני יגער יהוה	4	"And YHWH said unto Satan, YHWH rebuke you, O Satan, YHWH that has chosen

5 Jerusalem rebuke you. Is this not a brand plucked out of the fire?". Amen, Amen, Selah.

בך הבחר בירואשלם הל זי אוד מצאלא מאש אמן אמן סלה

6 "I would hasten escape" for him "from the stormy wind and tempest". sʿwr [...]' from tempest. Amen, Amen, Selah. And sou(nd).

איש מפלט לה מרוח סעה מסער סעור [...]א {מי} מיסער אמן אמן סלה ושר

1. **mḥm**: Error for **mḥtm**.

2–3. **bʿyzqt dšl{mlk}mw {k} mlkh**: "by the signet-ring of King Solomon"; the scribe has made a series of errors in writing this phrase. The 3 p. masc. sg. pron. suffix has been omitted from ʿyzqt. The scribe then wrote **šlmlk** as haplography for **šlmw mlk(h)**, before correcting himself with **mw {k} mlkh** on the next line (the superfluous *kaph* could also be an incomplete superfluous *lamedh*).

3. **bh**: "by it"; the scribe has rewritten the *beth*, leaving the right hand side of the initial effort visible.
wrʿh: "and earth"; a phonetic spelling for **wʾrʿh**.

4–5. Zech 3:2. Note **hsṭny** for MT **hśṭn** both times; **ygʿr** for MT **wygʿr**; **byrwʾšlm** for MT **byrwšlm**; **hl zy** for MT **hlwʾ zh**; and **mṣʾl** for MT **mṣl**.

6. Ps 55:9. Cf. JBA 55:14, where the same verse is similarly adapted. Note **ʾyš** for MT **ʾyšh**.
wšr: "and sou(nd)"; apparently the scribe ran out of space and was unable to write the full **wšryr**.

I.4.1. THE SIGNET-RING OF SOLOMON

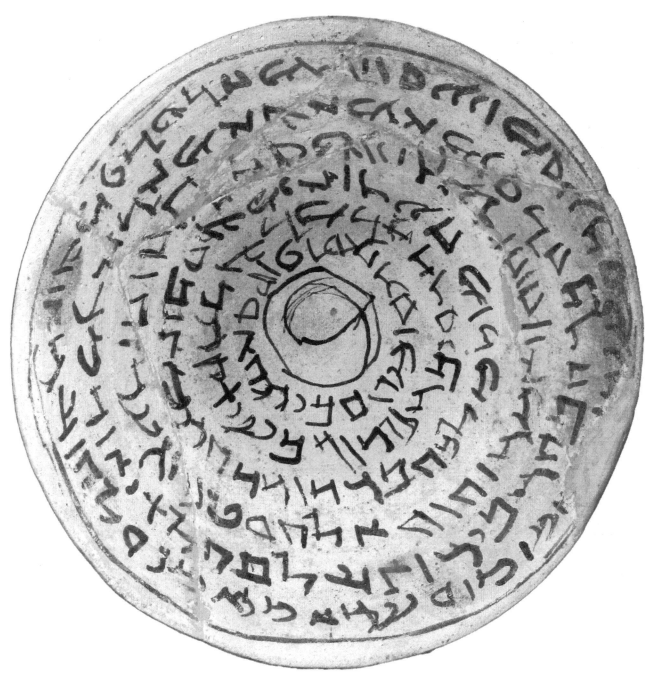

PHOTO 64 JBA 109 (MS 2053/230)

JBA 110 (MS 2053/240)

150 × 65 mm. Semi-formal hand. The text is faded on one side of the bowl. One word is in a cartouche. At the end of the text, there appears to be a minute design, perhaps resembling a cross.

Linguistic and orthographic features: Note the use of **-h** rather than **-yh** for the 3 p. masc. sg. poss. pron. suffix in **ʾyntth** (l. 6), **ʾlh** (l. 5), **byth** (l. 6), **bnh** (l. 6), **ydh** (l. 3), **lh** (l. 6), and **mynh** (ll. 6 and 7). Note also the use of ʾaleph for historical ʿayin in the prep. **ʾl** (l. 5). Note the complete loss of ʿayin in **šb** (l. 1). Note the defective spelling of the pass. ptc. in **nqṭ** (l. 3).

Clients: Bayyazaddād son of Gušnay; Dukhtay daughter of Hormizdukh.

1 תוב תיתסרון בשום {שבה} שב חומרין דמריא בגדנא בר יבול אבוכון
 Again, may you be bound by the name of the seven seal stones of Lord Bagdana son of Ibol, your father,

2 ופכ[יריתו]ן [...] וחמרין ואסריתון איסתרתא וקטיריתון בקיטרא
 and [yo]u [are] clas[ped ...] and amulet spirits, and you are bound, goddesses, and you are tied with a knot

3 דחר[...] שליפה בידה נקט תוב אסריתון אין אתון
 that/of [...] a drawn (sword) in his hand he holds. Again, you are bound, yes, you,

4 בעיזקתיה דשלמה מלכא בר דוד בשום מלאכיה בזרב דימקמם להון על חומרתא דיכותיכון
 by the signet-ring of King Solomon son of David, by the name of the angels, by the bolt that they use to restrain the amulet spirit that is like you.

5 [וא]סירין כל[הון חיל]וותה ד[מ]רומא ניקלון נידרא וקריתא אלה דביזדד בר גושני ודדוכתי בת הורמיזדוך ונישתקלון
 [And bo]und are all the [power]s of the [he]ight. May the vow demon and the mishap abate (from) upon Bayyazaddād son of Gušnay and Dukhtay daughter of Hormizdukh, and may they be removed

6 מינה וניסתלקון מן ביתה ומן אינתתה ומן בנה בשום יהוה צבאות דניהון לה בנין ויתיקימון ל[ה] מילי דמלאכיה
 from him, and may they depart from his house and from his wife and from his children, by the name of YHWH Sabaoth, in order that he may have children, and the words of the angels may be fulfilled for [him],

7 ונישרון מינה לוטתא בשום יוש[.]ה אמן אמן סלה הלליויה
 and may they loosen from him the curse. By the name of **ywš[.]h** Amen, Amen, Selah, Hallelujah.

3. [...] **šlyph bydh nqṭ**: "[...] a drawn (sword) in his hand he holds"; the traces at the end of the lengthy lacuna do not suggest **ḥrbʾ** or the like. Compare JNF 254:2, which reads: **wḥrbh šlypʾ wskynʾ bydy lgyṭnʾ** "and a drawn sword and a knife in my hands I hold".

4. **bzrb dymqmm lhwn ʿl ḥwmrtʾ dykwtykwn**: "by the bolt that they use to restrain the amulet spirit that is like you"; a tentative interpretation. For **zrb** "bolt", cf. Syr. **zwrbʾ** "bolt of door" (SL, 376). For the meaning of the *qeṭīl l-* form **mqmm lhwn** "(lit.) it is restrained by them",

cf. Syr. qmm *pa.* "to muzzle" (*SL*, 1378); the 3 p. masc. pl. pron. suffix refers back to the angels. The 2 p. masc. pl. pron. suffix in **dykwtykwn** "that is like you" refers to the evil spirits being addressed in line 3.

5. **nyqlwn... 'lh:** "may they abate ... (from) upon him"; i.e. from QLL (cf. *SL*, 1372). Compare the use of this verb with the prep. 'l in P 4 Mac 9:31, which has the phrase **'n' gyr ... ḥšy 'ly qlyn** "for I ... my pains are alleviated from me".

byzdd br gwšny: "Bayyazaddād son of Gušnay"; see the introduction to **I.3.1**.

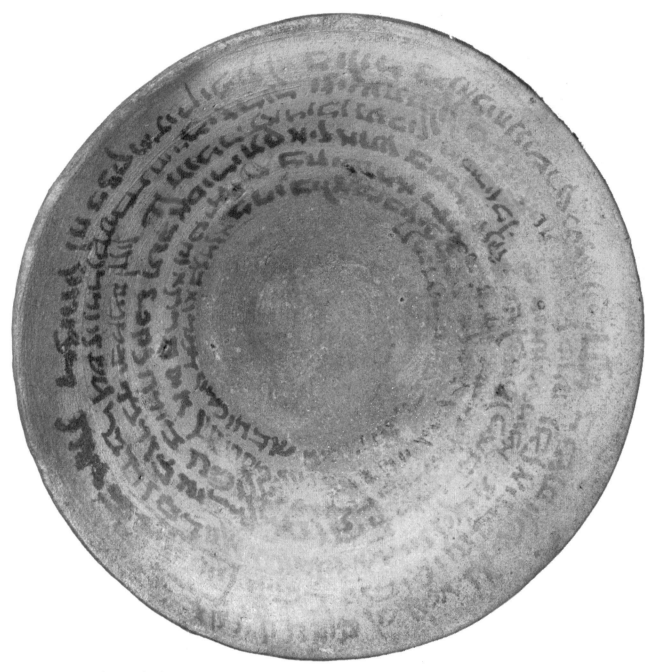

PHOTO 65 JBA 110 (MS 2053/240)

I.4.2

The Signet-Ring of El Shaddai

∴

Introduction

Both texts in this section refer to the signet-ring of El Shaddai, which is a very common motif in the Jewish magic bowls as well as in later Jewish magic. Other bowls in the Schøyen Collection that refer to the signet-ring of El Shaddai include JBA 23, JBA 24, JBA 43, JBA 46, JBA 65, JBA 95, JBA 107, MS 1927/30, MS 1927/41, MS 1927/49, MS 1927/60, MS 1929/14, MS 2053/179, MS 2053/199, MS 2053/252, and MS 2053/261; cf. JBA 105:6, which refers to ḥtm' d'l šdy "the seal of El Shaddai". The following texts are presented in this section because they lack another, more suitable, classification. JBA 111 was written by the same scribe and for the same client as JBA 76 and M 59 (Levene 2003a, 31–39).

Other spells that occur in the bowls in this section:
– The grabber and the snatcher—JBA 111:5

JBA 111 (MS 1929/13)

160 × 60 mm. Semi-formal hand. The writing is partly faded towards the rim. The arrangement of the text is irregular on account of the large image.

Linguistic and orthographic features: Note the use of –h rather than –yh for the 3 p. masc. sg. pron. suffix in **lh** (l. 3). The scribe inserts apparently superfluous –**ny** syllables into **zydnynyt'**, **'syrytynynyn** and **ḥtymytynyn** (all l. 5).

Clients: Ardōy son of Khwarkhšēddukh; Khwarkhšēddukh daughter of Yāwīṯā.

Image: In the centre of the bowl, there is a large image of two frontal figures standing beside each other, with their heads in profile facing outwards. They are not human, but appear to be feminine on account of their long, disheveled hair. Their bodies consist of a band, with short vertical stripes, that includes their shoulders and legs. Each pair of legs crosses the other, so that the lower parts of the two figures intertwine. Their feet are big, with curved claw-like toes. Only two arms are drawn, one for each figure, with small hands that end with straight fingers. Their heads are small, each with one large round eye, with pupil indicated, and a beak at the front. A rope appears to bind the figures by their shoulders and hands.

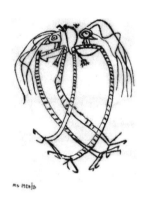

FIGURE 23: Artist's impression of image from JBA 111

דין קמיעה	1	This amulet is
לחתמתא דביתיה	2	for the sealing of the house
ואיסקופתיה ודירתיה ותרעיה וקיניה דארדוי בר כורכשידוך ודכורכשיד[ו]ך בת יויתא וכל שום דאית לה	3	and the threshold and the dwelling and the gate and the property of Ardōy son of Khwarkhšēddukh and of Khwarkhšēdd[u]kh daughter of Yāwīṯā, and any name that he has,
מן כל פגעין ומן שידין ומן שיבטי[ן] ומן לילייתא ביש[תא] דיכרי וניקבתא משמתא מב[כלתא] מלו[יתא ורו]חי בישתא	4	from all affliction demons and from demons and from afflictio[ns] and from evi[l] liliths, male and female, the ban demon, the *meva[kkalta]* demon, the compan[ion demon, and] evil [spir]its,

וחומרי זידניניתאסיריתיניני וחתימיתינין	5	and wicked amulet spirits. You are
בעיזקתיה דאל שדי תוב אסיריתינ]ינין ... לי[לי		bound and sealed by the signet-ring of
דברא ולילִיתא דמתא {דמתא} דמִיתקריא		El Shaddai. Again, yo[u] are bound [... li]li
שיליניתא וחטפיתא כולכין תליתיכין וארבעתִ]יכִין		of the field and lilith of the town, who is
[...		called the grabber and the snatcher, all of
		you, the three of you, and the four o[f you
		...]
[...] פוקו ושמעו [...]	6	[...] go out and listen [...]
[...]	7	[...]

2. The two words in this line are on opposite sides of the bowl, and are separated by the drawing.

3. **qynyh:** "his property"; see the notes to JBA 73:5, JBA 105:3 and JBA 116:4. In the corresponding sequence of terms in JBA 76:1–2, written by the same scribe for the same client, one finds the standard form **qynynyh**.
wkl šwm d'yt lh: "and any name that he has"; given the corresponding phrase in JBA 76:3 and M 59:8 (Levene 2003a, 35), in which only the son is named, the pron. suffix is probably referring to Ardōy son of Khwarkhšēddukh.

5. **zydnynyt'syrytynynyn:** "wicked (amulet spirits). You are bound"; i.e. a *sandhi* spelling for **zydnynyt' 'syrytynynyn**.

'syrytynynyn wḥtymytynyn: "you are bound and sealed"; i.e. pl. pass. ptc. with 2 p. fem. pl. encl. pron. in both cases. It is likely that the partially preserved **'syrytyn[ynyn]** was also written this way.
Note that the line resumes, with the reference to the "lili of the wild", on the other side of the drawing.
For the meaning of the expression **tlytykyn...** "the three of you ...", see Bhayro 2013, 193–194.

6. **pwqw wšm'w:** "go out and listen"; this sequence of verbs also occurs in JBA 19:12. It may be possible to read **mn bytyh w'ysqwp[tyh]** "from the house and the thresho[ld]" later in the line, but this is very uncertain.

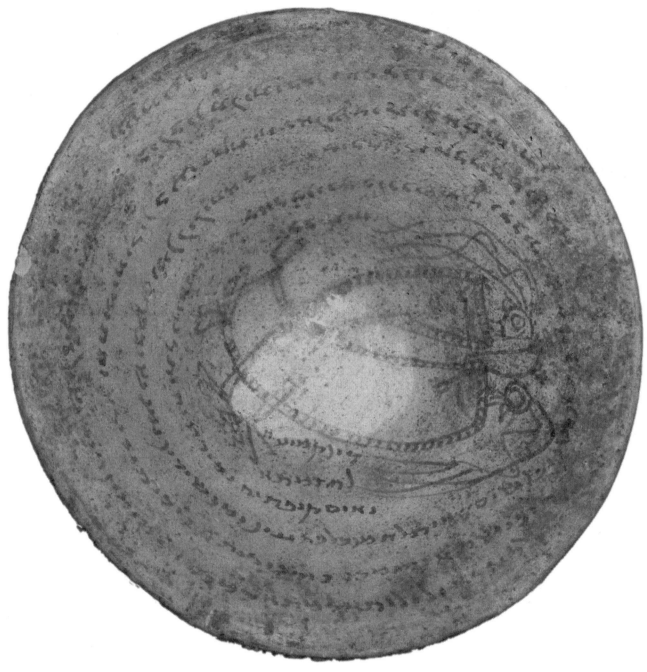

PHOTO 66 JBA 111 (MS 1929/13)

JBA 112 (MS 2053/84)

165 × 60 mm. Semi-formal hand. The bowl was broken, but has been repaired. Most of the writing is lost due to the flaking of its surface, and much of what remains is badly faded. The text appears to be surrounded by a circle.

[...] 1 [...]

[...] 2 [...]

[...] בר [...] 3 [...] son of [...]

[...] 4 [...]

[...] 5 [...]

[...] 6 [...]

[...] ובשמיה ד[...] 7 [...] and by the name of [...]

[...] ותוב צירתון וחתימיתון מינהו[ן ...] 8 [...] And again you are tied up and sealed from the[m ...]

[...] שבע איסקופתהון בעיז[ק]תיה דאל שדי רבה א[ל] שדי מ[...] 9 [...] their seven thresholds, by the sig[net]-ring of the great El Shaddai, E[l] Shaddai [...]

7. It may be possible to read **wbšmyh d'rgyh**, but the text is very unclear following **d-**.

8. It may be possible to read [...] **bt** [**m**]**'my** [**w**]**m**[**n** ...] "[...] daughter of [M]āmay [and] fr[om ...]" later in the line; again, this is very uncertain.

9. It may be possible to read **mry** "Lord of" following the second "El Shaddai".

PHOTO 67 JBA 112 (MS 2053/84)

I.4.3

The Signet-Ring of ʿwrbyd

∴

Introduction

The three texts in this section contain a formula that also occurs in JNF 96, JNF 197, M 9 and M 10. All seven of these texts appear to have been written by the same scribe, who probably also wrote the following texts: Anonyme Privatsammlung Deutschland, IM 142131, JBA 21, JNF 156, JNF 170, JNF 172, JNF 173, JNF 175, JNF 176, JNF 180, PC 85. The scribe generally distinguishes between *waw* and *yodh*.

Both JBA 113 and JBA 114 are badly faded in parts. They can be read, however, with the help of JBA 115, which is very well preserved. The main feature of this formula is the following passage: **ḥtym wmḥtm bzyr šyrʾ wbzmyn ʿyzqtʾ bgwšpnqʾ dʿwrbyd dḥtymyn bh kypy šmyh wʾrʿh** "Sealed and double sealed by the ring **zyr** and by the signet-ring **zmyn**, by the signet-ring of **ʿwrbyd**, by which the edges of heaven and earth are sealed" (JBA 113:5–6, JBA 114:10–11, JBA 115:4–5). For the meaning of the term **šyrʾ** in the phrase **bzyr šyrʾ wbzmyn ʿyzqtʾ**, see the introduction to I.4.1.1. For the interpretation of **kypy** as "edges", see Ford 2014, 236–237.

The name **ʿwrbyd** remains unexplained. It could possibly derive from Latin *orbita* "orbit, circle" etc., although the initial *ʿayin* would be unexpected—compare Syr. **ʾwrbṭʾ** "orbit" (< Latin *orbita*; SL, 20). If this were the case, however, the phrase **bgwšpnqʾ dʿwrbyd** could mean something like "the circular signet-ring".

This formula ends with the following sequence of words: **lʾ mnh ṣdyqʾ rbh rʾš dr dry lypy ʿly rʾš bmlkwtʾ ʿlyhy br mbrgyrʾ wʾplypr ʾṣyṣ ʾršyh ʾnqy ʾbq** (JBA 113:6–7, JBA 114:11–12, JBA 115:5–6; see also JNF 197:8–9). Although many of words make sense, it is not possible to propose a sensible translation. This appears, therefore, to be a magic sequence (compare also JNF 173:6). Another magic sequence occurs at the end of JBA 115.

The scribe concluded JBA 114 with **gbryʾl wmykʾl wrpʾl ḥtymyn ʿl hdyn ʿwbdʾ** "Gabriel and Michael and Raphael sign on this magical act". This appears to have been a favourite closing phrase for him, as it occurs at or near the end of the following bowls, regardless of the formulae they contain: IM 142131, JBA 21, JNF 156, JNF 172, JNF 180, PC 85 and, probably, Anonyme Privatsammlung Deutschland. In JNF 197:10, he substituted the words **hdʾ ḥtmtʾ** "this sealing" for **hdyn ʿwbdʾ**. Incidentally, this scribe also appears to have favoured using the Joshua bar Peraḥia formula (IM 142131, JBA 21, JNF 172, JNF 175, JNF 176, JNF 180, PC 85) and quoting Is 50:11 (JBA 113, JBA 114, JNF 176, JNF 197).

The clients in JBA 113, Guryā son of Mannevō and Mannevō daughter of Kakkōr, also appear in PC 85, which helps us restore the name of Mannevō's mother. Mannevō derives from ʾAmat-Nevō "Maidservant of Nabû", with loss of initial *ʾaleph* and assimilation of *taw*; for names of this type, see Ford and Morgenstern 2020, 102 (n. 380) and the bibliography cited there. The form **ʾmnbw** is attested in JNF 291 (**ʾmnbw bt škr**) and SD 22 (**mhyzyd br ʾmnbw**, where the first name, Māh-yazid, is typically Zoroastrian). We take Guryā as Semitic (< Aram. **gwryʾ** "cub"), but Gignoux, Jullien and Jullien 2009, 74, interpret the similarly written PN **gwryʾ** in Syriac documents as Iranian Gōriy (< MP *gōr* "onager, wild ass").

The clients in JBA 114, Mihraqān son of Hormizdukh and Farnaq daughter of Margānītā, also appear in JNF 269 (which was written by a different scribe). For **myhrqn** "Mihraqān", see Justi 1895, 214 (s.v. Miþrakāna), and for the wife's name, **prnq** "Farnaq", see ibid., 92 (s.v. Φαρνάκη).

Other spells that occur in the bowls in this section:
– I release, dismiss and divorce—JBA 114:8
– Gabriel and Michael and Raphael sign—JBA 114:13

JBA 113 (MS 1927/14)

120 × 50 mm. Semi-formal hand. The writing is badly faded in the centre and on one side.

Linguistic and orthographic features: Note the reduction of *'ayin* to *'aleph* in *'ʾyl* (l. 5), and in *'lylyh* (l. 10).

Clients: Guryā son of Mannevō; Mannevō daughter of [Ka]kk[ōr].

Biblical quotations: Is 50:11; Ps 125:2.

1 חתימא ומחת[מ]א [...] דגוריא	1 Sealed and double sea[le]d [...] of Guryā
2 בר מנבו ו[ד]מנבו בת [כ]כ[ור מ]כל ש[יד]ין [ו]שי[פ]טין ופגעין	2 son of Mannevō and [of] Mannevō daughter of [Ka]kk[ōr, from] all de[mon]s [and] affli[cti]ons and affliction demons
3 וסטנין וירורין ולילין [ו]מן כל [... ומז]יקין בישין דאית	3 and satans and *yaror* demons and lilis, [and] from all [... and] evil [tormen]tors that are
4 ב[ע]למא דידכיר ש[מיה]ון ודלא דכיר [שמיהון] חת[ימא] ומחתמא היא וכל ע[בורא]	4 in the [wo]rld, (both) those whose na[me] is mentioned and those who[se name] is not mentioned. Sea[led] and double sealed is it and all [the] gr[ain]
5 [ואעי]לא דאעיל ל[גו]ה מ[ן] יומא דין ולעלם חתים [ומח]תם בזיר שירא ובז[מי]ן עיזק[תא]	5 [and] the [inco]me that enters with[in] it, fro[m] this [day] and for ever. Sealed [and double se]aled by the ring zyr and by [the] signet-ri[ng] z[my]n,
6 בגושפנקא [ד]ע[ו]רביד ד[חתימין ב]ה[ה] כיפי שמיה [ו]א[רע]ה לא מנה צדיקא רבה ראשה	6 by the signet-ring [of] '[w]rbyd, by whi[ch] the edges of heaven [and] ea[rth are sealed]. l' mnh ṣdyq' rbh r'šh
7 דר דרי ליפי עלי ראשה במלכותא עליהי בר מברגירא ואפליפר אציץ ארציה אנקי אבק	7 **dr dry lypy 'ly r'šh bmlkwt' 'lyhy br mbrgyr'** and **'plypr 'ṣyṣ 'rṣyh 'nqy 'bq**
8 הן כולכם קודחי אש מאזרי [זיקות לכו] באור אשכם ובזיקות ביערתם מידי היתה זאת לכם	8 "Behold, all you who kindle a fire, who surround yourselves with [sparks; walk] in the light of your fire, and in the sparks that you have kindled. This came to you from my hand;
9 למעציבא תשכבון ירושלים ה[רים סביב] לה יהוה סביב לביתיה ולמדריה ולכלביה ולעבוריה ולכל	9 in sorrow you shall lie down". "As the moun[tains surround] Jerusalem, so YHWH surrounds" the house and the dwelling and the storehouse and the grain and all
10 אליליה דהדין גוריה ומנבו מעתה ועד עולם	10 the income of this Guryā and Mannevō, "from now and for ever".

4–5. The restoration of the phrase **wkl ʿbwrʾ wʾylʾ** "and all the grain and the income" is based on the occurrence of **wlʿbwryh wlkl ʾlylyh** in ll. 9–10.

5. **dʾʿyl**: "that enters"; i.e. a *pe.* masc. sg. act. ptc. of ʿLL "to enter" (see the note to JBA 103:9).

8–9. Is 50:11.

9–10. Ps 125:2, with **lʿmw** "his people" replaced with the clients' property and wealth.

10. **ʾlylyh**: "his income"; from ʿLL "to enter", with *ʿayin* reduced to *ʾaleph*. Compare **ʿlltʾ/ʾlltʾ** "produce, revenue" (*DJBA*, 866–867).

PHOTO 68 JBA 113 (MS 1927/14)

JBA 114 (MS 2053/45)

155 × 60 mm. Semi-formal hand. The bowl was broken, but has been repaired. The writing is badly faded in the centre and towards the rim on one side.

Clients: Mihraqān son of Hormizdukh; Farnaq (Farnak) daughter of Margānītā, his wife.

Biblical quotation: Is 50:11.

1 חתים [...] ביתיה 1 Sealed [...] his house

2 [...] הורמיזדוך 2 [...] Hormizdukh

3 [...] פרנ[ק] בת מרגניתה 3 [...] Farna[q] daughter of Margānītā,

4 ומח[תמין] כל בניהון ו[כל] ב[נ]תהו[ן] דאית להון ודה[ו]ן להון מיכען 4 and double se[aled] are all their sons and [all] thei[r] dau[ght]ers, [that they have] and that they w[i]ll have, from now

5 ועד עלמא ומחתמין כל אינשי ביתיה ומחתם כל קיניניה מן כל שידין 5 and for ever, and double sealed are all the people of his house, and double sealed is all his property, from all demons

6 ושיפטין ופגעין וסטנין וירורין וליליין בישן דיכרין ונוקבן דידכיר שמיהון ודלא 6 and afflictions and affliction demons and satans and *yaror* demons and evil lilis, male and female, (both) those whose name is mentioned and those whose

7 דכיר שמיהון דאינון שרן בביתיה ומיתחזן בחילמין ובחיזונין ומדחלין להון יומא דן 7 name is not mentioned, who dwell in his house, and appear in dreams and in visions, and frighten them. This day

8 פטרית ושבקית ותריכית יתהון מן כוליה ביתיה ומדריה דהדין מיהרקן בר הורמיזדוך ומן 8 I release and I dismiss and I divorce them from the whole house and dwelling of this Mihraqān son of Hormizdukh, and from

9 פרנק איתתיה בת מרגניתא מינהון ומן כל בניהון וכל בנתהון ומן כל קיניהון דאית להון ודהון להון מיכען 9 Farnaq, his wife, daughter of Margānītā, from them, and from all their sons and all their daughters, and from all their property, which they have and which they will have, from now

10 ועד עלמא חתים ומחתם בזיר שירא ובזמין עיזקתא בגושפנקא דעורביד דחתימין בה כיפי שמיה וארעה 10 and for ever. Sealed and double sealed by the ring **zyr** and by the signet-ring **zmyn**, by the signet-ring of **ʿwrbyd**, by which the edges of heaven and earth are sealed.

11 לא מנה [צדיק]א רבה [ר]אשה דר [ד]רי ליפי עלי ראשה במלכותא עליהי בר מברגירא ואפליפר אציץ א[רציה] 11 lʾ mnh [ṣdyq]ʾ rbh [r]ʾš dr [d]ry lypy ʿly rʾš bmlkwtʾ ʿlyhy br mbrgyrʾ and ʾplypr ʾṣyṣ ʾ[rṣyh]

12 'n[qy 'bq "Behold, a]ll you who kindl[e a fire], who surround yourselves with sparks; walk in the light of your fire, and in the sparks that you have kindled. This came to you from my hand; in sorro[w]

אנ[קי אבק הן כ]ולכם קודח[י אש] מאזרי זיקות לכו באור אשכם ובזיקות בערתם מידי היתה זאת לכם למעצב[ה]

13 yo[u] shall lie down". [Gabrie]l and M[i]cha[el and] Ra[phae]l [sign on] this magical act.

תשכב[ון גבריא]ל ומ[י]כ[אל ו]ר[פא]ל [חתימין] על הדין עובדא

12–13. Is 50:11.

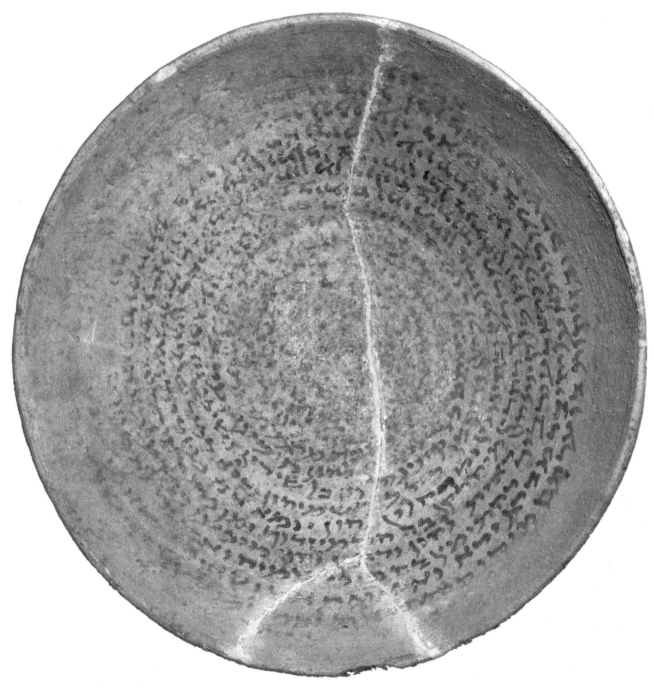

JBA 115 (MS 2053/129)

155 × 58 mm. Semi-formal hand. The bowl was broken, but has been repaired.

Linguistic and orthographic features: Note the use of –h rather than –yh for the 3 p. masc. sg. pron. suffix in **mdrh** (l. 1).

Client: Avīmārī son of Mešaršīṯā.

1 חתים ומחתם כוליה ביתיה וכוליה מדרה

1 Sealed and double sealed is the whole house and the whole dwelling

2 דהדין אבימרי בר משרשיתא מן סיפיה דבבא גואה

2 of this Avīmārī son of Mešaršīṯā, from the doorpost of the inner gate

3 ועד סיפיה דבבא בראה מכל שידין ושיפטין וכל פתכרין

3 up to the doorpost of the outer gate, from all demons and afflictions, and all idol spirits

4 וסטנין ולילין חתים ומחתם בזיר שירא ובזמין עיזקתא בגושפנקא דעורביד

4 and satans and lilis. Sealed and double sealed by the ring zyr and by the signet-ring zmyn, by the signet-ring of ʿwrbyd,

5 דחתימין בה כיפי שמיה וארעה לא מנה צדיקא רבה ראשה דר דרי ליפי

5 by which the edges of heaven and earth are sealed. lʾ mnh ṣdyqʾ rbh rʾš dr dry lypy

6 עלי ראשה במלכותא עליהי בר מברגירא ואפליפר אציץ ארציה אנקי אבק תוב

6 ʿly rʾš bmlkwtʾ ʿlyhy br mbrgyrʾ and ʾplypr ʾṣyṣ ʾrṣyh ʾnqy ʾbq Again,

7 הדין עובדא לאזהא ליליתא מן ביתיה ומן כל אינשי ביתיה דהדין אבימרי בר משרשיתא

7 this magical act is for causing the lilith to depart from the house and from all the people of the house of this Avīmārī son of Mešaršīṯā.

8 ארהום אספהרום איספהרום בגוזרא ארהום איספהרום בגוזרא ארהום אספהרום אספהרום

8 ʾrhwm ʾsphrwm ʾysphrwm bgwzrʾ ʾrhwm ʾysphrwm bgwzrʾ ʾrhwm ʾsphrwm ʾsphrwm

9 בגוזרא

9 bgwzrʾ

8–9. These lines contain another series of magic words. The decision to transcribe them with *he* rather than *ḥeth* is arbitrary.

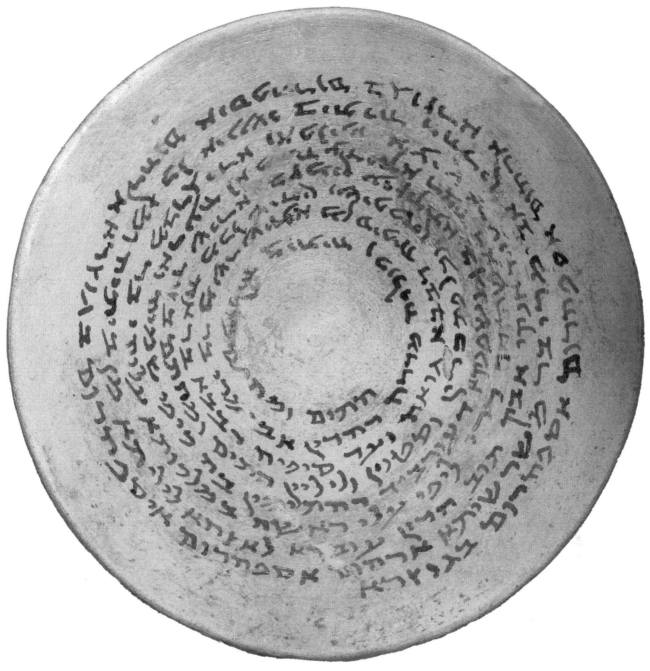

I.4.4

Other Signet-Rings

∴

Introduction

This section contains four distinct texts that refer to various signet-rings. The first, JBA 116, contains a rich and hitherto mostly unparalleled text, which, coupled with the difficulty in deciphering its faded sections, means that much remains obscure. It appears to refer to seven bonds and seven seals, and a signet-ring that is taken from before the divine throne (probably belonging to Solomon). It also contains the following enigmatic passage, which, unfortunately, is not fully preserved: **'pyhwn 'py nyšr' gpyhwn gpy 'wz'**... "Their faces are the face of an eagle, their wings are the wings of a goose" (l. 5). This appears to resemble Spell 302 of the Pyramid Texts of Unis (Fifth Dynasty, third millennium BCE), which is one of the so-called "ascension texts"—in this case, a spell for the king to ascend to the sky and to reach the sun, thus recalling the rebirth of Osiris (reference courtesy of Rita Lucarelli). In a passage that identifies the deceased with a series of birds in order to attain the power of flight, we read, "the face of Unis as that of falcons, Unis's wings as those of birds, his nails as the talons of Him of Atfet" (Allen 2005, 56). The term *apd*, here translated "bird", is often translated "goose" (although it is not certain which type of bird it is). Intriguingly, the bowl then gives a quotation from Ex 14:31, which describes YHWH's power that was wielded against Egypt. The male client, Abd-Īšū son of Aḥ[...], has a Christian name.

The second text, JBA 117, is badly faded, but it can be deciphered with the aid of its parallels, particularly Davidovitz 24 (which was probably written by the same hand)—compare also MSF Bowl 15. JBA 117 was written for a male client whose name is not preserved, but whose mother's name is preserved as Asmāndukh. The client, therefore, is probably Yazdānqerd son of Asmāndukh, who is also the client in Davidovitz 24 and MS 2053/222. It contains a variant of the **šyr šyr'** formula, for which see the introduction to 1.4.1.1.

The third text, JBA 118, is also badly faded, but, again, much of it can be deciphered with the aid of its parallels, particularly Wolfe 78 and SD 33. The text begins at the rim and proceeds to the centre of the bowl. It invokes the three bonds and seven seals, and the seal of the sun and signet-ring of the moon, and also contains "the bay tree and tamarisk" formula. It appears to have been written by the same hand as Wolfe 78 and SD 33, both of which also begin at the rim. All three bowls appear to contain a slightly distorted text. We would expect the phrase **wkl šydyn** "and all demons" (JBA 118:4) to occur as part of a list of evil spirits that follows the name(s) of the client(s)—compare, e.g., JBA 75:5. In JBA 118, Wolfe 78 and SD 33, however, the list of evil spirits is missing, thus leaving the **wkl šydyn** seemingly out of context. The clients in JBA 118 are Mirdukh daughter of Šahrēndukh and her daughter Khwar(kh)šēddukh. The scribe wrote the daughter's name twice, first with the historical spelling Khwarkhšeddukh, and then with the phonetic spelling Khwaršēdukh; see CPD, 96 (s.v. *xwar(x)šēd*). The latter form is already attested in the magic bowls, e.g. VA.Bab.2768 (*AMBVMB*, 139). The name Šahrēndukh is also attested in other magic bowls (e.g. VA.2182, which is edited in *AMBVMB*, 11–15).

The final text, JBA 119, is written mostly on the wide rim of a comparatively small and deep bowl that has a flat base. In language reminiscent of the official administrative letters in the biblical book of Ezra, the bowl purports to contain a copy of a letter sent to the evil spirits by two kings, Solomon and Ṭifros. In this respect, it resembles the motif of the *geṭ* sent by Rabbi Joshua bar Peraḥia (see Shaked, Ford and Bhayro 2013, 103–154). The spelling of the word "copy", **ptšgn**, accords with BH **ptšgn** (e.g. Est 3:14) rather than BA **pršgn** (e.g. Ezr 4:11). Both forms, however, are attested in JBA (see Shaked 1987, 260; Ciancaglini 2008, 241), and the parallels read **pršgn**. The second royal correspondent, Ṭifros (or perhaps Ṭufros), is described as **mlk' dšydy wšlyṭ' rbh dlylyt'** "the king of demons and the great ruler of liliths"—a role similar to that ascribed to Elisur Bagdana in the divorce bowls (e.g. JBA 47:2–3). The text also invokes the name of Metatron, as well as the seal of the sun, the signet-ring of the moon and the great seal of heaven. Unpublished parallels for this formula include JNF 132, JNF 151 and JNF 311.

Other spells that occur in the bowls in this section:
- The bay tree and tamarisk—JBA 118:5
- The seal of the sun—JBA 118:3; JBA 119:5

JBA 116 (MS 1927/50)

170 × 75 mm. Semi-formal hand. The bowl was broken, but has been repaired. The writing is badly faded towards the rim and the writing surface is worn in places. The text is surrounded by a circle.

Linguistic and orthographic features: Note the reduction of ʿayin to ʾaleph at the start of the proper noun **ʾbdʾyšw** (l. 4), for **ʿbdʾyšw** "Servant of Jesus", and the complete loss of ʿayin in **dšmn** (l. 1), corrected by the scribe to **dšmʿn**; note also the loss of ʾaleph in **lḥwr** for **lʾḥwr** (l. 9); finally, note that the usual lowering of /i/ to /a/ before reš does not occur in the act. ptc. **gzyr**.

Clients: Abd-Īšū son of Aḥ[...]; Ayyā daughter of Immī, his wife.

Biblical quotations: Ex 14:31; an unknown targum of Ps 114:3; Is 6:3.

1 אסירת אסירת שדתנסא די לגים לגים ומעורא עינין דחזין ומטרשא אונדין דשמ{ן}׳ען

1 You are bound, you are bound, little demoness (?), who is legion, legion (?), and blinds eyes that see, and deafens ears that hear,

2 ושריא בההיא זויתא רבתי דחשוכא מיחמת סיפא רבה דבית קומתה יצור דמיך יפיל בכוליתיך

2 and dwells in that great corner of darkness. Because of the great doorpost of the house of her body (?), your blood shall congeal, it shall fall into your kidneys.

3 בחיליך ובאסותיך יהוה צבאות מלכה רמא שבח שביחא ומשבח יתכולא ויתכולא ויתכסי יתכולא יתכסי

3 By your strength and by your healing, YHWH Sabaoth, the exalted king, praised, praiseworthy and praised. It shall be removed and it shall be removed and it shall be hidden. It shall be removed, it shall be hidden

4 מן ביתיה ומן אינתת[י]ה ומן בנ[י]ה ומן בנתיה ומן קיניה ומן כולה דירתיה דהדין אבדאישו בר אח[...] ועים

4 from the house and from the wife and from the sons and from the daughters and from the property and from the whole dwelling of this Abd-Īšū son of Aḥ[...], and with

5 איא בת אימי אינתתיה ועים כל אינשי ביתיה {אפי} אפיהון אפי נישרא גפיהון גפי אוזא [...]

5 Ayyā daughter of Immī, his wife, and with all the people of his house. Their faces are the face of an eagle, their wings are the wings of a goose [...]

6 [...] יתיב בשולטונא ובידינא [...]שא דכין כתיב וירא ישראל את היד הגדולא אשר עשה יהוה במי{צ}רים

6 [...] he sits with authority and in judgment (?) [...], for thus it is written: "And Israel saw the great power which YHWH wielded against the Egyp[tians],

7 ויראו העם את יהוה ויאמינו ביהוה ובמש[ה
ע]בדו גברא דמיגזר גזיר עליכון והדין מכניש לכון
מן חלא בגו טורי ומן חצצי

7 and the people feared YHWH, and they had faith in YHWH and in Mose[s] his [se]rvant". (This is) the man who indeed imposes a court oath upon you, and this one gathers you from sand within mountains, and from grains of sand

8 בגו [...] בדוך דאנא מדכר לכון ארי[א] גיזריה
שביק ותנינא משני מרבעתיה ושמיא מיתרגשין
וטוריא זעין מן קודמוהי [...]

8 within [...] In the place that I mention you, the lio[n] abandons its prey and the serpent leaves its resting place, and the heavens tremble and the mountains shake before him [...]

9 [...] ימא חזי והפ[י]ך יורדנא י[...] לחור משבענא
עליכון שידין ושיפטין ודוין וסטנין וירורין ונוסיא
ודונקא [...]

9 [...] "the sea sees and turn[s] back, the Jordan [...] backwards". I put you under oath, demons, and afflictions, and *dēv*s, and satans, and *yaror* demons, and trial and torment [...]

10 [...] איסרין וחתימית[ון ב]שבעא חתמין
בעיזקתיה דישקילין מן קודם כורסיה דמרי
מלכין קדוש ק[דוש קדו]ש יה[וה]

10 [...] bonds, and y[ou] are sealed [by] seven seals, by his signet-ring that they take from before the throne of the Lord of kings. "Holy, h[oly, hol]y, is YH[WH]

11 [צבאות מלוא] כל הארץ [כ]בדו אמן אמן ס[לה]
הללויה

11 [Sabaoth]; the whole earth [is full of] his [gl]ory". Amen, Amen, Se[lah], Hallelujah.

1. **šdtnsʾ**: "little demoness (?)"; a tentative interpretation. If our reading is correct, this would appear to be a diminutive of **šydtyn** "demoness" (*DJBA*, 1133). For the diminutive suffix written with –sʾ, see Epstein 1960, 115; see also Nöldeke 1904, 80.

dy lgym lgym: "who is legion, legion (?)"; another tentative interpretation. Compare Syr. **lgywnʾ** "legion" (*SL*, 673), which is also used metaphorically for "devil" (cf. Mark 5:9; Luke 8:30). For the shift of final *nun* to final *mem*, consider Mishnaic Heb. **pgywn** "dagger" and its variants **pgywm** and **pygwm** (Krauss 1899, 421).

ʾwndyn: "ears"; error for **ʾwdnyn**. It is possible that the given spelling indicates that the scribe pronounced the word *ʾūnnīn*, thus reflecting the more colloquial form (cf. *DJBA*, 91, s.v. **ʾwn**').

dšmn ʿn: "that hear"; the scribe has corrected himself, thereby giving the intended **dšmʿn**. The initial error suggests that the scribe did not pronounce the *ʿayin*.

2. **sypʾ rbh dbyt qwmth**: "the great doorpost of the house of her body (?)"; the meaning of this expression is obscure.

yṣwr dmyk: "your blood shall congeal"; cf. *SL*, 1304, s.v. ṢRR (meaning 2b).

3. **ytkwlʾ**: "it shall be removed"; i.e. KLY itpa. (*DJBA*, 582), with the *waw* indicating /a/ > /o/ or /u/ before *lamedh*. For this shift in the magic bowls, compare Syr. **mdwlyʾ** and Mand. **mdulia**—see Ford 2017, 20.

4. **qynyh**: "his property"; for standard **qynynyh**. See the notes to JBA 73:5, JBA 105:3 and JBA 111:3.

6. **wbydynʾ**: "and in judgment"; alternatively, "and the court".

6–7. Ex 14:31.

7. For the parallelism between **ḥlʾ** and **ḥṣṣy**, see P Is 48:19.

8. For the parallelism between **gyzryh** and **mrbʿtyh**, compare the parallelism between **gzrʾ** "prey" and **mrbwʿyth** "its resting place" with respect to lions in P Am 3:4.

See also M 1:13–14 (collated from a photograph kindly provided by Matthew Morgenstern): **'tr dyšmyh mdkr 'ryh gyzryh šbyq wtnyn' mrbʻtyh mšny** "(in) the place that his name is mentioned, the lion abandons its prey and the serpent leaves its resting place" (cf. Shaked 1995b, 207–211).

9. **ym' ḥzy whpyk ywrdn' y[...] lḥwr:** "the sea sees and turns back, the Jordan [...] backwards"; this is clearly based on Ps 114:3, which reads **hym r'h wyns hyrdn ysb l'ḥwr** "the sea saw and fled, the Jordan was driven backwards". Indeed, it may be possible to discern the faint traces of **yswb {l'}** in the bowl, with **l'** being a false start for **lḥwr**. In any event, the reading in the bowl differs slightly from the known Targum, which reads **ym' 'stkl** (or **ḥm'**) **w'pk ywrdn' ḥzr l'ḥwr**. Compare also Gy 174:12–13: **iama ḏ-hiziuia apak uiardna ʻhdar lʻuhra** "The sea, when one saw him, turned back, and the Jordan turned around" (see Greenfield 1981, 26–27).

wnwsy' wdwnq': "and trial and torment"; for this pair of terms, both of which are hitherto unattested in JBA, compare Syr. **nwsy'** "trial" and **dwnq'** "torment" (SL, 901 and 284).

10–11. Is 6:3; the text is very faded, but compare JNF 10:7–9, which reads: **'syrytwn bšbʻh 'ysryn wḥtymytwn bšbʻh ḥtmyn 'syrtwn wḥtmytwn bhhy' ʻyzqt' dšlmh mlkh br dwyd dšqylh mn qdm kwrsyh dmry mrwn dktyb qdwš qdwš qdwš qdwš yhwh ṣb'wt ml' kl h'rṣ kbwdw 'mn 'mn slh hllwyh** "you are bound by seven bonds and you are sealed by seven seals; you are bound and sealed by that signet-ring of king Solomon, the son of David, which is taken from before the throne of the Lord of lords; for it is written: 'Holy, holy, holy, holy is YHWH Sabaoth; the whole earth is full of his glory'. Amen, Amen, Selah, Hallelujah". It is likely, therefore, that the pron. suffix in **bʻyzqtyh** (l. 10) refers to Solomon, but the present text has been shortened somehow.

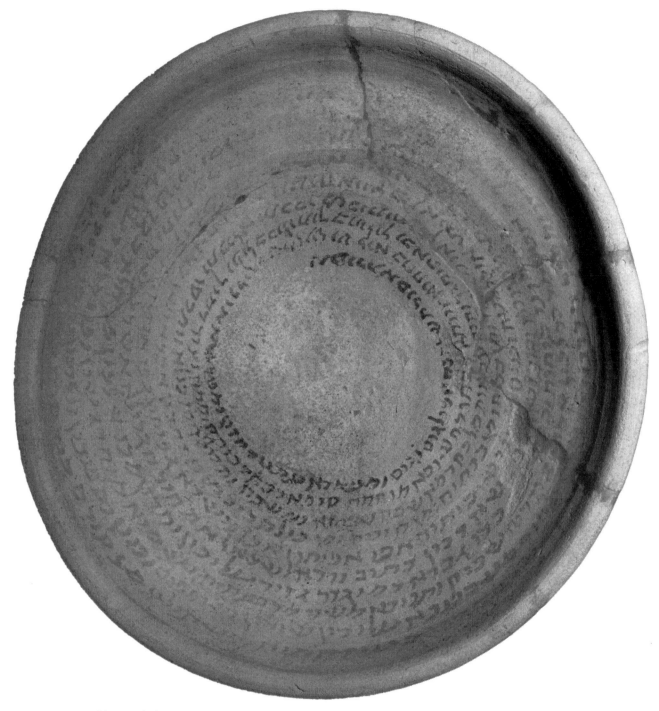

JBA 117 (MS 2053/59)

150 × 60 mm. Semi-formal hand. The bowl was broken, but has been repaired. The writing is badly faded, particularly on one side. The text is surrounded by a circle.

Client: [Yazdānqerd son of] Asmāndukh (see the introduction to **1.4.4**).

1 אילין יזוהו[ן ויפקון] מן בית[יה] ומן א[ס]קופתיה

1 These shall mov[e and depart] from [his] house and from his th[res]hold:

2 שידי ודיוי [...] וחומרי זידניתא וכל

2 demons, and *dēv*s [...] and wicked amulet spirits, and all

3 מיני פתכרי וכ[ל ...]א וגונחא וחומרתא [זידני]תא

3 types of idol spirits, and al[l ...], and the cough demon (?), and the [wick]ed amulet spirit,

4 ואישתא וערויאתא [... וכל] בני איגרי וכל בני חיצבי וכל [טו]לניתא

4 and fever, and shivering, [... and all] roof demons, and all jug demons, and all [sha]dow spirits

5 דיחשוכא וכל בני ד[...]א ובלמה ושידא דיתחות נרזא [בי]שמיה

5 of darkness, and all sons of [...] and **blmh**, and the demon that is under the drainpipe. [By] the name

6 דקדישא רבא ובישמי[ה ...] בזיר שירא בזר זור עיזקתא בהלין

6 of the great holy one, and by [the] name [...] By the ring **zyr**, by the signet-ring **zr zwr**. By these

7 תריעשר [רז]י כסיי [...] לב[...]יתיה [...] אסמנדוך הנון דחתימין בהון שמיא

7 twelve hidden [mysteri]es [... the] ho[use ...] Asmāndukh, those by which heaven and eart[h]

8 וארע[א] אמ[ן] א[מ]ן סלא

8 are sealed. Ame[n], A[me]n, Selah.

1. **yzwhwn**: "they shall move"; see the note in *MSF*, 116.

3. **gwnḥʾ**: "the cough demon (?)"; compare the discussion of **gwnḥʾh** in Ford 2011, 256, especially n. 21 (note that the given reading in Ford 2011, **gnnḥʾh**, is a misprint for **gwnḥʾh**).

5. **blmh**: The reading appears to be certain, and is confirmed by Davidovitz 24:7. The meaning, however, is far from certain. It is probably derived from the common Aram. root BLM "to gag, muzzle, stop up, prevent"; we cannot at present propose a precise interpretion.
nrzʾ: "drainpipe"; for **nrzbʾ** (*DJBA*, 777); cf. Davidovitz 24:7. For the drainpipe demon, see Morgenstern and Ford 2017, 208–209.

6. **bzyr šyrʾ bzr zwr ʿyzqtʾ**: "by the ring **zyr**, by the signet-ring **zr zwr**"; see the introduction to **1.4.1.1**. Following **zr**, there appears to be the top of an unfinished *yodh* or *waw*—perhaps read **bzry zwr**.

6–7. On the basis of Davidovitz 24, we can tentatively suggest the following reconstruction: **bhlyn tryʿśr rzy ksyy ḥtmwhy wnṭrwhy lbytyh wʾysqwptyh dyzdnqyrd br ʾsmndwk** "by these twelve hidden mysteries seal and protect the house and the threshold of Yazdānqerd son of Asmāndukh" (note that Davidovitz 24 lacks the reference to the client's house and threshold).

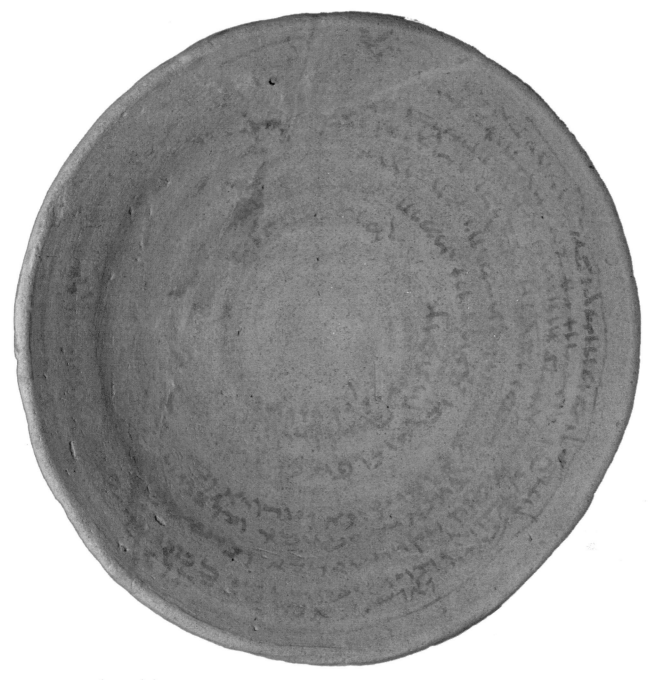

JBA 118 (MS 2053/88)

165 × 75 mm. Semi-formal hand. The bowl was broken. It has been repaired, but is missing two small portions on the rim. The text begins at the rim and proceeds towards the centre. The writing is partly faded. The text is surrounded by a circle.

Linguistic and orthographic features: Note the use of **-yh** rather than **-h** for the 3 p. fem. sg. poss. pron. suffix in **bytyh** (l. 1); note also the use of **'ym** for **'ym** (l. 4). Note also the omission of ḥet at the start of **tym** (l. 3)—a phonetic spelling for **ḥtym**.

Clients: Mirdukh daughter of Šahrēndukh; Khwar(kh)šēddukh daughter of Mirdukh.

1 חתים ומחתם ביתיה [ד]מירדוך בת שהרינדוך כורכשידוך בת [מ]ירדוך כו[ר]שדוך בת מ[יר]דוך מן פגעין ומן לילין ומן דיוין ומן סטנין [ומן]

1 Sealed and double sealed is the house [of] Mirdukh daughter of Šahrēndukh, Khwarkhšēddukh daughter of [M]irdukh, Khwa[r]šēddukh daughter of M[ir]dukh, from affliction demons, and from lilis, and from *dēv*s, and from satans, [and from]

2 ח[ומרי] פתכ[ר]י ומן ח[ומרי זידניתא אסירין בתלתא [א]יסרין [וחתימין ב]שבעה חתמי[ן] דחתימי[ן ב]הון שמיא וארעה

2 amu[let spirits], idol spi[rits, and from] wicked [amu]let spirits. They are bound by three [b]onds [and they are sealed by] seven seal[s by] which heaven and earth are sealed.

3 תים בח[תמא דש]משא [ו]בעיזקתא [דסיהרא בצ[ור]תא דארעה וברז[א רבה דרקיעה [דלא] תיקיר[בון]

3 Sealed by the s[eal of the s]un [and] by the signet-ring [of the moon, by the i]mag[e of the earth and by] the great [myste]ry of the sky, [that] you shall [not] come ne[ar]

4 [...] מרדוך בת שהרינדוך וכל שידין [ד]עים עבר[ין ע]ל מראימר[...]

4 [...] Mirdukh daughter of Šahrēndukh, and all demons. [For] if [they] transgress [agai]nst the command (?) [...]

5 [...] וניצטרי כי בינא [ו]נ[יזי קליה כי מנ]חשה ניקום ב[שמתא [כמא דקאם]

5 [...] and be split open like a tamarisk, [and] may his voice go like a di[viner], may he remain [under] the ban [just like] the evil

6 [ב]ה קאין בישא ב[ר בי]ש[א מן יו]מ[א ד]ין ול[ע]לם [...]

6 Cain [remains under] it, so[n of the ev]il [one, from th]is [da]y and for [e]ver. [...]

7 [...] לעלם אמן [אמ]ן סל[ה]

7 [...] for ever. Amen, [Ame]n, Sela[h].

8 הל[לויה חתים ומ]חתם לעלם

8 Halle[lujah. Sealed and double] sealed for ever.

3. **bṣwrt' d'r'h:** "by the image of the earth"; see the note to JBA 68:5.

4. **mr'ymr:** "command (?)". Note that Wolfe 78:5 and SD 33:5 similarly read **mr'ymryh**. All three bowls were written by the same hand, so it is possible that we have an idiosyncrasy that is specific to this scribe. It is likely that the present text read along the lines of SD 33:4–5: **d'ym 'bryn 'l mr'ymryh hdyn** "For if they transgress against this his command (?)". We cannot at present propose a convincing explanation of **mr'ymr** as written, so we tentatively interpret it as an error for **m'mrh** in accordance with the parallels (cf. JBA 75:6).

5. **mnḥš':** "diviner"; see the note to JBA 73:7.

6. **q'yn:** "Cain"; the same spelling occurs in SD 33:6.

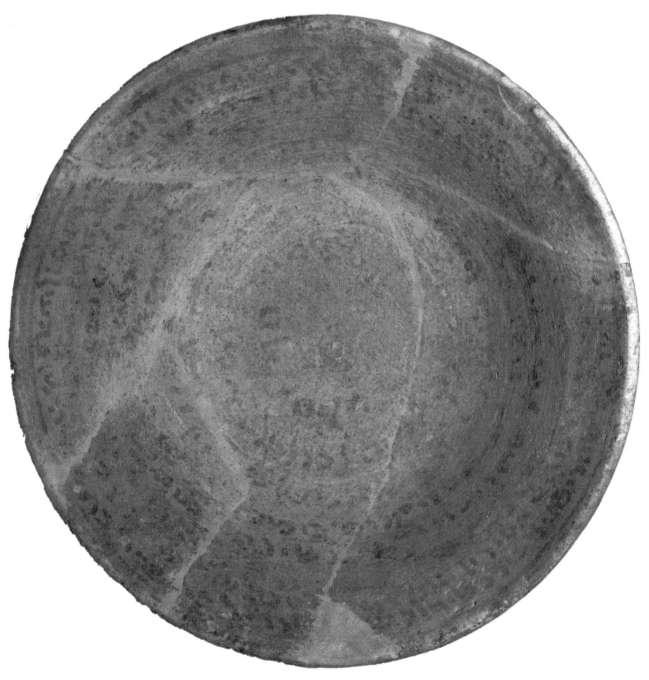

PHOTO 73 JBA 118 (MS 2053/88)

JBA 119 (MS 2053/142)

120 × 55 mm. Crude semi-formal hand. Client: Ardukh daughter of Immā-ḏ-avū.

Linguistic and orthographic features: Note the use of –**h** rather than –**yh** for the 3 p. masc. sg. pron. suffix in **šmh** (l. 4).

1 And this is the letter and this is a copy of the letter that came unto you from King Solomon son of	ודין איגרתא ודין פתשגן איגרתא דאתת עלכון מן שלמה מלכא בר
2 David and from Ṭifros, the king of demons and the great ruler of liliths. And the demon and *dēv* and Danaḥiš	דויד ומן טיפרוס מלכא דשידי ושליטא רבה דליליתא ושידא ודיוא ודנחיש
3 and lilith, male and female, who hears this oath, shall depart and go out from Ardukh daughter of Immā-ḏ-avū, and shall not try	ולילית דיכרא וניקבתא דשמע שבועתא הדא יזה ויפוק מן ארדוך בת אימדבו ולא ינסי
4 to spend the night again with her. By the name of Metatron, the great guardian angel. Amen, Amen, Selah. Sealed and double sealed is Ardukh daughter of Immā-ḏ-avū	יבות ולא יתני עימה בישמה דמיטטרון סרה רבא אמן אמן סלה חתימא ומחתמא ארדוך בת אימדבו
5 by the seal of the sun and by the signet-ring of the moon and by the great seal of heaven. Amen, Amen, Selah.	בחתמא דשימשה ובעיזק דסיהרא ובחתמא רבה דישמיא אמן אמן סלה

1. **d'tt**: "that came"; the parallels read **d'ytyty** "that I brought".

3. **ynsy**: "he shall try"; the reading is uncertain and does not appear in the known parallels.

4. **ytny**: We have understood this as being used adverbially with the preceding verbs (cf. *DJBA*, 1218).

5. **'yzq**: "signet-ring"; for **'yzqt'**.

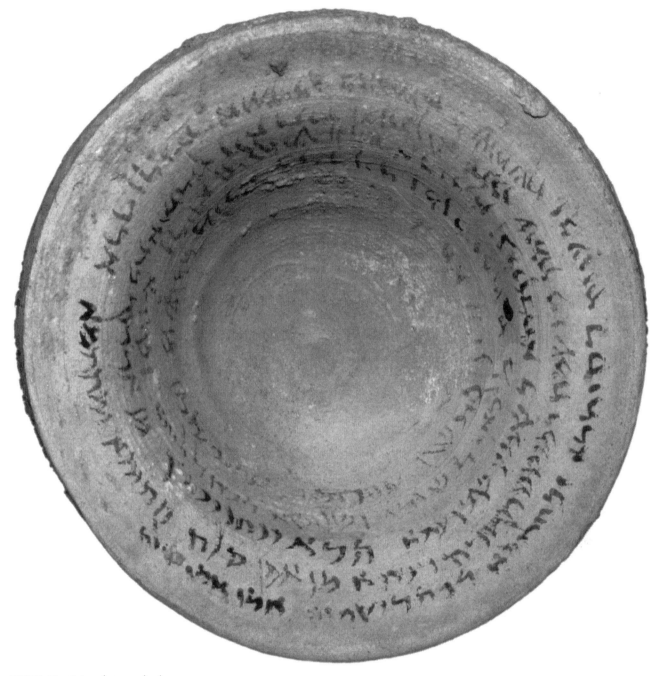

PHOTO 74 JBA 119 (MS 2053/142)

Bibliography

Abousamra, Gaby. 2010. "Une nouvelle coupe magique araméenne", in: J.-M. Durand and A. Jacquet (eds), *Magie et divination dans les cultures de l'Orient*, Paris, 109–121.

Allen, James P. 2005. *The Ancient Egyptian Pyramid Texts*, Atlanta.

Avigad, Nahman. 1958. "Ḥotam", in: *Encyclopaedia Biblica Volume 3*, 67–86 (in Hebrew). Jerusalem.

Bar-Asher Siegal, Elitzur A. 2013. *Introduction to the grammar of Jewish Babylonian Aramaic*, Münster.

BeDuhn, Jason David. 1995. "Magical bowls and Manichaeism", in: M. Meyer and P. Mirecki (eds), *Ancient magic and ritual power*, Leiden, 419–434.

Bhayro, Siam. 2013. "The reception of Mesopotamian and early Jewish traditions in the Aramaic incantation bowls", *Aramaic Studies* 11, 187–196.

Bhayro, Siam; James Nathan Ford; Dan Levene; and Ortal-Paz Saar. 2018. *Aramaic Magic Bowls in the Vorderasiatisches Museum in Berlin: Descriptive List and Edition of Selected Texts*, Leiden (*AMBVMB*).

Bivar, A.D.H. 1969. *Catalogue of the Western Asiatic seals in the British Museum. Stamp seals II: The Sasanian dynasty*, London.

Bohak, Gideon. 2008. *Ancient Jewish magic: a history*, Cambridge.

Borisov, A.Ja. 1969. "Epigrafičeskie zametki", *Epigrafika Vostoka* 19, 3–13.

Borisov, A.Ja.; and V.G. Lukonin. 1963. *Sasanidskie gemmy*, Leningrad.

Brunner, Christopher J. 1978. *Sasanian stamp seals in the Metropolitan Museum of Art*, New York.

Brunner, Christopher J. 1980. "Sasanian seals in the Moore Collection. Motive and meaning in some popular subjects", *Metropolitan Museum Journal* 14, 33–50.

Burtea, Bogdan. 2011. Review of Moriggi 2004, *Orientalistische Literaturzeitung* 106, 116–121.

Canepa, Matthew P. 2011. "The art and ritual of Manichaean magic: Text, object and image from the Mediterranean to Central Asia", in: H.G. Meredith (ed.), *Objects in motion: The circulation of religion and sacred objects in the late antique and Byzantine world*, Oxford, 73–88.

Ciancaglini, Claudia. 2008. *Iranian loanwords in Syriac*, Wiesbaden.

Conybeare, F.C.; J. Rendel Harris; and Agnes Smith Lewis. 1898. *The story of Aḥiḳar from the Syriac, Arabic, Armenian, Ethiopic, Greek and Slavonic versions*, London.

de Blois, François. 2000. "Bīrūnī, Abū Rayḥān. vii. History of Religions", in: *Encyclopaedia Iranica* IV/3, 283–285.

Drijvers, Han J.W.; and John F. Healey. 1999. *The Old Syriac inscriptions of Edessa and Osrhoene: Texts, translations and commentary*, Leiden.

Drower, Ethel S. 1953. *The Haran Gawaita and the Baptism of Hibil-Ziwa. The Mandaic text reproduced together with translation, notes and commentary*, Rome.

Drower, Ethel S.; and Rudolf Macuch. 1963. *A Mandaic dictionary*, Oxford (*MD*).

Durkin-Meisterernst, Desmond. 2000. "Erfand Mani die manichäische Schrift?", in: W. Sundermann, P. Zieme, and R.E. Emmerick (eds), *Studia manichaica. IV. Internationaler Kongress zum Manichäismus*, Berlin, 161–178.

Durkin-Meisterernst, Desmond. 2004. *Dictionary of Manichaean Middle Persian and Parthian*, Turnhout (*DMMPP*).

Epstein, Jacob Nahum. 1921. "Gloses babylo-araméennes", *Revue des Études Juives* 73, 27–58.

Epstein, Jacob Nahum. 1922. "Gloses babylo-araméennes (suite et fin)", *Revue des Études Juives* 74, 40–72.

Epstein, Jacob Nahum. 1960. *A grammar of Babylonian Aramaic* (in Hebrew), Jerusalem and Tel Aviv.

Faraj, Ali H. 2010. *Coppe magiche dall'antico Iraq con testi in aramaico giudaico di età ellenistica*, Milan.

Fassberg, Steven E. 2010. *The Jewish Neo-Aramaic dialect of Challa*, Leiden.

Ford, James Nathan. 2002. "Notes on the Mandaic incantation bowls in the British Museum", *Jerusalem Studies in Arabic and Islam* 26, 237–272.

Ford, James Nathan. 2006. Review of Levene 2003, *Journal of Semitic Studies* 51, 207–214.

Ford, James Nathan. 2011. "A new parallel to the Jewish Babylonian Aramaic incantation bowl IM 76106 (Nippur 11 N 78)", *Aramaic Studies* 9, 249–277.

Ford, James Nathan. 2012. "Phonetic spellings of the subordinating particle *d(y)* in the Jewish Babylonian Aramaic magic bowls", *Aramaic Studies* 10, 237–269.

Ford, James Nathan. 2014. "Notes on some recently published magic bowls in the Schøyen Collection and two new parallels", *Aula Orientalis* 32, 235–264.

Ford, James Nathan. 2017. "Three *hapax legomena* in the Babylonian Talmud", *Le Muséon* 130, 1–30.

Ford, James Nathan. (forthcoming a). *New Aramaic incantation bowls I: Syriac bowls*.

Ford, James Nathan. (forthcoming b). "Studies in Aramaic anti-witchcraft literature: I. A new parallel to the Talmudic Babylonian Aramaic magic bowl BM 135563".

Ford, James Nathan. (forthcoming c). "'My foes loved me': a new incantation bowl for popularity and success" (in Hebrew), *Mehqarim BeLashon* 17.

Ford, James Nathan; and Matthew Morgenstern. 2020. *Aramaic*

incantation bowls in museum collections volume one: the Frau Professor Hilprecht Collection of Babylonian Antiquities, Jena, Leiden.

Friedenberg, Daniel M. 2009. *Sasanian Jewry and its culture. A lexicon of Jewish and related seals*, Urbana-Chicago.

Friedmann, Yohanan. 1986. "Finality of prophethood in Sunni Islām", *Jerusalem Studies in Arabic and Islam* 7, 177–215.

Frye, Richard. 1970. "Inscribed Sasanian seals from the Nayeri collection", in: *Forschungen zur Kunst Asiens in memoriam Kurt Erdmann*, Istanbul, 18–24.

Frye, Richard. 1971. *Sasanian seals in the Collection of Mohsen Foroughi, Corpus Inscriptionum Iranicarum, Part III Vol. VI Plates Portfolio II*. London.

Frye, Richard. 1973. *Sasanian remains from Qasr-i Abu Nasr: Seals, Sealings, and Coins*, Cambridge MA.

Geller, Markham J. 1980. "Four Aramaic incantation bowls", in: G. Rendsburg et al. (eds), *The Bible world. Essays in honor of Cyrus H. Gordon*, New York, 47–60.

Geller, Markham J. 1986. "Eight incantation bowls", *Orientalia Lovaniensia Periodica* 17, 101–117, pl. IV–X.

Gignoux, Philippe. 1978. *Catalogue des sceaux, camées et bulles sasanides de la Bibliothèque Nationale et du Musée du Louvre. II. Les sceaux et bulles inscrits*, Paris.

Gignoux, Philippe. 1980. "Sceaux chrétiens d'époque sasanide", *Iranica Antiqua* 15, 299–314.

Gignoux, Philippe. 1985. "Les bulles sassanides de Qasr-i Abu Nasr (Collection du Metropolitan Museum of Art)", in: *Acta Iranica. Hommages et opera minora. Vol. 10, Papers in honour of Professor Mary Boyce*, Leiden, 195–215.

Gignoux, Philippe; and Rika Gyselen. 1982. *Sceaux sasanides de diverses collections privées*, Leuven.

Gignoux, Philippe; Christelle Jullien; and Florence Jullien. 2009. *Noms propres syriaques d'origine iranienne*, Vienna.

Gnoli, Gherardo. 2003. *Il manicheismo. Volume I. Mani e il manicheismo*, Milan.

Goldziher, Ignaz. 1874. "Beiträge zur Literaturgeschichte der Šīʿa und der sunnitischen Polemik", *Sitzungberichte der kaiserlichen Akademie der Wissenschaften, Philosophisch-historische Klasse* 78, 439–524 [reprinted in I. Goldziher, *Gesammelte Schriften* (ed. J. Desomogyi), Hildesheim, vol. 1, 261–346].

Gollancz, Hermann. 1912. *The Book of Protection*, London.

Gordon, Cyrus H. 1934a. "An Aramaic incantation", *Annual of the American Schools of Oriental Research* 14, 141–143.

Gordon, Cyrus H. 1934b. "Aramaic magical bowls in the Istanbul and Baghdad museums", *Archiv Orientální* 6, 319–334.

Gordon, Cyrus H. 1934c. "An Aramaic exorcism", *Archiv Orientální* 6, 466–474.

Gordon, Cyrus H. 1937. "Aramaic and Mandaic magical bowls", *Archiv Orientální* 9, 84–106.

Gordon, Cyrus H. 1941. "Aramaic incantation bowls", *Orientalia* 10, 116–141, 272–284, 339–360.

Gordon, Cyrus H. 1984. "Magic bowls from the Moriah Collection", *Orientalia* 53, 220–241.

Gorea, Maria. 2003. "Trois nouvelles coupes magiques araméennes", *Semitica* 51, 73–92.

Graham, Lloyd D. 2012. "The seven seals of Judaeo-Islamic magic. Possible origins of the symbols", at https://www.academia.edu/1509428/The_Seven_Seals_of_Judaeo_Islamic_Magic_Possible_Origins_of_the_Symbols.

Graham, Lloyd D. 2014. "A comparison of the Seven Seals in Islamic esotericism and Jewish Kabbalah", at https://www.academia.edu/5998229/A_comparison_of_the_Seven_Seals_in_Islamic_esotericism_and_Jewish_Kabbalah.

Greenfield, Jonas C. 1981. "A Mandaic 'Targum' to Psalm 114", in E. Fleischer and J.J. Petuchowski (eds), *Studies in Aggadah, Targum and Jewish liturgy in memory of Joseph Heinemann*, Jerusalem, 23–31 [reprinted in S.M. Paul et al. (eds), *'Al Kanfei Yonah: Collected studies of Jonas C. Greenfield on Semitic philology*, Jerusalem 2001, 388–396].

Gyselen, Rika. 1993. *Catalogue des sceaux, camées et bulles sasanides de la Bibliothèque nationale et du Musée du Louvre. I. Collection générale*, Paris.

Gyselen, Rika. 1995. *Sceaux magiques en Iran sassanide*, Paris.

Gyselen, Rika. 1996. "Notes de glyptique sassanide", *Studia Iranica* 25, 241–252.

Harari, Yuval. 1997. *The Sword of Moses: a critical edition* (in Hebrew), Jerusalem.

Harari, Yuval. 2012. "The Sword of Moses (Ḥarba de-Moshe). A new translation and introduction", *Magic, Ritual, and Witchcraft* 7, 58–98.

Harari, Yuval. 2017. *Jewish magic before the rise of Kabbalah*, Detroit.

Harper, P.O.; P.O. Skjærvø; L. Gorelick; and A.J. Gwinnett. 1992. "A seal-amulet of the Sasanian era: imagery and typology, the inscription, and technical comments", *Bulletin of the Asia Institute* 6, 43–58.

Harviainen, Tapani. 1993. "Syncretistic and confessional features in Mesopotamian incantation bowls", *Studia Orientalia* 70, 29–37.

Henning, Walter Bruno. 1947. "Two Manichaean magical texts, with an excursus on the Parthian ending -*ēndēh*", *Bulletin of the School of Oriental and African Studies* 12, 39–66.

Henning, Walter Bruno. 1958. *Mitteliranisch*, Leiden.

Herman, Geoffrey. 2014. "Religious transformations between East and West: Hanukkah in the Babylonian Talmud and Zoroastrianism", in: P. Wick and V. Rabens (eds), *Religion and trade. Religious formation, transformation and crosscultural exchange between East and West*, Leiden, 261–281.

Horn, Paul. 1904. "Some inscriptions on Sâsânian gems", in: *Avesta, Pahlavi and ancient Persian studies in honour of the*

late Shams-ul-ulama Dastur Peshotanji Behramji Sanjana, Strassburg and Leipzig, 224–230.

Horn, Paul; and Georg Steindorff. 1891. *Sassanidische Siegelsteine, Mittheilungen aus den orientalischen Sammlungen*, Berlin.

Ilan, Tal. 2011. *Lexicon of Jewish names in Late Antiquity. Part IV: The eastern diaspora 330BCE–650CE*, Tübingen.

Isbell, Charles. 1975. *Corpus of the Aramaic incantation bowls*, Missoula.

Jastrow, Marcus. 1950. *A dictionary of the Targumim, the Talmud Babli and Yerushalmi and the Midrashic literature* I–II, New York [reprint of the edition: London, 1903].

Juusola, Hannu. 1999. *Linguistic peculiarities in the Aramaic magic bowl texts*, Helsinki.

Justi, Ferdinand, 1895. *Iranisches Namenbuch*, Marburg [reprint, Hildesheim, 1963]

Khan, Geoffrey. 2008. *The Neo-Aramaic dialect of Barwar*, Leiden.

Kindler, Arie. 2003. "Lulav and ethrog as symbols of Jewish identity", in: R. Deutsch (ed.), *Shlomo. Studies in epigraphy, iconography, history and archaeology in honor of Shlomo Moussaieff*, Tel Aviv-Jaffa, 139–145.

Krauss, Samuel. 1899. *Griechische und lateinische Lehnwörter im Talmud, Midrasch und Targum*, Berlin [reprint, Hildesheim, 1964].

Lerner, Judith A. 1977. *Christian seals of the Sasanian period*, Leiden.

Levene, Dan. 2003a. *A corpus of magic bowls: Incantation texts in Jewish Aramaic from Late Antiquity*, London.

Levene, Dan. 2003b. "Heal O Israel: a pair of duplicate magic bowls from the Pergamon Museum in Berlin", *Journal of Jewish Studies* 54, 104–121.

Levene, Dan. 2013. *Jewish Aramaic curse texts from late-antique Mesopotamia*, Leiden.

Levine, Baruch A. 1970. "The Language of the Magical Bowls", in: J. Neusner, *A History of the Jews in Babylonia. V. Later Sasanian Times*, Leiden, 343–375.

Levinson, Joshua. 2010. "Enchanting rabbis. Contest narratives between rabbis and magicians in late antiquity", *Jewish Quarterly Review* 100, 54–94.

Lidzbarski, Mark. 1902. "Mandäische Zaubertexte", *Ephemeris für semitische Epigraphik* 1, 89–106.

MacKenzie, David N. 1971. *A Concise Pahlavi Dictionary*, London (CPD).

MacKenzie, David N. 1979–1980. "Mani's Šābuhragān", *Bulletin of the School of Oriental and African Studies* 42, 500–534; 43, 288–310 [reprinted in D.N. MacKenzie, *Iranica diversa* (ed. C.G. Cereti and L. Paul), Rome 2009, vol. 1, 83–153].

Manekin Bamberger, Avigail. 2015. "Jewish legal formulae in the Aramaic incantation bowls", *Aramaic Studies* 13, 69–81.

Margalioth, Mordecai. 1966. *Sepher ha-razim. A newly discovered book of magic from the Talmudic period* [ספר הרזים הוא ספר כשפים מתקופת התלמוד], Jerusalem.

Mirecki, Paul. 2001. "Manichaean allusions to ritual and magic: Spells for invisibility in the Coptic Kephalaia", in: P. Mirecki and J. BeDuhn (eds), *The light and the darkness: Studies in Manichaeism and its world*, Leiden, 173–180.

Montgomery, James A. 1912. "A magical bowl-text and the original script of the Manichaeans", *Journal of the American Oriental Society* 32, 434–438.

Montgomery, James A. 1913. *Aramaic incantation texts from Nippur*, Philadelphia.

Morano, Enrico. 2004. "Manichaean Middle Iranian incantation texts from Turfan", in: S.C. Raschmann, D. Durkin-Meisterernst, J. Wilkens, M. Yaldiz, P. Zieme (eds), *Turfan revisited. The first century of research into the arts and cultures of the Silk Road*, Berlin, 221–227.

Morgenstern, Matthew. 2004. "Notes on a recently published magic bowl", *Aramaic Studies* 2, 207–222.

Morgenstern, Matthew. 2005. "Linguistic notes on magic bowls in the Moussaieff Collection", *Bulletin of the School of Oriental and African Studies* 68, 349–367.

Morgenstern, Matthew. 2007. "On some non-standard spellings in the Aramaic magic bowls and their linguistic significance", *Journal of Semitic Studies* 52, 245–277.

Morgenstern, Matthew. 2010. Review of Müller-Kessler 2005a, *Journal of Semitic Studies* 55, 282–291.

Morgenstern, Matthew. 2011. *Studies in Jewish Babylonian Aramaic based upon early eastern manuscripts*, Winona Lake.

Morgenstern, Matthew. 2013. "Linguistic features of the texts in this volume", in: S. Shaked, J.N. Ford and S. Bhayro, *Aramaic bowl spells: Jewish Babylonian Aramaic bowls volume one*, Leiden, 39–49.

Morgenstern, Matthew. 2015. "A Mandaic Lamella for the Protection of a Pregnant Woman: MS 2087/9", *Aula Orientalis* 33, 271–286.

Morgenstern, Matthew; and James Nathan Ford. 2017. "On some readings and interpretations in the Aramaic incantation bowls and related texts", *Bulletin of the School of Oriental and African Studies* 80, 191–231.

Moriggi, Marco. 2004. *La lingua delle coppe magiche siriache*, Florence.

Moriggi, Marco. 2005a. "Peculiarità linguistiche in una coppa magica aramaica inedita", in: P. Fronzaroli and P. Marrassini (eds), *Proceedings of the 10th Meeting of Hamito-Semitic (Afroasiatic) Linguistics (Florence, 18–20 April 2001)*, Firenze, 257–266.

Moriggi, Marco. 2005b. "Two new incantation bowls from Rome (Italy)", *Aramaic Studies* 3, 43–58.

Moriggi, Marco. 2014. *A corpus of Syriac incantation bowls: Syriac magical texts from late-antique Mesopotamia*, Leiden (CSIB).

Müller-Kessler, Christa. 1996. "The story of Bguzan-Lilit, daughter of Zanay-Lilit", *Journal of the American Oriental Society* 116, 185–195.

Müller-Kessler, Christa. 1998. "Aramäische Koine—Ein Beschwörungsformular aus Mesopotamien", *Baghdader Mitteilungen* 29, 331–348.

Müller-Kessler, Christa. 1999. "Puzzling words and spellings in Babylonian Aramaic magic bowls", *Bulletin of the School of Oriental and African Studies* 62, 111–114.

Müller-Kessler, Christa. 1999–2000. "Phraseology in Mandaic incantations and its rendering in various eastern Aramaic dialects: a collection of magic terminology", *ARAM* 11–12, 293–310.

Müller-Kessler, Christa. 2005a. *Die Zauberschalentexte in der Hilprecht-Sammlung, Jena, und weitere Nippur-Texte anderer Sammlungen*, Wiesbaden.

Müller-Kessler, Christa. 2005b. "Of Jesus, Darius, Marduk ...: Aramaic magic bowls in the Moussaieff Collection", *Journal of the American Oriental Society* 125, 219–240.

Müller-Kessler, Christa. 2010. "A Mandaic incantation against an anonymous dew causing fright (Drower Collection 20 and its variant 43 E)", *ARAM* 22, 453–476.

Müller-Kessler, Christa. 2011. "Beiträge zum Babylonisch-Talmudisch-Aramäischen Wörterbuch", *Orientalia* NS 80, 214–251.

Müller-Kessler, Christa. 2012. "More on puzzling words and spellings in Aramaic incantation bowls and related texts", *Bulletin of the School of Oriental and African Studies* 75, 1–31.

Müller-Kessler, Christa. 2013. "Eine ungewöhnliche Hekhalot-Zauberschale und ihr babylonisches Umfeld: Jüdisches Gedankengut in den Magischen Texten des Ostens", *Frankfurter Judaistische Beiträge* 38, 69–84.

Muraoka, Takamitsu. 2011. *A Grammar of Qumran Aramaic*, Leuven.

Naveh, Joseph; and Shaul Shaked. 1985. *Amulets and magic bowls. Aramaic incantations of Late Antiquity*, Jerusalem and Leiden [further editions, Jerusalem, 1987 and 1998] (*AMB*).

Naveh, Joseph; and Shaul Shaked. 1993. *Magic spells and formulae. Aramaic incantations of Late Antiquity*, Jerusalem (*MSF*).

Nöldeke, Theodor. 1875. *Mandäische Grammatik*, Halle.

Nöldeke, Theodor. 1904. *Compendious Syriac Grammar*, translated from the second and improved German edition by James A. Crichton, London.

Payne Smith, Jessie. 1903. *A compendious Syriac dictionary*, Oxford (*CSD*).

Payne Smith, Jessie. 1927. *Supplement to the Thesaurus Syriacus of R. Payne Smith*, Oxford.

Payne Smith, R. 1879–1901. *Thesaurus Syriacus*, Oxford [reprint, Hildesheim, 1981].

Polotsky, Hans Jakob. 1935. "Manichäismus", in A. Pauly and G. Wissowa (eds), *Real-Encyclopädie der classischen Altertumswissenschaft*, Stuttgart, Suppl. VI, 240–271 [reprinted in H.J. Polotsky, *Collected papers*, Jerusalem 1971, 699–714].

Powers, David S. 2009. *Muhammad is not the father of any of your men. The making of the last prophet*, Philadelphia.

Puech, Henri-Charles. 1949. *Le manichéisme. Son fondateur. Sa doctrine*, Paris.

Puech, Henri-Charles. 1979. *Sur le manichéisme et autres essais* (ed. Yves Bonnefoy), Paris.

Rubin, Uri. 2014. "The Seal of the Prophets and the finality of prophecy. On the interpretation of the Qurʾānic Sūrat al-Aḥzāb (33)", *Zeitschrift der Deutschen Morgenländischen Gesellschaft* 164, 65–96.

Sachau, Eduard. 1923. *Chronologie orientalischer Völker von Albêrûnî*. Leipzig.

Schäfer, Peter. 1981. *Synopse zur Hekhalot-Literatur*, Tübingen.

Schäfer, Peter; and Shaul Shaked. 1994. *Magische Texte aus der Kairoer Geniza I*, Tübingen.

Schäfer, Peter; and Shaul Shaked. 1999. *Magische Texte aus der Kairoer Geniza III*, Tübingen.

Schoeps, Hans Joachim. 1946. "The sacrifice of Isaac in Paul's theology", *Journal of Biblical Literature* 65, 385–392.

Segal, Judah Benzion. 2000. *Catalogue of the Aramaic and Mandaic incantation bowls in the British Museum*, London (*CAMIB*).

Shaked, Shaul. 1977. "Jewish and Christian seals of the Sasanian period", in: M. Rosen-Ayalon (ed.), *Studies in memory of Gaston Wiet*, Jerusalem, 17–31.

Shaked, Shaul. 1981. "Epigraphica Judaeo-Iranica", in: S. Morag, I. Ben-Ami and N.A. Stillman (eds), *Studies in Judaism and Islam presented to S.D. Goitein*, Jerusalem, 65–82.

Shaked, Shaul. 1982. "Two Judaeo-Iranian contributions", in: S. Shaked and A. Netzer (eds), *Irano-Judaica: Studies relating to Jewish contacts with Persian culture throughout the ages*, Jerusalem, 292–322.

Shaked, Shaul. 1985. "Bagdāna, king of the demons, and other Iranian terms in Babylonian Aramaic magic", *Acta Iranica* 24, 511–525.

Shaked, Shaul. 1987. "Iranian loanwords in Middle Aramaic", *Encyclopaedia Iranica* II/3, 259–261.

Shaked, Shaul. 1993. "Notes on the Pahlavi amulet and Sasanian courts of law", *Bulletin of the Asia Institute* 7, 165–172.

Shaked, Shaul. 1995a. "Jewish Sasanian sigillography", in: R. Gyselen (ed.), *Au carrefour des religions. Mélanges offerts à Philippe Gignoux*, Leuven, 239–255.

Shaked, Shaul. 1995b. "'Peace be upon you, exalted angels': on Hekhalot, liturgy and incantation bowls", *Jewish Studies Quarterly* 2, 197–219.

Shaked, Shaul. 1997. "Popular religion in Sasanian Babylonia", *Jerusalem Studies in Arabic and Islam* 21, 103–117.

Shaked, Shaul. 1999. "The poetics of spells: language and structure in Aramaic incantations of late antiquity: 1. The divorce formula and its ramifications", in: Tz. Abusch and K. van der Toorn (eds), *Mesopotamian magic: Textual, historical and interpretative perspectives*, Groningen, 173–195.

Shaked, Shaul. 2000. "Manichaean incantation bowls in Syriac", *Jerusalem Studies in Arabic and Islam* 24, 58–92.

Shaked, Shaul. 2002. "Healing as an act of transformation", in: D. Shulman and G.G. Stroumsa (eds), *Self and self-transformation in the history of religions*, Oxford, 121–130.

Shaked, Shaul. 2006. "*Dramatis Personae* in the Jewish magic texts: Some differences between incantation bowls and Geniza magic", *Jewish Studies Quarterly* 13, 363–387.

Shaked, Shaul. (forthcoming). "Piety in Pahlavi literature. Notes on *mard ī ahlaw* and other themes".

Shaked, Shaul; James Nathan Ford; and Siam Bhayro. 2013. *Aramaic bowl spells: Jewish Babylonian Aramaic bowls volume one*, Leiden.

Smelik, K.A.D. 1978. "An Aramaic incantation bowl in the Allard Pierson Museum", *Bibliotheca Orientalis* 35, 174–177.

Sokoloff, Michael. 1990. *A dictionary of Jewish Palestinian Aramaic of the Byzantine period*, Ramat-Gan and Baltimore (DJPA).

Sokoloff, Michael. 2002. *A dictionary of Jewish Babylonian Aramaic of the Talmudic and Geonic periods*, Ramat-Gan and Baltimore (DJBA).

Sokoloff, Michael. 2009. *A Syriac lexicon. A translation from the Latin, correction, expansion, and update of C. Brockelmann's Lexicon Syriacum*, Winona Lake and Piscataway (SL).

Spier, Jeffrey. 2007. *Late antique and early Christian gems*, Wiesbaden.

Spier, Jeffrey. 2011. "Late antique and early Christian gems", in: Chris Entwistle and Noël Adams (eds), *'Gems of Heaven'. Recent research on engraved gemstones in Late Antiquity, c. AD 200–600*, London, 193–207.

Stoyanov, Yuri. 2000. *Dualist religions from Antiquity to the Cathar heresy*, New Haven.

Stroumsa, Guy G. 1986. "Seal of the prophets: the nature of a Manichaean metaphor", *Jerusalem Studies in Arabic and Islam* 7, 61–74.

Sundermann, Werner. 1988. "Der Paraklet in der ostmanichäischen Überlieferung", in: P. Bryder (ed.), *Proceedings of the first international conference on Manichaeism*, Lund, 201–212 [reprinted with *addenda et corrigenda* in Sundermann 2001, vol. 2, 813–825].

Sundermann, Werner. 2001. *Manichaica Iranica. Ausgewählte Schriften von Werner Sundermann* (ed. C. Reck et al.), Rome.

Sundermann, Werner. 2009. "Mani", in: *Encyclopædia Iranica, online edition*, available at http://www.iranicaonline.org/articles/mani-founder-manicheism (accessed on 20 September 2016).

Tardieu, Michel. 1981. *Le manichéisme*, Que sais-je?, Paris.

Ten-Ami, Alon. 2012–2013. "Giluyim nosafim meʿinyane Ašmeday: Ašmeday baqəʿarot hahašbaʿa mibavel", *Peʿamim* 133–134: 185–208 [in Hebrew].

Wansbrough, John. 1977. *Quranic studies: sources and methods of scriptural interpretation*, Oxford.

Widengren, Geo. 1961. *Iranische Geisteswelt. Von den Anfängen bis zum Islam*, Baden-Baden.

Widengren, Geo. 1968. "Heavenly enthronement and baptism: Studies in Mandaean baptism", in: J. Neusner (ed.), *Religions in Antiquity: Essays in Memory of Erwin Ramsdell Goodenough*, Leiden, 551–582.

Glossary

Only complete or partial words are included in this glossary. Words that are entirely restored are omitted. The first column contains the lemma, usually with the initial form according to how it appears in *DJBA*, while forms that actually occur in the bowls are listed in the third column. Significant variants are also listed in the first column. Hebrew and Aramaic words from Biblical quotations are not included.

א

אבא	n. "father"	– with pron. suffix 2 p. masc. pl. **'bwkwn** 81:3; 82:14; 84:6; 85:17; 110:1; **'wbwkwn** 86:4	
אבר	See עבר.		
אהלתא	See אלהותא.		
או	conj. "or, whether"	99:5, 6(×8), 7(×2), 16(×9), 17(×2), 18, 19	
אודנא	n. "ear"	– pl. **'wndyn (!)** 116:1	
אווזא	n. "goose"	**'wz'** 116:5	
אוירא	n. "air"	– abs. **'wyr** 103:3	
אוריא	n. "cattle stall"	– with pron. suffix 3 p. masc. sg. **'wryh** 108:1	
אזי	See אזל.		
אזל אזי	vb. "go"	– impf. 3 p. masc. sg. **nyzy** 75:6; 76:9; 79:9; 118:5; **nyzyl** 73:7	
אחא	n. "brother"	– pl. cstr. **'ḥy** 89:12	
אחר	adj. "another"; see the note to JBA 77:2–3.	– fem. sg. **'ḥr'** 77:2	
אחרינא	adj. "another"	**'wḥrn'** 81:3; 82:14; 83:4; 84:5; 85:16; 86:3	
אחרמתא	n. "anathema"	**'ḥrmt** 88:2	

GLOSSARY

איברא	n. "limb"		– with pron. suffix 2 p. fem. sg. **'ybryky** 91:10 2 p. masc. pl. **'ybrykwn** 99:21
איגרא	n. "roof, roof-top"		– with pron. suffix 3 p. masc. sg. **'ygryh** 102:6 – for the expression **bny 'ygry**, see **br'**.
איגרתא	n. "letter, legal document"		119:1(×2)
אידרונא	n. "inner room"		86:1
איכורא	n. "shrine spirit"		– pl. **'ykwry** 98:11; **'ykwrt'** 95:3 – in the expression **'ykwry 'ykwry** 98:9
אילה	See אלה.		
אילין	dem. pron. "these"		100:8; 117:1
איך	adv. "further on"		81:5; 82:16; 85:19 **'lk** 84:8
אימא	n. "mother"		107:7 – with pron. suffix 2 p. masc. pl. **'ymykwn** 81:4; 82:15; 84:6; 85:17; **'ymkwn** 86:4
אין	int. "yes"		110:3
אינון	pron. "they" (masc.)		91:10; 92:7, 10; 93:7, 10; 94:7, 11; 99:18, 22(×2); 100:4 -**nwn** 92:6; 93:7; 94:7; 99:18 – as copula 114:7
אינשא	n. "man"		**'ynšh** 107:8 – in the expression "human beings" **bny 'ynš'** 91:2; 92:4; 93:4; 94:4; 96:2, 3; 98:10; 101:9; **bny 'ynšh** 99:14 – in the expression **'ynš 'ynš** "each one" 89:10 – pl. **'yn'šy** 68:1; **'ynšy** 69:1; 74:1; 103:10 – cstr. pl. **'ynwšy** 108:2, 4, 5; **'ynšy** 73:1, 5; 78:2; 79:8; 95:4; 98:12; 100:6; 101:12; 114:5; 115:7; 116:5
אינתתא	See איתתא.		
איסוי	See סייב.		

איסורא	n. "prohibition, bond, spell"	ʾswrʾ 73:9 swr 88:3 – cstr. ʾyswr 89:9; ʾswr 105:9 – with pron. suffix 3 p. masc. sg. ʾyswryh 89:7(×2); ʾswryh 105:4; 106:4 – pl. ʾyswryn 72:2; ʾswryn 75:2; 76:4
איסכופתא איסקופתא	n. "threshold"	– cstr. ʾyskwpt 93:8; 94:10 – with pron. suffix 3 p. masc. sg. ʾysqwptyh 76:1, 7; 77:1, 3, 4(×2), 5; 79:1; 80:1; 87:5; 105:2; 111:3; 117:1; ʾsqwpth 109:1; ʾsqptyh 108:4, 5 3 p. masc. sg. ʾysqwpthwn 112:9 – pl. ʾysqwptʾ 98:10; 101:9
איסקופתא	See איסכופתא.	
איסרא	n. "bond, punishment, charm"	70:10 ʾsrʾ 99:3 – pl. ʾysry 70:4; ʾysryn 66:1; 73:3; 90:3; 116:10; ʾsryn 65:2; 69:2; 71:2; 74:3; 79:3; 80:2; 95:9; ʿyśryn 98:15
איסתרא	n. "goddess" (type of demon)	– pl. ʾystrtʾ 73:9; 89:10; 95:3; 102:10; 103:4, 11; 110:2
איצבעתא	See אצבעתא.	
אישתא	n. "fire; fever"	68:6; 82:18; 117:4; ʾyšth 74:2
אית	part. "there is/are"	68:1; 69:1; 74:2; 76:8; 87:7; 92:6, 8; 94:7; 99:5, 18; 111:3; 113:3; 114:9 ʾt 93:7 yt 97:2 – with pron. suffix 3 p. masc. sg. ʾytwhy 89:11 3 p. fem. sg. yth 89:6 3 p. masc. pl. ʾytynwn 91:6; ʾytnyhw 91:6

איתתא אינתתא	n. "woman, wife"	107:7 'yntt' 92:2; 93:4; 94:4 'tt' 91:3 – with pron. suffix 1 p. sg. 'ntty 70:1 3 p. masc. sg. 'yntyh 104:16; 'yntth 110:6; 'ynttyh 66:1; 73:6; 87:6; 90:2; 91:7, 9; 92:3; 93:3; 96:5; 98:6, 7, 12, 14, 17; 99:2, 5, 19, 22; 101:7, 12, 14, 17; 102:5, 11; 107:3; 116:4, 5; 'yttyh 74:1; 100:5, 7, 9; 105:4; 106:4; 114:9; 'nttyh 91:8; ytth 88:1; yttyh 88:3 – pl. nšy 96:3; 98:10; 99:14; 101:10
אכלא	n. "hammer, mallet"	103:5
אלה אילה	conj. "but"	'ylh 86:6(×2)
אלהא	n. "god" (sometimes in reference to God)	– with pron. suffix 2 p. masc. pl. 'lhkwn 99:20 – pl. 'ylhy 73:9; 'lhyn 99:25
	n. fem. "goddess"	– pl. 'ylhwt' 89:4
אלהותא	n. "worship of (pagan) deities"	'hlt' 88:2 (see the note to this line)
אלילא	n. "income"; see the note to JBA 113:10.	113:5 – with pron. suffix 3 p. masc. sg. 'lylyh 113:10
אלפא	num. "thousand"	100:7
אם	conj. "if, whether"	91:8, 9; 92:9(×2); 93:8, 9(×2); 94:9; 99:8; 20(×2); 100:6 'ym 75:6; 76:8; 79:8; 118:4
אמן	(Heb.) "Amen"	65:10(×2); 66:4(×2); 67:6(×2), 8(×2); 68:9–10; 71:6(×2); 72:7(×2); 73:2(×2), 7(×2), 8, 10(×3); 75:7(×2); 76:11(×2); 77:3(×2); 78:7(×2); 79:10(×2); 81:6(×7), 7(×2); 82:17(×2), 20(×2); 84:9(×2); 85:8, 19, 20(×11); 86:8(×4), 10(×8), 11(×10); 87:9(×2); 88:5; 89:13(×2); 90:6, 7; 91:11(×3); 92:12(×2); 93:11; 95:15(×2); 96:6(×2); 97:8; 98:18(×2); 99:3(×2), 12(×2); 100:9(×2); 101:18(×2); 102:13(×2); 103:5(×2), 14; 104:13(×2), 16(×2), 17(×2); 105:9(×2); 106:6, 7, 8(×3), 9(×2); 107:9(×2); 108:7, 9(×2); 109:5(×2), 6(×2); 110:7(×2); 116:11(×2); 117:8(×2); 118:7(×2); 119:4(×2), 5(×2) 'myn 81:5; 82:16; 84:8; 85:19 mn 86:7
אמר	vb. "say, speak"	– ptc. masc. sg. with 1 p. sg. encl. pron. 'mrn' 99:10 masc. pl. 'mryn 103:4

אמר	(Heb.) **vb.** "say, speak"	*ni.* "be said" – pf. 3 p. masc. sg. **n'mr** 65:9; 95:13; 98:17; 101:17	
אנא אנה	**pron.** "I"	70:8; 116:8; **'nh** 99:28; 103:1, 4, 7	
אנחנא	**pron.** "we"	70:1	
אני	(Heb.) **pron.** "I"	86:1, 2; 90:1; 105:1	
אנתה/אנתא	**pron.** "you" (masc. sg.)	99:17	
אנתי	**pron.** "you" (fem. sg.)	91:1, 6; 92:1, 7; 93:2; 94:2, 7; 100:4	
אסותא	**n.** "healing"	78:1; 82:1, 4, 6, 9, 18; 85:5, 9, 14; 86:1; 93:1; 99:1 **'swth** 108:1 – abs. **'sw** 83:1; 90:1 – with pron. suffix 2 p. masc. sg. **'swtyk** 116:3	
אסי	**vb.** "heal"	*itpa.* "be healed" – impf. 3 p. fem. sg. **tytsy** 82:18; 92:12 3 p. masc. pl. **ytswn** 99:3; 108:1	
אסיא	**n.** "doctor, healer"	**'syh** 106:6	

אסר	vb. "bind"	– pf.
		1 p. sg. **'sryt** 99:28
		– ptc.
		masc. sg. **'sr** 81:6; 82:17; 84:9; 85:19; 91:3; 92:5; 93:5; 94:5; 97:4
		masc. pl. **'sryn** 91:9; 92:9; 93:10; 94:10; 96:6
		– pass. ptc.
		masc. sg. **'syr** 89:5; 90:3; 106:3; **syr** 88:1, 3(×2)—see Ford 2012, 243 (n. 79).
		fem. sg. **'syr'** 89:7(×2), 11; **'syrh** 105:1; 106:1
		sg. with 2 p. masc. sg. encl. pron. **'syrt** 96:3; 99:17
		sg. with 2 p. fem. sg. encl. pron. **'syrt** 81:5; 82:16; 84:8; 85:19; 91:1, 3; 92:1, 4; 93:1, 5; 94:1, 4; 116:1(×2)
		masc. pl. **'syryn** 73:2; 75:1; 79:3; 80:2; 81:2; 82:13(×2); 83:2, 3; 84:4(×2); 85:15(×2); 86:2, 8; 89:8, 9, 12; 104:15; 110:5; 118:2(×2)
		pl. with 2 p. masc. pl. encl. pron. **'syrytwn** 65:2; 95:5, 6, 8; 96:1; 98:12, 13, 14; 99:12, 15; 101:7, 12, 13, 14; 110:3; **'srytwn** 110:2
		pl. with 2 p. fem. pl. encl. pron. **'syrytynynyn** 111:5(×2)
		itpa. "be bound"
		– impf.
		2 p. masc. pl. **tytsrwn** 81:6; 82:17; 84:9; 85:19; 110:1
		3 p. masc. sg. **nytsr** 105:9
אף	conj. "even, also, moreover"	91:6; 91:7; 99:18; 100:4
אפא	n. "face"	– cstr.
		'py 116:5
		– pl. with pron. suffix
		3 p. masc. pl. **'pyhwn** 116:5
אפך	vb. "overturn"	– pass. ptc.
		masc. sg. **'pyk** 73:8(×2), 9; **'pk** 73:8
		fem. sg. **'pyk'** 73:9(×2)
אצבעתא / איצבעתא	n. "finger"	– pl. with pron. suffix
		1 p. sg. **'yṣb'ty** 103:7; 104:1
ארא	See ערא.	
ארבעא	num. "four"	**'rby** 102:5(×2)
		'rb' 94:8
		– with pron. suffix
		2 p. fem. pl. **'rb'tykyn** 111:5
		3 p. masc. pl. **'rbt'yhwn** 91:11; **'rb'tyhwn** 92:10; 93:11; 94:11; 99:22
ארגוונא	n. "purple cloth"	**'rgwn'** 103:1
אריא	n. "lion"	89:7; 116:8

ארעא	n. "earth"	117:8 ʼrʻh 65:6; 66:4; 68:5; 70:7; 71:5; 72:5; 73:3, 4(×2); 74:7; 75:4; 76:6; 77:3; 79:6, 7; 80:6, 7; 86:8, 9; 95:11; 98:16; 101:16; 103:3; 105:7, 9; 113:6; 114:10; 115:5; 118:2 rʻh 109:3
אשלמתא	n. "spell"; perhaps a type of demon, "spell demon"	šltʼ (!) 73:9
אשתקופתא	n. "blow demon" (see also שיקופתא)	ʼyštqwptʼ 107:6 ʼštqwptʼ 88:2
את	pron. "you" (masc. sg.)	99:20; 102:11(×2), 12(×2); 103:12(×2), 13(×2); 104:8(×2), 10(×2) – used for fem. sg. 102:11, 12(×2); 104:9, 11
אתון	pron. "you" (masc. pl.)	99:16, 18; 100:8; 110:3
אתי	vb. "come"	– pf. 3 p. fem. sg. ʼtt 119:1 – impf. 3 p. masc. pl. ytwn 91:11; 99:22; yytwn 92:11; 93:11 – ptc. fem. sg. ʼtyʼ 89:6 af. "bring" – ptc. masc. sg. with 1 p. sg. encl. pron. mytynʼ 91:9(×2); 92:12(×2); 93:9, 10; 94:10; 96:6; 99:8, 20, 21
אתרא	n. "place"	– abs. ʼtr 91:6(×2); 99:18(×2); 100:4, 5 – in the locution kl ʼtr wʼtr "each and every place" 92:6, 6–7; 93:7(×2); kwl ʼtr wʼtr 94:7(×2)

ב

-ב	(1) prep. of place/time "in, into, at, during, by, among"; + inf. cstr. "when"	83:1; 86:6; 89:6, 11, 12; 91:1, 2(×2), 6(×2), 9, 11; 92:2(×2), 3, 4; 93:2, 3, 4(×2); 94:3, 4; 95:7; 96:2(×2), 3; 98:6, 9(×2), 14; 99:14(×4), 17, 20(×3), 29; 100:4, 6(×2), 9; 101:9(×3); 103:2, 9, 10; 110:3; 113:4; 104:6(×4); 114:7(×3); 116:2(×2), 8 by- 73:6 – with pron. suffix 3 p. masc. sg. byh 89:11; 99:5, 18; 100:4, 5
	(2) prep. of agent "by, through"	65:6(×2); 67:3; 73:2; 81:3(×2); 82:14, 20; 84:6(×2); 85:16, 17; 86:4; 90:3; 91:8, 10(×2); 92:9, 10(×2); 93:5, 8, 10; 95:8, 11; 98:16(×2); 99:10, 20(×2); 100:6; 101:16(×2); 102:6(×3), 9(×5); 103:10(×3), 11; 104:4(×3), 5(×2); 107:8; 110:1, 4, 6, 7; 112:7 by- 65:1; 72:6; 82:17; 98:14; 101:14; 117:6; 119:4

	(3) **prep.** of instrument "with, by (means of), in"	65:2(×2), 5(×3), 6; 66:1(×2), 2(×3), 3(×4), 4(×3); 67:3(×4); 68:3, 5(×2); 69:2, 3; 70:4(×2), 6(×2), 7, 9, 10; 71:2, 4, 5(×3); 72:2, 4, 5; 73:2, 3(×2), 4(×5), 10(×2); 74:3, 6; 75:2(×3), 3, 4(×2); 76:4, 6(×4); 77:1(×2), 2(×3), 3, 4(×2), 7; 78:6(×2); 79:3, 4(×2), 6(×2), 7(×3); 80:2, 3(×2), 5, 6(×3); 81:2, 5; 82:13, 14, 17, 18; 83:3, 4, 8; 84:4, 5; 85:15, 16, 19; 86:2(×2), 3, 8, 9(×2), 10; 87:7(×2), 8; 88:3(×2), 4(×5); 89:7(×3), 8, 9(×3), 12; 90:3; 91:3, 4(×3), 5, 8; 92:5(×3), 10(×2); 93:5(×2), 6, 10; 95:5(×3), 8, 9, 10, 11(×4); 96:6; 97:3, 5; 98:13(×2), 14, 16(×3); 99:3, 16(×2), 17, 20(×3), 28; 100:3, 5; 101:13; 101:15, 16(×4); 102:3(×2); 103:1, 4, 7(×5), 8; 104:1(×4), 2(×2); 105:4(×2), 5, 6(×2), 9(×2); 106:4, 5; 107:4(×2); 108:6, 7; 109:2; 110:2, 4(×2); 111:5; 112:9; 113:5(×2), 6; 114:10(×3); 115:4(×3); 116:3(×2), 6, 10; 117:6(×3); 118:2, 3(×2); 119:5(×3) **by-** 69:2; 71:2; 72:2(×2), 4, 5; 74:3; 75:1; 76:4(×3); 77:5; 81:4; 82:15; 84:7; 85:18; 90:3; 92:4; 94:6, 11(×2); 98:15; 106:6; 116:6 **p-** 88:3 – with pron. suffix 3 p. masc. sg. **bh** 73:3, 4; 76:4; 79:4; 80:3; 88:4; **byh** 72:5; 75:3; 76:6; 79:6; 80:3, 6; 86:2, 8, 9, 10; 105:7 3 p. fem. sg. **bh** 105:5; 109:3; 113:6; 114:10; 115:5 3 p. masc. pl. **bhwn** 66:2; 117:7; 118:2
	(4) **prep.** "in respect of, over"	**by-** 98:10; 101:9
	(5) **prep.** "subject to, under"	73:7; 75:6; 76:9; 79:9 – with pron. suffix 3 p. fem. sg. **bh** 79:9; 118:6 3 p. fem. pl. **bhyn** 76:9
	(6) **prep.** "as"	86:5
	(7) **prep.** "against"	107:5(×2)
	(8) **prep.** "according to"	89:10
	(9) with vb., marking obj. (ordered by the vb. immediately preceding it)	ḤṬY + **b-** 81:5; 82:16(×2); 84:8(×2); 85:18(×2); 91:7(×2), 8(×2); 92:4, 8(×2); 93:4; + **by** 91:3; 92:8(×3); 96:5(×3); 99:20(×2); 100:5(×2), 6(×4) + **t-** (!) 81:5; + 3 p. fem. sg. **bh** 92:8; + 3 p. masc. pl. **bhwn** 81:5; 82:16; 84:8; 85:18 ḤṬP + **b-** 86:5, 6; + 3 p. masc. pl. **bhwn** 86:5 NZQ *af.* + **b-** 91:3; 102:10, 11; 94:9(×2) ŠMʿ + 3 p. masc pl. **bhwn** 103:5
	(10) in a locution	– **bgw** "within" 97:2; 116:7, 8; + 3 p. masc. sg. **bgwyh** 89:5
-בְּ	(Heb.) **prep.** of agent "by, through"	**by-** 86:1, 2; 105:1
בבא	n. "door, gate"	86:6; 115:2; 115:3

בגדנא	n. "*bagdana*-spirit" (type of demon)	– pl. **bgdn'** 89:12; **bgdny** 89:9
בות	vb. "spend the night"	– impf. 3 p. masc. sg. **ybwt** 119:4
בזי	vb. "debase"	*pa.* "shame" – ptc. fem. sg. **mbzy'** 95:2; 98:10; 99:15; 101:10
בטל	vb. "cease"	– impf. 2 p. masc. pl. **tbṭlwn** 98:6 *pa.* "remove" – ptc. sg. with 2 p. fem. sg. encl. pronoun **mbṭlt** 94:2
בידינא	See ביתא.	
בין	prep. "between, among, whether"	**bn** 98:5
בינא	n. "tamarisk"	73:7; 75:6; 76:9; 79:9; 118:5
ביש	(1) adj. "evil"	107:8 **byš'** 73:7(×2); 75:7(×2); 76:10(×2); 79:9, 10; 88:3; 99:6, 7; 103:11; 108:4; 118:6(×2) – fem. sg. **byšt'** 89:11; 91:1, 6; 92:7; 93:2, 7; 94:2, 7; 100:4, 8 – for the expression **'yn' byšt'**, see **'yn'**. – masc. pl. **byšy** 74:2; 88:1; 89:9; 95:7; 98:11, 13; 99:8; 107:8; **byšy'** 82:19; 101:14; **byšyn** 77:3; 82:19; 95:2; 98:11; 101:11; 103:12; 107:7; 113:3; **byšn** 114:6 – fem. pl. **byšwt'** 88:2 **byšt'** 68:2, 6; 70:3; 72:6(×2); 76:3; 86:4; 89:4; 98:4; 99:8, 11; 104:7, 15; 111:4(×2)
	(2) n. "evil"	– fem. sg. **byšt'** 82:19

ביתא	n. "house"	82:15; 84:2; 89:5, 6, 10, 12; 90:1, 3	
		– cstr.	
		byt 99:10; 116:2	
		– in the expression **bydyn'** "court" 116:6 (?; see note)	
		– with pron. suffix	
		3 p. masc. sg. **byth** 74:1; 95:4, 5, 7; 99:4; 104:1, 5, 8, 15; 109:1; 110:6; **bytyh** 72:1; 73:1(×2); 75:1, 5; 76:1, 7; 77:1, 3, 4(×2), 5; 79:1; 80:1; 81:1, 4; 83:1; 84:7; 86:4, 9; 87:5; 88:1, 3; 91:1, 7, 8, 11; 92:2, 11; 93:2, 8(×2); 98:5; 98:12, 14; 99:19, 22; 100:4, 6, 8; 101:14; 102:5; 107:2; 108:1, 2, 4(×2), 5(×2); 111:2; 113:9; 114:1, 5, 7, 8; 115:1, 7(×2); 116:4, 5; 117:1, 7	
		3 p. fem. sg. **byth** 85:2, 14, 17; 92:7; 97:2; **bytyh** 72:5; 79:7, 8; 82:12; 83:3; 118:1	
		3 p. masc. pl. **bytyhwn** 89:2, 3, 12; 100:6; **btyhwn** 73:5; 92:9; 93:11; 94:10; 94:12; 98:7, 12(×2); 101:12(×2)	
בלמה	See the note to JBA 117:5.		
בניינא	n. "building"	– with pron. suffix	
		3 p. fem. sg. **bynynyh** 82:12	
בעירא	n. "cattle"	– with pron. suffix	
		3 p. masc. sg. **b'yryh** 73:1; 91:8; 96:5	
		3 p. masc. pl. **b'yrhwn** 73:5; 99:20; 100:6	
בעלא	n. "husband"	– with pron. suffix	
		3 p. fem. sg. **b'lh** 92:8; 102:2	
בקעתא	n. "valley"	– pl.	
		– in the locution **bq't' bq't'** "various valleys" 98:9; 99:14; 101:9; **pq't' byq't'** 96:2	

ברא (1)	n. "son, child"	– cstr.
		br 65:3(×2), 8(×2); 66:1, 3, 4; 67:5; 68:1, 3, 4(×2); 69:1; 70:1, 5(×2), 7, 8, 9; 71:3, 4; 72:3(×3), 5; 73:1, 5, 7, 8, 9, 10; 74:1, 4(×2), 5; 75:5, 7; 76:2, 7, 10; 77:1(×2), 2(×2), 3, 4(×2), 5; 79:2, 8, 10; 80:1; 81:1; 83:2; 84:3, 7; 86:1, 5, 7, 9, 10; 87:6, 8; 88:1, 3; 90:1; 91:2, 5, 7, 8, 11; 92:2, 6, 11; 93:3, 6, 9; 94:6; 95:4, 6, 8, 9(×2), 13; 96:4, 5, 7; 98:5, 7, 12, 13, 14, 15(×2), 17; 99:2, 4, 18, 19, 22, 24; 100:3, 5, 7, 8; 101:14, 15, 17; 102:2, 4(×2), 10; 103:8; 104:1, 2, 5, 8, 16; 105:4; 5(×2); 106:3, 4(×2); 107:3, 4; 108:2, 3, 5(×2); 109:2, 3; 110:1, 4, 5; 111:3; 112:3; 113:2; 114:8; 115:2, 7; 116:4; 118:6; 119:1
		– in the expression **br ḥry** "nobleman" 98:9; 101:8
		– in the expression **br mwtʾ** "one condemned to death", **brmwtʾ** 99:6, 8, 11
		– with pron. suffix
		3 p. masc. sg. **brh** 69:1(×2)
		– pl.
		bny 79:2; **bnyn** 110:6; 117:5
		– in the expression **bny bny** "grandchildren", with 3 p. masc. sg. pron. suffix **bny bnh** 69:1; 74:1
		– cstr.
		bny 89:2, 6, 13; 106:3
		– in the expression **bny ʾygry** "roof demons" 117:4
		– in the expression **bny ḥyṣby** "jug demons" 117:4
		– with pron. suffix
		3 p. masc. sg. **bnh** 74:1; 104:6; 110:6; **bnyh** 91:7; 96:5; 105:2, 3; 116:4
		3 p. fem. sg. **bnh** 92:7, 8, 11
		3 p. masc. pl. **bynyhwn** 73:5; **bnyhwn** 35:3; 87:7; 99:19; 100:9; 114:4, 9
	n. fem. "daughter"	**brtʾ** 107:7
		– cstr.
		br (!) 88:3; **bt** 70:2(×2), 8; 72:2, 6; 73:2, 5; 75:5; 77:1; 79:2, 8; 81:4; 82:2, 12, 15, 17, 19, 20; 85:3, 14, 17; 86:5(×2); 87:6; 88:1; 90:2; 91:2, 7, 8; 92:3, 7, 11; 93:1, 3, 8, 9; 94:3, 8; 97:2; 98:5, 7, 12, 14, 17; 99:2, 5, 19, 23; 100:5, 7, 9; 101:12, 14, 17; 102:2, 7, 11(×2); 103:1, 4, 7, 9, 12, 13; 104:3, 9, 16; 105:4; 106:2, 4; 107:3; 110:5; 111:3; 113:2; 114:3, 9; 116:5; 118:1(×3), 4; 119:3, 4
		– in the expression **bt ḥry** "noblewoman" 95:1; 96:3; 98:10; 101:10; **bt ḥryn** 99:15
		– in the expression **bt qlʾ** "voice" 91:1
		– pl.
		– with pron. suffix
		3 p. masc. sg. **bnth** 69:1; 74:1; **bntyh** 91:7; 96:5; 105:2, 3; 116:4
		3 p. fem. sg. **bnth** 92:8(×2), 11
		3 p. masc. pl. **bnthwn** 73:5; 114:4, 9
בראה	adj. "outer"	115:3
		fem. sg. **brytʾ** 79:11
בראשית	(Heb.) a phrase meaning "in the beginning"; used as a n. "creation"	**bryšyt** 108:7
ברזלא	See פרזלא.	

ברך	(Heb.) vb. "bless"	– pass. ptc. masc. sg. **brwk** 107:4
בת	See ברא (1).	

ג

גבל	vb. "knead"	– ptc. masc. sg. **gbyl** 103:10
גברא	n. "man"	116:7 – abs. **gbr** 91:2; 92:3; 93:4 – pl. **gbry** 98:10; 101:10; **gbryn** 81:4; 82:16; 85:18; 86:5; 91:9; 92:9; 93:10; 94:10; 96:6; 99:21
גו	See -ב or -ל.	
גואה	adj. "inner"	115:2
גובלא	n. "dough"	103:10
גונחא	n. "cough demon" (?); see the note to JBA 117:3.	117:3
גופא	n. "body"	– with pron. suffix 3 p. masc. sg. **gwph** 104:6; **gwpyh** 105:4
גושפנקא	n. "signet-ring"	113:6; 114:10; 115:4
גזר	vb. "decree, impose a court oath"	– inf. **mygzr** 116:7 – ptc. masc. sg. **gzyr** 116:7
גיבר	adj. "strong, mighty"	– masc. pl. **gybryn** 86:5; 99:21
גיזרא	n. "prey"	– with pron. suffix 3 p. masc. sg. **gyzryh** 116:8
גינתא	n. "garden"	– pl. – in the locution **gyny gyny** "various gardens" 101:9
גיסא	n. "troop"	– pl. **gysyn** 99:9

גללא	n. "stone"	77:5	
גלף	vb. "carve"	– pass. ptc. masc. sg. **glyp** 108:7	
גנב	(1) vb. "steal"	*pa.* "deceive" – ptc. fem. sg. **mgnb'** 95:1; 96:3; 98:10; 99:15; 101:10	
	(2) adj. "thieving"	92:3; 93:4 – fem. sg. **gnbyt'** 91:3; 92:4; 93:4 – masc. pl. **gnbyn** 81:4; 82:16; 83:6; 84:8; 85:18(×2); 86:5; 92:9; 93:10; 94:10; **gbyn (!)** 82:16	
גנזא	n. "treasure house"	– pl. **gnzy** 91:8 – with pron. suffix 2 p. fem. sg. **gynyk (!)** 100:6; **gnzyk** 92:9; 93:8; 94:9 2 p. masc. pl. **gnzykwn** 99:20	
גער	vb. "be rebuked"	– impv. fem. sg. **g'wry** 92:7; 93:7; 94:8	
גפא	n. "wing"	– cstr. pl. **gpy** 116:5 – with pron. suffix 3 p. masc. pl. **gpyhwn** 116:5	

ד

-ד	(1) conj. "(in order) that"	73:5, 6, 9; 76:7; 77:3, 6; 79:7; 81:4; 82:15, 19; 84:7; 85:17; 86:4; 89:9; 91:8; 92:8, 9; 93:9; 94:9; 98:14; 100:6; 102:10; 103:12; 104:5; 108:1; 110:3, 6; 118:3 **dy-** 89:3
	(2) "for"	75:6; 76:8; 79:8; 91:10, 11; 116:6

GLOSSARY

	(3) **genitive marker** "of"	65:1(×2), 3(×2), 4(×2), 5(×4), 6(×3); 66:1, 2, 3(×3), 4(×2); 67:2(×2), 3(×3); 68:3(×2), 4(×2), 5(×3); 69:4; 70:4, 5(×3), 6(×4), 7(×2), 9; 71:3(×2), 4(×3), 5(×3); 72:1, 2, 3(×3); 72:4(×4), 5, 6, 7; 73:1, 2, 3(×4), 4(×4), 5, 8(×2), 9(×3), 10; 74:4(×3), 6(×3), 7; 75:1, 2, 3(×4), 4(×3), 5(×2); 76:2, 5(×4), 6, 7; 77:1(×3), 2(×5), 3(×2), 4(×2), 5, 6; 78:3(×2), 4; 79:1, 2, 5(×3), 6(×2), 7(×4), 8(×2), 11; 80:1, 4(×2), 5(×3), 6(×2), 7; 81:2(×2), 3, 4, 5(×2), 6; 82:12, 13, 14(×2), 15, 16(×2), 17, 18; 83:2, 3, 4(×2), 8; 84:3, 5(×3), 7, 8(×2); 85:2, 14, 16(×3), 17, 18(×2), 19; 86:1, 2, 3(×3), 5(×4), 6, 9(×2); 87:6(×2), 7(×2), 8; 88:3, 4(×2); 89:2, 6, 7(×3), 8, 9(×2); 90:1(×2); 91:1, 2, 3, 4, 7(×2), 8(×2), 10(×3), 11; 92:2, 3, 5(×3), 10(×4), 11(×2); 93:3(×2), 5(×2), 8(×2), 9(×2), 10(×2); 94:3, 5, 8, 11(×3); 95:4; 95:5(×2), 6(×3), 7(×2), 9, 10(×5), 11(×4); 96:6; 97:2; 98:5, 7(×2), 10, 12(×2), 13(×4), 14(×3), 15(×4), 16(×5); 99:4, 5, 7(×5), 8(×5), 11(×9), 12, 16(×2), 17, 19(×4), 21(×2), 22(×2); 100:3, 5(×2), 6, 7; 101:13(×3), 14(×2), 15(×3), 16(×3); 102:3; 103:5(×3), 8, 9, 10; 104:1, 2, 5, 8, 16; 105:4(×2), 5(×2), 6(×2); 106:4, 5(×2); 107:3, 4; 108:2, 4, 5, 6(×2); 109:2(×2); 110:1, 4, 5, 6; 111:2, 3(×2), 5(×3); 112:7; 112:9; 113:1, 10; 114:8, 10; 115:2(×2), 3, 4, 7; 116:2(×2), 4, 10; 117:5, 6; 119:2(×2), 4, 5(×2) **dy**- 5:3; 66:3(×2), 4; 71:3; 72:3, 5; 73:5, 8; 74:3; 75:3; 76:5, 7; 77:3, 4(×2), 5; 79:5; 80:5; 86:9; 88:1, 3; 91:4(×2), 5, 9(×2), 10; 95:6, 9(×2); 98:13(×2), 15; 99:7, 11, 21(×2), 22, 28; 101:13, 16; 113:4; 117:5; 119:5
	(4) **rel. pron.** "(the one) that, who, which, where"	66:2, 4(×3); 68:1, 2, 7; 69:1; 73:3, 4, 6; 74:1; 75:2, 3; 76:3, 4, 6, 7, 8; 79:4, 6; 80:3(×2), 6; 81:3, 4, 6; 82:14, 16, 17, 19; 83:1; 84:6, 8, 9; 85:18, 19; 86:2, 4(×2), 5, 8, 9, 10; 87:7; 88:4, 5; 89:5, 6(×2), 10(×2), 11; 90:1; 91:1, 2, 3(×2), 4, 5(×2), 6(×3), 9(×4), 10; 92:2, 5, 6, 7, 8(×2), 9(×2), 10; 93:5, 6, 7(×2), 9, 10(×2); 94:3, 5, 7(×2), 10(×2), 11; 95:1, 2, 6, 11; 96:2(×5), 4(×2); 97:2; 98:6, 10, 13; 99:5, 12, 13(×2), 14(×3), 15(×2), 17(×2), 18(×3), 20, 22; 100:3, 4, 5, 7(×3); 101:8, 9; 103:9; 105:5, 7(×2), 8; 107:5, 8; 109:3; 110:4, 5(×2); 111:3, 5; 113:3, 4, 5, 6; 114:4, 6, 7, 9(×2), 10; 115:5; 116:1(×2), 7, 8; 117:7; 118:2; 119:1, 3 **dy**- 68:2, 6; 72:5; 78:3; 96:3; 98:10; 101:9, 10(×2); 110:4; 114:6; 116:1, 10; 117:5
	(5) in a locution	– **kmʾ/kmh d-/dy-** "just as, like" 73:7; 75:6–7; 76:9; 79:9 – see also **myṭwl d-** "because".
דכרא	n. "field, outlying area"	111:5
דוך	n. "place"	116:8
דוכנין	See the note to JBA 99:8–10.	
דונקא	n. "torment" (see the note to JBA 116:9)	116:9
דותקא	n. "family"	– with pron. suffix 2 p. masc. sg. **dwtqyk** 102:13; 104:11; 103:14 3 p. masc. sg. **dwtqh** 104:4; **dwtqyh** 102:9; 103:9; 105:3
דחל	vb. "fear"	– ptc. masc. pl. **dḥlyn** 91:6; 92:6; 93:6; 96:4; 99:18 *pa.* "frighten" – ptc. masc. pl. **mdḥlyn** 114:7

דיד-	**possessive pron.**	– with 1 p. sg. pron. suffix "my" **dydy** 103:7(×2); 104:1	
דיוא	**n.** "*dēv*" (type of demon)	77:5; 89:4, 11; 99:6, 11; 119:2 – masc. pl. **dwyn** 116:9; **dywy** 68:1, 6; 70:2; 83:4; 85:16; 86:3; 89:3, 13; 90:2; 95:6; 98:8, 11, 13; 99:7, 16; 100:3; 101:7, 13; 103:3; 104:15; 105:7; 117:2; **dywy'** 81:3; 82:13, 19; 84:6; **dywyn** 72:6; 73:2, 6; 75:1, 5; 76:3, 8; 79:3, 8; 80:2; 87:8; 91:5; 92:6; 93:6; 94:6; 95:2; 118:1	
דיכרא	**n.** "male" (often as adj.)	89:5; 98:4; 107:6; 119:3 – abs. **dkr** 98:8 – pl. **dykry** 68:2; 70:3, 4; 73:9; 76:3; 86:3; 90:2; 96:1; 102:10; 103:4; 103:11; 104:7; 107:5; 111:4; **dykryn** 114:6	
דיירא	**n.** "inhabitant"	– pl. **dy'ry** 89:5	
דין דן	**dem. pron.** "this" (masc.)	68:7; 75:1; 78:7; 81:1; 82:12; 83:1; 84:1, 3; 85:1, 14; 99:7; 111:1; 113:5; 118:6; 119:1(×2) **dn** 92:12	
דינא	**n.** "law, lawsuit, judgment"	116:6 (?)	
דיקלא	**n.** "date palm tree"	– pl. – in the locution **dyqly dyqly** "various date palm trees" 99:14; 101:9	
דירתא	**n.** "dwelling"	86:6; 89:12 – with pron. suffix 3 p. masc. sg. **dyrtyh** 76:2; 76:7; 81:1; 83:2; 87:5; 100:7, 8; 105:2; 108:1, 4, 5; 111:3; 116:4; **drytyh** 86:4 3 p. fem. sg. **dyrth** 72:2, 5; 73:1; 81:4; 91:2, 7, 8; 92:1, 11; 93:3, 9; 94:3, 8; 99:5, 19, 22; **dyrtyh** 82:12 3 p. masc. pl. **dyrthwn** 95:4; **dyrtyhwn** 89:12; 91:9; 93:9, 11; 94:10; 94:12; 98:12	
דכר	**vb.** "mention"	– pass. ptc. masc. sg. **dkyr** 68:2, 6, 7; 78:3; 113:4(×2); 114:6, 7 masc. pl. **dkyryn** 73:6(×2) *af.* "call to remember, recite, mention" – ptc. masc. sg. **mdkr** 116:8	
דמא	**n.** "blood"	– with pron. suffix 2 p. fem. sg. **dmyk** 116:2	
דמותא	**n.** "form, figure"	– cstr. **dmwt** 81:4; 82:15; 84:7; 85:18	

GLOSSARY

דמי	vb. "be similar"	*itpe.* "resemble, appear in the guise of" – impf. 2 p. masc. pl. **tydmwn** 81:4; 82:15; 84:7; 85:18 – ptc. fem. sg. **mydmy'** 91:2	
דן	See דין.		
דנן	dem. pron. "this" (masc.)	73:7; 75:7; 76:10; 77:3; 79:10; 82:15; 99:19, 22; 102:13; 104:12; 114:7	
דעדקא	See דרדקא.		
דרדקא דעדקא	n. "boy, child"	– pl. **drdqy** 91:3; 92:4; 93:5; 98:10; 101:10 – with pron. suffix 3 p. masc. pl. **dʿdqyhwn** 99:13; d[...]yhwn 93:1	
	n. (fem.) "girl"	– pl. **drdqt'** 98:10; 101:10	
דרמנא	n. "remedy"	82:5, 7–8; 85:14; **drmn** 82:18 – cstr. **drmn** 82:10	

ה

-ה	(Heb.) def. art. "the"	*passim*	
הדא	dem. pron. "this" (fem.)	77:7; 82:12; 86:6; 89:11, 12; 99:5, 8; 119:3	
הדין	dem. pron. "this" (masc.)	66:4; 68:1; 73:7; 74:1; 75:6; 76:9; 78:1; 79:9; 89:5, 6, 10; 90:1, 3; 91:6; 92:7; 93:7; 94:7; 99:3, 4(×4); 100:4(×2), 7; 105:8(×2); 113:10; 114:8, 13; 115:2, 7(×2); 116:4, 7	
הדמא	n. "limb, member"	– pl. cstr. **hdmy** 92:11	
הדר	vb. "return, come back; surround"	– pass. ptc. masc. pl. **hdyryn** 77:6	
ההיא	dem. pron. "that" (fem. sg.)	73:10; 99:17; 116:2	

הוא	**pron.** "he, it"	65:7; 67:4; 95:12; 97:4(×2); 98:16; 101:16; 103:9; 107:4 – as copula 66:4; 81:3; 82:14; 84:6; 86:4; 91:9, 10; 99:22 **hy'** 3 p. fem. sg. "she, it" – as copula 86:4; 91:4, 5; 99:17; 113:4
הוי	**vb.** "be, become"; see also חוי.	– impf. 2 p. fem. sg. **tyhwy** 86:1; 91:11 3 p. masc. sg. **yhy** 90:1 3 p. fem. sg. **tyhwy** 99:1 3 p. masc. pl. **nyhwn** 110:6 – ptc. masc. pl. **hwn** 92:8; 114:4, 9
היא	See הוא.	
הלין	**dem. pron.** "these"	99:10; 117:6
הללויה	(Heb.) "Hallelujah"	65:10; 67:6; 78:7; 79:10; 95:15; 110:7; 116:11; 118:8 **hllyh** 86:10
הנא	**pron.** "this"; see the introduction to **I.3.4**.	89:1, 10, 11
הנהו	**pron.** "those, certain"	88:4
הנון	**pron.** "these"	103:4; 117:7

ו		
-ו	**conj.** "and, or"	*passim* (also -וי) **d-** (!) 103:3
-ו	(Heb.) **conj.** "and"	*passim*
ורודק	**n.** "*worodaq*" (type of demon)	99:7, 8, 11, 16

GLOSSARY

ז

זדקא	n. "righteousness"	**ztq** 88:3, 4
זויתא	n. "corner"	116:2 – pl. cstr. **zwyy'** 102:5
זוע	vb. "move, shake" (intransitive)	– impf. 3 p. masc. pl. **yzw'wn** 104:6 – impv. fem. sg. **zw'y** 91:7; 92:7; 93:7; 94:7 masc. pl. **zw'w** 99:19 – ptc. masc. pl. **z'yn** 116:8 *itpe.* "tremble" – ptc. masc. pl. **mytz'yn** 105:7
זידן	adj. "wicked"	– fem. sg. **zydnyt'** 107:7; 117:3 – fem. pl. **zydnynyt'** 111:5; **zydnyt'** 98:4, 11; 103:2; 117:2; 118:2
זיוא	n. "radiance"	103:1, 5
זימתא	n. "carnality, obscenity"	95:1; 98:10; 99:15; 101:10
זיפא	n. "falsity"	– masc. pl. **zypyn** 77:6
זיקא	n. "blast demon; wind"	– masc. pl. **zyqy** 82:19; 88:2; 103:3; **z'yqy** 89:9(×2), 12
זכיא	n. "*zakya*" (type of demon)	99:6, 7, 11, 16, 20; 103:9
זמן	vb. "designate"	*af.* – pass. ptc. masc. sg. **mzmn** 86:11; 89:1
זמרתא	n. "singing-girl"; see the introduction to I.2.3.	95:1; 96:3; 99:15; 101:10
זנותא	n. "fornication"	95:1; 98:10; 99:15; 101:10

זני	vb. "act promiscuously"	pa. "act promiscuously" – ptc. masc. pl. **mznyn** 98:10; **mznn** 95:1	
זעא	n. "shaker" (type of demon)	– pl. **zʿyn** 73:2	
זעי	vb. "shake"; see the note to JBA 92:6.	– ptc. 3 p. masc. pl. **zyʿyyn** 93:6; **zyʿyn** 99:18; **zʿyyn** 92:6	
זעיר	adj. "small, young"	– pl. with pron. suffix 2 p. masc. pl. **zʿyrykwn** 98:8	
זרבא	n. "bolt"; see the note to JBA 110:4.	110:4	
זרז	vb. "strengthen"	pa. "strengthen" – pass. ptc. masc. sg. **mzrz** 72:1; 77:1; 106:3 fem. sg. **mzrz{l}ʾ** (!) 105:1	
זרעא	n. "seed, offspring"	86:5, 6 – with pron. suffix 3 p. masc. sg. **zrʿyh** 98:7 3 p. fem. sg. **zrʿh** 98:7 3 p. masc. pl. **zrhwn** 81:5; 82:16; 84:8; 85:18; **zrʿyhwn** 99:19; 100:5	
זרעיתא	n. "clan, family"	– pl. **zrʿytʾ** 73:10 – with pron. suffix 2 p. fem. sg. **zrʿytyk** 102:12 3 p. fem. sg. **zrʿyth** 102:8	

ח

חבב	vb. "love"	– pass. ptc. 2 p. masc. pl. **ḥbybyn** 99:20, 21	
חדי	vb. "rejoice"	– impf. 2 p. masc. pl. **tyḥdwn** 99:20	
חדיא	n. "chest"	– with pron. suffix 1 p. sg. **ḥdy** 103:2	
חדת	adj. "new"	– fem. sg. **ḥdtʾ** 86:6	

חומרתא	n. "seal stone; amulet; amulet spirit" (type of demon)	77:7; 89:5; 89:11; 91:4(×2); 92:5; 93:5; 99:16; 103:9, 13; 110:4; 117:3 – fem. pl. ḥwmry 89:10(×2); 98:4, 11; 103:2, 5; 111:5; 117:2; 118:2(×2); ḥwmryn 91:4, 5; 97:5; 99:17; 110:1, 2
חזי	vb. "see"	– ptc. masc. pl. ḥzyn 116:1 – inf. with 2 p. fem. sg. pron. suffix myḥzyky 100:4; myḥzk 92:7; 93:7; 94:7 *itpe.* "appear" – impf. 2 p. fem. sg. tytḥzn 100:5; ttḥzyn 97:7 – ptc. fem. sg. myḥzy' 91:6; 92:3; 93:3 mytḥzyt 97:3 masc. pl. mytḥzyn 98:6; mytḥzn 114:7
חזירא	n. "pig"	– pl. with pron. suffix 3 p. masc. sg. ḥzyryh 108:2
חטי	vb. "harm"	– impf. 2 p. fem. sg. tyḥtyn 91:7; tyḥtn 100:5, 6 2 p. masc. pl. tyḥṭ 82:16; 84:8; tyḥtw 81:5; 85:18; tyḥtwn 96:5; 99:20 – ptc. fem. sg. ḥty' 91:3; 92:4; 93:4; 94:4;
חטף	vb. "snatch"	– ptc. masc. pl. ḥtpyn 81:5; 82:16; 83:6; 84:8; 85:18; 86:5
חטפיתא	n. "snatcher" (type of demon)	111:5
חיותא	n. "beast, animal"	– pl. with pron. suffix 3 p. masc. sg. ḥywtyh 108:2
חיזונא	n. "vision"	– pl. ḥzwny 108:3; ḥyzwny 74:2; ḥyzwnyn 114:7
חילא	n. "strength, army"	– with pron. suffix 2 p. masc. sg. ḥylyk 116:3 3 p. masc. sg. ḥylyh 103:9, 11 – pl. ḥylwwth 110:5
חילמא	n. "dream"	97:3; 98:6; 100:5; 101:5 – pl. ḥylmy 74:2; 99:8; ḥylmyn 114:7; ḥlmy 108:3
חיתומא	n. "signature"	– with pron. suffix 3 p. masc. sg. ḥytwmyh 87:8

חלא	n. "sand"	116:7	
חמישאה	adj. "fifth"	65:4; 66:3; 67:2; 68:4; 70:5; 72:4; 74:4; 75:3; 76:5; 79:5; 95:10; 101:15; **ḥmyšʾ** 73:3; 80:5; 98:15	
חמרא	n. "donkey"	– pl. with pron. suffix 3 p. masc. sg. **ḥmryh** 108:1	
חמשא	num. "five"	– with pron. suffix 3 p. masc. pl. **ḥmyštyhwn** 99:22	
חמתא	n. "mother-in-law"	107:7	
חסין	adj. "powerful"	91:9(×2); 92:9; 93:10; 94:10; 100:7	
חצבא	n. "jug"	– for the expression **bny ḥyṣby**, see ברא.	
חצצא	n. "grain of sand, gravel"	116:7	
חרצא	n. "loin"	– pl. with pron. suffix 3 p. masc. sg. **ḥrṣyh** 99:11	
חרשא	n. "sorcerer"	– pl. **ḥršy** 95:7	
חרשי	n. "sorcery"	88:1; 98:13; 101:2, 13; 107(×3), 8; **ḥršyn** 77:3, 6; 82:19; 107:7	
חשוכא	n. "darkness"	73:8; 116:2; 117:5	
חשך	vb. "darken" (intransitive)	*pa.* "darken" (transitive) – ptc. fem. sg. **mḥšk'** 107:8	

חתם	vb. "seal, sign"		– pass. ptc.

masc. sg. ḥtym 72:1, 5; 73:1, 4; 74:1; 75:4; 76:1, 6; 77:1(×2), 3, 4; 79:1, 3, 6; 80:1, 6; 81:1; 82:12; 83:1; 84:2, 3; 85:1, 13, 14; 87:3, 5; 88:1, 3, 4; 90:3; 102:4; 104:1; 106:3; 108:1; 108:2; 113:5; 114:1, 10; 115:1, 4; 118:1; ḥtymym (!) 86:8; ḥtm 109:1; tym 88:3, 4; 118:3

fem. sg. ḥtym' 80:3; 82:17; 89:7, 8; 93:3; 99:17; 102:1; 113:1, 4; 116:4; ḥtymh 105:1; 106:2

sg. with 1 p. sg. encl. pron. ḥtymn' 103:4, 7

sg. with 2 p. masc. sg. encl. pron. ḥtymt 96:3; 99:17

sg. with 2 p. fem. sg. encl. pron. ḥtym' (!) 85:19; ḥtymt 83:7; 91:1, 4; 92:1, 5; 93:2, 5; 94:1; ḥtymt' 82:16; ḥtymth 81:5

masc. pl. ḥtym (!) 75:2; 80:2; ḥtymyn 68:1, 3; 69:1, 2; 71:2, 5; 73:2, 3(×2), 4; 74:2, 3; 75:2; 76:4(×2); 78:2; 79:4; 80:3; 81:2; 82:13; 83:3; 84:4; 85:15; 89:9(×2); 89:12; 103:2; 104:15; 105:5; 107:4, 5; 114:10; 115:5; 117:7; 118:2

pl. with 1 p. encl. pron. ḥtymn' (!) 70:1; ḥtymnn' 70:7

pl. with 2 p. masc. pl. encl. pron. ḥtymyntwn 105:6; ḥtymytwn 65:2; 95:5, 7, 8; 96:1; 98:7, 12, 13, 14; 99:12, 15; 101:7, 13(×2), 15; 112:8; 116:10

pl. with 2 p. fem. pl. encl. pron. ḥtymytynyn 111:5

fem. pl. (unless fem. sg.) ḥtym' 75:4; 76:6; 79:6; 80:6; 86:2, 8, 9, 10; 105:7; 109:3

pa. "seal, double seal"

– pass. ptc.

masc. sg. mḥm (!) 109:1; mḥt 77:6; mḥtym 76:1; 86:9; mḥtm 72:1, 5; 73:1; 74:1; 77:1(×2), 4(×2); 79:1; 80:1; 87:5; 88:1, 3; 102:4; 104:1; 107:2; 108:2, 5; 113:5; 114:5, 10; 115:1, 4; 118:1, 8

fem. sg. mḥtm' 93:3; 102:1; 113:1, 4; 116:4; mtm' 82:17

sg. with 1 p. sg. encl. pron. mḥtmn' 103:4, 7

sg. with 2 p. fem. sg. encl. pron. mḥtmt 94:1

masc. pl. mḥtmyn 68:1; 69:1, 2; 71:2; 73:2; 74:2, 3; 86:2, 8; 107:5; 114:4, 5

pl. with 1 p. pl. encl. pron. mḥtmnn' 70:1

itpe. "be sealed"

– impf.

3 p. masc. sg. ytḥtm 90:2

חתמא	n. "seal"		

65:3, 5; 66:2(×3), 3(×4); 67:3; 70:4, 6, 9; 72:2, 4, 5; 73:3(×2), 4(×2); 75:2(×2), 3, 4; 76:4(×2), 6(×2); 77:1, 2, 4; 79:4(×2), 6(×2); 80:3, 4, 5, 6; 81:1, 2(×2), 5; 82:12, 13, 14, 17; 83:1, 3, 4; 84:1, 3, 4, 5, 9; 85:1, 14, 15, 16, 19; 86:2(×2), 3, 8, 9(×2), 10; 89:1, 9; 90:1; 95:9, 10; 98:15; 101:15, 16; 105:6(×6), 7; 118:3; 119:5(×2)

ḥtm 88:4

ḥtmh 71:4; 74:3, 6; 83:8; 98:16

tm 88:3, 4

– with pron. suffix

3 p. masc. sg. ḥ'ṭ'myh 86:11; ḥtmyh 89:7, 8; 105:4; tmyh (!) 106:4

– pl.

ḥtmy 70:4; ḥtmyn 65:2; 66:2; 68:3; 71:2; 72:2; 73:3; 74:3; 75:2; 76:4; 77:1; 79:4; 80:3; 90:3; 95:9; 98:15; 101:15; 116:10; 118:2

חתמתא	n. "sealing"		70:12; 75:1; 91:11; 111:2

ט

טוליתא	n. "shadow demon"	– pl. ṭwlnyt' 98:3, 11; 101:11; 117:4
טוהמא טומא	n. "seed"; see the introduction to I.3.2.	– with pron. suffix 3 p. masc. pl. ṭwhwn 81:5; ṭwhmhwn 85:18; ṭwmhwn 82:16; 84:8
טורא	n. "mountain"	– pl. ṭwry 116:7; ṭwry' 116:8
טמי	adj. "unclean"	– fem. sg. ṭmyt' 97:3
טעיתא	n. "error spirit" (type of demon)	– fem. pl. ṭ'yt' 70:3
טרש	vb. "stop up, deafen"	pa. "stop up, deafen" – ptc. fem. sg. mṭrš' 116:1

י

ידא	n. "hand"	yd 65:8; 67:5; 95:13; 101:17 – cstr. – in the expression 'l ydy "by the hand of, by means of" 107:8 – with pron. suffix 1 p. sg. ydy 91:11; 99:23 3 p. sg. ydh 110:3 – pl. with pron. suffix 2 p. fem. sg. ydyky 91:10
יהב	vb. "give, place"	– impv. masc. sg. hb 99:10
יומא	n. "day"	68:7; 71:5; 73:7; 77:3; 78:7; 79:10; 82:15; 102:13; 103:14; 104:12; 114:7; 118:6 ywmh 92:12 ym' 75:7; 76:10
ימי	vb. "swear"	af. "adjure" – ptc. masc. sg. with 1 p. sg. encl. pron. mwmyn' 81:3; 82:14; 84:6; 85:16; 86:3; 97:1 mwmn' 83:4

יממא	n. "day, daytime"	81:5; 82:16; 84:8; 85:18; 99:19; 100:5(×2), 6 m'm' 86:6
יקיר	adj. "dear"	91:9(×2); 92:9; 93:9; 94:10; 100:7 – masc. pl. **yqyryn** 99:21(×2)
ירורא	n. "*yaror* demon"; perhaps "jackal demon"	– masc. pl. **yrwry** 70:2; **yrwryn** 113:3; 114:6; 116:9
ירתא	n. "heir"	– pl. with pron. suffix 3 p. masc. sg. **yrtyh** 105:2, 3
ישראל	(Heb.) n. "Israel"	60:10; 102:4; 104:2
ית	obj. marker	**yt** 100:8 – with pron. suffix 2 p. fem. sg. **ytyky** 91:11(×2); 92:10, 11; 93:10; 94:10; 96:6; 100:9; **ytky** 91:9; 94:12 2 p. masc. pl. **ytkwn** 99:21, 22, 23 3 p. masc. sg. **ytyh** 86:6 3 p. masc. pl. **ythwn** 114:8
יתב	vb. "sit"	– ptc. masc. sg. **ytyb** 103:10(×2); 116:6 masc. pl. **ytbyn** 96:2(×3); 99:13(×2), 14(×2); 101:8

כ

-כ	See כי.	
כביר	adj. "great"	– masc. pl. **kbyryn** 99:21
כבלא	n. "chain, shackle"	– pl. **kblyn** 91:9; 92:10; 94:11; 99:21, 22, 28
כבש	vb. "press down, subdue"	– pass. ptc. masc. sg. **kbyš** 77:5(×2)
כד	conj. "when"	77:5
כוכבא	n. "star"	– pl. **kwkby** 103:3

כולא		"every, all, any, whole"	– cstr. **kwl** 73:6; 89:9; 94:7(×2); 99:12(×12), 18; **kl** 66:4; 68:2, 6; 69:1; 70:3; 73:1(×2), 2, 5(×5), 6; 74:1; 75:1(×2), 5(×2); 76:3(×3), 8(×3); 77:3(×2); 78:2; 79:3(×3), 8(×3); 80:2(×3); 82:19(×2); 87:7, 8(×3); 88:2, 3; 89:4, 10, 11; 90:2; 91:5, 6; 95:3(×2), 7; 96:1, 4; 98:4, 11; 99:3, 7, 13, 16, 17, 18, 19, 20; 100:4, 5, 6; 103:11, 12; 104:7, 15; 105:7, 8; 106:5, 6, 8; 107:8; 108:1, 2, 4, 5; 111:3, 4; 113:2, 3, 4, 9; 114:4, 5(×3), 9(×3); 115:3(×2), 7; 116:5; 117:2; 117:3, 4(×2), 5; 118:4 – with pron. suffix 3 p. masc. sg. **kwlh** 102:7, 9, 11; 103:8, 9, 12; 104:2, 4, 8, 11; **kwlyh** 102:12; 114:8; 115:1(×2) 3 p. fem. sg. **kwlh** 99:17; 102:7, 8, 11, 12; 104:3(×2), 9, 10; 116:4 2 p. masc. pl. **kwlkwn** 95:3, 4; 98:8(×4), 11(×2); 101:7(×2), 11(×2); 102:10 2 p. fem. pl. **kwlkyn** 111:5 3 p. masc. pl. **kwlhwn** 68:1; 69:1; 73:6; 75:5; 76:8; 78:2; 79:8; 92:6; 93:6; 94:6; 95:2; 96:1, 4; 99:12, 13, 18; 102:8, 12; 103:8, 13; 104:4, 11; **klhwn** 110:5 3 p. fem. pl. **kwlh** 104:3, 9; **kwlhyn** 87:9; 99:11, 13; 102:7, 8, 12(×2); 103:8, 9(×2), 13(×4) – for the locution kl 'tr w'tr, see 'tr.
כוליתא		n. "kidney"	– pl. with pron. suffix 2 p. fem. sg. **kwlytyk** 116:2
כורסיא		n. "chair, throne"	**kwrsyh** 66:2; 116:10
כות		prep. "like"	– with pron. suffix 2 p. masc. pl. **kwtykwn** 110:4
כי כ-		prep. "like, as, according to"	73:7(×2); 75:6(×3); 76:9(×3); 79:9(×3); 91:2; 92:3, 4(×2); 93:4; 94:4(×2); 118:5(×2) **k-** 91:2, 3; 93:4(×2)
כיסא		n. "bond"; see the note to JBA 95:3.	– pl. **kysy** 95:3, 7; 98:11, 13; 101:11, 14
כין		See כן.	
כיפא		n. "edge, shore"	– pl. – cstr. **kypy** 113:6; 114:10; 115:5
כלי		vb. "be finished"	*itpa.* "be removed" – impf. 3 p. masc. sg. **ytkwl'** 116:3(×3)
כלילא		n. "crown"	– cstr. **klyl** 103:1
כלכא		n. "storehouse"	– with pron. suffix 3 p. masc. sg. **klkyh** 113:9
כלתא		n. "daughter-in-law"	107:7

GLOSSARY

| כן
כין | adv. "so, thus" | **kyn** 116:6 |

| כנש | vb. "gather" | *pa.* "gather"
– ptc.
masc. sg. **mknyš** 116:7 |

| כסא | n. "cup, bowl" | 86:6; 100:4 |

| כסי | vb. "cover, hide" | – pass. ptc. as adj. "hidden"
masc. sg. **ksyʿ** 88:3
masc. pl. **ksyʿ** 88:4; **ksyy** 117:7
pa. "cover"
– pass. ptc.
fem. sg. with 1 p. encl. pron. **mksynʾ** 103:1
itpa. "be covered, be hidden"
– impf.
3 p. masc. sg. **ytksy** 116:3(×2) |

| כען | adv. "now" | in the expression **mykʿn wʿd ʿlmʾ**
"from now and for ever" 114:4, 9
in the expression **mykn wʾylk**
"from now on" 81:5; 82:16; 84:8; 85:19 |

| כתב | vb. "write" | – ptc.
masc. pl. **ktbyn** 86:6
– pass. ptc.
masc. sg. **ktyb** 116:6 |

ל

| -ל | (1) prep. "to, for, at" | 65:8(×2); 68:1; 69:1; 71:6; 73:5(×6); 74:1; 75:1, 5; 76:7; 77:3(×2); 78:1; 79:7, 8; 82:2, 18; 86:1; 89:2; 90:1(×2); 95:13; 97:7; 98:17(×3); 99:1, 2, 4, 5, 10, 23; 100:5; 101:17(×2); 103:12; 104:5; 106:3, 6; 108:1(×3); 111:2
lʾ- 73:5
ly- 65:8
– with pron. suffix
3 p. masc. sg. **lh** 68:1; 69:1; 74:2; 75:4; 76:3, 8; 109:6; 110:6(×2); 111:3; **lyh** 77:3, 6(×2); 91:11; 99:1, 10
3 p. fem. sg. **lh** 86:1; 92:8(×2); 100:5; 103:12
3 p. masc. pl. **lhwn** 65:8; 76:7; 79:7; 82:15; 84:7; 85:18; 86:5; 87:7; 91:2; 92:3; 93:3, 4; 97:3, 7; 98:6, 17; 100:9; 101:17; 114:4, 7, 9(×2) |

	(2) with vb., marking obj. (ordered by the vb. immediately preceding it)	DKR *af.* + 2 p. masc. pl. **lkwn** 116:8 ḤṬY + **l-** 91:7; 96:5; + 3 p. masc. sg. **lyh** 91:7; 96:5 YMY *af.* + 2 p. fem. sg. **lyky** 97:1; + 2 p. masc. pl. **lkwn** 81:3; 82:14; 84:6; 85:16 KNŠ *pa.* + 2 p. masc. pl. **lkwn** 116:7 NZQ *af.* + **l-** 99:19(×3); + 3 p. masc. pl. **lhwn** 99:19 SBB (Heb.) + **l-** 113:9(×5) ŠBʿ *af.* + 2 p. masc. pl. **lkwn** 86:3; 99:10 – see also **l-** 117:7
	(3) + inf.	106:8(×2); 115:7
	(4) in *qeṭīl l-* forms	– with pron. suffix QMM *pa.* + 3 p. pl. **lhwn** 110:4 TRṢ + 1 p. sg. **ly** 103:2
	(5) in a locution	– **lgw** "within" + 3 p. masc. sg. **lgwyh** 89:11; + 3 p. fem. sg. **lgwh** 113:5 – **lḥwr** "backwards" 116:9 – see also the compound adv. **lʿylʾ**.
ל־	(Heb.) **prep.** of agent "by"	90:1
לא	negative part. "no, not, nor"	68:2, 7; 73:5, 6, 9; 76:7; 77:6(×2); 79:7; 81:4, 5, 6(×2); 82:15, 16, 17(×2); 83:7; 84:7, 8, 9(×2); 85:18, 19; 89:11; 91:3, 4, 7, 8, 9; 92:5(×2), 8, 9; 93:5(×2), 9; 94:5, 9; 96:5(×3); 97:4, 7; 98:14; 99:8, 12, 19, 20(×2); 100:2, 5(×2), 6, 7; 102:10(×2); 103:12; 104:5; 105:8; 113:4; 114:6; 119:3, 4 **l-** 85:19 – in the expression **lʾ ... (w)lʾ** "neither ... nor" 82:16; 84:8; 85:18; 86:5–6; 91:7(×2); 92:8(×3); 94:9(×2); 96:5(×2); 99:19(×2), 20; 100:5, 6(×3); 102:11(×2), 11–12, 12(×4); 103:12(×2), 13(×4); 104:6(×2), 8, 8–9, 9, 10, 10–11, 11; 105:8 **l- ... wl-** 40:5 **l- ... wlʾ** 100:5 **lʾ ... wl-** 81:5 – in the expression **lʾ ... lʾ ... wlʾ** "neither ... nor ... nor" 91:8
לבושא	n. "garment"	– cstr. **lbwš** 103:1 – with pron. suffix 2 p. masc. sg. **lbwšk** 99:17
לבש	vb. "put on clothes, dress, wear"	– pass. ptc. sg. with 1 p. encl. pron. **lbyšnʾ** 103:1
לגים	n. "legion"	116:1(×2)
לוות	prep. "to, towards"	– with pron. suffix 3 p. masc. sg. **lwtyh** 89:10

GLOSSARY

לוטניתא	n. "curse spirit"	– pl. **lwṭnyt'** 95:3
לוטתא	n. "curse, curse demon"	107:6; 110:7 **lwṭth** 88:2 – pl. **lwṭṭ'** 95:3, 7; 98:11, 14; 101:11; **lwṭṭh** 74:2
לטבא	n. "no-good one" (type of demon)	89:4 **lṭbh** 89:5 – masc. pl. **lṭby** 89:9; 100:3; 102:10; 103:3, 11; 104:7, 15; 105:5; **lṭbyn** 73:6
ליבא	n. "heart, stomach"; see also טופרסא.	103:10 – with pron. suffix 3 p. masc. sg. **lbyh** 77:6
לילחנא	n. "servitor" (type of demon); see Morgenstern 2015, 277.	– pl. **lylḥny** 98:11; **lylḥnyn** 72:6; 95:2; **llḥny** 105:7
ליליא (1)	n. "night"	81:5; 82:16; 84:8; 92:3, 6(×2); 94:4; 99:19; 100:5, 6(×2) **lyly** 91:2 **lylyh** 85:18; 86:5; 92:4
ליליא (2)	n. "lili" (type of demon)	**lyly** 111:5 – masc. pl. **lyly** 99:18; 104:7; **lylyyn** 113:3; 114:6; 115:4; **lylyn** 81:2; 82:13; 83:3; 84:4; 85:15; 95:2; 98:11; 118:1
	n. fem. "lilith" (type of demon)	**lylyt'** 73:9; 81:3; 82:15, 19; 83:5; 84:6; 85:17; 86:4; 89:6, 11; 91:1, 4, 5, 6; 92:1, 5, 7; 93:2, 6, 7; 94:2, 6, 7; 95:5; 98:13; 99:6, 16, 17, 18; 100:4, 8; 101:13; 111:5; 115:7; 119:3 – fem. pl. **lylyt'** 68:2(×2); 70:3; 72:6; 75:5; 76:3; 86:2, 3, 8; 87:9; 88:2; 89:3, 10(×2), 13; 90:2; 95:3; 95:7; 98:2, 8, 14; 99:8, 11, 13, 16, 18; 101:8, 11, 14; 104:7, 15; 107:5; 107:6; 111:4; 119:2
לית	part. "there is/are not" (לא + אית)	66:4
לעילא	adv. "above"	99:17

מ

מא	See מה.	
מאה	num. "hundred"	73:9; 103:5

מבכלתא	n. "*mevakkalta* demon"	82:19; 91:1, 6; 92:2, 7; 93:2, 7; 94:2, 7; 108:3; 111:4 – fem. pl. **mbklt'** 72:6; 86:4; 90:2; 104:15
מדרא	n. "dwelling"	– with pron. suffix 3 p. masc. sg. **mdrh** 115:1; **mdryh** 113:9; 114:8
מה מא	pron. "what"	**m'** 91:9
מהימן	adj. "trustworthy"	**mhymn'** 77:5
מוא	n. "century (of soldiers)"; see the introduction to I.4.1.2.	– pl. with pron. suffix 2 p. fem. sg. **mw'k** 104:12; **mwk** 102:12; 103:13 3 p. fem. sg. **mw'h** 103:8; 104:4
מובלא	n. "burden"	**mwblh** 89:9
מוטב	(Heb.) adj. "good"; adv. "well"	91:9; 93:9
מומתא	n. "oath, adjuration"	99:8
מזונא	n. "food"; pl. "livelihood"	– with pron. suffix 3 p. masc. sg. **mzwnh** 104:6 3 p. fem. sg. **mzwnh** 94:9 3 p. masc. pl. **mzwnhwn** 98:12 – pl. **mzwnh** 95:13; **mzwny** 65:8; 67:5; 91:3; 92:4; 93:4; **myzny** 98:17 – with pron. suffix 3 p. masc. sg. **mzwnyh** 91:8 3 p. masc. pl. **mzwnhwn** 73:5; 99:20; 101:12; **mzwnyhwn** 100:6
מזיקא	n. "tormentor" (type of demon)	– masc. pl. **mzyqy** 82:19; 95:3; 98:4; **mzyqyn** 88:2; 99:13; 103:12; 113:3
מזלא	n. "(sign of the) zodiac, constellation, fortune"	– pl. **mzly** 103:3
מחי	vb. "strike, smite"	– ptc. masc. pl. **mḥyn** 101:10; **mḥn** 77:6
מחמת מיחמת	prep. "because of"	**myḥmt** 116:2
מחתא	n. "wound"	– pl. **mḥt'** 99:10

GLOSSARY

מיא	n. "water"	103:3; 105:9 **myyh** 73:9
מידי	See מידעם.	
מידעם מידי	pron. "thing, something"	74:3; 99:3, 7, 16, 17, 19, 20; 107:8; **mydy** 88:3
מיחמת	See מחמת.	
מיטול	(+ -ד) conj. "because"	100:6
מילתא	n. "word, incantation"	86:6 – pl. **myly** 110:6; **mlyn** 103:4 – with pron. suffix 3 p. masc. sg. **mylwhy** 66:4
מימרא	n. "utterance, command"	73:7 **m'mr'** 76:8; **m'mrh** 75:6; 79:9; **mr'ymr (!)** 118:4
מינא	n. "species, category, type"	– pl. cstr. **myny** 117:3
מיצחותא	n. "brilliance, splendour"	– abs. **myṣḥw** 103:2 (unless Heb. מצח "forehead"; see the introduction to **1.4.1.2.**)
מיצעאה	adj. "middle"	– fem. sg. **myṣyt'** 102:6
מירסא	n. "stomach ache"	103:10
מלאכא	n. "angel"	94:5 **ml'kh** 73:2; 91:3, 10; 92:5, 10; 93:5, 10; 106:6 – pl. **ml'ky'** 96:4; 99:10, 18; **ml'kyh** 91:5; 110:4, 6; **ml'kyn** 100:7 – cstr. **ml'ky** 73:9
מלויתא	n. "companion demon"	111:4
מלך	(Heb.) n. "king"	– cstr. **mlk** 87:1 – pl. **mlkym** 87:2 – pl. cstr. **mlky** 87:1

מלכא	n. "king"	65:1; 70:7, 9; 73:10; 81:2, 3; 82:13, 14; 83:4(×2); 84:5(×2); 85:16(×2); 86:3(×2), 9; 92:6; 93:6; 94:6; 95:6; 98:13; 100:3; 101:13; 102:4; 104:2; 106:5; 107:4; 108:6; 110:4; 119:2 **mlkh** 91:5; 96:4; 99:17; 103:8; 105:5; 106:6; 109:3; 116:3; 119:1 **mlm'** (!) 106:6 – cstr. **mlk** 95:8; 98:14; 101:14; 102:4 – pl. **mlky** 95:6(×3); 98:13(×3); 101:13(×3) **mlky'** 82:18; **mlkyn** 116:10
מלכותא	n. "kingdom, government"	**mlkwth** 66:2 – with pron. suffix 2 p. masc. pl. **mlkwtkwn** 99:20
מלל	vb. "forge"	*pa.* "forge" – pass. ptc. fem. pl. **mmllt'** 103:5
מן	(1) **prep.** "from, by"	68:1(×3), 2(×2), 5(×2), 6(×4), 7; 69:1; 70:2(×4), 3(×4); 71:5; 72:6(×5); 73:2, 7; 74:2(×7); 75:1(×3), 7; 76:3(×4), 10; 77:3; 78:1; 79:3(×3), 10; 80:2(×3); 81:4(×2); 82:15(×2), 18(×5), 19(×6); 84:7; 85:6, 10, 17; 86:1(×2), 4; 87:8(×3); 88:1(×3), 2(×6), 3; 89:3(×2), 5(×2), 13(×2); 90:2(×2); 91:6(×2), 7(×2), 8(×2), 11; 92:6(×2), 7(×3), 8(×3), 9(×2), 11(×9), 12(×2); 93:7(×2), 8(×4), 9(×2), 11(×2); 94:7, 8(×6), 9, 10(×3), 12; 95:4(×3); 98:6, 7(×2), 12(×7); 99:3, 18(×2), 19(×2), 22(×4); 101:12(×7); 102:5(×2), 6, 7(×5), 8(×7), 9, 13; 103:8(×7), 9(×6), 14; 104:2(×2), 3(×3), 4; 104:8, 12(×2); 104:15; 105:7; 106:7(×2), 8, 9(×3); 108:1(×2), 3(×6), 4(×4); 110:6(×3); 111:4(×4); 113:3, 5; 114:5, 8(×2), 9(×2); 115:2, 7(×2); 116:4(×6), 7(×2); 117:1(×2); 118:1(×4); 119:1, 2, 3 **m-** 96:1; 106:8; 115:3 **m'-** 88:2 **my-** 81:5; 82:16; 84:8; 85:19; 96:1; 98:8(×3), 9; 99:1, 13(×2); 101:8; 104:2, 3(×3), 4(×2); 114:4, 9 **myn** 94:7, 9; 100:4(×2), 5, 7(×2), 8(×3); 100:6 – with pron. suffix 3 p. masc. sg. **mynh** 110:6, 7; **mynyh** 91:6; 92:6; 93:6; 99:18 3 p. masc. pl. **mynhwn** 112:8; 114:9 – see also the compound adv. **myk'n, mykn** (s.v. **k'n**). – see also the compound prep. **mn qdm** (s.v. **qdm**).
	(2) **prep.** "against"	107:5, 6(×6), 7(×4), 8(×2)
מן	(Heb.) **prep.** "from"	**my-** 108:7; 109:6
מנחשא	n. "diviner"	73:7; 75:6; 79:9; **mnḥš'** 118:5; (unless *sandhi* writing of **mn nḥš'** "bronze vessel"; see Ford 2014, 241–242)
מני	v. "count, appoint"	*pa.* "appoint" – pass. ptc. masc. sg. **mmny** 91:10; 92:10; 93:10; 94:11; 99:22

GLOSSARY

מסר	vb. "hand over"	*itpe.* "be surrendered" – impf. 2 p. fem. sg. **ttmsr** 91:11; **tytmsryn** 94:12; 100:9 2 p. masc. pl. **tytmsrwn** 99:23	
מעבדא	n. "magical act, sorcery"	– pl. **mbdy** 98:13; 101:14; **m'bdy** 95:7	
מרבעתא	n. "resting place"	– with pron. suffix 3 p. masc. sg. **mrb'tyh** 116:8	
מרומא	n. "height, upper world"	73:9; 110:5	
מריא	n. "master, lord"	105:6; 110:1 – cstr. **mr (!)** 100:6; **mry** 91:8; 92:9; 93:8; 99:20; 116:10	
מרכבתא	n. "chariot"	– pl. with pron. suffix 2 p. masc. sg. **mrkbtk** 103:13 2 p. fem. sg. **mrkbtyk** 102:12; 103:13; 104:10 3 p. masc. sg. **mrkbtyh** 103:8 3 p. fem. sg. **mrkbth** 102:7; 103:9; 104:3	
מרס	vb. "cause stomach pain"	– ptc. masc. sg. **mrys** 103:10	
משמתא	n. "ban demon"	94:2; 111:4; **mšwmwt'** 108:3	
משריתא	n. "retinue"	– with pron. suffix 2 p. masc. sg. **mšrytyk** 102:11; 104:9; **mšrytk** 103:13, 14 3 p. masc. sg. **mšrytyh** 102:7; 104:3	
מתא	n. "town"	111:5	

נ

נוסיא	n. "trial" (see the note to JBA 116:9)	116:9
נוקבתא ניקבתא	n. "female" (often as adj.; in many cases, our transcription of *waw* and *yodh* in this word is arbitrary)	**nyqbt'** 89:6; 98:5; 107:6; 119:3 – abs. **nyqb'** 98:9 – pl. **nwqbt'** 73:9; 103:4, 11; **nwqbn** 114:6; **nyqbyn** 86:3; **nyqbt'** 70:3, 4; 90:2; 102:10; 104:7; 107:5; 111:4

נורא	n. "fire"	91:4; 92:5; 93:5; 95:5; 98:13; 99:16; 103:3; 105:9	
נזח/נזה	vb. "depart, move"	– impf. 3 p. masc. sg. **yzh** 119:3 2 p. masc. pl. **tyzhwn** 81:4; 82:15; 84:7; 85:17; 86:4 3 p. masc. pl. **yzhwn** 104:6; **yzwhwn** 117:1 – impv. masc. sg. **zh** 89:4 *af.* "cause to depart" – inf. **'zh'** 115:7	
נזק	vb. "harm"	*af.* "harm" – impf. 2 p. fem. sg. **tnzqyn** 92:8; 94:9 2 p. masc. pl. **tyzqwn** 102:10; **tnzyqw** 99:19 – ptc. fem. sg. **mnzq'** 91:3; 92:4; 93:4	
נחשא	n. "copper, bronze"	**nḥšh** 77:5, 6 – abs. **nḥš** 91:9(×2), 10; 92:10; 94:11(×2); 99:21	
נחת	vb. "descend"	– ptc. masc. pl. **nḥtyn** 89:12 *af.* "lower, place" – pass. ptc. fem. pl. **mḥtn** 103:2	
נטר	vb. "protect"	– pass. ptc. masc. sg. **nṭyr** 77:6; 88:3 masc. pl. **nṭyry** 88:4 *pa.* "guard" – pass. ptc. masc. sg. **mnṭ** 77:6; **mnṭr** 72:1 *itpe.* "be protected" – impf. 3 p. masc. sg. **nytnṭr** 89:3, 12 3 p. masc. pl. **ytnṭrwn** 108:1	
נטרתא	n. "protection"	89:1	
נידרא	n. "vow"; also, a type of demon, "vow demon"	73:9; 107:6; 110:5	
ניכדא	See נכדא.		

נינא	n. "child, offspring" (Hebraism); see the note to JBA 15:10.	– with pron. suffix 3 p. fem. sg. **nynh** 92:8, 11; 94:8; (in the hendiadys **nynh ... nykdh**) 3 p. masc. pl. **nynhwn** 94:10
ניקבתא	See נוקבתא.	
נכדא ניכדא	n. "grandchild, offspring" (Hebraism); see the note to JBA 15:10.	– with pron. suffix 3 p. fem. sg. **nykdh** 92:8, 11; 94:8; (in the hendiadys **nynh ... nykdh**) 3 p. masc. pl. **nykdhwn** 94:10
נסי	vb. "try"	– impf. 3 p. masc. sg. **ynsy** 119:3
נפח	vb. "blow"	*af.* "cause despair" – ptc. fem. sg. **mpḥʾ** 107:8
נפל	vb. "fall"	– impf. 3 p. masc. sg. **ypyl** 116:2; **ypl** 73:9
נפק	vb. "go out, depart, proceed"	– impf. 2 p. masc. pl. **typqwn** 81:4; 82:15; 84:7; 85:17; 99:20 3 p. masc. sg. **ypwq** 119:3 – impv. masc. sg. **pwq** 99:20 fem. sg. **pwqy** 91:7; 92:7; 93:7; 100:4 masc. pl. **pwqw** 95:2, 4; 98:11; 99:19; 101:10, 12; 111:6 – ptc. fem. sg. with 2 p. fem. sg. encl. pron. **npqt** 91:8; 92:9; 93:8, 9; 94:9; 100:6, 7 masc. pl. **nypqwn** (!) 91:6; **npqyn** 92:6; 93:6; 99:18 *af.* "cause to go forth" – impf. 3 p. masc. pl. **ypqwn** 92:11; 99:22; **nypqwn** 91:11; with 2 fem. sg. pron. suffix **ypqwnky** 93:11 – impv. masc. pl. **ʾpyqw** 100:8
נפשא	n. "soul, self"	**npš** 107:8 – with pron. suffix 3 p. masc. sg. **npšyh** 105:3 3 p. fem. sg. **npšh** 95:2; 96:3; 98:11; 99:15; 101:10
נקט	vb. "hold, seize, fasten" (cf. לקט)	– ptc. masc. pl. **nqṭyn** 96:3; 99:14 – pass. ptc. masc. sg. **nqṭ** 110:3; **nqyṭ** 77:6
נקתא	See ענקתא.	

נרגא	n. "axe"	103:5	
נרזבא	n. "drainpipe"	**nrzʾ** (!) 117:5	
נשי	See איתתא.		
נשרא	n. "eagle"	**nyšrʾ** 116:5	

ס

סבא	n. "old person"	– masc pl. – with pron. suffix 2 p. masc. pl. **sbykwn** 98:8 3 p. masc. pl. **sbyhwn** 96:2; 99:13 – fem. pl.
סגא*	n. apparently a type of demon; see the note to JBA 103:11	– pl. **sgy** 103:11
סגי	vb. "increase" (intransitive)	*af.* "increase" (transitive), "make great, fortify" – pass. ptc. masc sg. **msgy** 107:2 masc. pl. **msgn** 107:5
סדנא	n. "base"	65:6; 67:3; 72:5; **sdnh** 98:16; 101:16
סוסטמין	n. "shackles"	99:22
סטן	vb. "accuse"	*af.* "accuse, seduce" – ptc. masc. pl. **msṭnyn** 99:15
סטנא	n. "satan"	99:6, 11; 108:3 – pl. **sṭny** 70:2; 90:2; 100:3; 103:3, 11; **sṭnyn** 73:2(×2), 6; 75:5; 76:8; 79:8; 91:5; 95:2; 98:11; 101:11; 113:3; 114:6; 115:4; 116:9; 118:1
סיהרא	n. "moon"	67:3; 68:5; 69:4; 70:6; 71:5; 72:4; 73:4; 74:6; 75:4; 76:6; 78:6; 95:11; 98:16; 103:3; 119:5; **syhrh** 77:2; **shyrʾ** 65:5; 79:7; 80:6
סייב סיואה	adj. "black"	– masc. pl. **ʾyswy** 73:9

סיפא	n. "doorpost"	116:2 – with pron. suffix 3 p. masc. sg. **sypyh** 115:2, 3
סלה	(Heb.) "Selah"	66:4; 67:6, 8; 68:10; 71:6; 72:7; 73:2, 7, 10; 75:7; 76:11; 78:7; 79:10; 81:6(×2), 7(×2); 82:17, 20; 84:9; 85:20; 86:8, 10; 87:9; 89:13; 90:7; 91:11; 92:12; 93:11; 95:15; 96:6; 99:3, 12; 100:9; 101:18; 102:13; 103:5, 14; 104:14, 16, 17; 105:9; 106:7, 8 (**sl**), 8, 9; 107:9; 109:5, 6, 7; 116:11; 117:8; 118:7; 119:4, 5 s 86:11 **sylh** 106:7
סלק	vb. "ascend"	*itpa.* "depart" – impf. 3 p. masc. pl. **nystlqwn** 110:6 – impv. fem. sg. **'ystlqy** 100:4
סני	adj. "unsavoury"	**sny'** 98:6; 101:5
סםתם	See שםתם.	
סער	(Heb.) n. "tempest"	109:6
ספא סיפא	n. "doorpost"	– pl. cstr. **sypy** 86:6; 94:8
סקר	vb. "look at, stare"	*af.* (or *pa.*) "regard with malice" – ptc. masc. sg. **msqr** 105:8
סרא	See שרא.	

ע

עבד	vb. "do, make, perform"	– pf. 3 p. masc. sg. **ʻbd** 107:5 *itpe.* "be done" – ptc. masc. pl. **mytʻbdyn** 107:8
עבדא	n. "slave, servant"	98:9
עבורא עיבורא	n. "grain"	113:4 – with pron. suffix. 3 p. masc. sg. **ʻbwryh** 113:9 3 p. masc. pl. **ʻybwrhwn** 98:12; 101:12

עבר אבר	**vb.** "transgress, pass (away)"	– impf. 3 p. masc. sg. **nyʿbr** 105:8 – ptc. masc. sg. **ʿbr** 66:4; 73:6 masc. pl. **ʿbryn** 75:6; 76:8; 79:9; 118:4
עד	**prep.** "until, to"	96:1, 2; 98:8(×3), 9; 99:13(×2); 101:8; 115:3 – for the expression 'd 'lm', see 'lm'.
עדאמי	See עדמא.	
עדי	**vb.** "pass (over), go away"	– impf. 3 p. masc. pl. **yʿydwn** 104:6
עדמא עדאמי	**conj.** "until"	106:5 – in the expression 'dʾmy l- "until" 105:9
עובדא	**n.** "(magical) act"	114:13; 115:7 – pl. **ʿbdyn** 82:19; **wʿbdyn** 77:3
עוור	**vb.** "be blind"	*pa.* "blind" – ptc. fem. sg. **mʿwrʾ** 116:1
עולימא	**n.** "young man, young one"	– pl. – with pron. suffix 2 p. masc. pl. **ʿwlymykwn** 98:8; 101:8 3 p. masc. pl. **ʿwlmyhwn** 96:1; **ʿwlymyhwn** 99:13
עולם	(Heb.) **n.** "world, eternity"	– in the expression lʿwlm "for ever" 75:7; 76:11; 102:13; 108:7
עזיז	**adj.** "strong"	– masc. sg. **ʿzyzʾ** 91:10; 92:10; 94:11; 99:22; 100:8
עטר	**vb.** "go away"; see the note to JBA 30:12.	– impv. masc. pl. **ʿyṭrw** 99:19
עיבורא	See עבורא.	
עיבידתא	**n.** "work, magical rites"	– pl. 107:5
עיזא	**n.** "goat"	– pl. with pron. suffix 3 p. masc. sg. **ʿyzyh** 108:1
עיזקא	**n.** "fetter"	– pl. **ʿyzqn** 94:11; **ʿyqyn** (!) 91:9

GLOSSARY

עיזקתא	n. "signet-ring; anus"	72:4; 73:4, 10; 75:4; 76:6; 77:4; 91:5; 95:5, 11; 97:5; 98:16; 101:16; 102:3(×2); 103:7, 8, 9; 104:2(×2); 107:4(×2); 108:6; 113:5; 114:10; 115:4; 117:6; 118:3 **yzqtʼ** 88:4 **ʻzqtʼ** 77:2; 86:9 **ʻyzyqtʼ** 99:17 **ʻyzq** 119:5 **ʻyzqth** 70:6; 95:11 – cstr. **ʻzqt** 93:6; 94:6; **ʻyzqt** 89:12; 92:5 – with pron. suffix 3 p. masc. sg. **ʻyzqt (!)** 109:2; **ʻyzqtyh** 65:5, 6; 67:2(×2); 68:5; 69:4; 71:5; 74:6; 78:6; 79:7; 80:6; 98:13, 16; 100:3; 101:16; 105:5; 106:5; 108:6, 7; 110:4; 111:5; 112:9; 116:10
עילא	See לעילא.	
עילאה	adj. "upper"	– fem. sg. **ʻylytʼ** 102:6
עים	See אם or עם.	
עינא	n. "eye"	– pl. **ʻynyn** 107:8; 116:1 – in the expression **ʻynʼ byštʼ** 82:18; 88:1; 99:8, 12, 16; 107:6–7 – in the expression **ʻynʼ tqyptʼ** 82:18
עירא	n. "watcher" (type of angel)	89:4
עכב	vb. "detain"	*pa.* "detain, tarry" – impf. 2 p. masc. pl. **tʻkbwn** 92:12
על	(1) **prep.** "upon, on, over, with"	77:5(×2); 86:6; 91:10(×5); 92:10(×2); 93:10(×2); 99:11(×2), 21(×2), 22; 103:2; 107:8 – with pron. suffix 2 p. masc. pl. **ʼlykwn** 116:7 3 p. masc. sg. **ʻlh** 110:5 3 p. fem. sg. **ʻlh** 91:5; 92:6; 93:6; 94:6; 95:6, 11; 96:4; 98:13; 99:18; 108:7
	(2) **prep.** "against"	73:7; 75:6; 76:8; 79:9; 105:8; 106:8; 118:4 – with pron. suffix 2 p. fem. sg. **ʻlk** 91:9; 96:6; 100:7; **ʻlky** 92:9(×2); 93:9, 10 3 p. masc. sg. **ʻlwhy** 66:4 2 p. masc. pl. **ʻlykwn** 99:9(×6), 20, 21
	(3) **prep.** "unto"	– with pron. suffix 1 p. sg. **ʻly** 91:9(×2); 99:21(×2) 2 p. fem. sg. **ʻlyky** 100:7(×3); **ʻlk** 91:9(×2); 92:9(×2); 93:9, 10; 94:10(×2) 2 p. masc. pl. **ʼlykwn** 99:20, 21(×2); **ʼlkwn** 119:1

	(4) with vb., marking obj. (ordered by the vb. immediately preceding it)	ḤTM + 3 p. masc. sg. ʿlyh 87:4 QMM + ʿl 110:4 ŠBʿ *af.* + 2 p. fem. sg. ʿlk 91:8; 100:6; ʿlky 92:8, 9; 93:8, 9; 94:9; + 2 p. masc. pl. ʿlykwn 99:20; 102:10; 116:9 – for the locution šry ʿl "haunt", see šry.
עלל	vb. "enter"	– ptc. masc. sg. ʿʾyl 103:9; 113:5
עלמא	n. "world, eternity"	95:8; 106:5; 113:4 ʾʿlmʾ 106:9 ʿlmʾ 106:8 – in the expression lʿlm "for ever" 68:7; 73:7; 77:3; 78:7; 79:10; 82:15; 92:12; 103:14; 104:12; 113:5; 118:6, 7, 8 – in the expression ʿd ʿlmʾ "for ever" 114:5, 10 – pl. ʿlmy 106:5; ʿlmyʾ 98:14; 101:14
עם	prep. "with"	ʿym 116:4, 5 – with pron. suffix 3 p. fem. sg. ʿymh 119:4
ענקתא	n. "neck(lace) charm" (type of demon)	nqth 88:2
ערא ארא	n. "bay tree"	ʾrʾ 73:7; 75:6; 76:9; 79:9
ערויתא	n. "shivering"	68:6; 74:2; 82:18 – pl. ʿrwyʾtʾ 117:4
ערק	vb. "flee, take flight"	– impf. 3 p. masc. pl. yʿyrqwn 104:7
עשה	(Heb.) vb. "do, act, make"	– ptc. masc. sg. ʿwśh 86:1, 2; 90:1; 106:1; ʿśh 105:1
עשמא	n. "wrath demon"; see the note to JBA 105:5.	– pl. ʿšmy 105:5
עשרא	num. "ten"	ʿśr 103:7; 104:1 – pl. "twenty" ʿyśryn 104:1; ʿśryn 103:7 – used in expressions for num. between eleven and nineteen: "twelve" trysr 88:4; tryʿśr 117:7

GLOSSARY

פ

פגעא	n. "affliction demon"	– masc. pl. **pgʿy** 70:3; 90:2; **pgʿyn** 72:6; 73:2; 75:1, 5; 76:3, 8; 79:3; 79:8; 80:2; 111:4; 113:2; 114:6; 118:1
פגרא	n. "body"	– with pron. suffix 3 p. masc. sg. **pgryh** 99:22 3 p. fem. sg. **pgrh** 99:22
פטירא	See פיטירא.	
פטר	vb. "exempt, release"	– pf. 1 p. sg. **pṭryt** 114:8
פיטירא	n. "enemy" (type of demon); see the note to JBA 21:5.	**pṭyrʾ** 108:1, 4
פיטירותא	n. "enmity"; see the note to JBA 21:5.	82:19
פירא	n. "fruit"	– with pron. suffix 3 masc. pl. **pyrhwn** 99:19; **pyryhwn** 100:5
פיתחא	n. "doorway"	– with pron. suffix 3 p. fem. sg. **pyth** (!)94:8; **pytḥh** 92:11(×2); 93:8(×2), 9; 94:8 – pl. **pytḥyn** 99:9
פכר	vb. "clasp, join"	– pass. ptc. with 2 p. masc. pl. encl. pron. **pkyrytwn** 110:2
פלגא	n. "army, phalanx"; see Müller-Kessler 2012, 22.	73:9 – with pron. suffix 2 p. masc. sg. **plgyk** 102:11; 103:12; 104:8 3 p. masc. sg. **plgyh** 102:7; 103:8; 104:2
פני	vb. "release (?)"	*pa.* – impf. 2 p. masc. pl. **typnw** 86:6(×2) – impv. masc. pl. **pnw** 86:6(×2)
פסק	vb. "cease, render judgement"	– ptc. masc. sg. with 1 p. sg. encl. pron. **psyqnʾ** 99:9
פקא	See פקע.	
פקדא	n. "*piqda*" (type of demon)	– pl. **pyqdy** 104:7; **pqdy** 103:3, 11; 105:7

פקע פקא	vb. "split, burst"	– impf. 3 p. masc. sg. **nypq'** 73:7; 75:6; 76:9; 79:9
פקעתא	See בקעתא.	
פרזלא ברזלא	n. "iron"	104:13 **brzl** 91:10; 93:10; 94:11; 96:6; 99:21 **brzl'** 77:5, 6 **przl** 92:10; 99:22, 28
פרש	vb. "depart; specify"	*pa.* "express clearly, specify" – pass. ptc. "specified" masc. sg. **mprš** 99:17
פרש	(Heb.) "depart"	*pi.* "depart, specify" – pass. ptc. "ineffable" masc. sg. **mpwrwš** 108:7
פתח	vb. "open"	– ptc. masc. sg. with 1 p. sg. **pthn'** 99:9 – impv. masc. sg. **pth** 95:13; 101:17 masc. pl. **pthw** 65:8; 67:5
פתכרא	n. "idol spirit" (type of demon)	99:5, 11, 17, 18 – masc. pl. **ptkry** 70:3; 73:6; 76:8; 79:8; 89:10; 95:6, 7; 96:1; 98:8, 13; 99:7, 16; 101:7, 13; 102:10; 103:3, 11; 104:7; 117:3; 118:2; **ptkry'** 96:4; 99:18 **ptkryn** 73:6; 95:3; 98:11; 99:12; 115:3 – fem. sg. **ptkt'** (!) 99:11; **ptkrt'** 99:5 – fem. pl. **ptkrt'** 95:7; 98:14; 99:7, 16; 104:15
פתשגן	n. "copy"	119:1

צ

צומא	n. "fast"	88:3
צוציתא	n. "curled (tufts of) hair"	– with pron. suffix 2 p. fem. sg. **ṣwṣytyk** 93:8; **ṣwṣytyky** 91:8; 92:9; 94:9; **ṣr'tk** (!) 100:6 2 p. masc. pl. **ṣwṣytkwn** 99:20

GLOSSARY

צור	vb. "draw, depict"	– pass. ptc. masc. sg. **ṣyr** 108:7 masc. pl. **ṣyryn** 91:5; 92:6; 93:6; 94:6; 95:6, 11; 96:4; 98:13; 99:18; 100:3; 101:13	
צור	(Heb.) n. "rock"	107:2	
צורא	n. "neck"	– with pron. suffix 2 p. fem. sg. **ṣwryky** 91:10	
צורתא	n. "image, form; (magic) circle (?)"	68:5; 71:5; 73:4; 75:4; 77:5; 78:6; 79:7; 80:6; 118:3	
ציביתא	See צפתא.		
צימחא	(1) n. "splendour"	– pl. **ṣymḥy** 103:2	
	(2) n. "plant"	– pl. – in the locution **ṣymḥy ṣymḥy** "various plants" 101:9	
צפתא ציביתא	n. "gemstone" (?); see the note to JBA 66:4.	**ṣpth** 66:4; **ṣybyth** 70:6	
צרי	vb. "split"	*itpe.* "be split open" – impf. 3 p. masc. sg. **nyṣṭry** 73:7; 75:6; 76:9; 79:9; 118:5	
צרר צרי	vb. "tie up, congeal"	– impf. 3 p. masc. sg. **yṣwr** 116:2 – pass. ptc. pl. with 2 p. masc. pl. pron. suffix **ṣyrytwn** 112:8	

ק

קבל	vb. "receive"	*pa.* "receive, accept" – impf. 2 p. masc. pl. **tqblwn** 99:8 – ptc. masc. pl. **mqblyn** 99:12	
קבלא	prep. "towards, opposite, before"	– with pron. suffix 1 p. sg. **qbly** 99:23	
קבלאה	adj. "first"	72:2	
קבר	vb. "bury"	– ptc. masc. pl. **qbryn** 86:6	

קדיש	(1) **adj.** "holy"	**qdyš'** 65:1; 95:8; 98:14; 101:14 – pl. **qdyšy'** 99:10
	(2) **n.** "holy one"	**qdyš'** 117:6
קדם	**prep.** "before, in the presence of"	73:9(×2) – with pron. suffix 3 p. masc. sg. **qwdmwhy** 105:7 – in the compound prep. **mn qwdm** "(from) before" 116:10 + 3 p. masc. sg. pron. suffix **mn qwdmwhy** 116:8
קדמאה	**adj.** "first, primeval"	65:3; 66:2; 68:3; 70:4; 73:3; 74:3; 75:2; 76:5; 77:1; 79:4; 81:5; 82:17; 84:9; 85:19; 95:9; 101:15; **qdm'** 80:4; 83:8
קולא	(1) **n.** "collar"; see the introduction to I.4.1.1.	– pl. **qwlyn** 91:10(×2); 92:10; 93:10; 96:6; 99:21
	(2) **n.** "bowl"	– pl. **qwlyn** 99:10
קום	**vb.** "stand, remain, wake up, get up"	– impf. 3 p. masc. sg. **nyqwm** 73:7; 75:6; 76:9; 79:9; 118:5 – ptc. masc. sg. **q'yym** 73:7; **q'ym** 75:7; 76:9; 79:9 masc. pl. **qymyn** *itpa.* "endure, live, be fulfilled" – impf. 3 p. masc. pl. **ytyqymwn** 110:6; **ytqymwn** 100:9
קומתא	**n.** "body"	103:10 – with pron. suffix 2 p. masc. sg. **qwmtk** 99:17 3 p. fem. sg. **qwmt'h (?)** 92:12; **qwmth** 116:2
קטינתא	**n.** "nerve"	– pl. **qṭynt'** 103:7 – with pron. suffix 1 p. sg. **qṭynty** 104:1
קטל	**vb.** "kill"	– ptc. masc. pl. **qṭlyn** 98:10; 99:25; 101:10
קטלא	**n.** "killing"	99:25

קטר	v. "tie"	– ptc. masc. sg. **qṭr** 91:3; 92:5; 93:5; 94:5; 97:4; 100:2 – pass. ptc. with 2 p. masc. pl. encl. pron. **qṭyrytwn** 110:2	
קיבלא	n. "charm, counter-charm"	**qyblh** 105:8 – pl. **qybly** 95:7	
קיטרא	n. "knot"	110:2	
קיים	adj. "established"	66:4; **qy'ym** 85:20; **qym** 77:3; 103:15	
קינא	n. "family, nest"	– with pron. suffix 2 p. masc. sg. **qynk** 103:14 – pl. – in the locution **qyny qyny** "various nests" 96:2; 99:13	
קינינא	See קניינא.		
קלא	n. "voice"	– with pron. suffix 3 p. masc. sg. **qlh** 75:6; 76:9; **qlyh** 73:7; 79:9; 118:5 – for the expression **bt ql'**, see **brt'**.	
קלל	vb. "be light"	– impf. 3 p. masc. pl. **nyqlwn** 110:5	
קמיעא	n. "amulet"	91:7; 94:7 **qmyʿh** 73:6; 75:1; 89:1, 10; 92:7; 93:7; 99:4; 105:8; 111:1	
קמם	vb. "restrain"	*pa.* "restrain" – ptc. masc. sg. **mqmm** 110:4	
קניינא קינינא	n. "possession, property"	– with pron. suffix 3 p. masc. sg. **qynyh** 105:3; 111:3; 116:4; **qynynh** 74:1; 104:6; **qynynyh** 73:1; 76:2; 107:2; 114:5; **qnyynyh** 108:2, 4, 5 3 p. masc. pl. **qynyhwn** 73:5; **qynynhwn** 87:7; 98:12; 100:6; 101:12; 114:9	
קרב	vb. "come near, approach"	– impf. 2 p. masc. pl. **tyqyrbwn** 102:10; 118:3; **tyqrbwn** 73:5; 103:12; **tqrbwn** 104:5 3 p. masc. pl. **yqyrbwn** 75:4; 76:7; 79:7; **yqrbwn** 77:3; **nyqrbwn** 89:11 – ptc. masc. pl. **qrbyn** 77:6	

קרי	vb. "call, summon"	– ptc. fem. sg. **qry'** 91:2; 92:3; 93:4; 94:3 *itpe.* "be called" – ptc. masc. sg. **mytqry** 76:7; 90:1 fem. sg. **mytqry'** 82:19; 111:5
קריתא	n. "accident, mishap" (type of demon)	73:9; 74:2; 88:2; 107:6; 110:5
קרנא	n. "corner"	– pl. **qrny** 102:5
קשי	adj. "severe"	– masc. pl. **qšyy** 74:2

ר

ראזא	See רזא.	
רב	(1) adj. "great"	**rb'** 65:1, 6; 67:3; 73:3, 4(×2); 75:2, 3(×2); 77:5; 79:4, 6(×2), 7; 80:3, 5, 6; 84:9; 95:8, 11; 98:14, 16(×2); 101:14, 16; 103:1, 5(×2); 104:16; 117:6; 119:4 **rbh** 66:2, 3, 4; 68:5; 71:5; 72:5; 73:3, 8; 76:4, 5, 6(×2); 77:3; 81:2, 6; 82:13, 17; 83:3; 84:5; 85:15, 19; 86:2, 8, 9; 89:9; 105:6; 112:9; 116:2; 118:3; 119:2, 5 – fem. sg. **rbt'** 73:10; **rbty** 77:4; 116:2 – masc. pl. **rbrby'** 99:10
	(2) n. "great one, adult"	– pl. – with pron. suffix 2 p. masc. pl. **rbrbykwn** 98:8 3 p. masc. pl. **rbrbyhwn** 96:1; 99:12; 103:2
רבותא	n. "greatness, majesty"	99:10
רביעאה	adj. "fourth"	66:3; 67:2; 70:5; 71:3; 73:3; 74:4; 75:3; 77:2; 95:9; **rby'ʿh** 65:4; 72:3; 79:5; **rby'ʿh** 76:5; 80:4; 98:15; 101:15
רביתא	n. "lying position"	96:3; 99:14
רברבי	See רב (2).	
רגם	adj. "accusing"	– masc. sg. **rg'm'** 89:4, 11, 13

רגש	vb. "tremble"	*itpe.* "tremble" – ptc. masc. pl. **mytrgšyn** 116:8	
רוחא	n. "spirit"	89:11 – pl. **rwḥy** 68:2, 6; 70:3; 104:7, 15; 111:4 **rwḥyn** 91:6; 95:2	
רושמא	n. "seal impression"	– pl. **ršmyn** 77:1	
רות	See רתת.		
רזא ראזא	n. "secret, mystery"	65:5; 66:4(×2); 67:3; 68:5; 73:4, 8(×3); 76:6; 88:3; 99:4; 118:3; **rʾzʾ** 79:7; 95:11; **rʾzh** 95:11; **rzh** 70:7; 71:5; 73:9; 77:3; 98:16; 101:16 – pl. **rzy** 88:4; 117:7 **rzyn** 73:10	
רחם	vb. "love, have compassion"	– ptc. masc. pl. **rḥmyn** 95:1; 96:6; 98:10; 99:15(×2); 101:10	
רחמי	n. "mercy"	– masc. pl. cstr. **rḥmy** 82:18; 99:3	
רחק	vb. "be far away"	*itpa.* "be far away" – impf. 2 p. masc. pl. **tytrḥqwn** 98:6 3 p. masc. pl. **ytrḥqwn** 104:6	
ריגלא	n. "foot"	– masc. pl. – with pron. suffix 2 p. masc. sg. **ryglk** 99:29 2 p. fem. sg. **ryglyky** 91:9	
רישא	n. "head"	– cstr. **ryš** 91:4, 5; 99:17 – with pron. suffix 1 p. sg. **rʾyšy** 103:2 3 p. masc. sg. **rʾšyh** 99:11	
רית	See רתת.		
רכובא	n. "chariot, rider"	– pl. **dwknyn (!)** 99:9	
רם	adj. "high, exalted"	**rmʾ** 116:3	

רמי	**vb.** "throw, hurl, cast"	– impf. 2 p. masc. pl. **yrmwn** 99:21 – ptc. masc. sg. with 1 p. sg. encl. pron. **rmyn'** 99:9(×2)	
רעא	**n.** "bond, band"	– pl. **ryʿyn** 99:21; **rʿyn** 91:10	
רקיעא	**n.** "sky, firmament"	65:6; 66:4; 70:7; 73:5; 79:7; 95:11; 98:16; 101:16; 118:3 **rqyʾ** 76:7; **rqyʿh** 72:5; **rqyʿh** 68:5; 71:5; 78:7; **rqʿh** 77:3 – pl. **rqyʿyn** 73:3; 75:2; 76:5; 79:4; 80:4	
רתת רות רית	**vb.** "tremble"	– impv. fem. sg. **rwty** 91:7; 92:7; 93:7; 100:4 – ptc. masc. pl. **ryytyn** 92:6; 93:6; **rytyn** 99:18	

ש

-ש	(Heb.) **conj.** "as"	65:9; 67:5; 95:14; 98:17; 101:17	
שבועתא	**n.** "oath"	119:3	
שבח	**vb.** "praise"	– pass. ptc. masc. sg. **šbḥ** 116:3 *pa.* "praise" – pass. ptc. masc. sg. **mšbḥ** 116:3	
שביח	**adj.** "praiseworthy"	**šbyḥ'** 116:3	
שביעאה	**adj.** "seventh"	66:3; 67:2; 68:4; 70:6; 71:4; 75:3; 77:2; 95:10; **šbyʾh** 76:6; 80:5; 98:16; 101:16; **šbyʾh** 65:5; 72:4; 79:6; **šbyʾ** 73:3	
שבע	**vb.** "swear"	*af.* "put under oath, make swear" – pf. 1 p. sg. **'šbʿyt** 91:8; 92:8(×2); 93:8; 94:9; 99:20; 100:6 – ptc. masc. sg. with 1 p. sg. encl. pron. **mšbʿn'** 86:3; 97:1; 99:10; 102:10; 116:9	

שבעא	num. "seven"	98:14; 100:7; 116:10	
		šb'h 65:2; 66:1(×2), 68:3; 70:4; 71:2; 72:2; 74:3; 75:2; 76:4(×2); 77:1(×2), 6; 79:4(×2); 80:3(×2); 90:3; 95:8; 101:15; 118:2	
		šb' 73:3(×2); 112:9	
		šb 110:1	
		– pl. "seventy"	
		šb'yn 73:10	
שבק	vb. "leave, divorce, dismiss, abandon"	– pf.	
		1 p. sg. šbqyt 114:8	
		– ptc.	
		masc. sg. šbyq 116:8	
שגר	vb. "heat up"	*pa.* "inflame with lust"	
		– ptc.	
		masc. pl. mšgryyn 98:10; mšgryn 95:1; 99:15	
שדרותא	n. "dispatch (of witchcraft)"; see the note to JBA 88:2.	šrwt' 88:2	
שדתנסא	n. "little demoness"; see the note to JBA 116:1.	116:1	
שוור	vb. "jump"	– ptc.	
		masc. sg. 105:8	
שוט	vb. "roam"	– ptc.	
		masc. sg. šyyṭ 105:8	
שוטא	n. "whip"	91:4; 92:5; 93:5; 95:5; 99:16; 103:5	
שולטנא	n. "authority"	šwlṭwn' 116:6	
שורא	n. "wall"	– pl.	
		šwryn 77:6	
שורבתא	n. "tribe, family"	– with pron. suffix	
		2 p. masc. sg. šwrbtyk 102:12; 104:10	
		3 p. masc. sg. šwrbth 104:3; šwrbtyh 102:8; 103:9	
שורײנא	n. "sinew"	– pl.	
		šwryny 103:7; 104:1	
שושליתא	n. "chain"	– cstr.	
		šyšyl 105:9	
		– pl.	
		šwšlyn 91:10; 96:6; šwšln 92:10(×2); 93:10(×2); 94:11	

שחרתא	n. "slumber"	100:5
שיבטא שיפטא	n. "affliction" (type of demon)	99:6(×2) – pl. **šybṭy** 68:1; 68:5; 99:7, 11; 103:11; **šybṭyn** 75:5; 76:8; 111:4; **šypṭyn** 73:2, 6; 91:5; 113:2; 114:6; 115:3; 116:9
שידא	n. "demon"	82:14; 84:6; 85:17; 86:4; 89:4, 5, 11(×2), 13; 99:6, 11; 103:9; 107:1, 6; 117:5; 119:2 – masc. pl. **šdy** 85:16; **šydy** 68:1; 68:5; 70:3; 81:2; 82:13; 83:2, 3, 4; 84:4; 85:15(×2); 86:2, 3(×2); 89:3, 9, 13; 90:2; 95:6; 98:8, 13; 99:7, 16; 100:3; 101:13; 102:10; 103:3, 11; 104:15; 105:7; 107:5; 117:2; 118:2; **šydyʾ** 81:2 (×2), 3; 82:13, 14, 19; 84:4, 5; 96:4; 99:18; **šydyn** 72:6; 73:2, 6; 75:1, 5; 76:3, 8; 79:3, 8; 80:2; 86:8; 87:8; 91:5; 92:6; 93:6; 94:6; 101:11; 111:4; 113:2; 114:5; 115:3; 116:9; 118:4
שיזב	quad. vb. "save"	*quad. refl.* "be saved" – impf. 3 p. fem. sg. **tyšṭyzb** 82:19
שיחן	quad. vb. "arouse (with lust)"	– ptc. masc. pl. **mšyḥnyn** 99:14
שימשא	n. "sun"	65:5; 72:4; 73:4; 75:4; 76:6; 79:7; 80:6; 95:10; 98:16; 101:16; **šymšh** 71:4; 74:6; 119:5; **šmšʾ** 67:3; 70:6; 77:2; 118:3
שיפטא	See שיבטא.	
שיקופתא	n. "blow demon" (see also אשתקופתא)	73:9
שירא	n. "ring"	77:4; 87:7; 88:4; 95:5; 98:13; 101:13; 103:7; 104:1; 113:5; 114:10; 115:4; 117:6
שיתא	num. "six"	**šyt** 73:9; 91:4, 5; 97:5; 99:17 – pl. "sixty" **šytyn** 89:12; 91:4, 5, 9; 92:9, 11; 93:10; 94:10; 96:6; 97:5; 99:17, 21; 103:5; 104:1; **šṭyn** 73:10
שכבא	n. "sleeper" (type of demon)	89:4
שלט	vb. "have power"	– ptc. masc. pl. **šlṭyn** 98:10; 101:9
שליטא	n. "ruler"	119:2
שלם	v. "be completed"	*af.* "hand over" – impf. 3 p. masc. pl. **yšlmwn** 91:11; 94:12; 99:23; 100:9
שלניתא	n. "grabber" (type of demon)	**šylnyṭʾ** 111:5

שלף	vb. "pull off, draw"	– pass. ptc. fem. sg. **šlyph** 110:3
שם	(Heb.) n. "name"	**šwm** 108:7 – with pron. suffix 2 p. masc. sg. **šmk** 86:1, 2; 90:1; 105:1; 106:1 – see also יהוה צבאות שמו in the list of divine names etc. in this volume.
שמא	n. "name"	87:7 **šwm** 76:3, 8; 111:3 – cstr. **šwm** 65:6(×2); 67:3(×2); 73:2; 82:20; 90:3; 95:11; 98:16(×2); 99:10; 101:16(×2); 102:9(×5); 103:10(×5), 11; 104:4(×5), 5(×2); 107:8; 110:1, 4, 6, 7 – with pron. suffix 3 p. masc. sg. **šmh** 119:4; **šmyh** 65:1; 72:6; 89:10; 91:3, 10(×2); 92:4, 10(×2), 12; 93:5, 10; 94:5; 95:8; 98:14; 99:21(×2); 117:5, 6 3 p. masc. pl. **šmyhwn** 68:2(×2), 7(×2); 73:6(×2); 78:3; 82:17; 99:17; 113:4; 114:6, 7 – pl. – with pron. suffix 3 p. masc. pl. **šmhthwn** 100:8
שמיא	n. "heaven"	72:5; 73:3, 4; 75:4; 76:6; 79:6; 80:3; 82:18; 86:8, 9, 10; 99:1; 103:3; 105:7, 9; 106:8(×2); 108:1; 109:3; 116:8; 117:7; 118:2; 119:5; **šmyh** 66:4; 78:1; 80:6; 85:6–7, 10–12; 86:1(×2); 101:14; 112:7; 113:6; 114:10; 115:5
שמע	vb. "hear, listen"	– impv. masc. pl. **šmʿw** 111:6 – ptc. masc. sg. **šmʿ** 119:3 masc. pl. **šmʿyn** 99:12; 103:4 fem. pl. **šmnʿn** (!) 116:1
שמש	vb. "minister, use"	*itpa.* "use" – ptc. masc. sg. **myštmš** 103:10
שמתא	n. "ban, excommunication"	73:7; 79:9; 118:5 – pl. **šmtʾ** 76:9
שני	vb. "be different"	*pa.* "change, leave" – ptc. masc. sg. **mšny** 116:8

שסטם שצטם ססטם	vb. "shackle"	*quad.* – pass. ptc. masc. pl. **mšṣṭmyn** 104:15 pl. with masc. pl. encl. pron. **msṣṭmytwn** 95:5
שער	(Heb.) n. "gate"	– pl. cstr. **šʿry** 95:13
שפודא	n. "spit"	77:5
שצטם	See שסטם.	
שקל	vb. "take"	– pass. ptc. masc. pl. **šqylyn** 116:10 *itpe.* "be removed" – impf. 3 p. masc. pl. **nyštqlwn** 110:5
שקף	vb. "beat"	– ptc. masc. pl. **šqpyn** 101:10
שרותא	See שדרותא.	
שרי (1)	vb. "dwell, reside"	– ptc. masc. sg. **šry** 89:12 fem. sg. **šryʾ** 116:2; with 2 p. fem. sg. encl. pron. **šryt** 100:5 masc. pl. **šryn** 95:7; **šrn** 89:5; 91:6; 92:7; 93:7; 94:7; 99:18; 100:4; 114:7 – in the locution **šry ʿl** "haunt" masc. pl. ptc. **šrn ʿl** 99:14; 103:9; **ʿwyr ʿl (!)** 96:2, 2–3; see also 98:10.
שרי (2)	vb. "loosen, unbind, dissolve"	– pass. ptc. masc. sg. **šry** 84:9; 85:19; 91:3; 92:5; 93:5; 94:5; 97:4; 100:2; **šryʾ** 82:17; **šrryʾ (!)** 81:6 – inf. **lmyšrʾ** 106:8 **lmšrʾ** 106:8 **myšrʾ** 105:9 *itpe.* "be untied" – impf. 2 p. masc. pl. **tyštrwn** 81:6; 82:17; 84:9; 85:19 3 p. masc. pl. **nyšrwn** 110:7 – ptc. masc. sg. **myštry** 91:4; 92:5; 93:5; 94:5; 97:5
שריותא	n. "permission, release"	103:5
שריר	adj. "sound"	66:4; 77:3; 85:20; 103:14; **šr** 109:6; **šryrh** 90:7 – fem. pl. **šryrn** 66:4

שרר	**vb.** "be strong"	*itpa.* "grow strong, prevail" (see the note to JBA 105:8) – impf. 3 p. masc. sg. **nyštrr** 105:8	
שררא	**n.** "strength"	77:4	
שש	(Heb.) **num.** "six"	– masc. sg. cstr. **šyšyt** 108:7	
שתיתאה	**adj.** "sixth"	65:4; 66:3; 67:2; 68:4; 70:6; 71:4; 72:4; 73:3; 74:5; 75:3; 76:5; 77:2; 79:5; 95:10; 98:15; 101:15; **štyt'** 80:5	

שׂ

שרא סרא	**n.** "guardian angel"	**srh** 119:4	

ת

תבר	**vb.** "break"	– impf. 3 p. masc. sg. **nytbr** 105:8	
תברא	**n.** "breaking"	– with pron. suffix 3 p. masc. pl. **tbrhwn** 99:7	
תוב	**adv.** "again"	**twb** 65:1; 70:7; 77:3, 4; 86:6; 88:3; 92:8; 95:5, 6, 8; 98:7, 12, 13, 14; 100:5; 101:7, 12, 13, 14; 102:4, 6, 9; 103:4, 7; 110:1, 3; 111:5, 8; 115:6	
תחות	**prep.** "under"	117:5	
תילא	**n.** "mound"	– pl. – in the locution **tyly tyly** "various mounds" 98:9; 99:14; **tly tyly** 96:2	
תינינא	See תניין.		
תליתאה	**adj.** "third"	65:3; 66:2; 70:5; 71:3; 72:3; 73:3; 77:1, 2; 79:5; 80:4; 95:9; 100:15; **tlyt'** 68:3; 75:3; 76:5; 98:15	
תלתא	**num.** "three"	69:2; 71:2; 73:2; 74:3; 75:1; 76:4; 79:3; 80:2; 103:4; 118:2; **tlt** 73:9; 103:5 – with pron. suffix 2 p. fem. pl. **tlytykyn** 111:5 3 p. masc. pl. **tltyhwn** 91:11; 92:10; 93:11; 94:11; 99:22	

תמניא	**num.** "eight"	72:2; 90:3; 98:15 **tmnyh** 65:2; 70:4; 95:9 – pl. "eighty" **tmnn** 89:12
תני	**vb.** "repeat, do again"	– impf. as auxiliary verb: 3 p. masc. sg. **ytny** 119:4
תניין תינינא	**adj.** "second"	**tynyn'** 65:3; 66:2; 70:5; 71:3; 72:3; 73:3; 74:3; 75:2; 76:5; 77:1; 79:5; 80:4; 95:9; 98:15
תנינא	**n.** "dragon, serpent"	89:7; 116:8
תפי	**vb.** "boil"	– ptc. masc. sg. with 1 p. sg. encl. pron. **tpyn'** 99:9
תקיף	**adj.** "mighty, severe"	**tqym'h** (!) 98:15; 101:15 **tqyp'** 65:4; 66:3; 67:2; 70:6; 72:4; 75:3; 76:5; 79:5; 80:4; 91:10; 92:10; 93:10; 94:11; 95:10; 99:22; 100:8; 105:6 **tqyph** 71:3; 74:4 – for the expression **'yn' tqypt'**, see **'yn'**. – masc. pl. **tqypy** 108:3; **tqypyn** 77:3; 82:19; **tqpy** 88:2
תקן	**vb.** "make fit, establish"	*pa.* "make fit, establish" – pass. ptc. masc. sg. **mtqn** 72:1
תרי	**num.** "two"	in **trysr** "twelve" 88:4; **try'śr** "twelve" 117:7 – with pron. suffix 3 p. masc. pl. **trwyhwn** 91:10; 92:10; 93:11; 94:11; 99:22
תרך	**vb.** "divorce"	*pa.* "divorce" – pf. 1 p. sg. **trykyt** 114:8 *itpe.* "be divorced" – impv. masc. pl. **'ytrykw** 98:11; 101:12; **'trkw** 95:4
תרעא	**n.** "gate"	– with pron. suffix 3 p. masc. sg. **tr'yh** 76:2; 111:3
תרץ	**vb.** "be straight, set"	– ptc. masc. sg. **tryṣ** 103:2

List of Divine Names, Names of Angels, Demons and Exemplary Figures, and *nomina barbara*

א

אבורית	Iborit	89:8
אבי	Abay; see יוכבר זיוא בר אבי.	
אבסוניא	**ʾbswnyʾ**	73:8
אבק	**ʾbq**	113:7; 115:6
אברחסיא	**ʾbrḥsyʾ**	65:1
אברחסיה	**ʾbrḥsyh**	95:8; 98:14; 101:14
אברכסוס (א)ברכסוס	Abraxos	105:6
אברכסיה	**ʾbrksyh**	66:5
אברכסס	Abraxas	81:6; 82:17; 83:8; 84:9; 85:19
אגרוס	**ʾgrws**	68:3; 71:3; 74:4
אגרת בת מחלת	Agrat daughter of Maḥlat	102:7, 11; 103:8–9, 13; 104:3, 9
אדי	**ʾdy**; see [...]רן בר אדי and זברן בר אדי.	
אדנחיש	(A)danaḥiš; see דנחיש.	
אה	ʾH	67:4
אהיה	"I am"	65:6(×2); 67:4(×2); 95:11; 98:16
אחיף	**ʾḥyp**	90:4
אטרמין	**ʾṭrmyn**	68:4; 71:4; 74:6; 77:2
איבול	Ibol	89:7
איבול	**ʾybwl**; see also איבול בר סגול.	66:2; 98:15
איבול בר סגול	**ʾybwl** son of **sgwl**; see also יבול בר איבול and סיגול.	72:3

איבול בר סיגול	**'ybwl** son of **sygwl**; see also איבול בר סיגול, יבול בר סיגול, and סיגול.	95:9; 101:15
אידי	See זבוזיר בר אידי.	
איספהרום	**'ysphrwm**	115:8
איפרסת	**'yprst**	90:4
אירי	**'yry**; see נבורין בר אירי and בירון בר אירי.	65:3
אל שדי אלשדי איל שדי	El Shaddai; see also שדי.	65:6; 67:3; 95:11; 98:16; 102:9; 103:11; 104:16; 105:6; 107:4; 111:5; 112:9(×2)
אלחי	**'lḥy**; see זברה בר אלחי.	
אלשדי	See אל שדי.	
אמורתת	**'mwrtt**	66:5
אני	**'ny**	104:3, 11
אני נהרא	**'ny nhr'**	102:8, 12; 103:8, 13
אנטטי	**'nṭṭy**	88:5
אנפראי	**'npr'y**	90:3
אנקי	**'nqy**	113:7; 114:12; 115:6
אס	**'s**	75:8
אספהרום	**'sphrwm**	115:8(×3)
אסריאל אסראל	Asriel	91:3; 92:5; 93:5; 94:5
אפליפר	**'plypr**	113:7; 114:11; 115:6
אציץ	**'ṣyṣ**	113:7; 114:11; 115:6
ארגיה	**'rgyh**; see זבורון בר ארגיה.	
ארגיה בר נורי	**'rgyh** son of **nwry**	66:3–4; 77:2
ארהום	**'rhwm**	115:8(×3)

LIST OF DIVINE NAMES, NAMES OF ANGELS, DEMONS AND EXEMPLARY FIGURES, AND NOMINA BARBARA

אריון בר זנך (א)ריון בר זנך	Arion son of Zank	105:5; 106:4
ארמ[.]א	ʾrm[.]ʾ	73:8
ארמין	ʾrmyn	72:4
ארמיס	ʾrmys	72:4
ארציה	ʾrṣyh	113:7; 114:11; 115:6
ארתת	ʾrtt	66:4
אשמדי שמדי	Ashmedai	81:2, 3; 82:13, 14; 83:3, 4; 84:5, 5 (šmdyʾ); 85:16(×2); 86:2, 3; 102:7, 11; 103:8, 12; 104:2, 8
אתקש	ʾtqš	88:5

ב

בגדנא	Bagdana	110:1
בגוזרא	bgwzrʾ	115:8(×2), 9
בוזיט	bwzyṭ	65:4; 67:2; 98:15
בול	bwl	73:3
בורגון	bwrgwn	65:4; 66:2; 95:10; 98:15; 101:15
ביאמך	byʾmk	106:6
בידיה	bydyh	73:3; 75:2; 76:5; 79:5; 80:4
בידת	bydt; see also בידתה.	71:3; 74:3
בידתה	bydth; see also בידת.	68:3
בינים	bynym	99:24
בירון בר אירי	byrwn son of ʾyry	95:9
במלכותא	bmlkwtʾ	113:7; 114:11; 115:6
בר	br	113:7; 114:11; 115:6
ברכסוס	See אברכסוס.	
בתיה	btyh	107:1

ג		
גברא	Gabra	73:10
גבריאל גבראל	Gabriel	91:10; 92:10; 93:10; 99:21; 100:8; 108:6; 114:13
גזיא	**gzy'**; see also גיא.	65:4; 67:2
גזריון	**gzrywn**; see also גר[...], גרזיין, and גרזן.	73:3
גיא	**gy'**; see also גזיא.	98:15; 101:15
גנב	Gannav	91:4; 95:5; 98:13; 101:13
גנבת	Gannavat	91:4; 99:16
גנקת	Gannaqat	92:5; 93:6; 94:6
גר[...]	**gr[...]**	76:5
גרום	**grwm**	90:4
גרזיין	**grzyyn**; see also גזריון, גר[...], and גרזן.	79:5; 80:4
גרזן	**grzyn**; see also גזריון, גר[...], and גרזן.	75:3
גרם	**grm**	90:4
ד		
דוד	See דויד.	
דודי	See דויד.	
דויד דוד	David (Biblical king of Israel)	70:7; 73:10; 86:9 (**dwdy**); 91:5; 92:6; 93:6; 94:6; 95:6; 96:4; 98:13; 99:18; 100:3; 103:8; 104:2; 105:5; 107:4 (**dwd**); 108:6; 109:3 (**dwd**); 110:4 (**dwd**); 119:2
דירמוסיס	**dyrmwsys**	66:3
דמדסת	**dmdst**	90:5
דנחיש אדנחיש	Danaḥiš	102:8, 12; 103:3, 9(×2), 11, 13; 104:3, 10; 119:2
דר	**dr**	113:7; 114:11; 115:5

דרי	dry	113:7; 114:11; 115:5

ה

הדין	hdyn	73:3
הימון	hymwn	99:24

ו

וסג[...]	wsg[...]	87:9

ז

זברה בר אלחי	zbrh son of 'lḥy	70:5
זבוזיר בר אידי	zbwzyr son of 'ydy	72:3
זבול	zbwl	75:3; 76:5; 79:5; 80:5
זבורון בר ארגיה	zbwrwn son of 'rgyh	66:3
זברן בר אדי	zbrn son of 'dy; see also רן בר אדי[...].	71:3; 74:4; 77:2
זדון	zdwn	90:4
זדן	zdn	90:4(×2)
זו זימרא זו זימרה	zw zymr' zw zymrh; see also זימרן.	88:4 (zw zymr'); 88:4 ([z]w zymrh)
זיה	zyh	87:7
זימרן	zymrn; see also זו זימרא.	87:8
זיר	zyr	113:5; 114:10; 115:4; 117:6
זכיא	zky'	102:9, 12; 103:13; 104:4, 11
זמין	zmyn	113:5; 114:10; 115:4
זנך	Zank; see אריון בר זנך.	
זר זור	zr zwr	117:6
זרדין	zrdyn	103:7
זרזין	zrzyn	104:2

זרזיר	zrzyr	88:4
זרי	zry	104:13

ח

חבלס	Ḥablas	85:17
חוטמין	ḥwṭmyn; see also חתימין.	71:4; 74:5
חי	ḥy	102:9; 103:10; 104:4(×2)
חית	ḥyt	104:4
חף	ḥp	90:4
חת	ḥt	102:9; 103:10
חתימין	ḥtymyn; see also חוטמין.	77:2

ט

ט[...]	ṭ[...]; see also טורמיס, טורמין, and טורמס.	70:6; 101:16(×2)
טבית	ṭbyt; see also טיבות.	75:2; 76:5; 79:4; 80:4
טורמין	ṭwrmyn; see also ט[...] and מין[...].	65:5; 67:2; 95:10
טורמיס	ṭwrmys; see also ט[...] and טורמס.	65:5; 70:6; 95:10; 98:16
טורמס	ṭwrms; see also ט[...] and טורמיס.	67:2; 98:15
טטיא	ṭṭy'	107:1
טטרא	ṭṭr'	88:5
טיבות	ṭybwt; see also טבית.	73:3
טיסאיפורין	ṭys'ypwryn; see also טיסו איפורן.	102:7, 11
טיסו איפורן	ṭysw 'ypwrn; see also טיסאיפורין.	103:8, 12; 104:2, 8–9
טיפרוס	Ṭifros	119:2
טסטעיתא	ṭssʿyt'	103:14

LIST OF DIVINE NAMES, NAMES OF ANGELS, DEMONS AND EXEMPLARY FIGURES, AND NOMINA BARBARA

י

יאניאל	Yaniel	106:7
יבול	Ibol; see also איבול.	110:1
יבול בר סגול	**ybwl** son of **sgwl**; see also יבול and איבול בר סגול בר סיגול.	65:3
יבול בר סיבול	**ybwl** son of **sybwl**; see also יבול בר סיגול.	77:1
יבול בר סיגול	**ybwl** son of **sygwl**; see also איבול בר סגול and סיגול.	68:3; 70:5; 71:3; 74:4
יה	Yah	67:7; 73:3; 75:3; 76:5; 79:6; 80:5; 106:7(×10)
יהו	YHW	102:9(×2); 103:10(×2); 104:4(×2)
יהוה	YHWH	65:6; 67:4; 72:7; 95:11; 98:16; 106:7; 107:8
יהוה צבאת יהוה צבאות	YHWH Sabaoth ("the LORD of hosts"); see also יהוה צבאות שמו.	75:3; 76:6; 79:6; 80:5; 105:6; 110:6; 116:3
יהוה צבאות שמו	YHWH Sabaoth is his name ("the LORD of hosts is his name"); see also יהוה צבאת.	65:7; 67:4; 95:11–12; 98:16; 101:16; 107:9
יוביזול	**ywbyzwl**	66:2
יוכבוד זיוא	Yokabod Ziwa	88:4
יוכבר זיוא בר אבי	Yokabar Ziwa son of Abay	87:8
יורבא	**ywrbʾ**	73:2
יורגא	**ywrgʾ**	73:2
יוש[.]ה	**ywš[.]h**	110:7
ייי	YYY	106:6
יייי	YYYY	73:4; 82:11
ילמ[.]ם	**ylm[.]m**	106:9
יפנך	**ypnk**	88:5

כ

כל	**kl**	106:9

כרי כרא	**kry krʾ**	106:5
כרכום	Karkum	73:8

ל

לא	**lʾ**	113:6; 114:11; 115:5
לאתידוסת	**lʾtydwst**	90:5
לויתן	Leviathan	73:8
ליליתא	Lilith	102:8, 12
ליפי	**lypy**	113:7; 114:11; 115:5
ליתר	**lytr**	106:6
למא	**lmʾ**	106:6, 7
למי[.]א	**lmy[.]ʾ**	106:5
לסלמה	**lslmh**	106:9

מ

מאגמי	**mʾgmy**	106:6
מברגירא	**mbrgyrʾ**	113:7; 114:11; 115:6
מהידוסת	**mhydwst**	90:5
מחלת	Maḥlat; see אגרת בת מחלת.	
מיטטרון	Metatron	119:4
מיכאל מיכואל	Michael	100:8; 114:13
מך	**mk**	106:6
מנה	**mnh**	113:6; 114:11; 115:5
מרק	**mrq**	90:4

נ

נבו[...] בר נורי	**nbw[...]** son of **nwry**	71:4

LIST OF DIVINE NAMES, NAMES OF ANGELS, DEMONS AND EXEMPLARY FIGURES, AND NOMINA BARBARA

נבודיד	**nbwdyd**	72:3
נבורין	**nbwryn**	65:3
נבורין בר אירי	**nbwryn** son of **ʾyry**	65:3; 98:15
נבידית	**nbydyt**	70:4
נבירון	**nbyrwn**	95:9
נגסוס	**ngsws**	70:5
נד	**nd**	88:5
נור	**nwr**	65:4; 67:2; 98:15; 101:15
נורי	**nwry**; see נרבוזיד בר [...]נבו, בר נורי, ארגיה בר נורי, בר נורי [...], and נורי.	
נוריאל	Nuriel	107:1
נטיא	**nṭyʾ**	107:1
נכיזורית	**nkyzwryt**	66:3
נרבוזיד בר נורי	**nrbwzyd** son of **nwry**	72:3
נרגין	**nrgyn**	72:4
נשבו	**nšbw**	99:24

ס

סגול	**sgwl**; see יבול בר סגול.	
סגניאל	Seganiel	66:2
סוריאל	Suriel	82:20(×2)
סיבול	**sybwl**; see יבול בר סיבול.	
סיגול	**sygwl**; see also יבול בר סיגול and איבול בר סיגול.	66:2
סיסא	**sysʾ**	87:9
סלמסוס	**slmsws**	99:10
סמא	**smʾ**	99:10

סםנגיאל	Sasangiel	66:3
ססס	sss	88:5
ססססססס	sssssss	97:8
סעור	sʿwr	109:6
סרבי	srby	99:10

ע

עורביד	ʿwrbyd	113:6; 114:10; 115:4
עזזיאל	ʿAzaziel	100:8
עזיזיאל	ʿAziziel	99:21
עזריאל	ʿAzriel	91:10; 92:10; 93:10
עלי	ʿly	113:7; 114:11; 115:6
עליהי	ʿlyhy	113:7; 114:11; 115:6

פ

פאלחס	Palḥas; see also פלחס.	86:4
פדי	pdy	88:5
פדין	pdyn	61:7
פזרהיא	pzrhyʾ	62:1
פלחדד	Palḥadad; see also פלחדוד.	81:3; 82:14; 84:6; 85:16
פלחדוד	Palḥadod; see also פלחדד.	86:4
פלחס	Palḥas; see also פאלחס.	81:3; 82:14; 83:5; 84:6
פתחיאל	Patḥiel	73:8

צ

צבאת צבאות	Sabaoth ("of hosts"); see also יהוה צבאת and יהוה צבאות שמו.	73:4; 102:9; 103:10, 11; 104:4, 5
צדיקא	ṣdyqʾ	113:6; 114:11; 115:5

LIST OF DIVINE NAMES, NAMES OF ANGELS, DEMONS AND EXEMPLARY FIGURES, AND NOMINA BARBARA

צורבין	ṣwrbyn; see also צורבן.	65:4; 67:2
צורבן	ṣwrbn; see also צורבין.	98:15; 101:15
צו[...]גיא	ṣw[...]gyʾ	95:10
צידן	ṣydn	90:4
צצלה	ṣṣlh	88:5
צצצץ	ṣṣṣṣ	99:26
ק		
קיטותיה	qyṭwtyh	66:5
קים	qym	77:4
קין קאין קיין	Cain (first son of Adam and Eve)	73:7; 76:9; 79:9; 118:6
קליא	qlyʾ	107:1
ר		
ראשה	rʾšh	113:6, 7; 114:11(×2); 115:5, 6
רבה	rbh	113:6; 114:11; 115:5
רוני	Roni	103:11
ריון בר זנך	See אריון בר זנך.	
רמסין	rmsyn	73:3; 75:3; 76:5; 79:5; 80:4
רפאל רפואל	Raphael	100:8; 114:13
רצר	rṣr	90:4
ש		
שבישא	šbyšʾ	77:2
שדי	Shaddai; see also אל שדי.	104:5
שיר	šyr; see also šr.	87:7; 88:4; 102:3; 103:7

שלמה שלומה שלמא שלמוה	Solomon (Biblical king of Israel)	70:7, 9; 73:10; 86:9; 91:5; 92:6; 93:6; 94:6; 95:6; 96:4; 98:13; 99:17; 100:3; 101:13; 102:3; 103:8; 104:2; 105:5; 106:5; 107:4; 108:6; 109:2–3; 110:4; 119:1
שמדי	See אשמדי.	
שמדיא	See אשמדי.	
שפר[...]	špr[...]	103:14
שר	šr; see also šyr.	104:1
ת		
תקין	tqyn	71:3; 74:4

Unknown first letter

[...] בר נורי	[...] son of **nwry**	68:4
[...]אל	[...]el	94:11
[.]אלמן	[.]'lmn	106:9
[...]ידי	[...]ydy	77:1
[...]ירן	[...]yrn	102:3
[...]מין	[...]myn; see also טורמין.	68:4
[...]רביי	[...]rbyy	108:7
[...]רן בר אדי	[...]rn son of 'dy; see also זברן בר אדי.	68:4
[...]שיל	[...]šyl	106:8

List of Clients and Adversaries

א

א[...] בר ח[...]	A[...] son of Ḥ[...]	75:5
אבאי בר מאמי	Abbay son of Māmay	86:1, 5, 7, 9
אבדאישו בר אח[...]	Abd-Īšū son of Aḥ[...]	116:4
אבה בר פועת	Abbā son of Puʿat	101:12, 14, 17
אבה בר אימא אבה בר אימה	Abbā son of Immā	79:1–2, 8
אבוי בר דידוך	Avūy son of Dēdukh	108:2
אבי בר דאדי	Avī son of Dāday; see also דאדי בת אחתא.	106:3
אבימרי בר משרשיתא	Avīmārī son of Mešaršīṯā	115:2, 7
אברהם בר אדרדוך אברהם בר אדרידוך	Abraham son of Ādar(e)dukh	104:1, 5, 8, 16
אדרדוך אדרידוך	Ādar(e)dukh; see אברהם בר אדרדוך.	
אדרוי	Ādarōy; see נרסוי בת אדרוי.	
אונדאס בר רשיונדוך אונדס בר רשיונדוך	Undas son of Rašewanddukh; see גונדאס בר רשיונדוך.	
אושעיה בר חתי	Ōšaʿyā son of Ḥāṯay	65:8
אח[...]	Aḥ[...]; see אבדאישו בר אח[...].	
אחא בר מחלפתא	Aḥā son of Maḥlaftā	79:2
אחא בר קאקאי אחא בר קאקי	Aḥā son of Qāqay	77:1, 3, 4(×2), 5
אחי בר גושנזדוך	Aḥay son of Gušnazdukh	89:2, 6, 13
אחת	Aḥāṯ; see בר אחת and מהוי בר אחת [...].	
אחת בת חתאי	Aḥāṯ daughter of Ḥāṯay, wife of אבה בר פועת.	101:12, 14, 17
אחתא	Aḥāṯā; see דאדי בת אחתא.	

אחתא	Aḥātā; see רבא בר אחתא.	
אחתה בת בתחיי	Aḥātā daughter of Bat-ḥayyē, wife of גיי בת בתחיי; see also דאדי בת אחתא.	105:4; 106:4
אייא בת אימי	Ayyā daughter of Immī	116:5
אייה	Ayyā; see מחלפתא בת אייה.	
אילו	Ilu; see ארדוי בר אילו.	
אימא אימה	Immā; see אבה בר אימא.	
אימא	Immā; see בתחפשבא בת אימא.	
אימדבו	Immā-d-avū; see ארדוך בת אימדבו.	
אימי	Immī; see אייא בת אימי.	
אימי בת נישדוך	Immī daughter of Nišdukh	75:5
אסמנדוך	Asmāndukh; see יזדנקירד בר אסמנדוך.	
ארדוי בר אילו	Ardōy son of Ilu	65:8
ארדוי בר כורכשידוך	Ardōy son of Khwarkhšēddukh (nicknamed Gayay)	76:2–3, 7; 111:3
ארדוך בת אימדבו	Ardukh daughter of Immā-d-avū	119:3, 4
ארדי בר חובאי ארדי בר חובי	Arday son of Ḥubbay	98:5, 7, 12, 14, 17
ב		
בהמן בר [...]	Bahman son of [...]	69:1
בהמנדד בר דודי	Bahmandād son of Dūday	66:1
בוסי בר [...]	Būsay son of [...]	107:3
בוסתאי בת רביקא	Bustay daughter of Rebecca	86:5
בורזק בר דוכתביה	Burzaq son of Dukhtbeh	83:2
ביבי בת מחלפתא	Bībī daughter of Maḥlaftā; wife of פאפא בר הורמיזדוך.	91:2, 7, 8
ביזדד	Bayyazaddād; see גושני בת ביזדד.	

LIST OF CLIENTS AND ADVERSARIES

ביזדד בר גושני	Bayyazaddād son of Gušnay	68:1; 70:1, 8; 95:4, 8, 13; 110:5
ברני בר חובאי	Barānay son of Ḥubbay	99:1–2, 4, 19, 22
בתחיי	Bat̲-ḥayyē; see גי בר בתחיי.	
בתחיי	Bat̲-ḥayyē; see אחתה בת בתחיי.	
בתחפשבא בת אימא	Bat̲-ḥapšabbā daughter of Immā; wife of ברני בר חובאי.	99:2, 5, 19, 22–23
בתשהדי	Bat̲-sāhdē; see זבינתא בת בתשהדי.	
ג		
גדנא בר חאתוי	Gaddānā son of Ḥāt̲ōy	100:4–5, 7, 8
גונדס(פ) בר רשיונדוך אונדאס בר רשיונדוך אונדס בר רשיונדוך	Gundas(p) son of Rašewanddukh, Undas son of Rašewanddukh	92:2, 11; 93:3, 8, 9
גוריא בר מנבו גוריה	Guryā son of Mannevō	113:1–2, 10
גושנוי	Gušnōy; see דוכתנשה בת גושנוי.	
גושנזדוך	Gušnazdukh; see נני בת גושנזדוך and אחי בר גושנזדוך.	
גושנזדוך בת סהדוי	Gušnazdukh daughter of Sāhdōy	87:6
גושני בת ביזדד	Gušnay daughter of Bayyazaddād	70:2
גושנצפפרי	Gušnaṣp-frī; see דוכתביה בת גושנצפפרי.	
גיא	Gaya, son of [...] בהמן בר	69:1
גי בר בתחיי	Gayye son of Bat̲-ḥayyē	105:4; 106:3–4
גיי	Gayay; nickname of ארדוי בר כורכשידוך	
ד		
דאדי בת אחתא	Dāday daughter of Aḥāt̲ā; see also חפשבה, אבי בר דאדי, [...]ו אחתה בת בתחיי, and בני דאדי.	106:2
דודי	Dūday; see בהמנדד בר דודי.	
דוכתביה	Dukhtbeh; see בורזק בר דוכתביה.	

דוכתביה	Dukhtbeh; see סימרו כוסב[.].רו בר דוכתביה	
דוכתבי בת גושנספפרי	Dukhtbeh daughter of Gušnasp-frī; wife of פרוך בר רשיונדוך	72:2, 6
דוכתי בת הורמיזדוך	Dukhtay daughter of Hormizdukh; wife of ביזדד בר גושני	70:1–2, 7–8, 8; 110:5
דוכתנשה בת גושנוי	Dukhtānšāh daughter of Gušnōy	103:1, 4, 7, 12
דותי בת פדדוס	Dūtay daughter of Pidaddōs	82:2–3, 12, 15, 17, 18, 20
דידוך	Daydukh; see כפני בר דידוך and אבוי בר דידוך.	
ה		
הורמיזדוך	Hormizdukh; see דוכתי בת הורמיזדוך.	
הורמיזדוך	Hormizdukh; see מיהרקן בר הורמיזדוך.	
הורמיזדוך	Hormizdukh; see פאפא בר הורמיזדוך.	
ז		
זבינתא בת בתשהדי	Zəvīntā daughter of Baṯ-sāhdē, wife of ארדי בר חובאי	98:5–6, 7, 12, 14, 17
ח		
ח[...]	Ḥ[...]; see א[...] בר ח[...].	
חאתוי	Ḥāṯōy; see גדנא בר חאתוי.	
חובאי חובי	Ḥubbay; see ארדי בר חובאי.	98:5, 7
חובאי	Ḥubbay; see ברני בר חובאי.	99:2
חיצקיל בר מאמי	Ḥiṣqīl son of Māmay	102:2, 4–5, 10
חפשבה	Ḥapšabbā; see חפשבה בני דאדי[...].	
חתאי	Ḥāṯay; see אחת בת חתאי.	
חתי	Ḥāṯay; see אושעיה בר חתי.	
י		
יויעי יועיי	Yōyay; see ריקיתא בת יויעי.	
יויתא	Yāwīṯā; see כורכשידוך בת יויתא.	

LIST OF CLIENTS AND ADVERSARIES

יזדנקירד בר אסמנדוך	Yazdānqerd son of Asmāndukh	117:7
כ		
כוכבוד בר קאקי	Khōkhbūd son of Qāqay	87:6
כורכשידוך	Khwarkhšēddukh; see ארדוי בר כורכשידוך.	
כורכשידוך בת יויתא	Khwarkhšēddukh daughter of Yāwīṯā	111:3
כורכשידוך בת מירדוך כורשדיך בת מירדוך	Khwar(kh)šēddukh daughter of Mirdukh	118:1(×2)
ככור	Kakkōr; see מנבו בת ככור.	
ככר	Kakkār; see ריבקא בת ככר.	
כפני בר דידוך	Kafnay son of Dēdukh	108:2–3, 4–5, 5–6
מ		
מאכוסרו בר מדוך	Mākhusrō son of Mādukh	73:1, 5, 9; 96:5, 7
מאמא בת ש[...]י	Māmā daughter of Š[...]y	104:16
מאמי	Māmay; see אבאי בר מאמי.	
מאמי	Māmay; see חיצקיל בר מאמי.	
מדוך	Mādukh; see מאכוסרו בר מדוך.	
מהדוך בת ניונדוך	Māhdukh daughter of Nēwāndukh	92:3, 7, 11; 93:1, 3, 8, 9; 94:3, 8
מהוי	Māhōy; see מישכוי בת מהוי.	
מהוי בר אחת	Māhōy son of Aḥāṯ	80:1
מושכוי בת מהוי	Muškōy daughter of Māhōy	81:4
מחלפתא בת איה	Maḥlaftā daughter of Ayyā	79:2(×2); 8
מחלפתה	Maḥlaftā, wife of בהמנדד בר דודי.	66:1
מחלפתא	Maḥlaftā; see ביבי בת מחלפתא.	
מחלפתא	Maḥlaftā; see נוכריתא בת מחלפתא.	
מיהרנהיד	Mihranāhīd; see שכרוי בת מיהרנהיד.	

מיהרקן בר הורמיזדוך	Mihraqān son of Hormizdukh	114:2, 8
מירדוך בת שהרינדוך	Mirdukh daughter of Šahrēndukh; see also כורשידוך בת כורשדוך בת מירדוך/מירדוך.	118:1, 4
מיריה	Mireh; see תילולא בת מיריה.	
מנבו	Mannevō; see גוריא בר מנבו.	
מנבו בת כבור	Mannevō daughter of Kakkōr	113:2, 10
מרגניתא מרגניתה	Margānīṯā; see פרנק בת מרגניתא.	
מרי	Mārī, son of [...] בר בהמן	69:1
מרי בר מחלפתא	Mārī son of Maḥlaftā	79:2
מרים	Miriam; see קאקאי בת מרים.	
מרקונתא בת [...]	Marqōntā daughter of [...]	107:3
משרשיתא	Mešaršīṯā; see אבימרי בר משרשיתא.	
נ		
נאנא	Nānā; see בר נאנא [...].	
נודוך	Nēwdukh (or possibly Nowdukh); see רסי בר נודוך.	
נוכריתא בת מחלפתא	Nukhraytā daughter of Maḥlaftā	102:1–2, 5, 11
ניונדוך	Nēwāndukh; see מהדוך בת ניונדוך.	
נישדוך	Nišdukh; see אימי בת נישדוך.	
נני בת גושנזדוך	Nānay daughter of Gušnazdukh	89:2, 6, 13
נרסוי בת אדרוי	Narsōy daughter of Ādarōy	73:2, 5–6
ס		
סהדוי	Sāhdōy; see גושנזדוך בת סהדוי.	
סימרו כוסב[.]רו בר דוכתביה	Simro Khusb[.]ro son of Dukhtbeh (nicknamed Farrokh-dād)	90:1

LIST OF CLIENTS AND ADVERSARIES

פ		
פאפא בר הורמיזדוך	Pāpā son of Hormizdukh	91:1–2, 7, 8, 11
פדדוס	Pidaddōs; see דותי בת פדדוס.	
פועת	Puʿat; see אבה בר פועת.	
פרוך בר רשיונדוך פרוך בר רשונדוך פרוך בר רשונדוכת	Farrokh son of Rašewanddukh(t)	72:1, 5; 81:1; 84:3, 7
פרוכדד	Farrokhdād; nickname of סימרו כוסב[.]רו בר דוכתביה	
פרנק בת מרגניתא פרנק בת מרגניתה	Farnaq (Farnak) daughter of Margānītā, wife of מיהרקן בר הורמיזדוך	114:3, 9
ק		
קאקאי בת מרים קאקי בת מרים	Qāqay daughter of Miriam, wife of גדנא בר חאתוי.	100:5, 7, 8
קאקאי קאקי	Qāqay; see אחא בר קאקאי.	
קאקה	Qāqā	108:1, 2
קאקי	Qāqay; see כוכבוד בר קאקי.	
ר		
רבא בר אחתא רבה בר אחתא	Rabbā son of Aḥātā	88:1, 3
רביקא	Rebecca; see בוסתאי בת רביקא.	
ריבקא בת ככר	Rebecca daughter of Kakkār	86:5
ריקיתא בת יויעי ריקתא בר (!) יועיי	Riqita daughter of Yōyay	88:1, 3
רסי בר נודוך	Rasay son of Nēwdukh (or possibly Nowdukh)	109:2
רשיונדוך רשודוך	Rašewanddukh; see גונדאס בר רשיונדוך.	
רשיונדוך רשונדוכת	Rašewanddukh; see פרוך בר רשיונדוך.	

ש		
ש[...]י	Š[...]y, see מאמא בת ש[...]י.	
שהרינדוך	Šahrēndukh; see מירדוך בת שהריבדוך.	
שכרוי בת מיהרנהיד	Šakarōy daughter of Mihranāhīd	85:2–4, 14–15, 17; 97:2, 7
ת		
תילולא בת מיריה	Tilula daughter of Mireh	90:1–2
Unknown first name:		
[...] בר אחת	[...] son of Aḥāṯ	67:5
[...] בת דרידוך	[...] daughter of Daredukh	77:1
[...] בר נאנא	[...] son of Nānā	74:1
[...] בת רושתפרי	[...] daughter of Roštafrī	67:5
[...]חפשבה בני דאדי	[...]-ḥapšabbā children of Dāday	106:2–3

List of Biblical Quotations

Gen 27:28 (TO) 65:9–10; 67:6; 95:14–15; 98:18; 101:18
Gen 49:18 87:9–10

Ex 3:14 65:7; 95:12; 98:16–17; 101:16; 102:9; 104:5
Ex 3:15 65:7; 67:4; 95:12; 98:17; 101:17
Ex 14:31 116:6–7

Num 9:23 73:8; 75:7–8; 103:6
Num 12:13 108:9

Is 6:3 116:10–11
Is 12:3 90:5–6
Is 40:31 65:7–8; 67:4–5; 95:12; 98:17; 101:17
Is 50:11 113:8–9; 114:12–13
Is 60:11 65:9; 67:5–6; 95:14; 98:17–18; 101:17–18

Zech 3:2 67:7–8; 103:6; 104:16–17; 108:8; 109:4–5

Ps 55:8 103:14
Ps 55:9 109:6
Ps 91:7 103:14
Unknown Targum Ps 114:3 116:9
Ps 121:7–8 67:6–7
Ps 125:2 113:9–10

List of Texts

Hebrew Bible
Ex 28 158
Is 47:4 20, 26, 131, 144, 156, 188
Is 60:11 17
Dan 4:10, 14, 20 97

Targumim
TO Gen 27:28 17
TO Lev 26:16 188
TO Deut 28:65 188
TPs-J Deut 28:65 188
Targum of Psalms 91:7 162

Dead Sea Scrolls
1QapGen 2:1, 16 97

Amulets and Geniza texts
AMB Amulet 1 17
AMB Amulet 2 17
AMB Amulet 12 17
MSF Amulet 21 17
MSF Amulet 22 17

Magic bowls (bold indicates main edition in this volume)
Abousamra 2010 186
Allard Pierson Museum bowl 87
AMB Bowl 1 53
AMB Bowl 3 17
Anonyme Privatsammlung Deutschland 209
BLMJ 10372 17
CAMIB 23A 42, 192
CAMIB 56A 87
CAMIB 83M 114
CSIB 17 95, 97
CSIB 25 95, 97
CSIB 35 95, 97
CSIB 39 95
Davidovitz 2 42
Davidovitz 24 219, 224
Davidovitz 46 9
Deutsch 6 17
Gordon 11 33
Gordon B 188
Gordon E 87
Gordon H 17
HS 3041 + hs 3070x 158
IM 142131 209
JBA 1 8, 114
JBA 2 114
JBA 3 114
JBA 4 114
JBA 5 8, 114
JBA 6 114
JBA 7 114
JBA 9 114
JBA 15 65, 115, 121, 127
JBA 18 65, 114
JBA 19 65, 203
JBA 21 209
JBA 23 17, 201
JBA 24 8, 65, 201
JBA 25 138, 166
JBA 26 87–89, 114
JBA 27 8
JBA 29 115
JBA 30 115, 149
JBA 31 8
JBA 32 8
JBA 34 8, 17
JBA 36 8
JBA 37 17, 115, 127
JBA 43 201
JBA 44 42
JBA 46 8, 201
JBA 47 188, 219
JBA 48 8, 191
JBA 52 167
JBA 53 167
JBA 54 91, 131, 144, 156, 167, 191
JBA 55 167, 195
JBA 59 17
JBA 62 8, 65
JBA 63 191
JBA 65 2, 17–18, **19–21**, 57–58, 62, 114–115, 131, 144, 201
JBA 66 17–18, **22–24**, 33
JBA 67 17–18, 20, **25–27**, 33, 114–115
JBA 68 17–18, **28–29**, 33, 36, 42, 47, 53, 55, 58, 62, 227
JBA 69 17–18, **30–31**
JBA 70 17–18, 23, **32–35**
JBA 71 3, 17–18, **36–37**, 53, 55
JBA 72 17–18, **38–39**
JBA 73 9, 18, 33, **40–43**, 47, 50, 58, 62, 115, 137, 180, 203, 221, 227
JBA 74 3, 17–18, **44–45**, 53
JBA 75 3, 18, 42, **46–48**, 227
JBA 76 9, 18, 42, **49–51**, 82, 201, 203
JBA 77 18, **52–54**, 114
JBA 78 17–18, 36, **55–56**
JBA 79 3, 17–19, 42, 47, **57–60**
JBA 80 3, 18, 58, **61–62**
JBA 81 65, **67–69**, 71, 73, 75, 78
JBA 82 65, 68, **70–72**, 78
JBA 83 68, **73–74**
JBA 84 65, 68, **75–76**, 78
JBA 85 65, 68, **77–79**, 81
JBA 86 50, 65, **80–83**
JBA 87 87, **88–89**
JBA 88 71, 87–88, **90–92**, 114, 140, 158
JBA 89 95, **96–98**
JBA 90 101, **102–103**
JBA 91 114–115, **116–119**, 127, 152
JBA 92 114–115, 118, **120–122**, 124, 127
JBA 93 114–115, 118, 121, **123–125**
JBA 94 65, 114–115, 118, **126–128**, 192
JBA 95 17, 20, 114–115, **129–136**, 138, 144, 156, 201
JBA 96 18, 40, 114–115, **137–139**
JBA 97 92, 114–115, **140–141**
JBA 98 17, 20, 101, 114–115, 117, 130–131, **142–145**, 154, 156
JBA 99 114–115, 117, 121, 138, 144, **146–150**
JBA 100 114–115, **151–153**
JBA 101 17, 114–115, 131, 144, **154–156**
JBA 102 114, 158, **161–163**
JBA 103 158–159, **164–168**, 211
JBA 104 53, 114, 158, **169–176**
JBA 105 9, 42, 178, **179–181**, 182, 201, 203, 221
JBA 106 178, 180, **182–183**
JBA 107 186, **187–189**, 201
JBA 108 186, **190–193**
JBA 109 186, **194–196**
JBA 110 17–18, 186, **197–198**
JBA 111 9, 18, 42, 180, 201, **202–204**, 221
JBA 112 **205–206**
JBA 113 8, 114, 167, 209, **210–211**
JBA 114 114, 209, **212–213**
JBA 115 209, **214–215**
JBA 116 8–9, 42, 95, 121, 180, 203, 219, **220–223**
JBA 117 114, 219, **224–225**
JBA 118 42, 219, **226–227**
JBA 119 219, **228–229**
JNF 8 65, 81
JNF 9 180
JNF 10 222
JNF 33 53
JNF 36 114–115
JNF 45 138
JNF 54 186
JNF 84 65, 81
JNF 88 158, 170
JNF 89 158
JNF 91 17
JNF 96 209
JNF 98 17
JNF 102 114
JNF 108 18
JNF 110 114
JNF 121 158, 170
JNF 122 9
JNF 123 186–187
JNF 132 219
JNF 145 18
JNF 146 18, 46–47
JNF 151 219
JNF 154 17, 23
JNF 156 209
JNF 162 186–187
JNF 163 186–187
JNF 170 209
JNF 171 87–88
JNF 172 209
JNF 173 209
JNF 175 209
JNF 176 209
JNF 178 18, 23

JNF 180 209
JNF 187 18
JNF 197 209
JNF 239 162
JNF 254 197
JNF 262 17
JNF 269 209
JNF 278 17
JNF 291 209
JNF 311 219
Louise Michail Collection Bowl 1 65
M 1 222
M 6 158–159, 166
M 9 209
M 10 209
M 15 114–115, 149
M 59 18, 201, 203
M 110 17
M-K 33b 95
Montgomery 4 162
Montgomery 6 17, 42
Montgomery 19 95, 178
Montgomery 34 178
MS 1927/9 121
MS 1927/10 87–88, 114
MS 1927/21 18, 58
MS 1927/30 201
MS 1927/34 178
MS 1927/41 201
MS 1927/44 140
MS 1927/49 9, 201
MS 1927/60 201
MS 1927/62 18, 42
MS 1928/31 107
MS 1928/49 101
MS 2053/2 18
MS 2053/11 87
MS 2053/23 9, 111
MS 2053/28 114
MS 2053/32 107
MS 2053/63 23, 101
MS 2053/74 18
MS 2053/80 18, 167

MS 2053/85 65
MS 2053/99 87, 107
MS 2053/102 18
MS 2053/116 115
MS 2053/134 87, 107
MS 2053/146 114
MS 2053/148 17–18
MS 2053/152 95
MS 2053/161 65
MS 2053/169 107
MS 2053/177 18
MS 2053/179 201
MS 2053/182 87
MS 2053/197 158
MS 2053/198 18
MS 2053/199 201
MS 2053/219 90
MS 2053/222 219
MS 2053/223 58, 111
MS 2053/247 87, 90–92
MS 2053/252 111, 158, 201
MS 2053/261 201
MS 2053/278 111
MS 2054/6 114
MS 2054/40 87
MS 2054/93 166
MS 2054/101 114
MS 2054/124 8
MS 2055/5 186
MS 2055/10 53, 114
MS 2055/13 114
MS 2055/14 178
MS 2055/26 91, 95, 97
MSF Bowl 14 17
MSF Bowl 15 219
MSF Bowl 22 158–159, 167
MSF Bowl 25 91
PC 19 8
PC 33 162
PC 34 162
PC 35 162
PC 44 158
PC 85 209

PC 89 158
PC 90 158
PC 91 158, 170
PC 92 158
PC 93 158
PC 104 114
PC 109 65
PC 114 186–187
PC 122 87–89
PC 128 114–115, 127
SD 22 209
SD 30 17
SD 33 18, 219, 227
SD 34 17
SD 58 191
VA 3854 42
Wolfe 5 17
Wolfe 78 18, 58, 219, 227
Wolfe 105 158
YBC 2364 42

Babylonian Talmud
BT MQ 28a 114

Other texts
1 Enoch 10:7, 9 97
Gy 174:12–13 222
P Deut 28:65 188
Pyramid Texts of Unis, Spell 302 219

Other manuscripts
DC 19 114
DC 35 17
DC 37 42, 87, 114, 158
DC 40 111
DC 43B 114
DC 43C 158
DC 43D 53
DC 44 87, 111
DC 52 87
Gollancz Codex A 111

List of Published Works in the Manuscripts in the Schøyen Collection Series

MSC 1 — *Buddhist Manuscripts in the Schøyen Collection I*, ed. J. Braarvig, J.-U. Hartmann, K. Matsuda, L. Sander. Oslo, 2000.

MSC 2 — *Coptic Papyri I. Das Matthäus-Evangelium im mittelägyptishen Dialekt des Koptischen (Codex Schøyen)*, H.-M. Schenke. Oslo, 2001.

MSC 3 — *Buddhist Manuscripts in the Schøyen Collection II*, ed. J. Braarvig, P. Harrison, J.-U. Hartmann, K. Matsuda, L. Sander. Oslo, 2002.

MSC 4 — *Medieval Seal Matrices in The Schøyen Collection*, R. Linenthal and W. Noel. Oslo, 2004.

MSC 5 — *Papyri Graecae (Schøyen I)*, R. Pintaudi, in: Papyrologica Florentina, vol. XXXV. Firenze, 2005.

MSC 6 — *A Remarkable Collection of Babylonian Mathematical Texts*, J. Friberg, in: Sources and Studies in the History of Mathematics and Physical Sciences. New York, 2007.

MSC 7 — *The Crosby-Schøyen Codex MS 193 in The Schøyen Collection (Coptic papyri II)*, ed. J.E. Goehring. Louvain, 1990.

MSC 8 — *Codex Sinaiticus Zosimi rescriptus*, A. Desreumaux, in: Histoire du texte Biblique 3. Lausanne, 1997.

MSC 9 — *Das Liesborner Evangeliar, The Schøyen Collection*, Oslo/London, MS 40, E. Overgaauw and B. Priddy. Warendorf, 2003.

MSC 10 — *L'Évangile selon Matthieu d'après le papyrus copte de la Collection Schøyen, analyse littéraire*, M.-É. Boismard, O.P. (Coptic papyri III) in Cahiers de la revue Biblique. Paris, 2003.

MSC 11 — *Sumerian Proverbs in The Schøyen Collection*, B. Alster. Bethesda, MD, 2007.

MSC 12 — *Buddhist Manuscripts in the Schøyen Collection III*, general editor: J. Braarvig. Oslo, 2006.

MSC 13 — *Babylonian Tablets from the First Sealand Dynasty in The Schøyen Collection*, S. Dalley. Bethesda, MD, 2009.

MSC 14 — *Babylonian Literary Texts in The Schøyen Collection*, A.R. George. Bethesda, MD, 2009.

MSC 15 — *Papyri Graecae (Schøyen II)*, D. Minutoli and R. Pintaudi. Firenze, 2010.

MSC 16 — *The Lexical Texts in the Schøyen Collection*, M. Civil. Bethesda, MD, 2010.

MSC 17 — *Traces of Gandharan Buddhism: An Exhibition of Ancient Buddhist Manuscripts in the Schøyen Collection*, J. Braarvig and F. Liland. Oslo and Bangkok, 2010.

MSC 18 — *Cuneiform Royal Inscriptions and Related Texs in the Schøyen Collection*, A.R. George with contributions by M. Civil, G. Frame, P. Steinkeller, F. Vallat, K. Volk, M. Weeden and C. Wilcke. Bethesda, MD, 2011.

MSC 19 — *Codex Schøyen 2650: A Middle Egyptian Coptic Witness to the Early Greek Text of Matthew's Gospel*, J.M. Leonard. Leiden, 2014.

MSC 20 — *Aramaic Bowl Spells, Jewish Babylonian Aramaic Bowls, volume 1*, S. Shaked, J.N. Ford and S. Bhayro. Leiden, 2013.

MSC 21 — *Babylonian Divinatory Texts Chiefly in The Schøyen Collection*, A.R. George. Bethesda, MD, 2013.

MSC 22 — *Mesopotamian Incantations and Related Texts in The Schøyen Collection*, A.R. George. Bethesda, MD, 2016.

MSC 23 — *Gleanings from the Caves. Dead Sea Scrolls and Artefacts from The Schøyen Collection*, ed. T. Elgvin, K. Davis and M. Langlois. London, 2016.

MSC 24 — *MS Dhammacetiya: Buddhist Relics. A Journey through ASEAN 2015–2016*, ed. S. Saenkhat. Bangkok, 2016.

MSC 25 — *Assyrian Archival Texts in the Schøyen Collection and Other Documents from North Mesopotamia and Syria*, A.R. George, T. Hertel, J. Llop-Raduà, K. Radner and W.H. van Soldt. Bethesda, MD, 2017.

MSC 26 — *Buddhist Manuscripts in The Schøyen Collection IV*, general editor J. Braarvig. Oslo, 2016.

MSC 27 — *Sumerian Administrative and Legal Documents ca. 2900–2200 BC in The Schøyen Collection*, V. Bartasch. Bethesda, MD, 2017.

MSC 28 — *Lilith's Hair and Ashmedai's Horns. Figure and Image in Magic and Popular Art: Between Babylonia and Palestine in Late Antiquity*, N. Vilozny. Jerusalem, 2017.

MSC 29 — *Old Babylonian Texts in the Schøyen Collection. Part I: Selected Letters*, A.R. George. Bethesda, MD, 2018.

MSC 30 — *Sumerian Religious Poetry in the Schøyen Collection.*, C. Metcalf. University Park, PA, 2019.

MSC 31 — *Ur III Texts in the Schøyen Collection.*, J.L. Dahl. University Park, PA, 2020.

MSC 32 — *The Schøyen Collection, Ian Fleming/James Bond. A Catalogue*, J. Gilbert. Royal Tunbridge Wells, 2020.

LIST OF PUBLISHED WORKS IN THE MANUSCRIPTS IN THE SCHØYEN COLLECTION SERIES

MSC 33 *Old Babylonian Texts in the Schøyen Collection. Part 2: School Letters, Model Contracts and Related Texts*, A.R. George and G. Spada. University Park, PA, 2019.

MSC 34 *The Saga of a Legendary Collection of World Heritage Manuscripts*, M. Schøyen. Oslo, 2020.

MSC 35 *Incunables from The Schøyen Collection*, P. Needham. New York, 1991.

MSC 36 *The History of Western Script I. Sixty Important Manuscript Leaves from The Schøyen Collection*, T. Bolton and C. de Hamel. London, 2012.

MSC 37 *The History of Western Script II. Important Antiquities and Manuscripts from The Schøyen Collection*, K. Sutton and E. Donadoni. London, 2019.

MSC 38 *Shakespeare and Goethe. Masterpieces of European Literature from The Schøyen Collection*, M. Ford and M. Wiltshire. London, 2019.

MSC 39 *The History of Western Script III. A Selection from The Schøyen Collection, in Celebration of the Collector's Eightieth Birthday*, T. Bolton. London, 2020.

MSC 40 *Henrik Ibsen. Norske og danske trykte utgaver 1850–1906. Tekst og bindvarianter*, M. Schøyen. Oslo, 2021.

For more details, see www.schoyencollection.com.

Index

Aaron 158
abbreviations 140
abstinence 5
Achaemenid period 1
Ahasuerus 1
Aḥiqar 127
Akkadian 9, 114, 130
al-Bīrūnī 5–7
amulets
 shaped like seals 2
Anāhīd 158
angels
 fallen 97
Arabic 97
assimilation of **d-** 68

Buddha 5

cartouche 70, 146, 182, 197
Christianity and Christians 5–8, 178
clients 7

Daniel, in lion's den 5
demons as promiscuous 114
dittography 186
divination 158
divorce bill 2, 219

economic magic 17
Egyptian Pyramid Texts of Unis 219
Elisur Bagdana 78, 219
Esther 1
Exile, Babylonian 4
Ezra 219

graphic errors 144, 152, 156
Greek 17, 23, 97

Haman 1
haplography 26, 186, 192, 195
High Priest 158
hypercorrection 144

Isaac, binding of 5
Islam 5–6

Jerusalem
 temple 4
Jesus Christ 5–6
Joshua bar Peraḥia 209, 219

Latin 209
legal documents 2
loanwords 17, 23, 65, 209

magic
 and religion 5
 dangerous 5
 in secret 5
Mandaic 8–9, 20, 29, 42, 53, 65, 71, 82, 87, 92, 107, 111, 114, 138, 149, 158, 162, 166–167, 221
Mani and Manichaeism 5–8
marriage of siblings 178
Middle Persian 4, 6, 65, 88
military terminology 149, 158
Mordechai 1

names of power 3–4

Ohrmazd 5
Old Turkish 6
Osiris 219
ouroboros 80

pagans 8, 209
Pahlavi script 4

Parthian 6
Parthian period 1
phonetic spellings 90, 102, 127, 131, 162, 195, 226

qamaṣ represented by *waw* 47, 190
qeṭīl l- forms 198

reduction
 of -*āʾā* 61
 of *ʿayin* 18, 65, 90, 116, 121, 131, 144, 156, 161–162, 164, 197, 210–211, 220–221

sandhi spellings 42, 131, 144, 203
Sasanian period 1, 4–5
scribes 7
Seal of the Prophets 5–7
sexual sin 97
sexual threat 97
shift
 /a/ > /i/ 118
 /a/ > /u/ 192
Sogdian 6
Syriac 6, 8, 23, 53, 82, 91–92, 95, 97, 107, 111, 114, 121, 127, 138, 162, 167, 178, 180, 186, 197–198, 209, 221–222

Tabernacles 4
Turfan 6

Vashti 1
vowel loss 146

xwēdōdah 178

Zoroastrianism and Zoroastrians 5–8, 178, 209